Through the Crosshairs

War Culture

Edited by Daniel Leonard Bernardi

Books in this new series address the myriad ways in which warfare informs diverse cultural practices, as well as the way cultural practices—from cinema to social media—inform the practice of warfare. They illuminate the insights and limitations of critical theories that describe, explain and politicize the phenomena of war culture. Traversing both national and intellectual borders, authors from a wide range of fields and disciplines collectively examine the articulation of war, its everyday practices, and its impact on individuals and societies throughout modern history.

Through the Crosshairs

War, Visual Culture, and the Weaponized Gaze

ROGER STAHL

Rutgers University Press

New Brunswick, Camden, and Newark, New Jersey, and London

Library of Congress Cataloging-in-Publication Data

Names: Stahl, Roger, author.
Title: Through the crosshairs : war, visual culture, and the weaponized gaze / Roger Stahl.
Description: New Brunswick : Rutgers University Press, 2018. | Series: War culture | Includes
bibliographical references and index.
Identifiers: LCCN 2017053389 (print) | LCCN 2018018443 (ebook) | ISBN 9780813585277
(epub) | ISBN 9780813585284 (web pdf) | ISBN 9780813585260 (cloth : alk. paper) |
ISBN 9780813585253 (pbk. : alk. paper)
Subjects: LCSH: Mass media and war—United States. | War in mass media. | Popular
culture—United States. | War and society—United States.
Classification: LCC P96.W352 (ebook) | LCC P96.W352 U5575 2018 (print) |
DDC 303.48/3—dc23
LC record available at https://lccn.loc.gov/2017053389

∞ The paper used in this publication meets the requirements of the American National
Standard for Information Sciences—Permanence of Paper for Printed Library Materials,
ANSI Z39.48-1992.

www.rutgersuniversitypress.org

Manufactured in the United States of America

I'm guided by the beauty of our weapons.
—MSNBC anchor Brian Williams,
"tempted to quote the great Leonard
Cohen" when reviewing images of a 2017
U.S. missile strike on Syria

It is a terrorist song.
—Leonard Cohen discussing "First We
Take Manhattan" in a 1988 interview

What is perceived is already finished.
—Paul Virilio, *The Vision Machine*, 1994

Contents

Through the Crosshairs

1

A Strike of the Eye

It was a war between the watchers and the
watched.
—Kevin Robins

A peculiar image attended the birth of television broadcasting. In 1928, Ernst
Alexanderson, chief consulting engineer at General Electric's research and
transmission facilities in Schenectady, began experimental transmissions
from the tower of W2XAD. Among the handful of moving pictures first sent
through the airwaves was a remarkable sci-fi vignette of a missile as it headed
for downtown New York City. The image appeared from the perspective of a
camera housed in the missile's nosecone. In a separate room, journalists hov-
ered over octagonal screens described as "about the size of a postage stamp"
(three by three inches) scanning at sixteen lines and twenty-four frames per
second.[1] Through this diminutive window, the city rose up to meet their
eyes, stretching in all directions, until a dark screen announced the missile's
detonation.

General Electric's choice of material betrayed a tendency for the camera
to align with the weapon. A few years earlier at RCA's laboratories, Vladimir
Zworykin had imagined affixing his iconoscope, the first practical television
camera, to surveillance rockets much as the military had done with still cam-
eras.[2] The W2XAD broadcast effectively dramatized his vision for those
attending the historical event. This included a visitor from the British Royal
Air Force who remarked that such a weapon would be an interesting possibility
for future wars.[3] In the decades to come, science fiction indeed became science

fact. Not only did optically guided munitions invade the battlefield; these ways of seeing bled onto the public screen. At first, mass audiences received only scattered glimpses, issued through newsreels and television broadcasts, shot from the perspective of the bombardier and gunner. By the Persian Gulf War of the early 1990s, an entire nation huddled around the television, like those who had come to witness the first television broadcast, to watch missiles close in on targets through nosecone cameras. Thereafter, the pictures came faster and faster, arriving in rapid-fire bursts from guidance cameras, targeting systems, reconnaissance satellites, and drones. As the twenty-first century caught its stride, a new visual economy fully penetrated the Western mediasphere. Today, these grainy, gray-toned, half-minute weapon-cam clips—some dead silent, others perforated by the staccato of radio voices—seem to be everywhere. They scan the ground, strafe white-hot clusters of infrared bodies, and spurt great inky clouds of destruction. They star in military press conferences, loop in network news b-roll, spread virally across social media feeds, make cameos in action and sci-fi movies, and superimpose themselves on interactive panels in video games.

In 2016, the satirical news site the *Onion* correctly diagnosed this state of affairs with a story entitled "Obama Gently Guides Michelle's Hand as She Maneuvers Drone Joystick." The scenario mixed the romantic and the macabre for its comedic effect. In the photoshopped image, the first couple sits in front of a bank of control monitors, which illuminates them like a warm fireplace. They gaze longingly through the drone's targeting camera rather than at each other. Barack whispers sweetly into Michelle's ear. With the squeeze of a trigger, they dispatch a Hellfire missile via radio uplink on some luckless locale. Indeed, the marriage between the camera and our weapons of war has been thoroughly consummated in the intervening years since Alexanderson's broadcast, even to the point that it can stand up to parody. The *Onion*'s send-up is less about life in the exotic corridors of power, however, and more about everyday life in front of the screen. Michelle Obama's strange initiation might as well be our own. It is we who have absorbed the weapon-camera's point of view, and it is we who lean forward toward the crosshairs that indelibly mark our contemporary screens.

This seduction of the eye happened gradually as the electronic flotsam of the war machine accumulated. What seemed only the by-product of our most advanced targeting systems began to flicker across the collective visual field via official military public relations, leaks, and fictional entertainment. At a certain point, perhaps through sheer force of numbers, the view through the weapon itself earned a primary place in the presentation of war in the postindustrial West. These images, after all, wielded the ultimate strategic advantage in this skeptical age: the ability to bill themselves as unfiltered, unadulterated,

unprocessed, and unblinking—leftover artifacts of a technical process rather than calculated pieces of propaganda. Instead of staking a position in an adversarial argument, they presented themselves as the eye's most powerful ally, its ultimate prosthesis. Our defenses down, they invaded public consciousness to plant their flags with imperial bravado. There it is, each iteration seemed to say, the unfathomable essence of war in its rawest and most immediate form. And here we are, as fate would have it, not just on what the consensus has declared the "right side of history" but on the right side of the screen.

Although such images seem self-apparent, bureaucratic, and almost innocent, even the simplest questions invite more: Who issues them, through what channels, and to what advantage? How are they selected, and how selective are they? What are the processes by which they are captioned, interpreted, and narrativized? How do these practices of watching coalesce into civic rituals? And what kind of citizen-subject do these gazing rituals ultimately imply? In traversing this field of questions, this book contends first that the view through high-tech weapons has come to dominate the Western presentation of war. To a significant degree, the civic eye has migrated from the third-party witness to the first-person constituent of the weapon's gaze. Not only does the citizen increasingly apprehend war through this aperture, this gaze has become a powerful means through which the military-industrial-media complex apprehends civic consciousness—suspending it, as it were, in a projected beam of light. This realignment, what I will refer to throughout as the "weaponized gaze," is anchored in the imagery of the targeting camera. The process can be defined more broadly, however, as the range of discursive practices that channel the civic understanding of violent conflict through the military apparatus. This alignment serves a disciplinary function by displacing the civic impulse to deliberate matters of state violence with a presentation of the world through the uncritical, docile circuitry of the weapon, whose purpose is to be fired. Such invitations have proliferated in recent years, working to harmonize the citizen with the dictates of military public relations.

The progressive retooling of the civic eye has a history that extends back through the twentieth century and beyond. By way of introduction, we begin by sketching the battlefield marriage of eye and projectile, including the thematic threads that have bound the two historically. The next section tracks the moments in the twentieth century when this marriage began to go public, a series of signature images that paved the way for the mass exposure of the weaponized gaze. The chapter rounds out this discussion by offering a theoretical take on the role of these images in producing the citizen-subject. On the whole, this opening salvo is intended to soften up the target, to clear the conceptual way for the case studies in the following chapters, which begin with the smart bomb videos of the early 1990s and continue through the likes of the

satellite, drone, sniper, and helmetcam. Doing so will help us understand not only how we have come to see the world through these eyes but also possibilities for seeing otherwise.

If Looks Could Kill

Weapons have always functioned as communicative channels. The expression that a missile "sent a message" may seem like a recent by-product of information warfare, but the notion has been embedded in our language for a very long time. This dual sense is captured in the English word *missive* as well as in the Latin root of all three, *mittere*. Arguably, the ability to send a message has been the weapon's essential function from the invention of the spear forward. When hot, weapons perform a "show of force" beyond their capacity for instrumental violence. When cold, they radiate signals designed to deter, intimidate, and terrorize.

Beyond their symbolic function, weapons channel perception. Violence has always kept close quarters with vision in particular, a historical affinity that can also be detected in language and mythology. Until the sixteenth century, for example, the word *explode* (from the Latin *explaudere*) meant to clap someone off stage. The Renaissance introduction of black powder repurposed the term's logic of annihilation-through-visual-exposure. Suddenly the battlefield became the stage off of which one might be violently clapped. This equation appears in the fables of Swedish king Gustavus Adolphus, which include his instructions to his musketeers in the early 1600s not to fire until they "see their own image in the pupil of their enemy's eye."[4] Here the eye not only appears as target but also functions as a mirror (*pupil* as the "little person" reflected) that marks oneself as target. The mythology of the American Revolutionary War carried forth a version of this image when the generals of the rebel army at Bunker Hill supposedly ordered the insurgents to "not fire until you see the whites of their eyes." Later, Napoleon proved his fondness for the term *coup d'oeil* ("strike of the eye"), which military theorist Carl von Clausewitz picked up as a way to express the genius some generals display in glancing at a situation and, in *ein Augenblick*, issuing a strategic decision.[5] The English description of a target as a "bull's-eye" appeared in the language around the same time, suggesting that the shift to the supremacy of artillery, evident in Napoleon's conquests, demanded a more prominent role for terms that cast war as a contest of vision. In the following century, it became common to speak of *theaters of war*, a term first uttered by Winston Churchill in 1914 that helped to metaphorically transition the battlefield from stage to screen.[6] Now American soldiers commonly speak of "lighting up" a target, a colloquialism that again conflates exposure with annihilation, the act of illumination-by-spotlight with the act of destruction-by-projectile.

If vision and violence marched in tight formation, the same held true for their technological progeny, the camera and gun. Indeed, the two inventions indeed seem to have been composed of the same substance and separated at birth. George Eastman of Eastman Kodak adopted the methods of interchangeable parts gleaned from the gun industry. In 1885, the company developed flexible film by coating paper in the same guncotton (nitrated cellulose) widely used at the time as an explosive. A guncotton-based celluloid came about four years later, permitting a one-hundred-exposure film roll. Around the same time, in 1866, a French inventor working in the arms industry made the first smokeless gunpowder out of gelatinized guncotton, lowering the brisance of the explosive material so it could be used as a propellant. This paved the way for the development of cellulose-based cordite used in pin-fired rounds. As Paul S. Landau puts it, "Breech-loading guns and the Kodak Camera not only drew on the same language; they both sealed the same sort of chemicals in their cartridges."[7]

Later, the machine gun inspired the invention of the motion picture camera. The Gatling gun (revolving barrels) and the Colt (revolving magazine) gave Frenchman Jules Janssen the idea in 1874 to create a camera that could take a rapid series of pictures through time. Etienne-Jules Marey refined the technique for his flipbook-producing "chrono-photographic rifle," which—due to its wooden stock, sight, and oversized "barrel"—could have been mistaken for a gun.[8] Carl Akeley modeled his Akeley Pancake Camera, which was standard equipment in early twentieth-century motion pictures, quite explicitly on the machine gun and turret. His initial goal was to invent a weatherproof and portable instrument to accompany the hunting rifle on African safari trips, which George Eastman himself sometimes attended. Akeley eventually took his camera hunting but not before the Army Signal Corps took it to World War I. Well aware of the resemblances between his camera and the weapon, he liked to recount the story of a group of German soldiers who mistakenly surrendered to one of his cameras in France.[9]

One could continue listing such correspondences into infinity, but we ought to step back to ask what they tell us. Thankfully, much of the necessary conceptualizing has been done by media and social theorist Paul Virilio, whose work is absolutely key to orienting the current investigation. It is worth dwelling for a moment on his masterpiece, *War and Cinema*, which tracks this coevolution: both the inspiration of the weapon on camera development and the camera's deployment on the battlefield as a sighting and surveillance device. Virilio observes most elegantly: "Alongside the 'war machine,' there has always existed an ocular (and later optical) 'watching machine' capable of providing soldiers, and particularly commanders, with a visual perspective on the military action under way. From the original watch-tower through the anchored balloon to the reconnaissance aircraft and remote-sensing satellites, one and the same

function has been indefinitely repeated, the eye's function being the function of a weapon."[10] Out of this fusion has arisen the dictum, reflected in the words of Undersecretary of Defense W. J. Perry in the 1970s, that to see a target is to destroy it.[11] In his characteristically aphoristic style, Virilio reformulates this in the idea that light has always been the "soul of the gun barrel."[12] He points to the metaphors of light in the blitzkrieg, the monstrous flashbulb effects in the atomic bombing of Hiroshima, and, in general, the feverish application of optical machinery to the battlefield since the beginning.

In Virilio's view, therefore, the history of war has been a "history of rapidly changing fields of perception," a contest of optical power where parties vie for absolute authority through light speed and the perfection of battlespace awareness.[13] He is characteristically ahead of the curve in describing how technological advances in tracking systems have made literal the figural correspondences between the eye and the weapon. At the end of *War and Cinema*, published in 1984, he notes that in the new era of electronic warfare, the projectiles had awakened and "opened their many eyes": "The fusion is complete, the confusion perfect: nothing now distinguishes the functions of the weapon and the eye; the projectile's image and the image's projectile form a single composite . . . The old ballistic projection has been succeeded by the projection of light, of the electronic eye of the guided 'video' missile."[14] This passage foresees the centrality of optics in the "smart bomb" and the later era of the drone, where neologisms like "non-kinetic warfare" acknowledge target illumination to be as significant as the dark "kinetic" task of "putting warheads on foreheads."[15]

We endeavor here to extend some of Virilio's more compelling observations into the future that is now, but we must also mark a departure from his approach. He expends much of his attention on the camera's battlefield application, which takes the form of strategies, tactics, and logistics regarding surveillance, simulation, and dissimulation. His detours into the public arena are by comparison sparse and sporadic. When he does discuss military propaganda, he describes the cinematic camera as a weapon aimed at the civilian nervous system to build mythologies, aggregate attention, and manipulate morale. In Virilio's estimation, however, the two realms—battlefield vision and the process of catalyzing public opinion—never quite meet. It is as if they are two soldiers, back-to-back, firing their weapons at two different fronts. As such, his otherwise wide-ranging analysis never extends to the notion that the "soul of the gun barrel" might align its point of view with the soul of the public.

This is forgivable in the case of *War and Cinema*. The Persian Gulf War was still almost a decade off. Weapon's-eye footage had yet to take center stage through its use in military public relations, and the cultural discourse that would train the public eye to see war through the targeting lenses of the

war machine was still in its nascent stages. In Virilio's writing about the Persian Gulf War in 1991, however, we might expect the celebrated footage of the smart bomb closing in on a target, widely regarded as the war's iconic image, to be featured front and center. Remarkably it passes through his radar undetected. (In its place, he offers prognostications of the "virtual war" promised by semiautonomous weapons and the "pure weapon" portended by precision targeting capabilities.[16]) If he does connect the weapon's eye to the public eye, it is only through the suggestion that both were remotely controlled. He notes, for instance, that Desert Storm ended with Iraqis surrendering not to the end of an actual gun but to a drone camera, which found its parallel in the civilian surrender to a "television controlled entirely by the army."[17] Virilio never comes full circle, however, to ask what it means to feed the drone-camera image back to domestic populations through television or some other medium.

What occupies this blind spot where civic consciousness progressively merges with the flight path of the projectile? Do we find a phenomenological short-circuit? Might the collapse of the civic eye into the weapon signal a surrender in its own right? To be fair, Virilio at least unconsciously acknowledges this new arrangement. At one point in *Desert Screen*, a collection of interviews and essays concerning the 1991 Persian Gulf War, he digresses into the story of Bruno Gouvy, the "missile man" who attempted to break the human freefall speed record by "throw[ing] himself into the void of several thousand metres, his head and arms sunken into a warhead." Virilio asks, "What perversion is this . . . to simulate our own death, to become a bomb?"[18] It is a good question, especially in this postindustrial age of extremisms and exceptions. At least since the September 11 attacks, mobility itself has been recoded as a weapon, prompting the security state to surveille and tag every citizen as a potential suicide bomber. The profusion of weapon's-eye footage plays a lead role in this discourse where, as Jeremy Packer puts it, we all are "becoming bombs."[19] Repeated invitations to peer through the eyes of the state war machine have, one might say, crammed us inside the warhead like so many missile men. The visual apparatus through which the state exacts violence has in some sense become our vision. "Either you are with us or with the terrorists," President George W. Bush famously announced to applause in the Joint Session of Congress speech following 9/11.[20] He might as well have declared, "You are either our bomb or theirs."

Gearing Up the Public

Whether or not we identify with the bomb itself, the presentation of weapons has long been a powerful mediator of citizen identity. As H. Bruce Franklin argues, weapons are products of the American imagination as much as the

arms industry. From the World War II bomber to Ronald Reagan's fanciful Strategic Defense Initiative, they function as symbolic catalysts of ideology. A case in point is the atomic bomb and its attendant doctrine of mutually assured destruction, whose madness trickled down as an undiagnosed mass psychosis in the guise of everyday common sense.[21] The Bomb was not just a bomb, in other words, but also functioned as a conduit through which the Cold War manifested, including popular speculation regarding national purpose, human nature, the mandates of technology, and global eschatology.[22] The names of our weapons, too, help to prime the public for their use. From Minuteman to Patriot, they play a key role in addressing one of the greatest human taboos—namely, killing another person. This ever-changing lexicon structures death and violence according to the needs of the time, whether they be retributive, memorial, stabilizing, or expansionist.[23]

In our image-saturated age, the visual presentation of the weapon has become its most salient dimension. Prior to this saturation, which coincided with the historical point when smart weapons began to open their many eyes, public vision had already been weaponized to a degree. Such habits of vision played out on a grand scale even before the invention of the camera and at least as far back as when the "cartographic God's eye" propelled European colonialism.[24] The arrival of the nineteenth-century fad of the cyclorama museum accommodated public vision on a more intimate scale. Growing out of the aesthetics of panoramic painting, these public installations took their subject matter to be great military battles in virtually every case, excepting the odd crucifixion scene. (The two surviving U.S. cycloramas, the Battle of Atlanta and the Battle of Gettysburg, can both be visited *in situ* today.) These monuments stood not simply as representations of war but as public rituals of battlefield immersion that threaded the civic eye through the foot soldier's.

As a feature of electronic media, the trope of the weaponized gaze began to populate culture at the beginning of the twentieth century, particularly as the weapons took to the skies. The year 1921 marked the first time that millions of American theatergoers witnessed an aerial view of a bombing. The footage came courtesy of General Billy Mitchell, regarded as the father of the modern U.S. Air Force. Following in the footsteps of Italian general Guilio Douhet, Mitchell sought to proselytize the gospel that the future belonged to air power. To do this, he staged and filmed, using new high-resolution film technology from Eastman Kodak, the aerial bombing and sinking of a captured "unsinkable" German warship in the Chesapeake Bay.[25] In these extraordinary newsreels, biplanes circle, bomb bays yawn open into the daylight, and payloads, gleaming angelically, fall away toward the doomed ship.[26] This watershed moment played a role in shifting national faith from naval to air power, but it also comprised a collective training exercise in reimagining national subjectivity through the eyes of this ascendant weapon.

The aesthetic intensified during World War II. French author and pilot Antoine Saint-Exupery captured the new way of seeing in his famous writings on the view from his bomber, describing himself as an "icy scientist" looking through "crystal frames in a museum" at the people below, who appear as so many "protozoa on a microscopic slide."[27] This meditative tone found its complement in the work of Italian futurists like Tullio Crali, whose painting *Nose Dive on a City* (1939), celebrated the suicidal speed of the bomb's-eye view as it plunged into the light. Such was the era of the Norden and Sperry bombsights, which developed a mystique all their own regarding the newfound ability of the eye-weapon assemblage to "drop a bomb into a pickle barrel."[28] Coupled with the bombsight, the newsreel camera came to deliver a view of strategic bombing runs that dappled the earth below, a perspective that structured the home front experience of war both at the time and later in collective memory as it replayed on the likes of the History Channel.

In the U.S., the bomber's view of the world came into its own in 1943 with the dissemination of Disney's animated propaganda film *Victory through Air Power*, which was based on a popular and apocalyptic book of the same name by Mitchell acolyte, Alexander P. de Seversky.[29] In the film, the view of the earth's curved horizon dominates the scene as crosshairs scan, bombs fall away, and flames rise from the purifying inferno below. The aesthetic continued in the wake of the atomic bombing of Japan with the signature footage from the war department's newsreel, "Tale of Two Cities," which guided viewers along the paths of the bombers and excitedly walked through the ruins.[30] The accounts of both Hiroshima and Nagasaki proceed according to the same sequence: we behold the B-29 as it cruises and banks, cut to a map that indicates the target, peer out the bomber window, return to the map, witness an explosion that consumes the screen, and then descend from the air to survey of the destruction on the ground. In both cases, it is a story told through the bomber's eyes, bleeding from the earlier God's-eye cartographic imagination into a new era governed by the aesthetics of the weapon-camera. In the Hiroshima account, which lacks actual blast footage of the mushroom cloud snaking up to the sky, the filmmakers manufactured a sequence that gestured toward an ideal yet to come: a map of ground zero toward which the camera falls as if encased in Little Boy itself. This camera-drop climaxes with an animated blast that begins at the center of the map and rips outward to reveal a denuded lattice of roads and rivers. The image conformed to its archetype, echoing the experimental W2XAD broadcast two decades earlier and foreshadowing the smart bomb view that would hit the screens more than four decades later. The bombardier's gaze occupied only a limited window of time in the national imagination, however, initiated by Mitchell's bombing footage, accelerated by Disney's *Victory through Air Power*, and ultimately ushered to a close by newsreels announcing the atomic bombing of Hiroshima and Nagasaki.

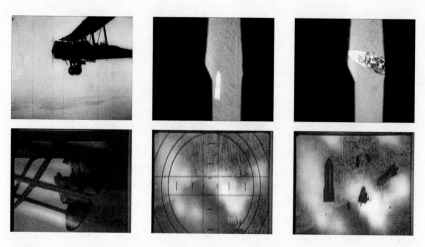

FIGURE 1 Air power vision. Top row: Sequence from General Billy Mitchell's *Aerial Bombing of Obsolete Battleships* (1921) newsreel. Bottom row: From Disney's 1943 *Victory through Air Power*.

As the air power of total war gave way to the counterinsurgency of limited war in Vietnam, the weaponized gaze realigned. Handheld film equipment allowed reporters new mobility to tag along with patrols on search-and-destroy missions. As the camera pushed through the elephant grass with army grunts, the image's center of gravity drew much closer to the ground. If the conflict had a signature weapon, however, it was the "Huey" helicopter. The significance of the Bell UH-1 in the eyes of veterans, journalists, and popular memory cannot be understated—from routine missions to the final scene atop the American embassy in Saigon. The Huey, according to Philip D. Beidler, *"was* the American project in Vietnam, from start to finish and everywhere in between, in our actualized experiences and also in our mentalized images of what was happening there, the ultimate wedding of conventional close combat with the perfection of twentieth-century non-nuclear, counter insurgency, rapid-reaction techno war . . . the master vehicle, emblem, image of the war."[31] Beidler goes on to plot the coordinates, in both literature and film, where the image resides to this day: the one galloping John Wayne into battle in *The Green Berets* (1968), those flitting through the dream sequences and "Ride of the Valkyries" scenes in *Apocalypse Now* (1979), and the chopper airlifting Charlie Sheen out of hell in *Platoon* (1986). The iconicity of the helicopter, especially its Vietnam-era associations with the Wild West cavalry, lasted far beyond the war and carried over into its later role in policing the stateside "urban jungle."[32]

Practically speaking, the prominence of the helicopter in Western news coverage of the Vietnam War stemmed from the fact that it was the chief

mode of transport for journalists. As Michael Arlen describes it in *Living-Room War*, Saigon reporters would start their day with a seven thirty breakfast at the Hotel Caravelle before "driving out to a helicopter base, going by chopper to where some military operation is occurring ... wandering around in the woods taking pictures until three-thirty, maybe getting shot at a bit and maybe not, then taking the chopper back ... meeting friends in the Continental bar at seven o'clock."[33] The helicopter, in other words, merged the communique with the commute, producing endless video of takeoffs, landings, and flight from the perspective of the cabin as it skimmed the jungle canopy.

Under these conditions, the news camera discovered an affinity with the point of view of the door gunner, taking up position as "shotgun rider," a coinage drawn from pulp frontier fiction that referred to the practice of arming a stagecoach. In this position, the lens scanned the earth below with the same intensity as the gunner, often with the mounted M60 muzzle protruding into the frame and spewing tracer fire. One of the more famous passages from Michael Herr's *Dispatches* relates a joke that orients the eye in this direction: A journalist asks a door gunner, "How can you kill women and children?" The gunner replies, "It's easy, you just don't lead 'em as much."[34] The joke reappeared in *Full Metal Jacket* (1987), the screenplay of which Herr cowrote, this time accompanied by the visual frame. A door gunner sprays rounds at the countryside villagers below screaming "Get some!" while a journalist rides along and snaps photos. The scene effortlessly glides from the perspective of the photographer to the perspective of the gunner's eye as it peers down the long barrel of the cannon.

Perhaps the most famous instance of the door-gunner view appears in the climactic scene of the second Rambo film, *First Blood Part II* (1985). After wresting a Huey from a duo of Russian attackers (curiously, the film features a multitude of Russian adversaries), Rambo flies the gunship to a Viet Cong camp in order to rescue his POW compatriots held in a bamboo cage. Firing rockets and machine-guns from the air, he mows down a parade of Vietnamese guards and yet more Russian masterminds. The sequence cycles through three perspectives: Rambo in the cockpit, gasoline-style explosions in the palm trees, and the view from the door through the crosshairs of a six-barreled M134 Minigun strafing defenders on the ground. Because Rambo is alone in the helicopter, it is impossible to say who the filmmakers assumed would be at the door. The effect, however, is to put the viewer squarely in the position of riding shotgun and unmercifully meting out revenge. After the helicopter lands, our hero rips what is now an M60 single-barrel from its door turret (a continuity glitch some superfans duly note) and lays waste to the camp's remaining defenders in what became the film's signature image. The sequence thus collapses the viewer into both the Vietnam War's emblematic door-gunner vision and that redemptive vessel of American identity, Rambo himself. Through his iconic, expressionless eyes we viewers pump our filmic lead.

FIGURE 2 Shotgun riders. From the top: *CBS News's Vietnam: Chronicle of a War* (1981), the Rambo film *First Blood Part II* (1985), and *Full Metal Jacket* (1987).

As these historical snapshots indicate, some version of the weaponized gaze has filtered into public view since the invention of the camera. The mainstay of this book, however, begins with the Persian Gulf War in 1991, which initiated a new era of intensity. Virilio suggested in 1989 that "a war of pictures ... is replacing a war of objects."[35] This was the same year that Nicholas Mirzoeff identifies as having initiated the "so-called visual turn in the humanities," which he argues was a "symptomatic response" to the new regime of visuality ushered in by the Revolution in Military Affairs—the satellite, cybernetics, and speed-driven incarnation of the U.S. military first applied to the Persian Gulf War.[36] He was probably referring to W. J. T. Mitchell's famous announcement, just after the war, that Western culture had undergone a "pictoral turn" and come to be "dominated by images." Mitchell's primary reference point for making this case was CNN's Desert Storm coverage, through which a "supposedly alert electorate ... witness[ed] the destruction of an Arab nation as little more than a spectacular melodrama."[37] From this historical point forward, imaging practices marched shoulder-to-shoulder with the exercise of military power. The events of 9/11 and its aftermath further proved that the visual practices of representing, contesting, and witnessing had migrated toward the center of this thing called war.[38]

Apertures of the Imperial Subject

One of the central questions of this book is whom the weaponized gaze calls into being. The gun-camera does not deliver a picture of events so much as it comprises an event itself that structures the subject with its built-in politics. As Susan Sontag reminds us in *On Photography*, the camera already harbors a kind of "aggression," an acquisitiveness that assumes an "imperial scope."[39] In harmony with Virilio, she draws out all the loading and shooting metaphors that mark the camera as "trying to be a ray gun" or at least a "sublimation of the gun," a "predatory weapon" capable of "soft murder."[40] This basic dynamic can be applied to the global scene. The history of European imperialism, as many have pointed out, is a history of subjecting the colonized other to the gaze as much as the gun.[41] These practices have continued unabated into the contemporary period, imbuing the "exotic encounters" of *National Geographic* and the like with hierarchies of power that invite the Western eye to inspect the non-Western other.[42] Michael Shapiro calls these dispositions embedded in the gaze "ocular enmity," a condition where the screen divides those "protected versus expendable bodies" that predicate the "hostile ways of seeing" eventually "implemented at points of lethal contact."[43] In these cases, the gaze—mediated by the camera—is the day-to-day taskmaster that asserts the right to subjugate the other with actual violence.

Alongside this imperial regime of inspection exists an equally powerful regime of disappearance. Typically mobilized as hostility gives way to violence,

the camera becomes an accomplice to the act of killing by hiding the body. In the contemporary period, the media-military assemblage stages the battle-field in advance, symbolically annihilating those on the receiving end to clear the way for their actual annihilation. The same holds in the wake of violence: bodies, once the intense object of the imperial gaze, melt into the landscape as if they never existed. This dynamic was particularly stark during the Persian Gulf War of 1991, which delivered almost godlike powers of weaponized vision to the American viewing public while cleansing the battlefield of anything resembling death. Margot Norris observed at the time that while estimates of the Iraqi fatality count ranged upward of 150,000 and footage from the weapon's camera flooded the news, it was virtually impossible as a citizen to bear witness to the war if doing so meant bearing witness to actual human destruction or suffering.[44] Jean Baudrillard in *The Gulf War Did Not Take Place* alternately named this the "clean war" or the "nonwar," terms that capture the dematerialization of the conflict that occurred in direct proportion to its televised simulation. In what Sontag calls the photograph's ability to produce "aesthetic distance," he recognized the "profound indifference" generated by the war's virtual double.[45]

Within these two frames—of simultaneous seeing and unseeing—the discourse of precision that marked the war's weapons achieved a lethal absurdity. This discourse, which offered the prospect of annihilating the enemy through perfect transparency, rendered the screen, when it came to the image of death, perfectly opaque. Donna Haraway described a version of this dynamic after the Gulf War when she posed the provocative question, "With whose blood were my eyes crafted?"[46] The question suggests not only that someone suffered the cost of scopic domination but that this "who" was invisible enough to warrant the question in the first place. Power must always clean up, in other words, and thrives according to its ability to erase its own dirty work. These metaphorical relations threatened to go literal in the case of blood-for-oil resource wars, which create sacrifice zones "over there" in order to maintain economic, technological, and ultimately military hegemony "over here." In a material sense, the hyperadvanced targeting camera through which one experienced the miracles of the high-tech war machine depended on the violent exploitation of those whom the very same camera—perhaps in deference to its namesake, the *camera obscura*—concealed from the public eye. Although bodies began to reappear in the U.S. wars following 9/11, particularly in the era of the drone, the tension between the appearance and disappearance of the target body remained the persistent paradox of gun-camera footage as it migrated from the battlefield to the home front screen. While the martial eye embarked on search-and-destroy operations to rout out enemy bodies in hostile territory, its simulacrum appeared to domestic audiences to suggest that those bodies never quite existed in the first place.

Ultimately, we must ask what kind of citizen-subject such ways of seeing invite into being. It is no longer sufficient, as W. J. T. Mitchell notes, to understand images in terms of mimesis or simple representation. Instead we should attend to "the complex interplay between visuality, apparatus, institutions, discourses, bodies, and figurality." This is especially the case when it comes to "*spectatorship* (the look, the gaze, the glance, practices of observation, surveillance, and visual pleasure)," which "may be as deep a problem as various forms of *reading*."[47] These observations harmonize with some of the core assumptions of this book, which seeks to understand *whom* the weaponized gaze means in addition to *what*.

A good anchor for this endeavor is Louis Althusser's notion of interpellation, the suggestion that the formation of the political subject takes place when some apparatus of the state addresses and thus fixes the subject on a grid of power relations. His famous example of the police officer hailing a pedestrian with a "Hey, you there!" is useful here insofar as the view through the weapon-camera, the soul of the military apparatus, calls out to the citizen with a "Hey, look!" In fact, it might be more accurate to cast the interpellative moment as an invitation to see. Althusser himself describes the political subject as "speculary," in an often-overlooked passage in the same essay, much like a structure of mirrors.[48] It is not that the subject hears the officer's "Hey, you there!" and is interpellated, in other words, but that the subject's head turns to behold the apparatus, resulting in a particular geometry of vision and recognition. With regard to postindustrial war, this hall of mirrors appears as the targeting mechanism, the perfect fusion of the looking glass and the police. To peer into this apparatus is to behold oneself suspended in relation to the security state, which constitutes the citizen-subject by funneling the gaze back through the its optical architectures. Jacques Ranciere adds yet another dimension to this process, riffing on—or, more accurately, against—his old teacher's famous image. For Ranciere, the police do not participate in the realm of politics as much as they partition the sensible from what is off-limits to perception in the first place. They should be understood, he argues, not by "Hey, you!" but rather by "Move along. There's nothing to see here."[49] Strictly speaking, these are two incompatible formulae, but we can sense the essence of each in the gun-gaze—both the manufacture of the subject through vision and the exclusion of death from the frame: the paradox of "Hey, look!" in the same breath as "Nothing to see here!"

Such insights urge us to think beyond representation and consider the way war positions subjects within a matrix of perceptual relations. Nicholas Mirzoeff provides a handy point of entry in his writings about the viewing patterns of the 2003 Iraq War. He notes that the global media system divided audiences into what he calls viewing "camps," a metaphor that suggests that in recent years media and military have merged to such a degree that the simple act of

viewing constituted publics as extensions of warring militaries.[50] The subject's membership in such a camp, of course, involved a broad spectrum of activity, from materially tuning in to the communications infrastructure to absorbing the rhetorical habits of a particular infosphere. If we continue down this metaphorical path, we eventually encounter the military encampment—the fortification, soldier, and weapon—as interface.[51] Indeed, as bombs and other weapons systems began to "open their eyes" following the 1991 Persian Gulf War, scholars began to mark the targeting screen itself as a master trope for governing the relationships between civil and military spheres in the West. Kevin Robins and Les Levidow suggest that witnessing through this lens was "less about the literal 'truth'" of the images from the bomber's-eye view and more about "seeking refuge from anxiety" in the arms and eyes of these "exterminating angels."[52] Media critic Robert Stam argues that a large part of the war's success in garnering public support could be explained by the fusion of television, already a window to the world, with the apparatus of military surveillance. This afforded the average viewer—in the form of the "armchair imperialist"—a quantum leap in prosthetic visual power.[53]

This prosthetic fusion should be understood not simply as a visual trope but also as a material shift that restructured the civic sphere as an extension of the military. Writing about global media "vectors" and the Gulf War, for example, McKenzie Wark notes that the missile-cam fused a global audience "eyeball to eyeball" with the projectile's line of flight such that we became complicit with the violation of that territory.[54] Judith Butler took this appraisal one step further, suggesting that the view through the smart bomb weapon-camera succeeded in "constituting the television screen and its viewer as the extended apparatus of the bomb," such that "by viewing we are bombing." These statements prompt the question of what kind of subject this image-prosthetic pins to the couch. Taken as a simple representation, after all, the image is patently absurd, a "recording of a thoroughly destructive act which can never record that destructiveness."[55] As perhaps the perfect combination of "Hey, look!" and "Nothing to see here!" the footage stood not simply as a representational event that describes what one sees, nor even as a participatory event that orders what one does, but as an ontological event that defines what one is.

These observations are not limited to smart bomb footage in the Persian Gulf War but also easily map onto any number of weapon-cameras. Two decades later, Butler invoked the concept again in her discussion of the photos of Abu Ghraib. Insofar as war had been mediatized, she writes, "there is no way to separate . . . the materiality of war from those representational regimes through which it operates and which rationalize its own operation."[56] The camera has become an integral mechanism in the apparatus of bombing, to be sure, but the key point is that the war machine has learned to steer the civic gaze through its stockpiles in order to "rationalize its own operation."

The result might be best expressed in Brian Massumi's term *ontopower*, the production of subjectivities through the management of time, perception, and attention, which, after 9/11, took on the logics of the preemptive strike.[57] Such images do not necessarily make a case for pulling the trigger as much as they craft an "imperialist subject" who has already done so—in many cases both authorizing and disavowing state violence in the same dissociative glance.[58]

The themes mentioned above all in one way or another help flesh out the concept of the "weaponized gaze" as a mode of control, but they also prod us to consider possibilities for alternative ways of looking. If its core is an authoritarian discourse that trains citizens to see like weapons, then the corrective is to recultivate civic vision. This may in some ways seem like a Habermasian exercise in idealization, but it ultimately entails a simple set of critical practices. To see like a citizen, first and foremost, is to reestablish political agency. Weaponized vision in most cases functions to demote the citizen to the status of effect, a silhouette discernable only in the afterimage of the bomb's flash. This is a precise reversal of the principle of the civilian-controlled military common to Western democracies like the U.S., which elects a civilian commander-in-chief who must gain congressional approval to declare war. According to this principle, the deliberative citizen resides at the top of the chain of command and must assume some responsibility for authorizing war. The weaponized gaze, in contrast, ritually shuttles this citizen to the end of the chain of command and to the moment of the order's execution. Conscripted by this charging light brigade, the subject's role, as Tennyson puts it, is "not to reason why" but rather, at least figuratively, "to do and die." Under these conditions, seeing like a citizen requires upending this logic and repicturing the military as an institutional tool under the sacred command of the deliberative civil sphere.

Part of this task too is recognizing the larger cultural stories that underwrite the weaponized gaze, in particular those that depict the military as an end in itself. Most commonly, these stories appear in the form of the military self-salvation narrative that can be detected in everything from the mantra of "support the troops" to *Saving Private Ryan* (1998). Here we encounter a similar reversal where, rather than rallying for the purpose of civilian defense, the military apparatus exists as the ultimate object of its own protection. It is no coincidence that this discourse began to accelerate in the 1990s, as the weaponized gaze fully installed itself as a feature of the public screen. Seeing like a citizen thus requires not only alternative pictures but also alternative captions to relocate the military as a means to preserve the health of the civic sphere rather than the reverse.

Another related set of recurring themes in this struggle revolves around the frame itself. The weaponized gaze continually presses vision into the confines of the weapon's pure functionality. The corrective to this restricted view is thus to widen the frame beyond the technical question of *what* to the political

question of *why*. Transcending the weaponized gaze, in other words, is an exercise in bringing war into focus as a product of active deliberation that raises the necessary questions rather than passive spectacle that moves serially from one foregone strike to the next. This means opening the civic eye to the history of conflict, the influence of vested interests, the role of national values, the governance of legal frameworks designed to limit state aggression, and especially the presence of those who stand to suffer.

Ultimately, the task of seeing like a citizen involves taking the screen seriously as a primary site of struggle between the deliberative civil sphere and the military complex. It is no secret that war has become increasingly "mediatized" in recent decades, colonizing ever more virtual territory.[59] The struggle has thus increasingly played out as a proxy war on the frontiers of the press, the defining institution of public deliberation, and entertainment media, which has perhaps even more power to animate history and stake the important narratives of the day. In this mediated space, civic interests that seek to open up critical conversation encounter the force of state and corporate interests that often work to foreclose the possibility. Here the machinery of public relations takes up position to define the knowable and the sensible, recast the screen as vital front, beat images into munitions, and pitch the field through channel management. This struggle determines the universe of perception that differentiates those who look from those who bear the look, those who are part of the circle of concern from those who falls outside, and those who are deemed worthy as vessels for identification from those who undergo annihilation through sheer invisibility.

In our current visual deluge, the weaponized gaze has appeared as a significant jet stream swirling ever closer—across newsreels, television shows, fictional films, and games—to the center of our screens. The following chapters begin this story in earnest with the 1991 Gulf War, or rather its military production for television, where a new superstar graced the stages of its press conferences: the view from the targeting camera as it tracked its precision ordnance. The "smart bomb vision" described in chapter 2 was less about representation, however, than about fusing television to the targeting system. Put another way, this was a "hypermediated" visual discourse that focused its attention not on the far-off places that might be seen through the medium but rather on the act of looking through apparatus itself. This image perfected the logic behind the press pools organized by the Pentagon, which funneled the civic gaze into prescribed channels, kill boxes to be targeted with the precision weaponry of new, finely tuned video news releases. The surrounding discourse also accelerated the general migration of war from the axis of the soldier to the axis of the machine, where weapons became the main characters and points of identification. The iconic footage from the nosecone of the standoff land attack missile (SLAM) as it closed in on its target best exemplified these dynamics,

pressing the eye into the projectile itself. The actual footage was only a short visual bite, but it reran on a rapid-fire loop during this time. Analysis of this footage—including its circulation and captioning—provides a glimpse into the weaponized gaze of this period, an optical prosthetic with its own disciplinary logic. As a focal point, it condensed the dominant official discourses of the war: precision, sexual conquest, deathlessness, distance, authenticity, and the proper role of the witness. Even after the war, smart bomb vision persisted in the public imagination, marching confidently into future conflicts.

The television coverage of the 2003 invasion of Iraq carried forth these conventions but also initiated its own: the god's-eye view of target territory. In some instances, these were actual photos taken by satellite or high-altitude aircraft. In others, the newsrooms recreated territory in animated form. Still others hybridized the two, rendering cityscapes in three-dimensional, scrollable swaths for news anchors to browse. The "satellite vision" examined in chapter 3 might be considered a throwback to the cartographic imagination of old were it not for the new aesthetics enabled by digitization. Animation, for example, allowed the satellite's "orbital gaze" to hover above target territory and often switch modes to assume the "projectile gaze" of the speeding aircraft, missile, or bomb. The view through the martial satellite had a long history in public consciousness in the prior half century, descending from the heavens into news stories, government press conferences, and Hollywood film. The public presence of such imagery thickened over the years, aligning the public eye with military apertures and grooming satellite vision itself for its eventual spotlight appearance during the Iraq War. By this point, changes in the political economy of aerial imagery—in both governmental and private realms—converged with the demands of wartime network news to deliver a set of new platforms for visualization. Armed with these tools during the Iraq War, TV news introduced new ways of beholding the enemy on the other side of the screen. These modes of looking spilled beyond the confines of the war as well. What we now know as Google Earth, for example, began life as the Keyhole platform, which provided the networks with the general's-eye view of the world during the Iraq War. In other words, our emergent ways of seeing the planet—this "world target," in Rey Chow's words—were first advertised by an unabashed celebration of unipolar power, unilateral military action, and U.S. exceptionalism.[60]

In retrospect, all this served as a preface to the drone warfare that proliferated under the Obama administration. The public circulation of actual footage captured by military drones in the process of firing missiles on their targets—the "drone vision" explored in chapter 4—is in some ways the beating heart of this book. Such images became ubiquitous, although their origins were not always apparent. Mapping their modes of selection and channels of distribution reveals in many cases that the videos were carefully selected for their public relations value, which is significant because they stood as one of

the few windows to a war that otherwise went off the public radar. Their circulation worked to buttress the ongoing official narrative that the day-to-day job of the War on Terror was being successfully carried out with prudence and precision. Leading up to its use in what some have called the "assassination complex," the weaponized drone represented a long history of perfecting the vision machine.[61] As it has moved toward the center of U.S. military strategy, this way of seeing went public, aligning the civic gaze with the pilot, the control center, and the targeting screen.

The shift also entailed diverting the eye from other sites of investment. The drone's drab, clinical aesthetic worked to dissuade one from appreciating it as an object in the sky. The White House, moreover, suppressed interest in policy questions by propagating the notion that such decisions were handled, almost algorithmically, by a "disposition matrix." Public interest in the nominally "secret" drone war instead turned to the drone control room as a site of obsessive public attention, and the story of the pilot became its signature anecdote. In the dominant portrayal, the pilot appeared as a stress point in the kill chain, a martyr, and the true victim of the drone war—the one who sees too much, suffers, and yet dutifully resolves to carry out orders. This discourse functioned to discipline the citizen insofar as the drone war appeared through the eyes of this "guilt-ridden assassin."[62] Opportunities for interactively engaging the drone war extended from the pilot's eyes outward. From films to toys to games, consumer capitalism put the citizen behind the virtual controls. All of this hardened the alignment of civic vision with drone vision. Paradoxically, the more drone-camera footage proliferated, the less visible those who endured life under its wrathful eye became.

If there were a single cultural event in recent history that spoke most directly to the weaponization of public vision, it was the 2014 film *American Sniper*, based on the life of the real Navy SEAL sniper Chris Kyle. As the most successful war movie ever produced in terms of box-office receipts, it almost single-handedly rehabilitated a flagging genre. The film played a powerful role in the remembrance and mythologization of the Iraq War, even recycling thoroughly debunked justifications for the invasion proffered by the Bush administration. Beyond these common critiques, the film also stood as the apogee of the sniper's rehabilitation from cinematic villain to hero. The alignment of the public gaze through this scope, what chapter 4 investigates as "sniper vision," was a gradual process that mimicked the citizen's larger acclimatization to the weapon's lens since the smart bomb.

In addition to threading the action through the scope, a rich set of visual metaphors permeate the film. Primary among these is a pastoral metaphor, a latent political motif in the West that, as Michel Foucault argues, ultimately functions to establish a field of obedience. The metaphor is relatively explicit in *American Sniper*, which casts Kyle as shepherd, the sniper rifle as crook,

his company of foot-soldiers as flock, and Iraqi insurgents as wolves. The cinematic gaze weaves itself into the motif, activating these rituals of oversight and crafting a subject nested in a series of surveillant relationships. Kyle's character, a surrogate into which the film invites the viewer, is a model of restricted vision: both eagle-eyed vigilance and willful blindness to anything outside this defined "scope." Not surprisingly, the film refracts the weaponized gaze through the figure of the martyr and in so doing captures the essence of the weaponized gaze as it has developed from the smart bomb through the drone war. Indeed, *American Sniper* completes its tale with the appearance of God-the-Father, whose eye appears in the guise of the sky-bound drone. In weaving these themes together, the film serves as a powerful cultural allegory for contemporary techno-war that reinforces the weaponized gaze with a structure of virtue.

As this discourse of control assumed a prominent role in public life, it inspired the recoil of resistance. In recent years, a whole range of artists, activists, jammers, and other image-makers have engaged the politics of militarized vision. Much of this subversion has seized on drone vision in particular, and each act has its own elegant way of provocatively redirecting the vectors of the public gaze. The "resistant vision" addressed in chapter 6 consists of three main strategies. At the near end of the weapon's line of sight, the first marshals excesses of vision that work to crack open the cockpit, as it were, and let a little daylight in. Some drone pilots, for example, seized on the sudden interest in their jobs to act as whistleblowers, telling stories that wandered outside the official frames of drone vision and into forbidden territory. Many went on record questioning the weapon's precision or assigning some measure of humanity to those in the crosshairs. Further down the weapon's line of sight we encounter strategies that seek to objectify the weapon. Working in this mode, artists and activists have sought to wrench audiences out of this first-person relationship with the drone's gaze and instead make the weapon itself visible, bring its materiality into view, and introduce the possibility of staring back through its camera. Closer to the ground, we encounter the most powerful and rare of these strategies: inversion. This strategy not only upends the weaponized gaze but humanizes those bodies under aerial occupation as points of identification. Taken together, these examples—from pilot horror stories to artistic experiments in confronting the weapon's aperture to documentaries that reveal what it is like to live under drones—attest that certain habits of seeing through the military apparatus are brittle and can be shattered by even the smallest gesture.

While the body remains a persistent theme through all of this, some questions remain to be asked directly. Whose bodies appear, and whose disappear? Whose bodies do we inhabit, and whose remain radically alien? Our investigation concludes with a direct meditation on the subject of "embodied vision"

in an effort to gain a broad perspective on the past and future trajectories of the weaponized gaze. This final appraisal explores the extent the West has been able to visualize the human toll of the Iraq war and the extent this has been an object of collective denial. We not only run the numbers but also track how the specter of the Iraqi dead has been quarantined from public consciousness. Part of the answer is a general dematerialization of the Iraqi body in public discourse, but we can also observe the equal and opposite hyperavailability of the U.S. soldier-body as a point of identification. The view through the soldier helmetcam in particular has populated television news and both documentary and Hollywood film as a primary mode of seeing. Here the vulnerable body of the soldier-surrogate—through whom the citizen-witness kills, bleeds, and sometimes dies—becomes the dominant vessel for understanding what is at stake in war. The enticement of helmetcam vision comes in the form of the experiential authenticity it purports to offer, but it is a profoundly limited vessel that reduces the conflict to a hyperlocal it-was-either-him-or-me drama. This drama in the end works to contain what is most objectionable in war: bodily destruction. In this sense, helmetcam vision represents the germinal core of the weaponized gaze, a point where the camera and the eye draw close to one another, threatening a complete merger that effaces the boundary between the solid material world and its virtualization.

At this juncture, the best critical point of entry may be the primordial figure of the dream, which has haunted the weaponized gaze since the beginning. From the estranged target bodies that appear in our sights to the insistent invitation to inhabit the uncanny body that pulls the trigger, this metaphor eternally returns. It is thus appropriate that our journey through the weaponized eye ends with a meditation on how the surreal, dreamlike smoothness on one side of the crosshairs masks the waking nightmare on the other. This metaphor alerts us to the critical task moving forward, which appears sometimes as a subtle form of dreamwork and other times as an effort to snap the screen out of its twilight state. Better worlds are more than possible, after all. They are within eyeshot.

2

Smart Bomb Vision

You can almost get airsick watching this.
—U.S. general Charles Horner during a
Gulf War press conference

On January 30, 1991, halfway through the combat phase of Operation Desert Storm, General Norman Schwarzkopf stepped out in front of a phalanx of television reporters. "I would like to now show you a little film," he uttered with an avuncular twinkle in his eye. The audience went silent with anticipation as he rolled out a TV and rolled tape. The screen flickered to life with a series of grainy black-and-white videos taken from targeting cameras in the sky. On this day, the theme would be airstrikes on bridges, complete with play-by-play narration. Schwarzkopf's voice quickened as he approached the main event: "I'm now going to show you a picture of the luckiest man in Iraq on this particular day." A pair of vertical gray stripes appeared, framed by a bombsight. Reporters chortled and shifted in anticipation. The general's cadence slowed with a command that all but initiated a new era of witnessing war: "Keep your eye on the crosshairs." Insistent now, he pointed to a Pong-like cluster of dark pixels: "Right there. Lookit here!" A vehicle crossed the screen from the bottom to the top. "Right through the crosshairs!" More scattered chuckling from the press. "And now, in his rear-view mirror—" The explosion appeared like a punchline, a black blotch silently erupting from the center of the screen, followed by a collective release of laughter. "Okay, stop the tape, please," he ordered in a feigned attempt to reestablish decorum.

So went one of the more famous screenings of Schwarzkopf's "little films," footage from guided bomb and missile cameras carefully selected for global rebroadcast. Such weapons-eye reels had become a familiar sight at the U.S. command headquarters in Riyadh, which doubled as a theatrical stage. Indeed, Schwarzkopf often referred to himself as the "theater commander."[1] The *Washington Post* captured the razzle-dazzle tone of these events: "As with most briefings, a military public relations officer counted down the seconds for live broadcasts to begin as Schwarzkopf walked to the podium under klieg lights." Another officer typically stood by with a television, armed with video from "aircraft nose cameras" depicting "bridges and Scud missile launchers being blasted apart by U.S. jets."[2] For this occasion, Schwarzkopf had chosen a comic frame, presenting the strike as a kind of near-miss slapstick one might recognize from the silent film era. The Luckiest Man might as well have haplessly stepped over a manhole while reading a newspaper. Charlie Chaplin once said that what was tragic close-up could be comic from a distance. Or as Geoff Martin and Erin Steuter observe, the psychological distance injected into the scene by every layer of mediation made "room for humor."[3] The screen had been drained of human presence, the concrete signs that normally work to invest audiences empathically in a real life. The Luckiest Man instead appeared as a caricature whose eyes, the size of saucers, blinked with astonishment in his rear-view mirror. He was at best an abstraction, worlds away from the man desperately venturing out into a war zone for food, the family fleeing the violence, and the woman heroically racing her sister to the hospital against all advice. In fact, the Luckiest Man barely existed amid the raining bombs, which is perhaps what made him so lucky. His absence made it easy to comply when the general commanded that we keep our eyes on the crosshairs.

This story did not end when Schwarzkopf stopped the tape. This dynamic of concrete presence and abstract distance occupied the minds of some in the media well after the laughter had died. The British *Sunday Times* reports that a few weeks later, advisors showed General Schwarzkopf another such video in a private setting, introduced to him as the "Unluckiest Man in Iraq." Here the camera, affixed to the head of a missile, zeroed in on another bridge marked for destruction. This time, however, the missile's camera barreled through the cab of a passing truck that happened to be crossing the bridge. The final frames of the video reportedly showed the terrified face of the truck driver moments before impact. Not surprisingly, the Pentagon deemed the video too sensitive for public consumption.[4] The episode exposed the heavy-handed process of selection that accompanied what was otherwise sold as direct access to the machinations of war. Certain images colonized the screen while others never made it out of the back room.

This chapter examines the Gulf War of 1991 as a period that established, in large part, the weapon's-eye view in public culture. The Luckiest Man

represents only one small slice of the emerging practice of slipping the civic gaze into the cockpit and often into the projectile itself. By the time the vehicle traced its ghostly route across the bridge, the ritual of watching through this lens had become familiar. In the preceding weeks, such images had arrived with the clocklike regularity of battlefield reinforcements, burning themselves rhythmically into the phosphor of the home television screen and the neurology of the collective retina. Under these conditions, the image rapidly evolved from ephemeral novelty to enduring archetype, at some point crossing a threshold of saturation that allowed Schwarzkopf to break form and inject what passed for a moment of levity. It had, in other words, become a genre worth bending. This was clear well after Operation Desert Storm ended. In his survey of the television war, venerable scholar of war and media Daniel C. Hallin listed the visual tropes, which included Patriot missiles intercepting Scuds, cruise missiles "arching gracefully" toward targets, jet fighters landing at sunset, soldiers giving the thumbs-up, "and most characteristically, the smart bomb video."[5] A reporter from the *St. Petersburg Times* offered a similar appraisal at the war's one-year anniversary: "The first 39 days of the 43-day war were fought from the air, and to this day its signature remains gun-sight footage from the video cameras mounted in the nose of laser-guided bombs."[6] Statements like these have since settled in as conventional wisdom. In only a matter of weeks, the image from the bomb camera had reached a critical intensity that survives in the Western imagination as the emblem of the Gulf War sine qua non.

Although scholars recognize the essential iconicity of this "smart bomb vision" in the public presentation of the Gulf War, attention to the image itself has consistently received short shrift. In some instances, it is as though the footage is so potent that it can only be observed at a glance; in others, it is relegated to the status of symptom. This chapter picks up on this prior scholarship as it takes the subject of the smart bomb camera head-on. Doing so helps us understand not only how this class of imagery functioned during this particular conflict but also how the Gulf War functioned as a watershed—perhaps an optical shed—that initiated a new era of seeing war through the weapon. We begin by understanding the smart bomb camera in its historical moment of appearance. Next, we put the footage into the context of other trends that characterized the media environment of the Gulf War, ultimately contending that smart bomb vision is not a representational phenomenon as much as it is a phenomenological experience that resolves in the annihilation of the witness. The final section examines the memory of smart bomb vision, how it persisted long after the war, and how it continues to inform the dynamic interface between civil and military spheres.

Like virtually all the other footage in the smart bomb genre, the Luckiest Man cannot simply be read as an image. It is in fact barely an image at all. Part of its aesthetic essence is its low resolution, which lends it the quality of an

endlessly scanned chain letter or Rorschach blot, a copy of a copy, recycled and filtered through multiple screens. To make sense of it, one needs an interpreter, a theater commander, to frame it with a narrative. We must understand these little films, in other words, not through what they represent on the screen per se but rather through the variety of framing devices that construct the ritual of watching. While it is true, as the *Washington Post* observed, that television became "an indispensable tool in the effort," the medium transcended its usual role of showing us something and became the show itself.[7] Here the general stepped aside, inviting the viewer at home to watch television reporters watching television of yet another screen witnessed at some point by a bomber pilot somewhere over Iraq. Layered to this extent, the sheer relationality of media itself came to bear the significance of the event. Under the guise of transporting the witness directly to the scene of righteous destruction, the ritual of this "raw footage" functioned as an exercise in beholding the technological apparatus of vision itself. In their treatise, *Remediation*, Jay David Bolter and Richard Grusin call this the aesthetics of "hypermediacy" (the polar opposite of "immediacy"), which renders the medium the object of attention.[8] The practice of processing the "news from the war" through these little films was rather the practice of aligning the civilian screening apparatus with a carefully selected slice of the weapon's apparatus. "And next, I'll put you into the cockpit of an F-15E for an air-to-ground sortie," another general told the press following Schwarzkopf's presentation. The blithe idiom of "in the cockpit," repeated so often in the era of the weaponized gaze, stood for the repeated act of tunneling the viewer through this sequence of interfaces. Once inside, the significance of the image at the end of the tunnel degraded; what remained was tunnel vision itself.

Pooled Optics

On February 9, 1991, *Saturday Night Live* aired a skit that dramatized the role of the press during Desert Storm. The scene was familiar by that point: a military press conference in Riyadh, the stage adorned with maps on easels. As the colonel steps to the podium, noisy reporters shoulder one another aside and ask one ridiculous question after another: "Where would you say our forces are most vulnerable to attack?" "Are we planning an amphibious invasion of Kuwait, and if so, where?" The colonel's frustration, which he attempts to conceal to comedic effect, stands in for our supposed frustration as a nation. The implicit message is that the entire concept of the free, investigative press—especially in an environment restricted to the technical question of strategy—is not only irrelevant but adversarial and dangerous. The skit drives the point home with a final question asked by the only reporter wearing a generic Arab kufiyah headdress, apparently meant to signify those with whom the U.S. was at war: "Where are your troops, and can I go there and count them?"

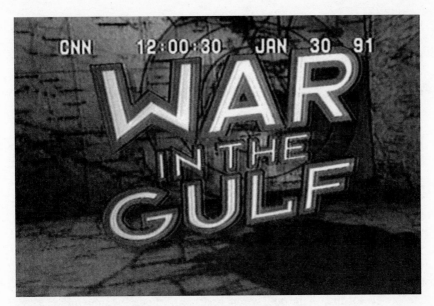

FIGURE 3 CNN's crosshairs-stamped Gulf War coverage.

This suspicion of the press had a history that went back to the waning days of Vietnam. The prevailing notion in the higher echelons of power was that the public aversion to war that grew in this period—later nicknamed the "Vietnam Syndrome"—was not due to the sacrifice of fifty thousand U.S. servicepersons nor even the killing of millions in Southeast Asia but rather a result of the military losing control of an instinctually antimilitary press. Although thoroughly debunked by scholars, this thesis eventually trickled down and assumed the status of conventional wisdom.[9] Under these assumptions, the military conducted its operations in the following decade—Grenada, El Salvador, Nicaragua, and Panama—either in clandestine fashion or under an enforced media blackout.[10] By Operation Desert Storm in 1991, the narrative had settled. The press became an object of suspicion if not ridicule, comically out of place and at best tolerated by those doing the serious business of prosecuting a war.

Messages of this sort helped underwrite a new official strategy known as the *press pool system* for dealing with the media in advance of Operation Desert Storm. The military invited reporters to get close to the action, but this in practice meant corralling them into restricted zones: the tent city in the Saudi desert to witness the military advance or the press conference center in Riyadh to hear the official narrative. Although it was not in the original pooling plan, the military also tolerated the presence of some television reporters at the Al Rashid hotel in Baghdad as the city underwent its massive shelling. In addition to managing the location of reporters, the Pentagon supplied the networks

with an official video feed that provided copious quantities of carefully selected, dramatic b-roll footage. As such, the pool system forged a limited number of channels through which the flow of information could be controlled.

The combined effect was a public relations victory that virtually eliminated the impulse to engage in independent investigative reporting. Reporters had "free news" coming out of their ears, so much that CNN, which had been up to this point a foundering experiment in satiating the appetites of a twenty-four-hour news channel, suddenly shot to the fore as a tenable economic model. In other words, the press pool system was built on the recognition that access to war could be a hot commodity. Rather than simply erecting an information dam to block the inevitable horrors from view, the strategy blasted the reticent public with high-caliber images and narratives. The new formula was simple: don't just restrict damaging information, crowd it out.

The view from the smart bomb must be understood within the new structure of the pool system, which involved much more than the simple containment of a fluid field of communications activity. Margot Norris suggests that the "pre-censorship" of the pool system itself constituted a "weapon for focusing public attention on . . . the military's own interests and aims," what she specifically calls a "rhetorical and discursive 'smart bomb.'"[11] Her use of the metaphor signals an affinity, perhaps the mutual entanglement, between the pool system and the concept of this new weapon. We might go further to suggest that the event of witnessing war through the smart bomb camera extended the logic of a system that already funneled the journalistic gaze—and by extension the civic gaze—into a limited set of channels, even annealing it to the very hardware of military violence. As Deborah Amos of NPR observed, this "turned officers

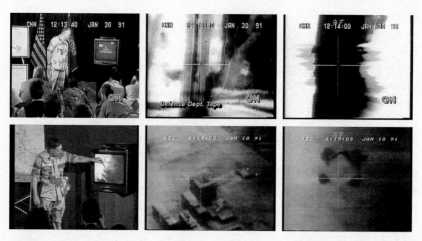

FIGURE 4 Two sequences of smart bomb vision. Top row: Schwarzkopf's "Luckiest Man in Iraq." Bottom row: Smart bomb going "down the chimney."

into assignment editors, determining story lines by dictating what reporters could see." With no independent access to the action, the news became dependent on "government-issued videotapes being promulgated in briefing rooms in Riyadh and Washington."[12] Media critic Robert Stam likened this news to "a form of military advertising" insofar as it mimicked the emerging public relations practice of distributing prepackaged news stories otherwise known as video news releases (VNRs).[13] Defense Secretary Dick Cheney said he rejected the notion that the tapes were a kind of press release, although he admitted that they did "clean it up" by removing the raw audio of "guys in combat."[14] Others like White House aide David Gergen, however, bragged that the military had taken the VNR practice to a new level, especially regarding weapon's-eye footage, which he surmised "had an enormous impact on the American public."[15]

While a typical VNR strategy is more akin to a carpet bombing, the strategy of pooling vision in advance made for a rich target that could be struck with laser-like precision by a limited number of feeds. From this perspective, the observation that smart bomb imagery simply represented or misrepresented something—the destruction of a target, the degree of precision, or the new Revolution in Military Affairs (RMA)—is not wholly adequate. We must also understand smart bomb vision as a logical condensation of the press pool system, an apparatus of attention management that laundered its product through the screens of journalism by using a strategy pioneered by commercial public relations. This explains why, as the *New York Times* observed, "the most enduring image of the war [was] the remarkable gun-camera footage of precision bombs, produced not by journalists but by the military."[16] This picture-perfect moment of image transference was the RMA's double, its recoil, and amounted to a surgical strike on public perception through a weaponized medium. Caren Kaplan notes that the notion of satellite-enabled "precision" had this same reversible quality, translating easily from the act of guiding bombs to the relaying CNN's stenographic coverage home.[17] The ubiquitous image of the satellite dish thus slipped between referents, suggesting that guiding bombs and guiding viewer attention was part of the same command-and-control process.

To a certain degree, the general public took note of the sudden collapse of the image and the weapon. One journalist captured the new operant metaphor in the headline "CNN: The Media's Own Missile" and remarked how it had taken on the mantle of the "war network."[18] By this time, too, the term *CNN effect* had begun to circulate publicly to describe the weaponization of media as the feedback loop between battlefield action and its real-time representation. Unfortunately, the term sacrificed most of its critical power in normal usage, which suggested that the real problem with the feedback loop was that television news interfered with strategic decision making on the battlefield. Another CNN effect that played out in the living room, however, was every bit as weaponized. This effect pooled public attention into manageable

containers that might otherwise have been called *kill boxes*, that Gulf War–era term of precision-warfare par excellence.[19] Smart bomb vision represented the fundamental gesture of pooling at its most concentrated, controlled, and digitized as it assumed the shape and size of the television screen upon which Schwarzkopf's little films flickered. The ordnance may have barreled along one's line of sight toward the target "out there," but the image itself found its real target between the civilian eyes tracking its flight path. The sense of reversal was palpable. Robert Stam wrote shortly thereafter that "the bombs seemed aimed at us as well."[20] Had Schwarzkopf lowered the lights in his briefing room, one could have expected a pair of crosshairs to appear on every forehead.

Battlebots

The Persian Gulf War and its smart bomb vision also participated in the broad turn toward the lionization of the weapon above all else. This turn began in the late 1980s as the prevailing culture began to leave the drama of Vietnam and its "syndrome" behind and lean forward toward the futuristic techno-drama of the Persian Gulf War. In terms of aesthetics, the two could not have been more different. Vietnam was a quagmire; the Gulf War was over in an instant. Vietnam seemed to be about attrition; the Gulf War featured overwhelming force. Vietnam was a body count; the Gulf War passed with virtually no mention of death. Perhaps most important for our purposes, Vietnam dramatized the soldier while the Gulf War dramatized the machine.

One convenient place to look to locate this turn in aesthetics is Hollywood film. We find it in Tony Scott's vapid, rapid-cut ode to futurism, *Top Gun* (1986), which marked the precise pivot insofar as it offered up a new set of master images and narratives. Produced with heavy involvement from the Pentagon, its success anchored the motif of the weapon as war hero in the American consciousness. In the film, the world literally revolves around the F-14A Tomcat, the primary protagonist, as it barrel-rolls through the sky. Cruise's character is at best a stowaway, a stand-in who satisfies the "need for speed" by dropping the viewer into the cockpit. These aircraft career off the deck to engage enemy fighters, of course, but the closest the film comes to referencing where or why these dogfights occur is the choice to call the (Soviet-made) MiG aircraft by name. Otherwise, the adversary appears out of the blue like a swarm of alien robots. They exist not to buttress the evil empire nor to threaten the American population but rather to antagonize the F-14s themselves and provide the conditions for a high-stakes test of nerves. As such, the film renders military activity a purely technical exercise insulated from the messy human domain of nation states, politics, and public deliberation. The orientation asks nothing of its audience except to decide which flight maneuver is the coolest.

This weapon-as-hero-in-a-machine-war motif departed from contemporary films that attempted to rescue the U.S. military from the clutches

of Vietnam Syndrome at the time, typified by the *Rambo* and *Missing in Action* franchises. Such films sought to cure the humiliation of retreat with a parade of hypermasculine, greased-up, vein-popped "hard bodies."[21] *Top Gun* abandoned the task of returning to Vietnam and instead elected to wipe its memory altogether. In place of hard bodies, it offered up a cadre of smirking, gum-chomping technicians comfortable with a certain degree of homoerotic high-fivery. The flesh withered away in the *Top Gun* universe, entombed as it was within the even harder body of the weapon itself, whose skin of space-age alloy made it virtually impervious to criticism. The film, a preview of coming attractions, made way for the Persian Gulf War television experience.

Indeed, there was no shortage of voices—both scholarly and journalistic—observing the sharp uptick in the prominence of high-tech weapons in news media coverage of the war. A few studies supply empirical evidence to support these claims. In their analysis of major magazine images, for example, Sandra Moriarty and David Shaw discovered that war equipment was a major theme in just 11 percent of the images during the Vietnam War, but that figure rose to 35 percent for the Persian Gulf War. In contrast, images of soldiers in combat dropped from 30 percent during Vietnam to 8 percent during the Persian Gulf War.[22] Although Daniel Hallin and Todd Gitlin found a slightly less dramatic discrepancy in their own study, they noted that "in this technological war, machines were no less 'characters' of the television drama than the soldiers. They were in fact spoken of as if they were human actors."[23] In the war's aftermath, an *LA Times* reporter made a similar observation after McDonnell Douglas took out ads to hype that its planes had been used to down Iraqi fighters. "What a difference from those World War II ads, in which the product served a larger cause," observed the reporter, adding, "Here it's practically the other way around."[24] Target bodies withered away alongside soldier bodies. Body counts, as Tom Engelhardt notes, were entirely replaced with "'weapons counts' (how many Scud missiles, tanks, or gunboats had been put out of action); only tanks and airplanes were to be 'killed'; and there would be no visible bags, for there would be no visible bodies."[25]

The drama had thus moved its center of gravity from flesh to weapon, from agent to agency, and from idealism to pragmatism.[26] The questions that guided coverage shifted in kind from "What are we fighting for?"—which dogged public opinion during Vietnam—to the more manageable "What is the best tool for the job?" and "Just how smart are these bombs?" The shift corresponded with the "end of ideology" pronounced by Daniel Bell in 1960 and again in 1992, under a different banner, by Francis Fukuyama.[27] The resolution of the Cold War dialectic made space for the entrance of a new value system. The exercise of military power no longer demanded justification as it once had because history had seemingly rendered a verdict. With all the discussion out of the way, the technician could move in and do the job of executing the divine right of empire.

Amid this shift to the technological frame came a proliferation of the language of "precision," a discourse that did much more work than may seem at first glance. This language was, of course, central to those rather objective claims about measurement and air strike capabilities, but it also served a broader metonymic function. The term rose to the status of master signifier in the presentation of the conflict, condensing the entire technological frame. Moreover, the language of precision bound itself to the smart bomb camera such that the appearance of one automatically invoked the other. As Kaplan notes, "In the absence of other visual records, the 'smart bomb' footage took on a privileged percentage of the display of technical prowess for which the war is known" with the image of the smart bomb's "objective eye" carrying forth the values of realism and action.[28] Together, this constellation of discourses had the advantage of appearing disinterested and empirical, giving what might otherwise be viewed as an obvious exercise in military public relations a high degree of credibility. This apolitical veneer served to obscure the eminently political maneuver, carefully choreographed through press conferences and selective video feeds, that restricted the range of broachable subjects. If the structure of the press pool system was the brute force that corralled the media system into a limited number of channels, the discourse of precision fine-tuned public perception to conform to the trajectory of the projectile. This language operated as a persistent caption that ordained the eye according to the ordnance, asking the viewer, in conjunction with the image, to see the world as the targeting system sees it. In some cases, this meant assuming the shape of the projectile as it plunged toward a spot on the earth; in others, it meant anticipating the inevitable puff at the dead center of the cross. Either way, precision implied the shedding of context, of any consideration that might interfere with the question of whether the coming strike will fulfill its promised perfection.

Captioned in this way, each smart bomb reel contained a second strike, just as surgical. Not only did it divert the conversation to the technical mastery of "precise" military weaponry, it also, in accordance with its Latin roots (to "cut in advance"), trimmed the civilian gaze along the contours of the weapon's visual frame. By inviting the field of consciousness to converge on its vanishing point, smart bomb vision should thus be understood not so much as a discourse of seeing but as one of unseeing. Here the image pretended to offer a revelation but instead performed an erasure, promised to resolve into a defined figure but instead plunged the eye into a whiteout.

Foreheads in Warheads

No targeting footage restaged the aesthetics of disappearance quite like a particular reel released on January 22, 1991, less than a week into the conflict—an image that quickly rose to iconic status. The footage, issued from the nosecone

of a standoff land attack missile (SLAM), deployed from the sky much like a present-day drone's Hellfire missile. Some version of this missile had been in production since the 1960s, but this was the first time that nosecone footage had been made publicly available, a fact that Admiral Conrad Lautenbacher, the video's presenter that day, made clear to the press. After initiating the ritual with the familiar benediction ("Can I roll tape, please?") and running video of another bombing, Lautenbacher introduced the SLAM, highlighting its capabilities as a "standoff" or remotely operated weapon. The video began as many others had, with the crosshairs etched on the screen and a gray box in the distance, but this time the target drew nearer, expanding to fill the frame and eventually resolving in a wall of static. Lautenbacher took a moment to explain: "This is a little bit different because this is on the front end of the weapon itself. You are seeing a TV picture from the front end of the weapon coming in towards the target . . . You can see it. That's it. TV goes out as it hits the center of the target."[29]

The novelty of this disappearing act did not go unnoticed. In replaying the day's video feed, Dan Rather of *CBS News* marveled at not only the technological wizardry of the targeting system but also the way vision itself was consumed in the act of watching: "US officials release more remarkable video of air strikes on Iraq, including this bombing of what appears to be a dam or hydroelectric plant along a river. Also a bomb's-eye view of another attack, a camera right inside a so-called smart missile beams back the picture to the pilot in the cockpit as it homes in on a target. The bomb camera itself is destroyed when the warhead hits."[30] Rather was not alone in his fascination with this image. This view from the missile nosecone gained special traction in network news coverage across the spectrum, eventually becoming the gold standard for weapon's-eye footage and a shorthand way of signifying Desert Storm. Given the fact that this "projectile gaze" was the exception in a military feed dominated by the more static view from the bomber plane and gunship, one might ask why. Part of the answer lies in those aspects that made it especially good television fare—brevity, immediacy, drama, sharp lines, and raw kinetics. Part of the answer also lies in the power of the image to condense many of the themes already circulating in the public presentation of the war into a purified six-second loop: speed, precision, remote targeting, and absolute dominance.

At core, however, the SLAM footage rose to its iconic status because it captured the essence of the television war: the disappearance of violence, the body, death, suffering, and even the bomb itself. In the shadow of Vietnam, the image was eminently safe, an ideal picture of the clean war that, on each airing, represented a handshake of goodwill between television news producers and military public relations. The SLAM footage swept the screen at regular intervals, covering the military's tracks when it came to the issue of

dead soldiers and civilians. Indeed, the image was the tip of the spear in a larger campaign of image management. The most astonishing tales of attempts to hide the body would not emerge until after the conflict,[31] but as it unfolded, the U.S. military—and the executive branch in general—veered far away from even the mere suggestion that war involved death, much less killing on a mass scale. This attitude produced an absurd range of official Iraqi body counts, from early estimates by the Defense Intelligence Agency of 50,000–150,000, to the figure of 10,000 from air campaign general Charles Horner, to Secretary of Defense Dick Cheney's final figure of 457 delivered to Congress.[32] For their part, journalists by and large did not dare risk losing access to their bread and butter by showing images of suffering Iraqis or asking where the bodies might be buried. The immateriality of the body in this discourse produced what Caren Kaplan calls a "landscape that appeared to be devoid of human beings."[33] The SLAM footage delivered this landscape in spades.

This aesthetic cannot simply be characterized in terms of absence, however.[34] The war-shaped hole in the presentation of the war left a vacuum into which a range of acceptably antiseptic discourses rushed. Official coverage traded terms like *bombing* for *the delivery of ordnance*, which Judith Butler notes shares etymological roots with terms like *ordinance* and *orderliness*.[35] This resignification process also involved a range of such language substitutions that cast the war as a medical procedure and abstracted bodies into the Iraqi "war machine." Under these conditions of erasure, envisioning actual human life under fire took effort. Canadian journalist Mary Rogan attempted to illustrate the depth of the contradictions inherent in CNN coverage, which deemed any talk of casualties off-limits but nonetheless received praise from its rivals as the highest form of journalism. Writing in the *Globe and Mail*, she urged audiences instead to exercise their "moral imagination" and try to picture a woman giving birth in Iraq as shells rain down.[36] The SLAM footage seemed almost uniquely capable of managing these contradictions. This special quality, combined with its ubiquity, attracted the attention of scholars. H. Bruce Franklin, for example, argues that the footage served as the ideal metaphor for contemporary Western military force—what he called "clean techno-war"—and a capstone to the two-hundred-year evolution of U.S. war imagery: "The target got closer and closer, larger and larger. And then everything ended with the explosion. There were not bloated human bodies, as in the photographs of the battlefields of Antietam and Gettysburg. There was none of the agony of the burned and wounded that had been glimpsed on television relays from Vietnam. There was just nothing at all. In this magnificent triumph of techno-war, America's images of its wars had reached perfection."[37] The real significance of the SLAM footage thus resided in the strict boundaries it imposed on the public imagination through what it carefully selected out of the frame. In his appraisal of Gulf War propaganda, Philip M. Taylor lays

bare the bait-and-switch scheme of the smart weapon-camera, which appeared to reduce the distance of the push-button war but went blank before any real witnessing could happen.[38]

There is more to the story of this iconic footage, however, than its use in surgically excising the realities of suffering. In some ways, smart bomb vision disappeared the witness before the question of "Where are the bodies?" could even be asked. Two important aspects comprised this act of stealth assassination. The first was the ability of this footage to refine public identification with the military apparatus by shifting from the soldier who aims and pulls the trigger to the ordnance already speeding toward the predesignated target. In doing so, the SLAM footage snuffed out even the limited sense of agency associated with the soldier, who at minimum makes tactical decisions and reserves the outside option of defying orders. The view from the nosecone poured witness attention into the targeting apparatus already in the process of running a set of preset commands. The image thus supplanted a sense of human election with clockwork inevitability. Second, as it rose to prominence, the SLAM footage overextended the gaze, exchanging an aesthetic of hypermediated remote control *over* the warhead into one of immediate identification *with* the warhead. The footage thus consummated the marriage of television and the weapon by pushing the public gaze into progressively hotter territory. The sense of prosthetic power intensified as the missile cruised down its flight path, closed in on the target, and searched out every last detail. At some indeterminate but fatal point, however, the gaze slipped into a trap. As if crossing over the horizon of a black hole, the observer passed from subject to object of military power, ultimately collapsing into the business end of the apparatus. The static that scrambled the screen upon detonation thus signified not only the annihilation of the target but also, in the same instant, the annihilation of the viewing subject. In doing so smart bomb vision played a key role in a larger war on the witness, operating under the principle that, as the saying goes, dead men tell no tales. Or, if we accept Butler's formula that this viewer assumed the shape of the "disembodied killer who can never be killed," we must add the caveat that this killer, like the undead stalker in a slasher film, saw the world through the mask of the automaton.[39]

At this particular press conference, the ritual annihilation of the witness continued to play out even after the wall of static faded from the screen. Lautenbacher continued: "Now, on the next run, you can use the TV as battle damage assessment, because you can see what the first weapon did." He suddenly stopped to have an off-mic exchange with a handler ("That was it?") before returning and announcing, "Okay, we lost that one . . . I'm sorry that that other tape—the tape that I reviewed this morning had that second shot on it."[40] There would be no images of the aftermath, which apparently had been fumbled, "lost" amid all the breathless talk of precision. It is not as if they

were simply unavailable, of course. Their retreat into obscurity—accidental, deliberately staged, or the result of strategic second-guessing—punctuated the strange ritual of the witness who appeared master of the universe one moment and perfectly helpless the next, blinded by the gods, yet another casualty staggering through the desert.

Compromised as it was, however, this position was not without its optical pleasures. Working in the idiom of psychoanalytic film theory, Robert Stam suggests that the theater of Desert Storm merged with the darkened home theater stateside. The thrill arose from "primary identification" with the camera, a scopophilia that transformed viewers into voyeurs and aficionados of schadenfreude.[41] Part of the power play also involved the practice of exposing the enemy, as Kevin Robins and Les Levidow note, by placing the orientalist figure of the veil and the "backward Arab as coy virgin" at the center of the drama.[42] Understood alongside Butler's suggestion that the smart bomb camera represented an "optical phallus," we can begin to make sense of another dominant caption in the discourse of smart bomb vision: sexual power and violation. The language of masculine penetration, alongside the actual weapon of rape, is, of course, ever-present in the culture of warfare more generally.[43] Consider the Associated Press story, ultimately censored by the military, that found air force pilots routinely watching pornography before their bombing runs.[44] As John Pettegrew puts it, in a twist on the second-wave feminist rallying call, "Pornography is the theory, killing is the practice."[45] Sexual metaphors were no less prevalent in the drama of Desert Storm. On civilian screens, this began with the application of the metaphors of sexual deviance to Iraqi government. The public relations bonanza that preceded the invasion questioned Saddam Hussein's sexuality and referred to his mobilization as the "rape of Kuwait."[46] This rhetoric naturally demanded that the U.S. undermine the enemy's deviant virility with a supposedly more righteous variety. This could be heard in ABC's Sam Donaldson's comments as he emerged from a press briefing "pumped up" and proclaiming that Saddam Hussein has "folded like a wet banana," a simile that only makes sense when one understands it as a statement about Hussein's flaccidity, compromised further by the archetypes of feminine wetness.[47] It can be heard in one the most memorable official statements of the television war

FIGURE 5 Iconic SLAM footage sequence from Pentagon press conference.

when Colin Powell, then chairman of the Joint Chiefs, invoked the language of castration when referring to the Iraqi military in a press conference: "First we're going to cut it off and then we're going to kill it."[48]

The term *war porn* would not enter the language until the second American invasion of Iraq in 2003, but the metaphor was under construction during Desert Storm.[49] Smart bomb footage in effect comprised a kind of coded "money shot," the climax of the sexual drama and the point at which the tension of the pornographic gaze releases. The term is especially useful here because it does double duty. Originally the term hailed from mainstream Hollywood, where it more innocently referred to the most expensive shot in the film, typically an explosion or some other act of destruction. In smart bomb vision, not only did the destruction expend the priciest weapons money could buy; it also symbolically violated the enemy's masculine integrity. The footage was central to this discourse insofar as it offered viewers the pleasures of, one might say, raping Hussein back, while cloaking the drama in the clinical language of precision.

In the common parlance of journalism, this violation appeared with the expression that the smart bomb went "down the airshaft" or "airholes" and "through the back doors" of various targets. Eventually these descriptions resolved in the phrase *down the chimney*, the shorthand with which smart bomb vision became most identified. This language gained initial traction in one the first press briefings to feature this variety of footage. On January 18, 1991, Lieutenant General Charles Horner of the air force ran several clips depicting what he called, in the bureaucratese of empire, "weapons delivery." This set of clips focused on the ability of bombers, using laser guidance, to hit weak points of their targets: "You'll see two bombs fly into the door of the storage bunker ... One, two. Those are 2,000-pound bombs." Another, aimed at an "air shaft," sent debris flying out the front door as it detonated. The highlight of this presentation was the strike on the Iraqi Air Defense Headquarters building, what Horner identified as "my counterpart's headquarters in Baghdad." After a bit of laughter in the press room, he went on to describe bombs going "down through the center of the building."[50] Journalists gladly recycled this language to couch the scene in terms of visual dominance.[51]

Horner himself made no mention in the press conference of bombs going "down the chimney," however. This cheeky phrase first took to the airwaves from the desks of *CBS News*, where it was used so consistently it may as well have been copyrighted. Paula Zahn coined the phrase on the morning after the briefing, uttering it at nine o'clock and again at ten.[52] By that evening, Bob Schieffer redeployed it in conversation with his in-house military analysts as they dissected the bombsight videos in detail: "[The bomb] literally went right down the chimney." The on-air expert, General Michael Dugan, responded by extending the metaphor more explicitly along its corporeal dimensions: "It

went down in the bowels of the building and then exploded in the inside of the building."[53] It was not long before "down the chimney" fused with smart bomb vision as its constant caption, spreading rapidly through the glib news coverage of the high-tech war. It had a certain pop, juxtaposing the image of a benevolent Santa Claus delivering a gift with the sexual violence of entering through the exit.

These vignettes, with all their libidinous language, were vital to winning public support in 1991. As the *Washington Post* put it, "Two weeks of smart bombs, right-stuff pilots and take-charge generals have made the military, by leaps and bounds, the most confidence-inspiring institution in the country."[54] At this point, 85 percent of Americans expressed a "great deal" or "quite a lot" of confidence in the military, the highest since the years prior to Vietnam. The discourse of precision played a major role. Upward of 69 percent of Americans reported that weapons performance had increased their "faith in American know-how."[55] The success of increasing American faith in "know-how," unfortunately, came at the expense in attention to "know-why."

The Reel Unwinds, or The Luckiest Man's Revenge

As the stateside public relations campaign came to live by the sword, however, it tempted death by the sword. So central was the image of smart bomb precision to the military's presentation of the war that the first cracks in the edifice of public faith showed here. A week into Operation Desert Storm, a rogue journalist in the Riyadh press corps confronted Pentagon spokesperson Pete Williams about the selective nature of the bomb and missile footage: "You certainly have pictures . . . of less than success and perhaps even collateral damage. How come that's not being released?" Perhaps thrown off guard by this sudden insubordination, Williams balked, "I'm sorry, I don't understand the question." The reporter persisted, despite the knowledge that this kind of question jeopardized future access to military press conferences: "We have checked footage from the—I think from the cameras in your planes. We've seen smashing successes in every case. I'm wondering why we're not seeing anything other than smashing successes?" After taking exception to what he framed as yet another demand from the press, Williams promised to "look into" releasing some of that footage.[56] Reporters took note and waited. Two weeks passed—a lifetime in a war that only lasted one month—and still the Pentagon produced no footage of smart bombs missing targets.

A reporter from the *St. Petersburg Times*, one of the few outlets that refused to conform fully to the Pentagon's stenographic expectations of the press, ticked off a list of the footage rolled out in the subsequent weeks: "Images showed the destruction of a MiG-25 Foxbat jet by a radar-seeking missile fired from a U.S. F-15E; the bombing of mobile Scud missile launchers; a

truck driver Schwarzkopf dubbed the 'luckiest man in Iraq' as he drove across a bridge just ahead of a smart bomb. The videotapes still didn't show any bombs missing targets, as Pentagon spokesman Pete Williams has promised in an effort at balance."[57] Despite efforts to wish it away with more of the same footage, the question, which might have otherwise been asked by a child, had quietly pricked the illusion. The thoroughly unsatisfying answer lingered on stage thereafter like a naked emperor. Not only did it reveal that the Pentagon had cherry-picked the videos it chose to release, but in its own uncomplicated way, the question directly challenged the governing logic of war's presentation, which was the containment of public attention within a progressively narrow frame. Attending to what had been framed out—even if it was only another targeting video—ran counter to the directionality of smart bomb vision. Rather than converging at the point of impact, this gesture widened the frame. It was equivalent to running the footage in reverse, past the point where the target stabilizes, and even past the instant where camera's aperture flicks open for the first time. Perhaps unwittingly, the rogue reporter momentarily renounced the role of accomplice in the visual economy of the strike.

In retrospect, this was only the opening salvo in one of the dominant controversies to follow Desert Storm. To this point, the question of "Just how precise?" had been a point of pride for Pentagon public relations eager to roll tape. About three weeks into the air campaign, it had acquired a critical flavor. Some news outlets began printing official but unpublicized estimates of smart bomb accuracy that put the portion that hit their targets at a near-scandalous 60 percent.[58] This lent credence to the notion that the Pentagon should have easily been able to locate footage of munitions hitting far afield of the chimney. The issue of smart bomb accuracy shrank, however, in the face of a bigger question: What portion of the American campaign was waged with precision weapons? After all, the bombing of Iraq was as intense as any in the twentieth century. In only the first fifty-four hours, the campaign flew twice the number of sorties as raided Normandy on D-day and dropped the tonnage equivalent to that unleashed on Hanoi during the eleven-day Operation Linebacker II in 1972, one of the Vietnam War's heaviest bombardments.[59] As these carpet-bombing numbers began to trickle into public consciousness after the conflict, the question naturally shifted to why so many bombs were necessary if they were all so smart.

In late February, days before the air war ended, the *Washington Post* did a serious investigative piece on the matter, quoting military officials who said that more bombs had missed their targets in Iraq and Kuwait than political leaders wanted to admit. Although the editors at the *Post* gave the article a softball title—"Not All Munitions Used in the Gulf Were Smart"—the fine print revealed that "not all" meant a scant 5–10 percent. The rest were run-of-the-mill ballistic "dumb" bombs of the kind that had been in use

since WWII.[60] Next came a November report by the human rights group Middle East Watch, which concluded that the civilian death toll, including the three hundred incinerated in the clearly marked Ameriyya air raid shelter, was partly due to the U.S. military's penchant for dumb bombs.[61] The final blow came in 1996 when the U.S. General Accounting Office released a 250-page report on the efficacy of military weapons systems, especially laser-guided bombs, which concluded that official claims "were overstated, misleading, inconsistent with the best available data, or unverifiable."[62] The press reprinted this conclusion widely alongside the final figure that only 8 percent of bombs dropped in Desert Storm were in fact guided.[63]

Such reports, of course, implied that the military should have used more smart weapons, but their circulation harbored a second scandal regarding the selectivity of smart bomb vision. This appeared in the signifier of the *dumb bomb*, a term unintelligible in U.S. public life before the onslaught of smart bomb videos. Now the dumb bombs seemed to crash through the roof of the briefing room to everyone's embarrassment. They symbolized our collective gullibility of having fallen for the dog-and-pony show of military PR as well as that which lay beyond the smart bomb screen, the vast public blind spot, a universe of dark matter. While some managed to "go dumb" and fail to be "smashing successes," the vast majority of them were dumb from the start. "Dumb" was a descriptor not just of the weapon but also suddenly of the eye, which for so long had been happily married to the bomb. Military public relations sold the war with a promise to extend the visual powers of the sky-god general—the intelligence, virtuosity, and the ethical high ground embedded in the concept of precision—to the civilian on the couch. The sudden specter of the smart bomb's invisible counterpart raised the possibility that if Schwarzkopf's little films cast any light, it was through a pinhole in a dark cell. Here the civic eye briefly beheld itself as a virtual prisoner of war, held captive by a succession of shadows on the wall, each of which restaged a drama whose ultimate moral was the nobility of ignorance. Or, as the *Sydney Herald* put it upon the release of the General Accounting Office's 1996 report: "Smart Weapons Stupid."[64]

As "precision" itself came under fire, both conceptually and aesthetically, it pried open space for questions beyond the technical prowess of U.S. weapons, such as "What else didn't we see?" As journalists began to suspect, the Unluckiest Man was perhaps the rule and not the exception in the available Pentagon film stocks. One particular moment late in the conflict suggested that the veneer of the clean war had worn thin. In a closed session, the Eighteenth Airborne Corps screened video for a select group of reporters of a nighttime Apache helicopter strike on an Iraqi infantry bunker. One of these reporters, John Balzar of the *Los Angeles Times,* filed a story for Reuters-AP that described the footage. From the infrared gun-camera, he wrote, Iraqis appeared "like ghostly sheep, flushed from a pen . . . bewildered and terrified, jarred from

sleep and fleeing their bunkers under a hellstorm of fire." He continued to describe the fate of these soldiers, "big as football players on the TV screen," in grisly detail: "One by one they were cut down by attackers they couldn't see or understand. Some were literally blown to bits by bursts of 30 mm exploding cannon shells. One man dropped, writhed on the ground and struggled to his feet. Another burst tore him apart." He juxtaposed this scene with the images reporters and the public had become used to consuming. "These are not bridges exploding or airplane hangars," he took pains to point out. "They are men."[65] Among the reporters present, Balzar appeared to be the only one who mentioned the video that was otherwise carefully shielded—some might say censored—from public view. His vivid description, however, was picked up by outlets in Canada, the U.K., and, astonishingly, the U.S. In a rare challenge to the sanctity of the one-hand-washes-the-other relationship between military and press, CBS anchor Dan Rather mentioned the footage's existence. "The first video of the Gulf War ground fighting has been screened for reporters," he declared, a striking introduction insofar as it revealed that up to that moment, the military's video releases had virtually ignored the ground and especially the human beings who inhabited it. Rather's words, which would normally set the stage for viewing official footage, however, instead marked its absence. "Under what one can only call the weird rules of this pool arrangement," he explained, "you aren't allowed to see that video." He went on to paraphrase Balzar's description of what we could not see: sleep-deprived conscripts, oblivious to their attackers, being methodically "torn apart" by cannon fire in high definition.[66]

With this small gesture, Rather revealed the fragility of the TV war's antiseptic aesthetic. His invocation of the video twice that day—at both eight and eleven o'clock—stood as a small corrective. Indeed, Rather appears to have deliberately timed his comments to butt up against CBS segments that giddily celebrated the Apache weapon system. In a typical instance of military-sponsored programming, the first segment invited a CBS reporter to tag along with chief warrant officer Bill Murray at Alabama's Fort Rucker to ogle the weapon. The Apache had already ascended into the pantheon of Desert Storm heroes, rivaling the smart bomb on the Olympus of the public screen. And like the smart bomb, the helicopter achieved its fame via its onboard targeting camera and the military's choice to selectively air its tank-destroying exploits during press conferences. In the CBS report, the attack helicopter's night vision and targeting capabilities were first on Officer Murray's itinerary. When coupled with the 30 mm cannon and Hellfire missiles, the reporter noted, its optical powers made it a "night-stalking" killer. "In many ways, it's almost like a big video game," remarked the reporter on the heels of an animated sequence of the Apache in action. "That's exactly right," Murray replied, "The better you are at playing video games, the better you can operate this system."[67] Three

hours later another reporter repeated the script: "All the pilot has to do is turn his head and his helmet points the Apache's weapons . . . In the cockpit, it looks like a video game as the Apache closes in." This time, the reporter dwelled longer on the figure of the targeting camera "that takes pictures of everything that the pilot sees." And as he had done before, Rather immediately followed this vivid description with the story of the gruesome footage taken from one of those very cameras: "Even hardened soldiers held their breath when it was shown in the briefing tent."[68]

The effect of these interchanges is a kind of optical whiplash. One moment we are in a virtual cockpit that promises guiltless transparency, and the next we are forced to confess that we are in fact as groggy and confused as those Iraqi conscripts who stumbled out of the bunker into a hail of gunfire at night. One moment a reporter praises the all-seeing eye of the Apache camera, and the next another reporter admits, "I can't truthfully say to you I know why [the footage has been withheld]."[69] CBS eventually attempted to cross this widening gulf when it filed multiple requests for the video. This quest, unfortunately, led only to an informational no-man's land. After much stonewalling, defense chief spokesperson Commander Keith Auterburn finally replied that he did not have access to the video and that it must have been held up at central command. Another spokesperson explained that in any case graphic content would not be a reason to withhold footage.[70] The exact reasoning behind the Pentagon's evasions would remain unknown. We do know, however, that the PR machine's gun-camera, which had hummed along pleasantly enough for most of the conflict, had developed a noticeable rattle.

Persistence of Vision

The legacy of this image bombardment is a complex mix of public celebration of military weaponry and skepticism. After the U.S. pulled out the troops, the little films, full of a momentum all their own, continued to loop on the public screen as part of the marketing blitz that followed.[71] CNN did not waste time in rereleasing its second draft of history in the form of a collectable video entitled *Desert Storm: War Begins* on March 1, 1991, one day after the official end of hostilities. The video's opening montage praised CNN itself as the war's primary hero. Here one can almost mistake images of producers shouting in the control room for generals in a war room. Field reporters, who don safari vests and bark orders at their camera operators, resemble soldiers in battle. Of course, there are jets taking off and explosions on the horizon, but the repeated image of the satellite dish binds the story together. At its climax, the montage pairs an image of Peter Arnett with a dish over his head as he radios a report from his satellite phone ("Baghdad continues to be the target") against the nosecone footage of the SLAM missile closing in. The progression reads as if Arnett, a

surrogate for the citizen at home, were calling in a strike himself. Armed with this teaser, the video works through the official timeline—the "crisis," threats, hostages, protests, and mobilization—eventually building up to the money shot: the first iconic scenes of night vision tracer fire over Baghdad, followed by a series of explosions in the targeting camera's crosshairs. The video lingers on the bombing footage of what the U.S. Air Force commander called his "counterpart's headquarters in Baghdad."[72] Smart bomb vision thus opens and closes the video, foreshadowing the events that inevitably lead to the moment of release. CNN, with its array of communications equipment, is there to make sure both the bombs and their little films strike with the utmost precision.

More documentaries were on the way. In June, the Arts & Entertainment Network aired a four-part documentary entitled *Desert Storm*, produced by the aptly named firm Video Ordnance Inc. and later repackaged as one of many collector's sets. The production firm's chair at the time, Steven J. Zaloga, had taken a short leave from his career as a marketing consultant for the arms industry to work on *Desert Storm* as well as the Discovery Channel series *Firepower*. After his tenure was up, the company continued as a broker of official weapons footage for films like *Crimson Tide* (1995) and *Charlie Wilson's War* (2007). As one might expect, *Desert Storm* staked its aesthetic on fetishizing the weapon, dancing rhythmically between beholding its glory and witnessing its destructive powers through the targeting camera. As the *New York Times* put it in a yawning review, "it all works so smoothly," rendering a "feeling that you have been subjected to a Pentagon commercial" with "no pictures of corpses" and, in their stead, "again, those cross-hair videos of bombs hitting their targets with unfailing accuracy."[73] In a sense, *Desert Storm* answered the question of what the television war might have looked like had the Pentagon bypassed the rather onerous task of stage-managing the charade of journalism. This was the PR campaign boiled down to its raw material. The same set of conventions took form just a few months later when ABC released a made-for-TV film entitled *The Heroes of Desert Storm* starring Billy Baldwin. Here filmmaker Lionel Chetwynd collaborated closely with the George H. W. Bush administration to dramatize the TV war through the personal stories of U.S. soldiers. As in the case of its progenitors—the TV war, *Desert Storm* the documentary, and *Top Gun*—the real heroes of the film the blinking weapons themselves, especially those that provide the alibi for rerunning long stretches of targeting footage.

In the decade that followed, smart bomb vision persisted as an expectation. When it became clear that the media were not invited to the "quiet war" of Operation Desert Fox, President Clinton's escalation of the bombing of Iraq in the late 1990s, visions of smart bombs remained, if only as a conspicuous absence. Much of this coverage came from outside the U.S., where reporters puzzled over the blackout: "The Pentagon briefings have stopped, and there is no footage of the smart weapons at work, but the destruction of Iraq

continues."[74] The reasons for the blackout may have had everything to do with the pall of disillusionment that fell with the discovery that the smart bombs were not so smart. A reporter for the U.K. *Sunday Times* captured the sentiment that such "video game imagery" was all smoke and mirrors: "It is an echo of 60 years ago, when Mussolini was filmed reviewing his small number of planes in different cities and then cut the shots together to give the impression of a large air force. These days he would digitally multiply them to his heart's content and few of us would be the wiser."[75]

For some, therefore, the smart bomb became an emblem for the postmodern unreality of images, bluster, political dissimulation, and public spectacle. Clinton's critics began circulating the idea that he was cynically using Operation Desert Fox to distract from the Monica Lewinsky affair.[76] The arrival of the film *Wag the Dog* (1998) restaged this narrative and secured its place in the public understanding of events. As one reviewer put it, the lesson from the film is that "wars need, more than anything else, an image: the smart bomb going down the chimney in Iraq, for instance . . . The whole thing can be concocted as a special effect in Hollywood."[77] This narrative has often been mistaken for a necessary critique of the spectacle, but it worked instead to contain the disillusionment. In more enlightened times, the critique of the smart bomb image could have led to a serious reckoning with the devastation of Iraq after a decade of continued bombing and the enforcement of near-genocidal economic sanctions. At the very least, it might have involved the basic recognition that real human beings existed on the other side of the crosshairs. Instead, the "real thing" from which the shadow play of the smart bomb distracted was the tabloid story of the president's sexual indiscretions. This was indeed a bold reversal, suggesting that war, not Clinton's torrid tryst, was the true circus sideshow. Smart bomb vision, in other words, began life as a mode of capturing the civic eye. Thereafter, the dominant national narrative conscripted it to help hide the bodies by implying that the war was as unreal as it seemed.

Although quarantined, this disillusionment did not dampen the smart bomb's appeal as an object of fascination. After the attacks of September 11, 2001, journalists were primed for version 2.0. The vice president of programming at *Fox News*, Kevin Magee, ruminated on whether the Pentagon, despite its plans to limit press access in Afghanistan, would again dazzle Americans with "smart bombs [going] down the chimney."[78] The Australian newspaper the *Age* managed to mix the question with an ironic wink: "Remember the laughter? The joy? . . . The smart bombs as their nose-mounted cameras took us not just to their targets, but into the windows of their targets? Bada bing! Now that was television." The reporter went on to speculate that the images must have gotten even sharper after ten years and thus would make for excellent television: "Bomb Iraq Now. We need the footage."[79]

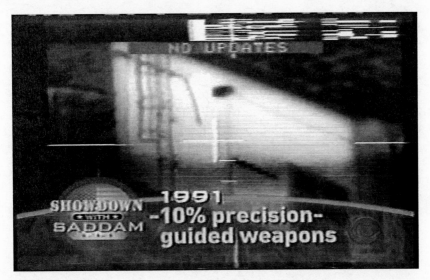

FIGURE 6 CBS recycles the SLAM footage in the lead-up to the Iraq War in 2003.

The U.S. military did indeed bomb Iraq in March of 2003, unleashing a fire-storm of official imagery that elaborated on the basic features of smart bomb vision. Not surprisingly, the original footage made a reprise as well. A few months after the initial invasion, in September of 2003, the History Channel aired an installment in its long-running *Modern Marvels* series called "Smart Bombs." The documentary appeared just before the wave of turgid national-ism and worshipful techno-fetishism broke in the face of a long occupation and nagging casualty counts. It was as good a time as any to ask how those weapons—those whose grainy gray camera footage exploded in a permanent loop on the television—got to be so great. Naturally, the documentary zeroed in on the 1991 Persian Gulf War as a turning point, what it acknowledged as a "media event" wherein the guided weapon went "prime time" as it merged with the live twenty-four-hour news network. The narrator kicks off the seg-ment amid a concussive parade of greatest hits: "During the thirty days of aerial bombardment, all the talk was of smart bombs." At other points, the eye plunges toward a building, packaged tightly inside the image and precision-guided with declarations like "You are the bomb, hunting the enemy, and hur-tling toward him at thousands of feet per second."[80] Remember when.

With the civic eye fully assimilated into its circuitry, the smart bomb con-tinued as a cultural reference point. The *Atlantic* ran an article about the "logic of suicide bombing" that suggested that those who resort to the desperate act represent the "the ultimate smart bomb," the kind of reversal common in impe-rial discourse that suggests the lone global superpower is instead working from an essentially defensive and even disadvantaged position.[81] The metaphor

even proliferated as a way of invoking the concept of precision in endeavors as diverse as marketing (as it was already understood in terms of marketing a war) and the fight against antibiotic-resistant bacteria (as it was already understood in terms of antiseptics and surgery).[82] The basic outlines of smart bomb vision were so recognizable that as recently as 2017, corporate stock image sites like Shutterstock sold black-and-white clips that restaged a nosecone hit on a boxy building. Alive as ever, the metaphor retained the ability to conjure the gunsight's grid and superimpose it over the screen. Smart bomb vision persisted, in other words, although it had diffused into a multitude of sometimes contradictory uses. This footage inspired both trust in military prowess and wariness of military public relations; both desire for access and the sense that one is being manipulated through that same access; both the hot exhilaration of immediacy and the cool numbness of hypermediation; both the sense that the stakes could not be higher and the sense that one's attention has been hijacked by empty spectacle. Such contradictions do not necessarily add up to critique, of course, especially if we recall that through it all, the realities of violence, destruction, and human suffering have never quite seen the light of day.

Indeed, rather than fading away like an old soldier, smart bomb vision has if anything sharpened over time into a seductive cultural fixture. Its ultimate legacy may be its penchant for putting us "inside the bomb," a phrase recycled almost as much as the footage. Sometimes it is uttered in excitable tones to suggest the immediate presence of visual supremacy. In more sober moments, it expresses the power of the image to enclose consciousness, to describe a new era wherein the civic eye is the primary target onto which weapon locks. In a review of the history of war imagery, novelist J. G. Ballard notes that by "urging us to become a cruise missile," these images "incite our imaginations in a wholly new way."[83] Like its supposed counterpart, the suicide bomber, its destination is annihilation of a sort: of any thought that a bomb might not think, any world outside of the point of impact, any choice outside of the programmed inevitability, and any consequence following the much-anticipated detonation. Eyes bleary with speed and static, heart pounding from kinetic thrills, and stomach turning from a touch of air sickness, we return to base. Or as Ballard puts it, "Before anyone is hurt we are back to General Schwarzkopf, the P. T. Barnum of Desert Storm, jovially commenting on what some lucky Iraqi driver saw in his rear-view mirror as he crossed a bridge disintegrating behind him."[84]

3

Satellite Vision

A vision of the future: when this conflict is forgotten, we will still have news from the front. In order to assess the condition of these places, we will no longer watch CNN live, but rather meteorological updates. Day after day, month after month, the Meteosat satellite will show us, above Kuwait, or Iraq or Saudi Arabia, *the dirty war in real time . . .*
—Paul Virilio, February 27, 1991

Even if he sometimes speaks in riddles, Virilio has a good track record as a prognosticator. Here we explore the future that he had in mind: a period whereby aerial and orbital images of the globe, what Denis Cosgrove calls the "Apollonian perspective," rose to prominence in representing war to the public.[1] This new mode of witnessing saturated the televised lead-up to the 2003 invasion of Iraq and its subsequent occupation, comprising a set of image practices that scanned territory from stratospheric altitudes in the service of everything from marking targets to surveying bomb damage to speculating on the whereabouts of Saddam Hussein. These images were distinct to the digital age: scrollable bird's-eye views, scalable landscapes, multiperspective 3-D models, and flyovers that overlaid photographic imagery with virtually rendered animations. In a word, U.S. television coverage of this war filled the visual field with the invitation to try on "satellite vision." This view implied

an intimacy with the war machine at its highest levels as it spread its strategic gaze over the space of imperial desire. The Earth appeared through the eyes of the general, which skimmed along the horizon, drew kill boxes, and conducted reconnaissance in the crevices of the urban landscape. The new mode followed on the heels of the smart bomb vision that characterized the 1991 Persian Gulf War, but this time the frame widened to assume the point of view of those celebrated satellites that, at least in their popular depiction, directed the bombs to their precise targets.

It is no mere coincidence that in 2006, not long after this wave of war imagery crested, Rey Chow declared that we had entered the age of the "world target." She argued at the time that we had moved beyond Heidegger's 1930s notion of the "world picture" and the modern period that both represented the world as a system of rationalized, scientized knowledge-objects.[2] Instead, she contended that the atomic bombings of Hiroshima and Nagasaki initiated a new era of feverish intellectual activity whereby Western attempts to catalog, comprehend, and represent cultural difference around the world ultimately merged with the military-industrial complex: "In the age of bombing, the world has also been transformed into—is essentially conceived and grasped as—a target."[3] Its increasing virtualization from the Cold War onward, moreover, allowed the concept of *war* to transcend its former role as a "state of exception" to be "thoroughly absorbed into the fabric of our daily communications."[4] This colonization went vertical as well. Chow references the Iraq wars of 1991 and 2003 specifically, noting that the world had been divided visually into above and below, where the "aggressiveness of panoramic vision went hand in hand with distant control and the instant destruction of others" in accordance with the dream of establishing "God's-eye" vision.[5]

This chapter takes a cue from Chow's notion of the "world target" but asks the question from a slightly different vantage point. How has this omniscient, stratospheric military view been made available to the masses, and how has it worked to condition the appearance of state violence in the public imagination? We begin with a historical sketch, starting in the early days of the Cold War, of how satellite and aerial imagery, once the exclusive province of military strategists, eventually trickled into public view through news and entertainment channels. The second section focuses on how satellite infrastructure was eventually repurposed for television news coverage during the 2003 invasion of Iraq. It was then that satellite images took center stage, refashioning the news studios into elaborate "war rooms." The chapter ends with a meditation on Google Earth, itself made possible by the sudden rush to create user-friendly imaging platforms for war coverage. Such practices suggest that the aesthetics of "world target" persisted and eventually cleared the clouds for the drone's-eye view.

The Satellite Eye's Slow Unveiling

The purely strategic use of satellite imagery began in the early years of the Cold War, continued with the space race, and intensified with efforts to map planetary targets for the emerging nuclear intercontinental ballistic missile system. The feverish creation of this world target, named the "World Geodetic System," was the obverse of the effort to develop perfectly accurate missiles, which would obviously fail "if the intended target [did] not actually lie at that point."[6] A fair amount of this top-secret information routinely flowed into the unclassified public realms of Geographical Information Systems research and onto the average schoolhouse map. The figure of the reconnaissance satellite and the view through its lens, however, remained a matter of utmost secrecy largely quarantined from the public imagination.[7] Indeed, it was not until 1978 that President Jimmy Carter declassified the "fact of" satellite photo-reconnaissance and publicly acknowledged it in a speech at Kennedy Space Center.[8] Until the more regular appearance of actual satellite images on the news in the mid-1980s, this mode of vision existed only as speculation coupled with the rare glimpse through the vessels of the space program. If the photo-reconnaissance satellite program did sporadically see print, it was mainly to highlight the threat that the Soviets were developing their own systems. Occasionally, too, folktales circulated about the ability of satellites to read a license plate from orbit, especially as the provocative codename of the KH ("Keyhole") satellite series began to leak. This section tracks the historical exposure of satellite vision, first through its appearance on the news and then through its fictionalization in feature film.

Decades before real satellite imagery appeared on the news, this way of looking began to take shape. As Timothy Barney documents in his fascinating book on the role of mapmaking in symbolically constructing the Cold War, magazines like *Time* and *Life* featured spreads that dramatized potential Soviet aggression. Among the most prominent of the 1950s were illustrations from the hand of Richard Edes Harrison, who drew "perspective maps." These were designed to give the reader a spectacular 3-D view of a section of the globe, topography and all, as its horizon curved across the page. In Harrison's "air-age aesthetic" the viewer hovered at a theoretical altitude of about forty thousand miles, a position that anticipated the orbital view to come.[9] Barney follows this aesthetic through the 1960s as mapmakers replaced Harrison's implied pilot with the "omniscient cartographic perspective" that was, through satellite photography and its later digitization, increasingly produced via machine.[10] What characterized these maps at the time—and the later echoes in Reagan-era literature that warned of the Soviet nuclear threat—was the sense of precariousness they engendered. The viewer, suspended in space, beheld the world from the perspective of the Soviet Union. Western Europe

and the Americas, in contrast, appeared as fruit ripe for the picking. This protosatellite vision, in other words, was a primarily defensive mode of looking that terrorized itself by peering through the looming eyes of the imperial enemy. This gesture supported the prevailing argument for the necessity of containment and deterrence.

By the late 1950s, the U.S. Air Force and CIA began experiments with satellite reconnaissance technologies, in particular the secretive CORONA program. While the government withheld the codename and details from public view, it routinely issued press releases from 1958 to 1960 publicizing the Discoverer missions that sent satellites into space for surveilling the Soviets. The language of "eye in the sky" or "spy in the sky" populated the headlines, which told stories of rocket launches, lost satellites, and the practice of catching ejected film capsules as they fell to earth. Such press releases abruptly ended after May 1, 1960, when the Soviets shot down a CIA-operated U2 spy plane over its territory, an international incident of the highest order that significantly chilled relations and prompted the U.S. government to go dark regarding its reconnaissance satellite program. While this ensured that the satellite image of the Earth remained virtually invisible for the next few decades, the seeds of satellite vision had already been planted. Months before the U2 incident, on August 14, 1959, NASA's Explorer VI sent the first live satellite picture of planet Earth from space via radio transmission, a striated white horizon marked by the islands of Hawaii. The image eventually graced the front page of the *New York Times*.[11] Although not publicized as a military reconnaissance mission, the image was likely the inspiration for another *Times* article a few months later that connected orbital vision with international espionage of the U2 variety. The article superimposed its title, "Long-Range Lessons of the U-2 Affair," over a large aerial photo of the globe taken from an Atlas rocket in the process of shedding one of its stages. The caption read, "VIEW FROM SPACE—As high-altitude photography is improved . . . aerial reconnaissance will become routine."[12] Such stories signaled that the figure of the strategic satellite and an aerial view of the globe—echoing Harrison's maps of the 1950s—had begun to merge in the public eye.

Satellite vision remained in the relative dark of speculation until, in the 1980s, actual images of the earthly terrain began to make public appearances. It was then that the commercial remote sensing industry—including platforms like the U.S.-based Landsat, the French SPOT, and the Soviet Soyuz Karta systems—began to sell geopolitically oriented satellite images to news organizations. While such practices operated outside of official governmental public relations, the newsgathering function of the satellite still largely cleaved to the official U.S. foreign policy agenda. A sample of these imagery requests at the time includes the Iran-Iraq border in 1985, a Soviet naval facility in 1986, suspected Iranian Silkworm missile sites in 1987 and '88, and a Libyan chemical

weapons plant in 1989.[13] As satellite vision crystallized, it aligned the public eye with the strategic gaze of the state. Doing so reinforced public discourses of geopolitical tension by habitually demarcating certain parts of the globe as territory of collective martial concern.

Given the accumulation of such imagery in the 1980s, one might expect that the 1991 Persian Gulf War would have overrun the television with the view from space, especially amid the worship of live satellite communications that infused the coverage. Although simple maps with labels—a.k.a. "balloon maps"—were everywhere (Peter Jennings even carried a pointer stick across one the size of a room), satellite imagery of war-related places and events was conspicuously absent.[14] The blackout was part of a broader agreement to preserve coalition military secrecy, codified in a U.N. agreement.[15] The French SPOT satellite system, for example, opened itself up to U.S. military use in this period while simultaneously cutting civilian access.[16] Most news agencies also voluntarily shied away from using available satellite images for fear of appearing to compromise the U.S. military mission.

This did not stop some investigative reporters from going rogue when presented with questionable governmental claims, however. In September of 1990, to bolster its case for military action, the Pentagon announced it had secret satellite evidence that 250,000 Iraqi troops and 1,500 tanks had amassed along the Saudi Arabian border and were poised to invade. Days later, that figure grew to 360,000 troops and 2,800 tanks. The *St. Petersburg Times* decided to check the claim by acquiring images from a Russian Soyuz Karta satellite. Experts who reviewed them found no evidence of any troop buildup, especially one so massive. When asked for comment, the Pentagon balked and insisted that its intelligence must be kept secret.[17] The lasting embarrassment of the episode perhaps demonstrated to the defense department that public relations would be best served not by blackouts but by filling the screen with its own more favorable satellite imagery. Indeed, the demand was there. The ABC network, which had historically led the way in the purchase of satellite imagery, even met with delegates from the former Soviet Union after the war to explore the creation of Mediasat, a system that would be used exclusively by a collective of large news organizations. For the time being, however, the group determined such a system would be too costly.[18] This left open the possibility that the Pentagon, much as it had done with smart bomb footage, could offer the press access to satellite imagery in order to gain control of the public image.

The U.S. executive experimented with leveraging this demand in August of 1995 when Ambassador Madeleine Albright appeared before the United Nations to allege that Bosnian Serb forces had engaged in widespread "ethnic cleansing." To bolster the case for intervention, she revealed satellite images of alleged mass graves in eastern Bosnia, the supposed aftermath of what became known as the Srebrenica massacre. Although this was the first to use satellite imagery,

these kinds of presentations had a history on the public screen. The first highly publicized instance was the 1962 Cuban missile crisis, where the Kennedy administration released fifty thousand photographic prints taken of suspected Soviet nuclear installations by reconnaissance aircraft to the U.S. Information Agency. Adlai Stevenson also showcased them in a speech to the United Nations that set out to prove the extent of the Soviet threat.[19] A similar but less apocalyptic moment occurred in 1984 when the U.S. State Department held a press conference to make the case that the Nicaraguan Sandinista government had been funneling Soviet arms to revolutionary groups in El Salvador. The administration had been making this claim since 1981 to harden the narrative of Soviet interference in Central America and boost public support for continued arming of the Nicaraguan Contras. At the press conference, General Paul F. Gorman of U.S. Southern Command in Panama presented as "proof" a handful of blurry still photos and one video taken from the infrared camera of an AC-130 gunship that showed someone unloading a crate from a larger ship to a canoe.[20] The 1995 Albright presentation elevated the genre to new altitudes. While here too, as Lisa Parks notes, "there was nothing 'evident' about [the photos]," the event unveiled a strategic gaze that had long been kept secret. Imbued with this new significance, the ritual offered a view that was "highly symptomatic of the US's position vis-à-vis the Balkans more generally" as supposedly objective, neutral, and omniscient.[21]

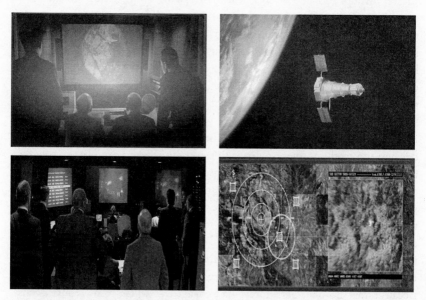

FIGURE 7 A selection of satellite vision in film. From the top left: War room from *Fail Safe* (1964); spy satellite from *Ice Station Zebra* (1968); CIA agents witness a strike on a terrorist camp via real-time satellite in *Patriot Games* (1992); and navy brass track a pilot downed in Bosnia in *Behind Enemy Lines* (2001).

The unfolding of satellite vision on the news tracked closely with its appearance in Hollywood film, which in some ways wielded more power to compose and mythologize this mode of seeing. Sydney Lumet's *Fail Safe* (1964) provided perhaps the first public glimpse, albeit well beyond actual technical capabilities, of the view through the fabled reconnaissance satellite's camera. In a "war room" similar to the iconic one depicted in Kubrick's *Dr. Strangelove* that same year, a U.S. general shows a congressman a global map of SAC capabilities. The general asks him if he wants to see what the satellite is "photographing right now." The map resolves to a picture of Earth seen twirling through a camera rotating in space. After stabilizing the image, the officer zooms in on a Soviet ICBM site. The congressman jokes that before long the satellites will be able to see the hairs on their heads.

It was not until 1968 and the release of *Ice Station Zebra*, however, that the reconnaissance satellite itself took the spotlight. The film's entire plot revolved around the loss of a satellite film capsule and a battle between Americans and Soviets to recapture it in the Arctic. Based on Alasdair MacLean's 1963 novel of the same name, the film was for a number of reasons the decade's most visible public representation of the strategic reconnaissance satellite. Unlike *Fail Safe*, the U.S. defense department assisted with the production of *Ice Station Zebra*, which thus stood as one of the few official acknowledgments of the satellite program's existence. Additionally, the plot for MacLean's novel and ultimately the screenplay probably derived from an actual incident in 1959, covered on the front page of the *New York Times*, involving a lost capsule.[22] Documents from the National Reconnaissance Office declassified in 2006 appear to confirm this. Indeed, one report notes that the capsule "might have been recovered by the Soviets," that both the book and the film closely resembled the incident, and that "an individual formerly possessing CORONA access" served as the film's technical advisor.[23] Given both its popularity and proximity to these events, the film served to stitch together a master narrative regarding the role of strategic remote sensing. This narrative held long after *Zebra* largely because the satellite's public aperture went dormant for two decades, a casualty of the same forces that took it out of news circulation.

The reexposure of satellite imagery on the news in the late 1980s changed all this and once again primed audience interest. In the 1990s, the reconnaissance satellite suddenly found itself featured in some of the biggest spy and war films. For the most part, the films in this list rehashed a plot familiar from the post–Cold War era: some rogue entity obtains a weapon of mass destruction and must be hunted down before the countdown strikes zero. Because these stories lionized the surveillant security state, the satellite often emerged as a tacit hero. As early as 1990, the plot for *The Hunt for Red October* revolved around satellites that picked up "heat signatures" of enemy submarines headed for the U.S. The film received enthusiastic production support

from the defense department and particularly the navy, so one can read it as one of the first official acknowledgments of the strategic satellite system in the decades since *Ice Station Zebra*.

Satellite vision itself does not reappear on the big screen, however, until the release of the sequel, *Patriot Games* (1992). In this film, supported by both the defense department and the CIA, Tom Clancy's hero Jack Ryan tracks down an IRA terrorist who has taken up residence in Libya (a mecca, apparently, for all alleged terrorists, from Palestinian militants to Peru's Shining Path). The film plunges its camera fully into the orbital optics of the satellite. Ryan pores over still images, zooms in, and orders techies to "enhance" them as he searches for clues. Later, as a commando team choppers in to destroy the camp, Ryan watches in real time from a dark control room. Blinking computer monitors flank a wall of large satellite images that an operative suggests comes from the "Keyhole." Rendered in infrared, the team approaches, kills a dozen people as they sleep, and then pounds the camp with rockets. Ryan beholds the exercise with both fascination and horror as he stands bathed in cold, digital hues. Although many films would copy *Patriot Games'* trope of the war room in the years to come, these scenes highly exaggerated the reconnaissance satellite's capabilities. Even the director of the CIA, James Woolsey, whose agency materially supported the film's production, reportedly found the hovering, real-time, close-up imagery to be "funny." Tricia Jenkins speculates that the agency supported the film regardless because its interests—striking fear into the hearts of foes and garnering budgetary support for future capabilities—lay in portraying itself as omniscient and omnipresent.[24] From an audience point of view, these scenes helped merge the familiar aesthetics of satellite news coverage, the iconic war rooms of *Dr. Strangelove* and *Fail Safe*, and gun-camera footage fresh in collective memory from the Persian Gulf War.

The mid-1990s continued in the footsteps of *Patriot Games* with visions of satellite command centers. The James Bond film *Goldeneye* (1995) pitted the state's satellite surveillance capabilities against the evil superweapon, "Goldeneye," a satellite that not only surveys the earth but also promises to deliver a world-ending electronic pulse. The drama plays out as a contest of vision. The evil mastermind, a former MI6 agent gone rotten, prepares the weapon for this dastardly task in his underground bunker. Simultaneously, Bond and fellow agents at MI6 track down the terrorist control center through their own spy satellites, which Goldeneye's EMP blasts occasionally scramble. The Bond brand had long identified with its signature view through the pistol's rifled barrel. *Goldeneye* extended the gaze further through the satellite's aperture, casting it as the protagonist locked in an epic battle with the evil forces that sought to blind it.

On a more realistic register, *The Peacemaker* (1997) returned to the general framework of *Patriot Games* in both its plot and its impulse to connect

satellite vision with the experience of smart bomb vision from the Persian Gulf War. The film stars George Clooney and Nicole Kidman as the duo that tracks down a stolen nuke and ultimately the terrorists bent on detonating the device in New York City. At one point, our heroes wander through a spectacular Pentagon command center splashed with images of globes, satellites, maps, and grainy pictures of the ground—a setup for the pivotal scene when they finally locate the weapon on its way to Iran. We watch as the two zoom in on a live satellite image of a line of transport trucks in a long traffic jam. Clooney's character phones up the driver, the corrupt Russian general who stole the weapon. He tries to induce the Russian to do something erratic so that his truck—and, of course, his license plate—can be picked out of the crowd. Clooney's character stages the ruse with a notable image:

> Hey, Alex. You watched CNN during Desert Storm. Remember all those television shots from the nosecone of the GBU missile slammin' into those trucks? Remember that picture? [Alex cranes his head out the window and looks to the sky.] How it kept getting closer and bigger on the screen? You could just about see the faces of those drivers, and then . . . zap, the picture went dead, we didn't get to see what happened next. Well, guess what, Alex, you will, you son of a bitch.

With these words, the film superimposes satellite vision over the memory of Desert Storm in a gesture that foreshadowed its starring role in the Iraq War.

The remaining films leading up to 9/11 each approach satellite vision in idiosyncratic ways, but together they suggest that this gaze had settled in as a conventional visual trope. Director Tony Scott fed the satellite gaze through his signature slice-and-dice machine for *Enemy of the State* (1998), which portrays the NSA as a ruthless organization that assassinates an unsupportive congressman, covers it up, and then hunts down our protagonist (Will Smith) while he attempts to expose the plot. The film stood as perhaps the most satellite-saturated film Hollywood had yet produced—from the command center of the NSA to the scruffy clutch of intelligence nerds who follow Smith's character from the sky. Although we identify with our hero's paranoia, the story appears through the eyes of the security state and the spy satellite, what Scott himself considered to be the "third character."[25] The film departs from the usual formula in that the satellite eye through which we see belongs to the villain. Indeed, the NSA considered the film to be a public relations nightmare, and documents uncovered in 2016 suggest that the CIA assisted its production in what appears to be an episode of interagency competition.[26] Despite this, the satellite eye simultaneously appears as the tacit hero, affording the viewer god-like powers of surveillance in a manhunt that, given its racial dynamics, plays out like a high-flying version of *Cops*.[27] The film thus

carried forth the project of marrying the cinematic lens with the state satellite apparatus, which pass through one another with nary a blip.

Roughly the same picture appeared in *Behind Enemy Lines* (2001), which trained the satellite gaze on the task of saving a soldier lost in enemy—that is, Serbian—territory. A quasi-official state production, the film received extraordinary assistance from the U.S. Navy, which even integrated it into recruitment ads. In the pivotal scene where the admiral (Gene Hackman) finds his lost pilot (Owen Wilson), he does so by tapping into another real-time satellite feed in his ship's cloistered command center. The view from above is an infrared picture that follows Wilson's character as he runs from his would-be executioners and dives into an open mass grave among the ethnically cleansed. The scene, filmed before 9/11, not only recapitulated Madeline Albright's satellite presentation in front of the United Nations just a few years prior but also inserted one of our own soldiers into the list of victims. Apart from serving as an advertisement for the navy, the film hosted innumerable product placements. The logo for weapons manufacturer Northrop Grumman, in particular, graces the screen on several occasions and is even mentioned by name as the "relay satellite" through which our lost pilot appears. At the time, the company did not manufacture satellites and claimed it had nothing to do with the film. Its CEO, Kent Kresa, expressed gratitude for the spike in name recognition his brand received, however. As the company geared up for the 2003 invasion of Iraq, he told *Forbes* magazine that the film inspired him to pursue development of eye-in-the-sky remote sensing platforms like the Global Hawk that would forge a "hot link between the sensor and the shooter."[28] The film's depiction of satellite vision, in other words, harbored the nascent logic of the weaponized drone.

The Sum of All Fears (2002), a terrorist disaster movie shot before but released after 9/11, rounds out this short history of satellite vision in film. Here Clancy's favorite CIA agent, Jack Ryan, returns to track another rogue nuclear device. This time a terrorist succeeds in destroying Baltimore in a far-fetched plan to provoke the U.S. and Russia into an all-out nuclear war that will establish a fascist Europe as the planet's lone superpower. The action resolves as Ryan foils the sinister plot and de-escalates the reciprocal U.S.-Russia attacks. Like the others in the Tom Clancy franchise, the film received government production assistance from the defense department and CIA.[29] In contrast to earlier films of the series, however, *The Sum of All Fears* invoked satellite vision not as a plot device but rather as a rather naturally integrated aesthetic feature to signal changes of scene. It is as if the surveillance satellite, rather than the cinematic camera, is the eye's primary reference point. Orbital views of CIA Headquarters, Damascus, Haifa, and Baltimore precede the action in those locations. In the case of the big target, for example, the aerial gaze looms over Baltimore before the nuclear blast levels the city. Later in the film, this weaponized gaze

takes a different form when the U.S. orders retaliatory strikes on the Russians. The film represents these strikes by recycling real smart bomb footage familiar from the Persian Gulf War, which fills the screen in a series of explosions. Like the war room scene in its predecessor, *Patriot Games*, the satellite view in *The Sum of All Fears* meshes comfortably with the frame of the gun-camera, thus conditioning the public eye for the orgy of satellite vision that came with the invasion of Iraq in 2003.

The Iraq War through Apollo's Eye

It is appropriate that the centerpiece of the public relations extravaganza orchestrated by the Bush administration in the lead-up to the invasion of Iraq arrived via satellite vision. On February 5, 2003, Secretary of State Colin Powell delivered his infamous speech to the United Nations in an attempt convince the world that Saddam Hussein had an active program for manufacturing weapons of mass destruction, an imminent threat that only a full-scale military invasion and government overthrow could stop. In the style if not substance of his predecessors—from the Cuban missile crisis through Albright's warning of Bosnian ethnic cleansing—this reluctant witness and most credible of the administration's salespeople trotted out a series of satellite photographs that supposedly depicted active chemical and biological weapons installations, including "mobile production facilities" able to evade U.N. inspection.[30] The parade of images filled the screen, but something was missing. As David Zarefsky notes, the entire case stemmed from an "argument from ignorance" and took two basic forms: "we cannot know that A is true; therefore it is false," and "we cannot know that A is false; therefore it is true."[31] As such, it would be a mistake to say that the images functioned as "evidence." Instead, they issued a standing invitation for the public to see through the military apparatus, thereby eliminating the need for evidence, argument, and assent. The images helped to lock the national gaze on a target whose destruction, as virtually all the anchors and pundits had been repeating to this point, was inevitable. The administration's fright show at the U.N. was only the first shot in a barrage of satellite imagery aimed at the civic eye. The vast majority would arrive via commercial television news, which took a cue from Powell's PowerPoint and retooled itself for the main event by placing the satellite's eye at the center of the action.

Gearing up for the satellite spectacular meant taking advantage of a new political economy of aerial imaging. Until 1994, remote imaging had been restricted to governmental agencies, but that year President Clinton opened up such endeavors to private interests. Companies like Earthwatch, Space Imaging, and DigitalGlobe, among others, began releasing detailed satellite imagery to the paying public, which included anyone from individuals to

FIGURE 8 Satellite slide from U.S. Secretary of State Colin Powell's speech to the United Nations on February 5, 2003. Source: U.S. Department of State Archive.

news agencies to government research groups.[32] This explosion in private data collection eventually led to NASA's dream of a "Digital Earth," later popularized by Al Gore, that would aggregate mountains of satellite imaging with cultural and ecological research into a virtual planet.[33] In 2001, a company calling itself "Keyhole, Inc." released a computer platform that, for a subscription price, provided a commercial version of this global public project, mapping terabytes of satellite imagery and geographical information onto a virtual, surfable globe. Unlike their Cold War counterparts in the intelligence services or even other competing commercial services like Terraserver, high-end business subscribers to Keyhole could fly over vast swaths of seamless ground or through sophisticated 3-D renderings of cities with video game–like alacrity. This was not surprising given that the company's "Earthviewer" interface, according to CEO Tom Hanke, "grew out of the tradition of technology for flight simulators."[34]

The feel of Keyhole's Earthviewer was a natural fit for the video game aesthetic that infused news coverage of Iraq War in 2003.[35] The service had been used on a limited basis by CNN for its coverage of the Afghan invasion and the space shuttle Columbia disaster.[36] As the invasion of Iraq approached, CNN, ABC, and CBS thrust Earthviewer and other geotech firms onto center stage. With a general's-eye view, war coverage glided over proposed targets, guessed at troop placements, zoomed down capitol streets, hunted for fugitive

Ba'athist leaders, and performed day-to-day amateur bomb damage assessments (BDAs) of buildings and towns.

A number of other geotech companies joined the fray, looking to capitalize on the intense network and cable news appetite for computerized mapping. Colorado-based imagery firm i-cubed created a special "Middle East mosaic" for use with Earthviewer. The mosaic provided especially fine detail of certain Middle Eastern locations, "draping" 2-D maps over 3-D topographical models and balancing colors between images to create seamless backdrops for war news coverage. The company's president, Russell S. Cowart, gave the pitch: "Keyhole's Earthviewer complements the mosaic superbly by allowing users to zoom in to specific areas in a fluid and aesthetically pleasing application."[37] Other companies, like Salt Lake City–based Evans & Sutherland Environment Processor (EP), used imagery from private companies like DigitalGlobe and GIS Xpress to create smaller, high-definition 3-D environments, such as downtowns and airfields. In the midst of the invasion, a Florida company, ImageLinks, announced the availability of its True Terrain technology, which innovatively merged layers of image resolution to give the viewer the much sought-after illusion of descending in an aircraft (or perhaps bomb) through increasingly rich ground detail.[38] Richard Goodman, the man who directed much of ABC's war footage, explained his office's use of Earthviewer and EP:

> We had rooms standing by for visual scenarios. If the Bunker Buster bomb went into a bunker where they thought Saddam was, the information was relayed from the ground from a GPS or laser system, and then we tried to take that information and turn something around so that five or 10 minutes later, Peter Jennings could say, "What you see right now is a simulation of what we think took place." That was something that we did in this war that we weren't capable of doing in 1991.[39]

At times, these scenarios would be rendered in advance. As Goodman noted, however, the technology was so good that 90 percent of the time its operators—or "pilots," as they were called in the studio—could take audiences on live virtual flybys of action sites in real time.

For the companies that supplied this technology, the publicity was palpable. Over each flyover or bombing simulation, for example, CNN dutifully showed the Earthviewer.com logo. On March 20, the day after the much publicized "shock and awe" opening blitz of Baghdad, throngs of curious clickers overran the Earthviewer networks, forcing the site to shut down for most of the day.[40] Fortunately for the company, a month prior to this massive infusion of free advertising, Keyhole had teamed up with video game graphics company NVIDIA to release a consumer version of Earthviewer that lowered the subscription fee from $599 to $79 a year, a price suitable to the average CNN viewer's budget. This allowed the company to ride the tidal wave of U.S.

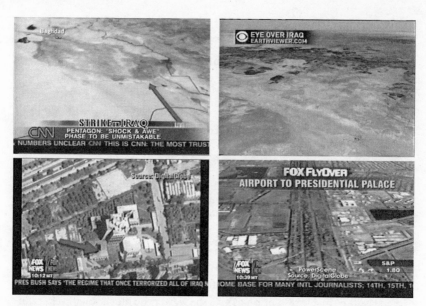

FIGURE 9 Satellite vision during the 2003 Iraq War. Top row: CNN and CBS's "Eye over Iraq" use Earthviewer to mark the advancement of U.S. troops. Bottom row: *Fox News* uses DigitalGlobe imagery to do bomb damage assessments and flyovers.

military power into the hearts and minds of would-be American earth-surfers. The company's sudden popularity within this context took CEO and founder John Hanke by surprise: "It's unfortunate that it took a war to cause people to discover our technology. We'd have been perfectly happy if it never happened, but it's brought a lot of attention to us and had a very significant impact on our business."[41] As the bright lights of the blitz faded into the long gray occupation, Keyhole set upon the task of turning its war publicity into a sustainable commercial enterprise. "You [can] take that stuff generals use to plan wars and plan your mountain-biking trip," said Hanke, unwittingly highlighting the ease with which one could transfer attention from one kind of tourism to another.[42] Steve Jennings of the satellite imaging provider DigitalGlobe spoke in similar tones the following year when announcing upgrades in the Keyhole-DigitalGlobe partnership, noting that the same "satellite imagery that captivated television audiences worldwide will enable business users to interactively view the earth on their desktop."[43]

Despite its efforts to distance the Earthviewer platform from war, the company would retain its military associations, both symbolic and economic. In June of 2003, In-Q-Tel, a relatively new venture capital arm of the CIA that had invested in civilian industries since 1999, put its money in Keyhole with the hopes that the company might in the end benefit intelligence-gathering efforts. Shortly thereafter, the U.S. military began to use its visualization technologies

in Iraq to support the ground war.[44] This kind of investment was a direct result of shifts in executive branch philosophy regarding the relationship between the commercial remote sensing industry and the military. In the lead-up to the Iraq invasion, the U.S. intelligence community had become more reliant on commercial imaging firms, sometimes sparking debates about "shutter control," entropy within information dominance, and, in more idealistic moments, the democratization and public transparency of war intelligence.[45] In the midst of the invasion, President Bush signed a law that pushed the Clinton-era deregulations further. In addition to allowing higher resolution, higher image frequencies, and greater access, the Bush initiative directed the Department of Homeland Security to use the commercial sector as a first resort. Such actions built on larger trends toward military privatization by folding the private remote sensing industry back into formal military intelligence-gathering operations.[46]

The political economy of this emerging military-media-geotech complex drew the military and the citizen-viewer into feedback loops of making and witnessing war. Beyond any individual message that might be sent, the larger symbolic environment created by the new 3-D virtual flybys and target zooms in effect wired the citizen to the military infrastructure through disciplined modes of looking. The sheer force of the invasion realigned the civic eye. Companies like Keyhole did not set out to be a primary means of envisioning war; rather, television news coverage elected its Earthviewer platform, integrating it seamlessly into conventional narratives and aesthetics already in motion. These imaging practices, moreover, were not ideologically neutral. By entering the existing power matrix, they replicated dominant assumptions about geopolitical realities. The abstract global camera cut the world into two, prescribing vectors of force between those who rightfully export violence and those who rightfully receive it. In her work on the use of static satellite images in the Bosnian conflict, Lisa Parks notes that such a gaze accomplishes ideological work by "promulgat[ing] new categories of otherness as it spotlights the world's 'trouble spots.'"[47] The explosion of satellite imagery during the invasion of Iraq in 2003 no doubt intensified these dynamics. Here the commercial satellite camera, working with major news outlets, amplified and naturalized practices that allied the civic gaze with the imperial gaze. This charged zone of vision, what we might call the "martial aperture," translated public attention into the tacit legitimation of targets.

Beyond simple directionality, this news environment promoted hierarchies of surveillant intensities. Satellite and aerial imaging companies, eager to capitalize on the opportunities presented by the television war, sought to maximize their chances of being enlisted in the effort by cultivating high levels of image richness for certain areas of the Earth's surface. The company i-cubed, for example, focused its efforts on detailed renderings of Iraq, Kuwait, Bahrain, Syria, Jordan, and Israel/the West Bank with portions of Lebanon, the

Gaza Strip, and Egypt.[48] True Terrain data sets covered locations of "political interest" such as Iraq, Afghanistan, Turkey, Qatar, and the Korean peninsula. The highest resolutions and picture frequencies were reserved for city centers and landmarks in Iraq, where news anchors could do amateur bomb damage assessments on a day-to-day basis. For example, the platform captured Baghdad at a resolution of two meters; Basra, Mosul, and the H3 airfield at .7 meters.[49] The word *captured* is an apt metaphor, especially considering the increasing correspondence between "target-rich" regions and their "image richness." The regimes of visibility were not just a way of seeing the terrain but rather constructing a value hierarchy of sites, a kind of advanced target acquisition that worked through the civic gaze to mark off—using scales of resolution, dimension, and intensity—objects of imperial concern. In so doing, the military took on a rather different public relations strategy than it had in the Persian Gulf War, when remote sensing platforms went dark to the public. For the Iraq War, the satellite's aperture, alongside the embedded reporting system, flooded the news with positive public relations optics.

In assuming the visual space in the Iraq War that smart bomb vision had occupied during Desert Storm, satellite vision carried forth many of the same surreal, clean-war logics. This time, however, the dominant images abstracted the city through the aesthetics of detail rather than distance. The television news practice of swooping through virtual cities or staring down at airfields invariably presented large civilian geographies as ghost towns filled with inanimate trophies waiting to be taken. Rather than having to "hide the body," as had been the case in 1991, televised geospatial imaging gave proof of a clean war from the start by presenting a depopulated target area.[50] This virtual evacuation meshed with dominant metaphors that already abstracted the country into what Elaine Scarry calls the "machine colossus": heads to be decapitated, nervous systems to be disrupted, and so forth.[51] Satellite imagery fostered the dispassionate, absent gaze that portrayed the nation not in terms of its humanity but rather as constituent mechanical parts.

In this way, satellite vision assisted in the overall shift in focus, represented in the coverage of the earlier Persian Gulf War, away from the axis of the body and toward the axis of technology. It would be difficult to argue that CNN's use of Earthviewer flybys served to enlighten its viewership. Instead the images functioned almost purely for their own spectacular and fetishistic value: a demonstration that American journalists, like the American military, held the big guns. As such, the dominant storyline naturally turned inward from the information the satellite technology could reveal to the pyrotechnics of what it could do. The orbital eye rose to the status of superstar, recapitulating the path of other wartime technologies—such as the smart bomb, Patriot missile, and Apache helicopter—during the previous desert invasion. Like these self-justifying and righteous weapons, the high technology of the satellite

became a signifier of the usual civilization-barbarism dichotomies that function to reify the "natural order" of power.[52] The virtuosity of this technology became a sign of its virtue, which preordained the divine right of preemptive strike. Like smart bomb vision, the satellite's gaze sold itself on the prospect of granting the home viewer god-like powers, but this gesture instead became a primary means of targeting, managing, and politically disarming the citizen-subject. Such image management did not function through the negative channels of denial and censorship but instead by embedding the civic eye into the strategic gaze of a war machine already in motion. This orientation maximized the seductive pleasures of the crosshairs while minimizing the unconsumables that might appear in its frame. In purporting to bring the citizen closer to the action, satellite vision subtracted the citizen from political participation in matters of actual military power. As far as the civic authorization of war was concerned, satellite vision appeared to have already selected the target if not already pulled the trigger.

In terms of aesthetics, the satellite spectacular of 2003 worked to bridge two dominant modes of weaponized vision that had developed in the prior decade. The first is the kinetic "projectile gaze" best represented by the smart bomb vision of the Persian Gulf War. The second mode is what Lisa Parks calls the "orbital gaze" of its opposite, the traditional satellite view.[53] The appearance of 3-D satellite imaging systems in 2003 resolved the severe dichotomy by imbuing the dispassionate and omniscient satellite gaze with the momentum of the neurotically focused projectile. The networks learned to maximize the drama of this paradox by toggling back and forth between modes to dizzying effect. One moment the news invited viewers to turn Donna Haraway's "god trick" and see everything from nowhere.[54] The next moment this gaze might take the form of an aircraft descending, a missile cruising, a bomb dropping, or a bullet speeding. This mode of seeing married the aesthetics of temporal collapse (i.e., the doctrine of prevention) with global acquisition (i.e., unipolar exceptionalism). The interplay thus gave birth to the visual trope of the *earth zoom*, which, as a god might, beholds the entire world before plunging down to claim possession of any of its details. In this mode, television news outlets

FIGURE 10 Earth zoom during the 2003 Iraq War. A CNN sequence scanning potential Iraqi government targets in Baghdad using Keyhole's Earthviewer platform.

utilized animated satellite imagery to illustrate anything from the suspected location of enemy leaders to the exact flight path of a Tomahawk missile as it tracked its target. The appearance of this war thus departed from the relatively fixed representations of the past and instead encouraged viewers to enter immersive, fluid, global, and interactive fields of virtual action.

The free-form movement of the flyby naturally infused satellite vision with video game aesthetics. As mentioned, technologies like Earthviewer self-consciously based themselves on the visual logics of the flight simulator. This choice perhaps more than anything made for the seamless integration of 3-D satellite imaging into the television war environment, which had already taken steps toward wrapping the viewer in digitally rendered polygons. Cable and network news made endless use of animations that depicted weaponry and hypothetical scenarios, often gratuitously refashioning scenes for which there was real footage available. Studio anchors used interactive platforms like Earthviewer and others to fly through cities, zoom in on bomb craters, and recapitulate routes of attack. This was more than a high-tech map, however; it was a seamless integration of larger visual practices of encountering war. Every earth zoom, flyby, and banked turn stitched these ways of seeing into the fabric of the Iraqi landscape. The television portrayal of war thus took on a hyperreal sheen akin to a game, which radiated a sense that this was indeed a hypothetical war fought in virtual space for common consumption. This aesthetic blended easily with actual video game culture. In anticipating the television war, game makers raced to provide venues in which one could interactively play out the unfolding Iraq War in as close to real time as possible.[55] Together, television news and commercial game culture fused into a spectrum of digital war-gaming that increasingly allied with the Pentagon public relations apparatus for access, technical specifics, and dramatic arc.

The Legacy of Target Earth

The televised spectacle of the Iraq War served as the ultimate infomercial for the satellite vision that saturated its news coverage. Popular demand for Keyhole's Earthviewer platform was so strong that Google bought the company in October of 2004 and immediately cut the subscription price in half. The purchase was the first step the company would make toward ultimately offering its free service, Google Earth, which appeared in 2005. At the same time that Google reached out to the masses, it continued to intensify what had been Keyhole's synergy with the Department of Defense, shifting its market role in the next few years toward increased government contracting with the National Geospatial-Intelligence Agency (NGA).[56] Not only were the new visual affordances delivered by Google Earth fully integrated in the military-geospatial complex; they also first appeared to the public at large through the frame of military targeting operations.

This martial aura haunted Google Earth well after the war. Governments worldwide showed a wariness toward of this new regime of visibility, and stories circulated about Google Earth's role in inflaming existing political tensions. India's government protested that the imagery could exacerbate the struggle surrounding the disputed Indo-Pakistani region of Kashmir as well as jeopardize the security of certain governmental buildings. The country asked Google Earth to honor its own list of sensitive sites—to only show them in high latency and low resolution—just as the American company must do with certain areas of Israel-Palestine under U.S. law. Russia, South Korea, and Thailand expressed similar concerns that Google Earth exposed certain military installations, entering into talks with the company to negotiate territorial representation.[57] The governments of China, Bahrain, Sudan, and Jordan all worked on some level to ban Google Earth, and Sweden was caught doctoring satellite photos of its National Security Headquarters by replacing buildings with trees.[58] In the U.S. controversy swirled around the many critical areas, such as nuclear power plants, that remained open for viewing, while other sites—from West Point Academy to PepsiCo headquarters in New York to Dick Cheney's house in Washington, D.C.—received the coveted pixilation.[59]

Google Earth also entered the calculus of asymmetrical warfare and the discourse of terrorism. The concerns populated the headlines in a wave of panic. Early on in 2005, Lieutenant General Leonid Sazhin, an analyst for the Russian federal security service, sounded the alarm: "Terrorists don't need to reconnoiter their target. Now an American company is working for them."[60] The Australian government worried publicly about the visibility of a nuclear reactor in Sydney. U.S. soldiers in Iraq expressed concern that insurgents might use Google Earth to map out Camp Anaconda for mortar or rocket attacks.[61] A few months later, actual attacks on oil pipelines in Yemen were found to have been carried out using Google Earth maps.[62] The British military claimed in January of 2007 that insurgents were using satellite photographs to plot targets inside British bases near Basra.[63] The association between Google Earth and the War on Terror was perhaps publicly cemented in October of 2007 when a reporter from the *Guardian* released intimate video of Palestinians using Google Earth to launch rudimentary rockets into Israel.[64]

Awash in such headlines, public users naturally developed practices that infused Google Earth with the strategic gaze. At times, these seemed to reanimate Cold War mythologies of satellite reconnaissance. Immediately upon its release, for example, throngs of amateur Google Earth "spies" began the task of seeking out the planet's secret spaces, pooling their findings in online communities. Perhaps the most famous of their discoveries was an enormous Chinese military training area, a mock-up of a section of the Chinese-Indian mountain border, discovered by a Californian living in Germany. The intrigue of this discovery propelled the story around the world with the momentum of

a Hollywood espionage blockbuster.[65] Other more enlightened projects have arisen from Google Earth's politically charged surfaces, but these too have been tempered by hegemonic forces. In 2007, Google Earth teamed up with the United States Holocaust Memorial Museum for a project entitled *Crisis in Darfur*. While the project ostensibly sought to use Google Earth to give presence to the genocidal actions of the Janjaweed and the Sudanese government, some have argued that the lack of context for the killing (e.g., maps of weapons trade routes, desertification, and the location of contested natural resources) instead staged the event as yet another "African tragedy" available for privileged Western consumption.[66]

Still other practices specifically invoked the crosshairs-etched frame from the Iraq War, recruiting a nation of desktop generals who scanned the contours of the globe with bombsight eyes. Among the array of online games that utilized Google Earth as a platform, for example, perhaps the most popular was *Mars Sucks* (2006), which hypothesized that an alien army of Martians had established hidden bases on the planet. The goal of the game was to follow clues, find the alien bases, and blast them into oblivion. The game accomplished this, notably, through a first-person laser gunsight, aimed at the ground, that framed the Google Earth screen. *Mars Sucks* might well have been called *Earth Sucks* insofar as it made good on the urge, now inescapably embedded in satellite vision, to behold life on this pale blue dot through the optics of annihilation.[67]

The diffusion of satellite vision into an array of civilian practices in the years following the Iraq War might lead us to conclude that satellite vision was progressively demilitarized. It is more accurate to say, however, that the transference draped the globe with a militarized image of itself, a version of Chow's "world target." In this sense, the Iraq War was not the end of satellite vision as a public interface for understanding conflict but rather a waypoint in its evolution, a mutation that spliced the projectile gaze of smart bomb vision with the orbital gaze long incubated in the Cold War imagination. Its offspring would take to the public screen later in the era of the drone.

4

Drone Vision

You'll never see it coming.
—President Barack Obama, joking about
the Predator, 2010

The rapid rise of the unmanned aerial vehicle (UAV), remotely piloted vehicle (RPV), or "drone" has provoked a spectrum of questions regarding its rightful use as a weapon, but much less attention has been granted to the drone in its capacity as a *medium*. From a tactical perspective, the drone is a vision machine before all else, designed to produce "situational awareness" before kinetic engagement. Its visual dimension, moreover, has extended beyond military utility into the civilian realm of politics and culture. In so doing, the drone has risen to prominence not only as the signature mode of warfare of the twenty-first century but also as an array of signs, interfaces, and screens that orient the Western citizen-subject's relation to the state military complex. Over the years, battlefield images shot through these aerial cameras percolated through the public mediascape, appearing first as spectacular novelties and portals to the future but eventually settling onto the screen as icons of military intervention under the Obama presidency. Some of these images arrived via official channels, while others leaked. Some appeared in mainstream venues like television news and film, while others circulated virally through user networks. Along the way, the drone's camera feed underwent an interpretive process, beginning with the selection of images for the civilian screen and continuing with the process of captioning, framing, and fictionalizing. These images, together comprising a mosaic of

"drone vision," invited publics to see the drone war through the very apparatus that prosecuted it.

This chapter begins with a sketch of the drone's sudden ascendancy to weapon of choice and its history as a mode of seeing. We then turn to drone vision as a series of interlocking themes that have refracted the civic gaze through the targeting camera. These include diverting attention away from the drone as a political object and instead establishing the figure of the pilot as the primary site of attachment. The analysis then explores the culture of interactivity—from news to film, video games, and toys—that has infused public consciousness with dreams of climbing into the cockpit, handling the controls, and melding with the interface. The chapter concludes by examining the way that these discourses, which aspire to encapsulate the civic eye with the targeting camera and its prejudices of vision, have framed out those populations who must live and die under this new regime of aerial occupation.

Arming the Camera

The contemporary U.S. deployment of drones after 9/11 divided itself between two programs. The first was the defense department's overt use of the weapon in publicly declared zones. While all four major branches used drones of one variety or another, the air force fleet naturally led the way in installing major platforms like the Predator and Reaper at the center of its operations. This began in earnest in the late 2000s when the drone presented itself as a low-risk way to replace ground troops withdrawing from Iraq and Afghanistan. Another big boost to the air force Predator program came during the 2011 U.S. intervention in Libya.[1] The statistics charting the rise of the drone's military use are stunning. Before September 11, 2001, the U.S. military had around two hundred drones in its arsenal; by the end of 2011, the number had grown to seven thousand.[2] In 2005, drones accounted for only 5 percent of all planes; by 2011, that figure had climbed to 31 percent.[3] In 2004, the number of daily air force drone flights stood at only five; by 2015, this number had climbed to around sixty with even greater expansions on the horizon.[4] In 2010, the air force began training more drone pilots than fighter pilots, and that same year the U.S. Defense Department's *Quadrennial Defense Review* report put the development of "unmanned aerial systems" on the short list of military priorities in counterterrorism and counterinsurgency.[5]

The second and much more controversial drone program consisted of covert operations conducted by the CIA and Joint Special Operations Command. The opening shot of these "targeted killing" operations came in 2002 when the CIA guided a Hellfire missile from a Predator drone in Yemen. The blast killed Abu Ali al-Harithi, the man suspected of plotting the 2000 bombing of the USS *Cole*, a destroyer stationed in a Yemeni port.[6] In addition to its

intended target, the strike incinerated five others in the vehicle driving down the highway, including one American citizen. In 2004, under the George W. Bush administration, the agency initiated the sustained use of drones in Pakistan despite resistance from the Pakistani government. Thereafter, the use of drones rose dramatically, moving from peripheral status to weapon of choice. In its first thirteen months, the Obama administration fired more drone missiles than had been used in the entire eight-year Bush presidency, expanding operations into Somalia, Yemen, and the Philippines.[7] By the time the administration publicly acknowledged the existence of the CIA program in 2012, it had developed into a massive bureaucratic edifice for gathering data, tracking targets, and making the decision to kill—known internally as "find, fix, and finish."[8]

The sudden normalization of the drone—especially its covert use—grew to become a signature controversy of the Obama presidency. The public conversation tended to focus on the ethics of long-distance weaponry, but as Jeremy Scahill noted upon the *Intercept*'s release of the leaked "Drone Papers," the policies guiding the use of this tool, not the tool itself, were the most questionable.[9] As an ongoing series of assassinations, the program violated both international and U.S. law. In its secretiveness, the program amounted to a war waged without a declaration or congressional authorization. As a sprawling and evolving global network, the program skirted international law regarding the integrity of sovereign states. As a mode of executing individuals alleged to be involved in unsavory activities, even American citizens, the program stood as a black box that denied due process and other legal protections taken for granted in democratic countries. In its decided preference for killing over capture, the program violated just war standards that prescribe the use of minimum force, proportionality, and violence as a last resort. Finally, despite claims of precision, this program all but ignored the principle of distinction and claimed an astonishing amount of civilian life.

Given these excesses, one must ask how this particular projection of imperial power received tacit public authorization. Conventional wisdom has located the answer in the weapon's capacity for "unmanned" and therefore "riskless" war. In addition to this quality, however, we must consider the way the apparatus of the drone has presented a way of seeing—not only as a tool of strategic surveillance, but also a prism through which state violence publicly manifests. In order to fully see the drone war, in other words, we must understand how drone vision has trained us to see. This means fully appreciating the weapon's function as an aperture embedded within the larger edifice of military public relations. To do this, a brief technical genealogy is in order.

The evolutionary history of the drone reveals a distinctly camera-centric lineage, beginning with the hot-air reconnaissance balloons of the nineteenth century, continuing through the rise of air power during WWII, and finally

settling into the advanced command-and-control grids of the twenty-first century. The full application of the camera to the flying weapon began with the first cruise missile experiments in the wake of WWI. These included the Curtiss-Sperry aerial bomb and the Kettering Bug, which consisted of radio-controlled or automatically piloted airplanes programmed to dive on a target. In 1934, the British tested a radio-controlled system that steered a pilotless Tiger Moth from another aloft biplane called the "Queen Bee." This metaphor, in combination with the earlier invocations of "bugs," gave birth to the moniker of the "drone," which in the WWII era mainly attached itself to the unmanned planes launched for target practice.[10] The drone continued to evolve with the development of more advanced guided missiles during WWII that first took to the air as the winged German V-1 "doodlebug" rocket and later in a more conventional shape as the V-2. At the same time, the American military launched operations Aphrodite and Anvil, which repurposed old B-17 bombers by loading them with explosives to be flown via radio at hardened German V-1 and V-2 launch positions. These experiments ultimately failed, but insofar as they used cameras to navigate, these "video bombers" presaged the next wave of drone projects geared toward surveillance during the Cold War.

A turning point came in 1960, when the Soviet Union famously shot down the American U2 spy plane and captured the pilot, CIA agent Gary Powers. The two safeguards that would have otherwise "unmanned" the mission in such an emergency failed. The U2 did not disintegrate in the atmosphere as expected, and Powers declined to use the poison pin hidden on his person in a drilled-out silver dollar.[11] To avoid a reprise, the defense department sought to remove the pilot from the reconnaissance equation by marrying cameras to a series of winged rocket fuselages in the 1960s and '70s. These radio-controlled missile-cameras were the ancestors of the electro-optically-guided explosives that populated the Gulf War and brought us the view from "smart" munitions. Although many conceive the drone as an airplane, mainly due to its reusability and ability to fire missiles,[12] we must recognize that it also developed out of the lineage of the guided projectile.

It is somewhat misleading to describe the contemporary drone as a singular weapon, however. More than other systems, it is enmeshed in a complex apparatus of communications networks, launch bases, flight and sensor operators ("pilots"), data analysts ("squinters"), and maintenance workers. A single Predator might require up to 150 support personnel, and most operations involve multiple teams. Major drone operations, moreover, are part of a larger network called the Distributed Common Ground System (DCGS), which aggregates reconnaissance information in a centralized big data clearinghouse. Seen from this angle, as Jeremy Packer and Joshua Reeves point out, one of the drone's major ancestors is the Cold War–era Semi-automatic Ground Environment

(SAGE) program, which sought the centralized real-time comprehension, through surveillance and data crunching, of global nuclear capabilities and aircraft trajectories.[13] The UAV should thus be understood as a chimera, a convergence technology imbued with the hovering capacity of a plane, the guidance capacity of a long-range missile, the surveillance capacity of a spy jet, the striking capacity of a gunship, and the analytic capacity of a network. All of this conceptual clutter aside, however, Grégoire Chamayou settles on what might be the best definition of the new weapon, which comes by way of Mike McConnell, former director of national intelligence: "a high flying, high resolution camera armed with a missile."[14] Such an elegant description makes good on Virilio's earlier assertions about the merger of camera and projectile. The history of the drone is thus a history of how the eye rose through the ranks to assume high office in the form of an MQ-1 Predator.

This short excursus through the genealogy of the drone indicates how its technical development has fed into its institutional and legal deployment. Just as the "unmanned" aspect of the armed, high-flying camera allowed it to project riskless violence, its apertures have projected a certain image on the public screen. Among the questions that should be asked of the drone, then, is how its own targeting camera has entered the picture. What *subjectivity* has the drone vision invited? With whom has the gaze allied, who has gained presence, and who has disappeared behind the drone's crosshairs? As a first step, we attend to the discourse that has encouraged the view through the drone camera by muting the ability to behold the drone in other ways. As we will see, for drone vision to fascinate, the drone had to become spectacularly dull.

Soporific Skies

The Predator drone has presented itself as a decidedly unsexy specimen whose power to draw the look seems to have been exchanged for its powers of looking. In this sense, the drone followed in the contrails of smart weapons still smoldering from the Gulf War. The celebrated SLAM missile, for example, was virtually invisible from any vantage point outside the camera embedded in its own nosecone. Recall that scholars at the time regarded this perspective as "prosthetic" insofar as it aligned the smart weapon-camera with the civic eye through the home television set. This invocation of the language of prosthetics likely drew inspiration from Donna Haraway's cyborg ontology and, further back, Marshall McLuhan's theory of media as bodily extensions.[15] Indeed, McLuhan provides some handy tools for deciphering the visual codes of the weaponized eye. In *Understanding Media*, he suggests that every prosthetic media extension in one place requires an amputation somewhere else. The aesthetic alteration of the sensorium, in other words, is a kind of surgery maneuver that requires anesthetic. (This is evident in the myth of Narcissus,

whose mirror McLuhan reads as the original medium and whose name has etymological roots in the word *narcosis*.[16]) If drone vision is in some sense a new prosthesis, then we might expect to encounter a discursive anesthetic to accompany the amputation. After all, McLuhan tells us, "sensation is always 100 per cent."[17] As we will see, the fundamental narcosis induced by the drone-object has enabled a kind of oculectomy to make way for a novel prosthetic encounter: the subjective beholding of the world through the drone's own visual circuitry.

The drone in the sky indeed degraded itself as an object of perception. As Jessy J. Ohl points out, one of its more striking qualities has been its ability to elicit boredom. Since the beginning, official representations have consisted mainly of still photographs, and what little b-roll video exists of drones taking off and landing is about as exciting as the municipal airport. Ohl ruminates on the curious absence of drama: "There are no pictures of jubilant drone pilots celebrating a successful mission or dutifully observing a collection of monitors for a subsequent strike. No images of a charred crater or anguished cries from a distraught family. No snarling terrorists deserving of retributive justice or testimonials of gratitude from frightened villagers."[18] One might at least expect to see drones in the midst of firing missiles, one of their essential functions, but official photos have expunged this detail. "Few things," Ohl observes, "are more insipid than weapons that do not fire."[19] In 2013, the *Atlantic* revealed (with the help of digital artist James Bridle) that the lone and most recognizable photo of a Reaper releasing its payload was a fabrication by a digital designer named Michael Hahn in 2009 using 3-D modeling software and Photoshop. Said Hahn, "I had never seen an image of a drone actually firing a missile so that is what I decided to create."[20]

The same can be said of the MQ-1 Predator, which was so thoroughly neutered by its available stock imagery that it appeared less as a weapon than a paperweight. The "canonical image" of the Predator, included on its Wikipedia page and reprinted *ad infinitum* in the press, captures the spirit of the genre. Awkwardly balanced with tail angled downward like a fleeing animal, the machine appears in all its homeliness, cast in muted gray tones and suspended in a still life above an abstract band of hazy, arid Afghani mountains. The image is credited to Lieutenant Colonel Leslie Pratt, who released it sometime between 2009 and 2011 during her tenure as Air Force Reserve Command director of public affairs. It is part of a mosaic of official stock photos that depict the drone as a supremely banal object that practically resists the look. Unless forcibly altered by some rogue photoshopper, this drone hides in the bureaucratic labyrinth of the public imagination, where it quietly strives to visually decommission itself. When it must appear, it buzzes near the vanishing point of attention. The drone's status as imperceptible object was on display at the 2010 White House Correspondents' Dinner when President Obama

jokingly warned the teenage musical group in attendance, the Jonas Brothers, to stay away from his daughters: "Two words for you: Predator drones. You'll never see it coming."[21] What allowed this to read as a joke was the premise that the drone already existed as an absence, forever flying "over there" and occupying the twilight category of "never see it." The weapon's mythical stealth, in other words, was not just tactical but also aesthetic.

In addition to eliminating the drone as material object, this discourse sought to eliminate it as political object. Presidential quips about vaporizing the Jonas Brothers aside, communications from the White House eventually migrated to the notion that the decision to strike had been taken out of human hands and turned over to a complex algorithm. This story begins after the September 30, 2011, killing of Anwar al-Awlaki, the first American citizen specifically targeted by the program, which drew plenty of controversy by itself. In the year that followed, however, the U.S. public learned that the drone program had killed not one but three American citizens without due process: al-Awlaki, his associate Samir Khan, and al-Awlaki's sixteen-year-old son, Abdulrhaman, who had recently flown from the U.S. to find his father.[22] When asked about the Abdulrhaman's killing, which occurred in a separate strike two weeks after Anwar's, White House press secretary Robert Gibbs suggested that the latter "should have been a far more responsible father."[23] Public outcry regarding these executions prompted the administration to promise more transparency. Eventually, the administration invited two *New York Times* reporters to one of its "Terror Tuesday" meetings in which officials deliberated about whom to target next. The resulting front-page article invited readers into a world where a president agonized over "baseball card" profiles of high-level terrorists and reluctantly constructed the final "kill list" with the aim of protecting the American people.[24] This public relations operation masquerading as exposé served to quiet objections for a while, but it did little to make the process truly more transparent. Rather than opening the black box, the gesture put it on display with a placard that read, "Trust in the president. He's a good man."

A few months later, the administration rolled out another "transparency" campaign, this time with the help of Greg Miller of the *Washington Post*. The story lede in this case was that the president's "kill list" had been replaced by something called the "disposition matrix," a nebulous calculation involving data and flow charts that "map out contingencies, creating an operational menu that spells out each agency's role in case a suspect surfaces."[25] This language was likely an attempt by the administration to claim the program entailed "due process," a protection that Attorney General Eric Holder suggested in 2011 that could entirely reside within an internal military review. ("The Constitution guarantees due process, not judicial process," he said in one of the more chilling moments of the Obama administration.[26]) That same

year the *New York Times* revealed that the administration had crafted a secret memo making this legal case, a position that *NBC News* later uncovered in a Department of Justice white paper.[27]

Apart from staking a legal claim to due process, the new language of the disposition matrix functioned to depoliticize the decision-making process and avert public attention from it. The administration now implied that there was no political decision to be made and no wizard behind the curtain. Out went a vision of Obama as judge, jury, and executioner and in went a vision of a vast, faceless, and objective bureaucratic machine capable of milling the data, refining the exact nature of the threat, and spitting out target names on ticker tape with perfectly bland pragmatism. For years, Daniel Swift noted in *Harper's* magazine in 2011, press coverage of the drone war showed a sharp preference for the passive voice ("The convoy was bombed") and handing agency to the weapon ("The Predator struck"), language that most certainly reflected the only consistent source on the matter, what "U.S. officials said."[28] The arrival of the disposition matrix quietly quenched the public appetite for answers by uniformly applying a sense of operational passivity to the entire enterprise. The executive decision to assassinate, it seemed, was as byzantine, inert, and dull as the drone itself. Having suppressed interest in beholding the weapon from the outside, the discourse went to work on funneling civic attention through its targeting camera.

A discourse of secrecy guided this reorientation. On the one hand, the program operated in an authentically clandestine manner, often electing to conduct assassinations under the CIA rather than the military. Such a shrouding strategy gave journalists at the Bureau of Investigative Journalism and the *Intercept* very good reasons to conduct ongoing exposés. On the other hand, the program existed for most of its life as what the *New York Times* called "one of Washington's worst-kept secrets."[29] From the beginning of Obama's first term, administration officials routinely discussed the program with journalists in private and strongly alluded to it in public. Perhaps using a reveal-a-little-to-hide-a-lot strategy that also satisfied the need to project a tough-on-terror image, CIA director Leon Panetta frequently spoke about "operational efforts" and surveillance in the context of known drone strikes, always stopping just short of acknowledging that the agency had fired missiles.[30] Journalists often ignored the subtleties of the administration's rhetorical maneuvers. Initial press reports from Yemen of the killing of Anwar al-Awlaki in 2011, for example, quite confidently suggested the strike had been carried out by the CIA and Joint Special Operations Command. Later that day, however, when President Obama publicly took credit for the death of al-Awlaki as "a major blow to al-Qaida's most active operational affiliate," he maintained a thin veneer of secrecy by omitting the fact that the CIA had done it.[31] By April of 2012, when presidential advisor John Brennan officially

acknowledged the program's existence in a public speech, this open secret had practically turned itself inside out.[32] The announcement prompted Spencer Ackerman of *Wired* to declare with some measure of sarcasm, "It's official. The US drone war . . . really does exist."[33] As a number of media scholars have observed, contemporary techno-capitalism after 9/11 has come to traffic in commodified secrets, structuring an economy of buying and selling voyeuristic opportunities.[34] It was in this environment of alluring secrecy that the drone's gun-camera—intentionally or not—became a rarefied object of pursuit, tempting publics with a peek through the eyes of covert state power.

The Drone Channel

With other sites of investment thoroughly suppressed, drone discourse aligned the subject with two primary scenes: the control booth and the view through the targeting camera. These in turn fused into a singular vector of attention directed, with laser-like focus, through the eyes of the pilot and through the crosshairs gliding over the ground. The official source for much of what characterized the drone war on mainstream news and social media was a defense department organ known as DVIDS (Defense Video & Imagery Distribution System), headquartered on the outskirts of Atlanta. DVIDS began in 2004 as a public relations effort to supply military-produced footage and even fully produced segments to mainstream commercial news agencies. At a time characterized by a mass exodus of embedded reporters from Afghanistan and Iraq, DVIDS stepped in as a primary information source, supplying b-roll of drones taking off and landing, profiles of service personnel, cockpit video, and importantly, iconic gray-toned strike videos from the targeting camera. Between 2009 and 2013, the period of greatest adjustment to the new normal of the drone program, the DVIDS service was the most bountiful public source of strike footage.

Not surprisingly, newscasters rotated heavily through only a few videos. If there was a canonical drone strike video, it might be the DVIDS release "UAV Kills 6 Heavily Armed Criminals," an extraordinarily blurry clip that follows several black figures around a city block before an enormous explosion wipes out the frame. Although dramatic, these strike videos were profoundly generic and decontextualized. Only the barest details survived in captions like "Unmanned Aerial Vehicle Destroys Rocket Rails" and "Kinetic Strike on Bridge." The use of such footage in television news naturally replicated this generic quality, cleansed of anything that might resemble information. Rather than tell the story of a particular strike as in the style of Schwarzkopf's smart bomb films of the Gulf War, this footage generally played out in the background as abstract, animated wallpaper, intermingling with other images atmospherically: drones in the air, satellite earth zooms on target areas, and

"baseball card" graphics of individuals to be hunted. Strike footage was less of a window to an event than window dressing that helped transform the "situation room" of the news studio into the drone operation's "war room." As constant as the drone war itself, the view through the drone thus became a familiar fixture on the twenty-four-hour news screen, a kind of instrument panel occupying its own quadrant. If smart bomb vision of the Gulf War was a temporary prosthesis, drone vision settled in as a natural and all but permanent extension of the senses, comfortably integrated into the visual cortex of public life.

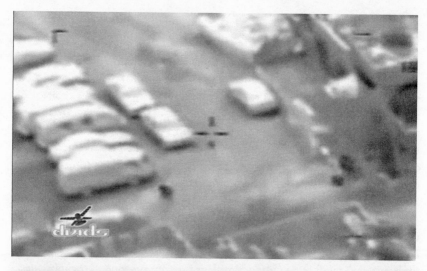

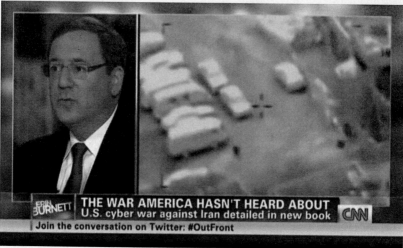

FIGURE 11 CNN's favorite DVIDS drone strike video release, "MND-B Soldiers Kill Two Terrorists." Shown at top with watermark from the DVIDS YouTube channel and on the bottom on CNN in 2012.

Drone targeting footage had a life outside television news as well. To interface more directly with the public, DVIDS hosted its own channels on YouTube and LiveLeak.com, a site known for hosting violent content, both under the user-name of "dvidshub." While much of the drone footage that circulated outside these official channels consisted of endlessly recycled DVIDS material, video-hosting services like YouTube, Military.com, and LiveLeak had offerings that exceeded the DVIDS catalog. It is difficult to track the source of these seem-ingly unofficial videos. Some were quite likely true leaks by service members or, just as likely, videos allowed to leak by official military gatekeepers and weap-ons contractors. Some may have even been official video releases laundered into public view through ostensibly unofficial channels. During the time of greatest activity, for example, the bulk of drone-camera footage on LiveLeak appeared to issue mainly from a user named "IRAQI_TRANSLATOR_USMC." Although the nature of this channel suggested its owner had connections, its true status—whether it be an unofficial conduit for leaks or a secondary offi-cial outlet for a more gruesome grade of footage not fit for mainstream news distribution—was not readily apparent. These videos circulated as though they had been verified, however. For example, "Rise of the Drones," a 2013 PBS *NOVA* documentary that had heavy cooperation from multiple U.S. military branches and weapons contractors, recycles one of IRAQI_TRANSLATOR_USMC's videos, first posted on LiveLeak.com, as its primary exemplar of a drone strike.[35]

In the context of social media, the drone strike video settled in as a rec-ognizable genre such that some in the mainstream press declared the genre a "YouTube hit" and sounded the alarm of "drone porn."[36] This was probably an overstatement. The view counts for drone strike videos were rather modest by social media standards. Some saw a lot of click exposure, such as DVIDS's most popular video, "UAV Kills 6 Heavily Armed Criminals," which by mid-2013 had garnered more than 2.7 million views. A handful weighed in at the half million mark, and still dozens more settled in the lower six-digit range. Other popular viewing sites like Military.com and LiveLeak do not post hit counts, but one can assume they fell into the drone strike video's long tail. Like their presence on mainstream news, these videos did not exist to be watched, exactly. Instead, they marked off the outlines of the frame and registered the genre: abstract des-ert architecture, a motorist on a strip of road, infrared bodies moving in groups, dusty detonation. This "seen one, seen 'em all" quality established the drone strike video as a common reference point at the extremities of visual culture, a mode of signaling the ongoing state of emergency, and a master visual trope for the weaponized eye in its many forms. This frame inherited the legacies of both the "orbital gaze" of the satellite and the existing gun-camera footage from years of occupation in Iraq and Afghanistan. Indeed, many of the videos reposted on YouTube made no distinction between drones and other weapons systems like the Apache helicopters and AC-130 gunships. The fact that these

views were often mislabeled as "drone footage" underscores the fact that the drone—with its remote logic and targeting camera—had come to thoroughly infuse the concept of state violence in the public imagination.

Drone Operator as Martyr

In addition to selectively exposing drone-camera footage, aligning civic vision with the vectors of the drone camera entailed a discourse rendering the operator's perspective available as a primary point of identification. Amid the program's aura of secrecy, the figure of the drone operator received a level of public scrutiny not extended to other gunners and pilots. The control room in some ways appeared as a locked jewel box that, once pried open, allowed the public eye passage into the first-person world of the cockpit, the ultimate man cave of flat screens, joysticks, and blinking lights. In representing what life is like in this environment, the camera typically searches for its resting place by first lingering on the pilot's eye and, within it, the watery reflection of the screen. From here, the gaze might hover over the shoulder or follow hands as they wander over the control panel. These generic visual conventions became standard fare from DVIDS b-roll to television news and fictional film.

The gravitation to this perspective is predictable. Not only did the drone operator serve as a key to the deep, clandestine state; the figure also provided a refined opportunity to turn Haraway's god trick of seeing everything from nowhere. The refrain became familiar: a cockpit somewhere in the Nevada desert, seven thousand miles from the battlefield, through a million-dollar camera that can follow a car from five miles high. Beyond satisfying pure scopic desire, the pilot's perspective dominated the drone drama because it was politically safe. The glimpse stolen through the pilot's eyes, while harboring a transgressive flavor, did little to open the program to actual public scrutiny and instead normalized the opacity of power. Specifically, this perspective obscured the two ends of the kill chain that mattered most: the formation of policy on the one hand and life under aerial occupation on the other. Hovering over the head of the pilot, official representations suspended civic attention in the limbo of pure functionality. The obsessive focus on the mechanics and psychology of the cockpit, in other words, submerged the deliberative civic question of "why" and replaced it with purely technical question of "how."

The pilot's story reflected this position. As told in both news and popular entertainment, the story zeroed in on a character racked with guilt for having to "do what needed to be done." The greater security of the nation demanded the sacrifice of the drone operator's conscience, if not body, to the gods of national security. The figure of the drone pilot thus followed in the footsteps of "the troops," who transitioned from hero to victim status in post–Cold War U.S. culture.[37] In this governing mythology, the drone pilot stands not

as a victim of the hubris of empire but rather of the very targets in the crosshairs, who, although unable to shoot back, make necessary the psychologically onerous task of killing "bad guys" and sometimes, unavoidably, civilians. This causes the drone pilot emotional and mental trauma, "moral injury," and sometimes diagnosable PTSD. In the typical story, this injury is compounded, not lessened, by the absence of bodily risk and the loss of the "warrior ethos." These factors converge to craft the drone pilot as a vessel for anguish.

This narrative is consistent across the spectrum, but it finds its most powerful form in television and film. Here we find on full display the archetype of the "guilt-ridden assassin," what Matthew Alford argues is the primary mode of cloaking imperial violence in the twenty-first century.[38] *Zero Dark Thirty* (2012), the CIA and Pentagon-supported reenactment of the Osama bin Laden execution, provided an early model for this officially sanctioned character. The film follows Maya, a young CIA operative, as she pieces together clues as to bin Laden's whereabouts and ultimately orders the kill. In the climactic scene, she oversees the raid through a circling drone camera from her perch in a bustling control room. Although ground troops ultimately do the deed, she is the point of identification through which we movie patrons see. After it is all over, Maya sits alone in the back of a transport plane bathed in soft, mournful music. It is here, at the very moment she might have celebrated, that our protagonist breaks down in tears. The camera lingers for a full thirty seconds on her streaked face before the screen goes black. The film thus does not so much argue that methods like torture and assassination are unproblematic as it implies that the enemy has made them necessary. Indeed, the film portrays Maya as the real victim insofar as she must endure the psychological torture of having to carry out the task. Through the surrogate eyes of this guilt-ridden assassin, we behold ourselves as subjects of the War on Terror.

A more direct invocation of this character type within the context of a drone strike occurs in the CIA-sponsored television serial *Homeland*, which began its multiseason run in 2011. A drone strike gone wrong sets the first season's drama into motion. Rather than killing its intended target, a bona fide terrorist, the CIA strike hits a school and kills eighty children including the terrorist's son, Issa. This was likely a direct reference to an actual 2006 strike on a Pakistani school that killed sixty-nine children and eighty civilians total.[39] At first blush, the CIA's choice to authorize a scene like this is astonishing, especially considering that *Homeland* is the agency's most successful intervention into popular culture to date. It is even more astonishing that the episode allows viewers to briefly sympathize with Issa before his death. The inclusion of these plot points makes sense, however, given that it was an opportunity for the CIA to rescript the public memory of the event. Here the massacre appears not as imperial violence run amok but as a consequence of a terrorist's use of "human shields." The agency, otherwise acting on good faith,

FIGURE 12 The drone pilot in anguish. From top, *Ender's Game* (2013), *Drones* (2013), *Good Kill* (2014), and *Eye in the Sky* (2015).

appears as victim to these nefarious tricks and must contend with the popular outrage and political fallout they were designed to create.

The drone reappeared as the series kicked off its fourth season. In "Drone Queen," Claire Danes's character, Agent Carrie Mathison, must decide whether to strike a particular terrorist. After she scrupulously eliminates possibilities for civilian victims, she gives the green light. The next morning, she learns that the strike kills not only her intended target but also forty civilians inside attending a wedding. Another PR nightmare ensues. Mathison also experiences personal trauma when she examines, via the drone camera, the aftermath in gruesome detail. Under normal circumstances, this might produce sympathy for the bombing victims, but the dynamics of the narrative divert all sympathy back to Mathison. She and her well-meaning agency were lured into a trap, after all, and thus appear as the actual targets. The ultimate message is not that killing forty civilians is unacceptable, nor even that it is a terror campaign in its own right, but that it will happen inevitably as a consequence of doing what is necessary. Through Mathison's character, who functionally occupies the pilot's seat, we viewers enter the drama. With her, we harbor the best intentions, make the tough calls, flash the furrowed brows, and then endure the sleepless nights. The message is clear: Those bearing the cross

of drone warfare are not those who live in its shadow. Rather, this distinction belongs to those who must pull the trigger and oversee PR damage control. Here, as in *Zero Dark Thirty*, this distinctly Obama-era drama supplants the usual masculine hero with a fair, fine-featured, and female CIA agent whose essential quality is knowing what needs to be done in spite of her empathy. She is the long-suffering one of the long war. Through her veil of tears, we citizens of empire understand ourselves as the true victims.

This basic archetype survives outside of CIA captivity, even in films celebrated for critically taking on the drone war. The big three in this department are *Drones* (2013), *Good Kill* (2014), and *Eye in the Sky* (2015), all of which are more about the pilot than the war. *Drones*, the sleeper of the three, takes place entirely in the hot box of the two-person control room. Here we encounter a male flyer and female sensor, a formula common to all three films that pairs the virtues of masculine duty with feminine empathy. Familiar themes appear early on regarding the loss of the warrior ethos. The two play drone video games between drone strikes, and they bemoan having to wear flight suits like "frauds" as the sounds of "real" fighter jets thunder overhead. This soft victimhood sets up the main act. Their commanding officer orders them to perform a strike on a top terrorist, who happens to be visiting a birthday party full of civilians. The rest of the drama plays out as arguing, anguishing, second-guessing, stalling, and even fisticuffs. In the end, however, the tortured duo resolves to carry out the task. The camera lingers on their grief-stricken faces, lit by the red lights of the console, as they peer through the drone camera at the smoke clearing over the strike.

Good Kill (2014) restaged much of the same story but with established stars, higher production values, better reviews, and, at least nominally, a more critical edge. In the film, Ethan Hawke plays Tommy, who appears as a broken, wizened, and crestfallen version of Maverick from *Top Gun* (1986). Not only has the military grounded his dream of flying real jets, but the CIA has also commandeered his crew to perform a distressing series of strikes that clearly involve civilians. As he undergoes these tests, his countenance withers, his alcoholism worsens, and his marriage implodes. On the one hand, *Good Kill* is vocal in its critique of the CIA program, railing against the use of double-tap strikes (the practice of firing again once rescue workers begin digging for survivors) and raising the possibility that drone strikes only serve to create more animosity. On the other hand, as critical as the film is, it carefully quarantines its outrage in Tommy and his patient wife (January Jones), who appear as the principal casualties of the drone war. The master image here is Tommy's face reflected in a mirror, cracked and spattered with blood from his own fists, crucifix gazing down at him from the wall. To complete this motif of the sacrificial lamb, Tommy's officer gives a speech to his squadron where he declares that the drone war is necessary despite the emotional pain it causes his crew.

After all, he continues, we find ourselves in a cycle of violence that, like the cosmic war between good and evil, is unavoidable, unstoppable, and unknowable. The centrality of the pilot-victim narrative to *Good Kill*—and, for that matter, the larger cultural story of the drone war—can also be observed in the film's reviews. *Newsweek*'s promise to reveal "What 'Good Kill' Gets Wrong about Drone Warfare" might have stirred one to consider those under occupation whom the film leaves out of the frame. Instead the review asserts, rather absurdly, that the film does not dwell on Tommy's anxiety enough.[40] The *New York Times* similarly boiled the moral of the story down to the fact that "our blind infatuation with all-powerful technology is stripping us of our humanity" with no mention of those whom the drone war strips of their lives. In this way, the drone appears not as a tool of imperialistic violence but rather as an abstract allegory for generalized techno-anxiety. Or, as the *Times* put it, *Good Kill* is "a contemporary horror movie about humans seduced and hypnotized by machines into surrendering their souls: 'Invasion of the Body Snatchers' for techies."[41]

The most commercially successful of the three and last in the series, *Eye in the Sky* (2015), is also the most narratively complex. Rather than strictly focusing on the pilot (Aaron Paul), it extends its drama of anxiety up the kill chain into various control rooms where the opinions of military personnel clash with those of civilian politicians. At the center of the action is a British Army colonel (Helen Mirren) who learns that the Nairobi terror suspects she has been surveilling for many months with the honest intent to capture are now planning a suicide bombing event. She thus must convince a very reluctant panel of military and political personnel to authorize a drone strike. This process precipitates much hand-wringing about killing British and American citizens in the "safe house" and civilians outside the house, especially a young Kenyan girl dressed in a bright-red headscarf selling bread alongside the road. After all the arguing, the order for the strike goes down, the missiles launch, and the crew learns that the girl dies along with the terrorists. The film thus provides the most generous possible reading of the drone war: a single strike rather than an ongoing occupation, a clear imminent threat, and well-intentioned people taking every possible precaution.

In the end, though, the film is about the grief of those who must pull the trigger. After the climactic strike scene, the camera scans a long parade of trembling, tear-stained faces up and down the kill chain. Aaron Paul, who became famous for his vulnerability after test-piloting it in the TV series *Breaking Bad*, seems to have been specifically chosen for this moment. The ultimate moral of the story arrives at the very end, out of the mouth of the most trigger-happy character at the table, the lieutenant general of the Royal Marines (Alan Rickman). He has some words of advice for the most vocal opponent of the air strike, a British advisor to the prime minister (Monica Dolan). As she listens

with moist eyes, he aridly explains that her sympathies do not make as much sense as his rational calculation of harm. "I have attended the immediate aftermath of five suicide bombings," he tells her. "What you witnessed today with your coffee and biscuits is terrible. What these men would have done would have been even more terrible." Slowing his cadence, he then commands her with some contempt, "Never tell a soldier that he does not know the cost of war." He then exits, clearly burdened by the moral weight of his job, or as the *New York Times* put it, "suffused with a dyspeptic world-weary understanding of war and human nature."[42] Alone in the room now, she begins to weep freely. Mournful music follows everyone home, including the parents of the slain girl who must take her body to the morgue. Images like these might otherwise serve to humanize those under drone occupation. Their larger purpose here, however, is not to tell their story but rather to amplify the anguish our protagonists must bear.

At a basic structural level, there is little to distinguish these three films. All reduce the drama to some version of the old Ethics 101 dilemma known as the "trolley problem": Should the operator let the train kill twenty people or divert the train so it only kills one? The assumption that the drone war is a trolley problem in the first place—rather than, say, an act of illegal aggression—is, of course, a matter of framing. It grants the questionable premise that the drone war is a reaction to an unstoppable destructive force barreling down the tracks. This contains the violence in a neat utilitarian choice that casts this operator, more than anyone else, as its victim because he or she must live with this terrible decision. Whether it be the pilot staggering out of the dark control trailer into the blazing Nevada sun or the general shuffling down the hallway at MI5, the sacrifice renders the drone war as beyond reproach. "Never tell a soldier" commands us to be silent at the altar of the martyr. In place of deliberation, the drama invites the citizen to take part in the alternate ritual of drone vision, of seeing through the sacrificial switchman's tortured eye in the sky.

The repeated ritual of playing victim has cleared the way for first-person relationship with drone vision. In this frame, the figure of the drone pilot barely exists beyond its function as a surrogate body. Flesh mortified, this body dematerializes before our eyes in a haze of questions about real pilots and real war, finally appearing as an empty vessel for the public gaze to occupy. The fact that unmanned vehicles are often confused in the public imagination with autonomous vehicles is a symptom that the pilot has become porous. In this sense, Nikola Tesla's early vision of future wars fought by automata and today's disposition matrix algorithms have converged to deliver an image of the war machine whose human agent is only a placeholder.[43] It is this ghostly pilot avatar who ushers us toward the Naugahyde Barcalounger swiveling in front of the control panel. What remains is an invariable feature of drone war discourse, which is authorized by the assumption of the pilot's guilt: the invitation to

crawl into the drone pilot's skin. The unremitting call to do so reflects the will of the discourse, driven by its internal contradictions, to capture, enclose, and discipline the citizen within this set of subjective relations.

Interactive Droneplay

This ever-present fantasy of trying one's hand at the controls naturally summons the specter of the video game. In one sense, this metaphor has been deployed to such an extent that it seems to have squandered all its critical usefulness. The references litter the landscape from General Norman Schwarz-kopf's warning in 1991 that Desert Storm was "not a Nintendo game" to Orson Scott Card's 1985 novel *Ender's Game* to films like *The Last Starfighter* (1984), *Toys* (1992), and the eventual screen adaptation of *Ender's Game* (2013).[44] Each of these narratives features video game players who have been conscripted to use their skills in fighting real wars, knowingly or not. It should surprise no one that the remote-controlled nature of the drone is uncommonly susceptible to such comparisons. Nevertheless, if approached in the right way, the metaphor of the video game can still lend insight. The question is not "In what ways is the drone war like a videogame?" but rather "In what ways does drone war discourse enlist the citizen in an interactive fantasy?"

Before we even approach the video game per se, we must recognize that drone discourse harbors a particular interactive kernel: the enticement of crossing over from the humdrum existence of everyday life to the extraordinary circumstances of high-tech war. Again, the pilot serves as the primary site of investment as this story plays out, spiriting back and forth between safe domestic life and the anxious battle zone of the control booth, what can be seen as a high-frequency version of the deployment-return motif. This story typically intertwines this interactive enticement with the drama of the pilot's sacrifice.

Journalistic portrayals strictly adhere to this template. For example, in a series of articles about drone warfare, *Der Spiegel* describes what it called the "bizarre lifestyle" of the drone operator, which consists of a laundry list of mundane activities—taking the kids to school, getting a hamburger, sending some emails—interspersed with stints at the base flying drones and firing missiles.[45] A *New Yorker* article notes that drone operators, after killing a few insurgents, go home and "have dinner with their families," a phrase that appeared time and again in press accounts.[46] The *Christian Science Monitor* repeats the refrain: "At the end of the day, these pilots then get in their cars and drive home to their families, mow the lawn and make dinner, or take their children to soccer practice."[47] The PBS *Frontline* documentary, "Digital Nation," features a section on drones attended by the tagline: "The air force pilots who take out the Taliban by day, but make it home for dinner."[48] The 2009 *60 Minutes* segment referred to above virtually ignores all other aspects of

drone warfare to narrowly focus on the lifestyle of a drone pilot, working "just 45 minutes from the Las Vegas strip" at Creech Air Force Base. "The pilot," the correspondent informs us, "can take [insurgents] out and still make it home in time for dinner." To further investigate "what that's like," she rides home with him in his truck back to the house where his spouse chops vegetables in the kitchen. The reporter can hardly contain herself: "It's sort of like being in a movie, you know? You can wake up, have breakfast with the wife, and head to war." The pilot laughs. She then asks the requisite question of whether being a drone pilot is "like playing a video game." The pilot predictably replies that it is much more than that.[49] The series of metaphors and images completes a circuit, wiring the pilot's mundane existence to the excitement of taking out the "bad guys," the drone control panel to the home game console, and footage of insurgents planting improvised explosive devices (IEDs) in Afghanistan to the spouse cooking dinner in quintessentially domestic space.

Beyond the human-interest value of this character, who seems to be undergoing a strange experiment in human psychology, this repeated story works to contain citizen subjectivity within safe, officially sanctioned parameters. The obsession with the hyperordinariness of the pilot's off-duty life serves as a portal into this particular avatar, which then rhythmically extends to a first-person encounter with the drone command console and its familiar screens. Within this perspective, the story flits breezily between the security concerns of the personal sphere and prosecutorial concerns of the technical sphere, thus entirely bypassing the public sphere and the opportunity to deliberate questions of state violence. Here, too, the story of "what it's like" to pull the trigger and then go home and have dinner with the kids thoroughly insulates from questions such as "what it's like" to live under the constant hum of drones in the sky or "what it's like" to dig a six-year-old girl out of the rubble. Finally, the story reinforces the underlying logics of the War on Terror, which is the new interpermeability of domestic space and battlespace. Indeed, the narrative joins a discourse that pushes the domestic distribution of martial concern, what has come to be called "net-centric warfare," as an inevitable dimension of distributed information networks.[50] As Mark Andrejevic puts it, "When we can multi-task thanks to the proliferation of networked devices, we are invited to participate in the war on terrorism from the privacy of our homes and from our offices, wherever we might happen to be."[51] The drone has indeed become an emblem of a borderless war, enacted and normalized by the pilot's high-frequency journey.[52] The rhythmic exchanges of "this isn't war, is it?" and "yes, this too is war," methodically chip away at distinctions that separate domestic space and battle space.

The emergence of *Ender's Game* as a summer Hollywood blockbuster in 2013 signaled that the drone war had fully conscripted the interactive imagination of the citizen. The titular character is a video game whiz kid pulled from his family

FIGURE 13 Drone games. Top row: Two Predator drone views in *Call of Duty: Modern Warfare 2*. Bottom row: A TALON-type drone in an airport scene in *Modern Warfare 3* and a Fire Scout-type drone about to take off in *Battlefield: Bad Company 2*.

life to command a fleet that must destroy a threatening civilization of aliens. While the original novel makes no mention of "drones," the film calls them by name. In promotional interviews, Harrison Ford, who plays Ender's superior officer, stated that the story was quite plainly an allegory for drone warfare. Reviewers, too, considered the conceit obvious enough to take for granted.[53] In the film, Ender, the ultimate drone pilot, directs a swarming squadron from a fantastic command center with a swiping conductor's dance. In tune with the drone movie genre, his psyche is the ultimate focus. Duped by the powers that be, he destroys the enemy in what he thinks is only a simulation. After the big reveal, he spends the last part of the film tortured by guilt for what he has done. Through all of this, the job of his superiors is to attend to his mental health. The futuristic setting allows the pilot-as-avatar trope to come across more strongly than a typical drone film. Ender's superiors have the ability to enter his consciousness and look around as he trains. "I've watched through his eyes, listened through his ears," says one. Like the archetypal drone pilot, Ender too becomes a vessel through which we experience the thrills and agonies of the kill.

Consumer culture has presented myriad other opportunities to take the drone war for a test-drive. The UAV gained an increasing presence in video

games themselves, including the two of the most successful war-themed franchises to date: *Battlefield* and *Call of Duty*. From early on, the *Battlefield* series integrated the view through the drone's infrared-targeting camera. *Battlefield 2* (2005) featured the ability to command the Predator drone, as did *Call of Duty: Modern Warfare 2* (2009) and *Modern Warfare 3* (2011). The *Call of Duty* series raised the ante somewhat by embedding its camera in the missile nosecone, Gulf War–style, as it homed in on its target. Both *Battlefield: Bad Company 2* (2010) and *Modern Warfare 3* featured a replica of the MQ-8B Fire Scout, an armed rotary-wing drone whose camera produces an image similar to the Predator's. Outside of these two big franchises, the second-tier military strategy game series *ARMA* endeavored to replicate the drone-flying experience the closest. *ARMA II* (2010) allowed the player to stroll up to a command trailer and meld with the MQ-9 Reaper targeting camera, and *ARMA III* (2013) set in 2030 afforded a view through the drones to come. These are the primary attempts to replicate conventional imagery from the drone war, but there were many other invocations of the remote-controlled gun-camera. The futuristic *Battlefield 2142* (2006) put the player into the virtual cockpit of a "flying wing" drone not unlike the RQ-170 Sentinel, which was in development at the time at Lockheed Martin and eventually captured by Iran in 2011. The ground-based Foster-Miller TALON, the bomb-defusing robot that rolled famously through the opening sequence of *The Hurt Locker* (2008), can be found in both *Modern Warfare 3* and *Battlefield 3* (2011). *Battlefield 3* also allowed players to fly a surveillance MAV (micro air vehicle) designed after the Honeywell RQ-16 T-Hawk, which both *Battlefield 4* (2013) and *Call of Duty: Black Ops II* (2012) upgraded to a small winged aircraft capable of running kamikaze strikes. Small-time games for download on the Apple Store round out the list, including *UAV Fighter*, *iDrone*, and *DroneSwarm Command*.

With very few exceptions, all these depictions grant a first-person relationship with the drone's camera. Typically, the scene visually melds the drone control pad in the avatar's hand with the control panel in the player's hand. In contrast to a traditional flight simulator where a fair amount of translation is necessary to reimagine the game console as a cockpit, drone vision easily splices into the video game experience. Further enhancing this effect is the fact that many real-world drone control systems, painstakingly reproduced in games, have themselves been designed after the ergonomics of video game controllers.[54] As the gaming world absorbs the drone as a device, it retrofits an already virtual medium to a virtual war. This process demands even more robust signs of authenticity to elicit player enjoyment, including the merger of actual and fictional events, game and weapons interfaces, and player and soldier identities. This is one reason the *Ender's Game* narrative became increasingly salient in the context of the drone war. The drama played out the primary fantasy of drone vision as it had been harnessed to sell a consumer experience:

the prospect of gaining access to telepresent military power through a fusion of interfaces that shade from simulated to real.

This fusion has expressed itself also in the arrival of consumer drones whose most immediate referent is combat. In the mid-2000s, groups like DIYdrones.com began to appear, trading in the "radio-controlled aircraft" of old for "amateur UAVs," usually with cameras attached. In 2010, the company Projet introduced a consumer mock-up of the MQ-9 Reaper drone with a ninety-eight-inch wingspan. A year later, the electronics retailer Brookstone began selling drones in quantity. The first to appear was the "Rover App-Controlled Spytank with Night Vision," a TALON-like ground vehicle with a camera that could be controlled with an iPad or iPhone. "Low-light setting? No problem!" exclaimed the product description. "The undetectable infrared night vision lets you see items in the dark. Mission. Accomplished." Among other retailers, Brookstone continued with the trend by marketing the Parrot AR.Drone 2.0 Quadricopter. This sophisticated toy, flown with an iPhone or iPad, featured an "augmented reality" system that fitted the streaming image from the camera with shooter-game frills. Using the device with AR.Hunter game, one could pretend to fire virtual ordnance at real people and objects appearing in the drone's sights.[55] By 2013, the company had moved more than half a million units, and the Quadricopter emerged as the signature consumer drone.[56] These practices displayed an impulse to commandeer the smartphones and the tablets that populated everyday life. A remarkable symmetry emerged. On the battlefield, "signature strikes" targeted cell phones involved in supposed patterns of suspicious activity, and on the home front, these same devices assimilated drone vision through YouTube clips, game apps like *iDrone*, and opportunities to fly the weaponized eye through the neighborhood. It is no wonder that metaphors of violence—of "blowing up the phone," "blowing up the internet," and "photo bombing"—colonized the language by which we talk about our communications technologies.

Something like this blending of worlds had been imagined back in 2006, when the U.S. Air Force ran its "Cross into the Blue" recruitment campaign. One prominent ad in this series begins with a boy flying a paper airplane and tracks his life as he progresses through bigger and more sophisticated remote-controlled planes. The words "we've been waiting for you" eventually flash on the screen alongside a drone pilot at a control station. The air force doubled down on this motif in 2010 with the "It's Not Science Fiction. It's What We Do Every Day" campaign. Against a fanciful backdrop of what looks to be a war on Mars, the inaugural ad featured the drone or, more accurately, drone vision as the central character, inviting the viewer to take the controls. As we have seen, these ads were only a bellwether of a culture that easily transmuted the business of state violence into immersive practices of consumption.

The Disappeared

The containment of the subject within the envelope of drone vision meant the erasure of those sentenced to live and die under occupied skies. Under this regime, if one absolutely had to envision what life was like on the other side of the crosshairs, the discourse typically substituted a decontextualized Westerner as its hypothetical target-victim. This orientation appears to have been present early in the cultural life of the drone. In 2007, for example, the Discovery Channel's *Future Weapons* devoted an episode to profiling the Predator. In the episode, host Richard "Mack" Machowicz, a former Navy SEAL, challenges the drone to a game of hide-and-seek. With a ten-minute head start, Mack drives a four-wheel drive somewhere into the Mojave Desert, after which an operator attempts to find him. "Remember," he tells viewers, "as a potential target, I could be anything from a driver of a stolen vehicle on the highway to a band of terrorists armed to the teeth, hell-bent on causing havoc." For the rest of the sequence, the viewer tacks between Mack and a variety of gray-toned images from the sky that show he has been successfully located. In the end, he reminds the viewer that had he been a "bad guy," he would have been "toast." A *60 Minutes* segment on drones that aired in 2009 repeated this motif by tracking the host and her news crew from the sky as they loaded into their pickup truck. The 2013 PBS *NOVA* documentary "Rise of the Drones," which functioned mainly as promotional spot for its military-industrial complex sponsors, struck a similar rhythm in its depiction of a training exercise. Indeed, following an actor from both the ground and sky is the closest the documentary came to representing those actually affected by drone warfare. Otherwise, targeted populations appeared only through the usual official strike videos and, in an extremely brief treatment of possible blowback to the drone war, as a chanting mob burning an American flag.

The world of games did not deviate from this formula. Consider the premise of *Call of Duty: Black Ops II* (2012), which at the time set the record for the biggest release in the history of media. The game paints a nightmare scenario where an international terrorist hacks the U.S. drone fleet and turns it on Los Angeles. As part of the marketing campaign, the game makers released a "documentary" that featured commentary on the scenario by Oliver North, Iran-Contra convict turned cable news commentator, and Peter Singer, Brookings Institution fellow and author of the best seller *Wired for War*. In an upbeat but ominous montage of explosions and computer blips, North grimly (and somewhat comically) warns that most people do not understand "how violent war is about to become." Singer explains that the main problem with drones is that our technology is outpacing our ability to keep it out of the wrong hands. Both speculate about the prospect of terrorist hackers seizing the controls. As the video winds up to a final title screen (flashing its catchphrase "The Future

Is Black"), the action rapidly intercuts scenes of suburban homes and city streets with the famous 1991 smart bomb camera footage closing in.

These examples illustrate that when there was a need to represent what it is like to inhabit the target-body, the image of a Westerner or a Western domestic scene has commonly been enlisted as substitute. Such image-narratives scrupulously avoid identifying the viewer with those who actually exist day to day in the crosshairs. In his excellent commentary on distance and drones, Derek Gregory notes that media coverage has indeed focused on life in the command center, leaving life in the target zone "radically underexposed."[57] These choices cast the subject of drone vision in a two-dimensional relationship to the surveillant weapon, one that flashes between guilt-ridden assassin and hypothetical target. This dual victimhood serves to inoculate against what is perhaps most objectionable in the drone war: the presence of those who suffer under its eye.

Civilian casualties have been a routine part of drone strikes from the beginning. Their appearance within the frame of drone vision, however, has been at best intermittent, blunted, and largely scrubbed from public consciousness. Before examining the numbers, let us begin by weighing two notable incidents and whether they registered (or failed to register) on Western screens. The first occurred on day three of President Barack Obama's first term when he authorized dual personnel strikes in Pakistan that killed up to nineteen civilians, including four children.[58] The second occurred later that year, just after Obama received his Nobel Peace Prize. It was then that the U.S. rekindled military action in Yemen with another strike—a Tomahawk missile sighted by drone—that killed forty-one civilians. The details of this second example are particularly notable. The supposed target in this case was one man, Saleh Mohammed al-Anbouri. A former militant who had just been released from prison, al-Anbouri told locals he wanted to "start a new life," returned to his extended family, and was in the process of digging a well when the missile struck. The warhead contained cluster munitions, which sprayed antipersonnel shrapnel and bits of molten zinc 150 meters in all directions. More than half of the dead were children; five of the adults killed were pregnant women. Three more civilians died later when they stepped on unexploded bomblets from the missile, a common aftereffect that had prompted 107 nations (but not the U.S.) to sign a cluster munitions ban in 2007. A tribal leader described the scene: "If somebody has a weak heart, I think they will collapse. You see goats and sheep all over. You see heads of those who were killed here and there. You see children. And you cannot tell if this meat belongs to animals or to human beings. Very sad, very sad."[59]

The common frames of drone vision had largely excised the ability for the U.S. public to envision scenes like these. This was the case especially in the beginning when the promise of surgical precision—within the larger frame of

a humane biopolitical war—still had credibility. For many years, the White House was silent on the matter of civilian deaths, even as scattered reports suggested high tolls. In 2012, the Bureau of Investigative Journalism (BIJ) finally asked both CENTCOM and the State Department to comment on the 2007 incident described above that had killed forty-four civilians. Had there had been an investigation, disciplinary action, or compensation for the victims? Both institutions demurred, neither confirming nor denying that civilians had died. Instead, the Obama administration praised the program (without directly naming the CIA) for its supernatural ability to distinguish combatants from civilians. In 2011, the administration's top counterterrorism advisor, John Brennan, boasted that for the prior year there had not been "a single collateral death because of the exceptional proficiency, precision of the capabilities we've been able to develop." Other officials chimed in with more of the same: the drones had killed more than six hundred militants without so much as scratching a single civilian.[60] This position had its detractors, including the administration's own internal intelligence reports, which were later leaked to the McClatchy news service. These reports referenced the "hundreds" of civilian deaths that were becoming a problem because they aided in insurgency recruitment efforts.[61] The administration's claims were also curious considering that just three months earlier, a strike had killed forty-two prominent community leaders in an open-air bus terminal as they held a *jirga*, a common dispute resolution meeting where participants sit in large circles. In this case, as in others, the administration repeated its well-worn alibi that anyone killed by a drone must be a combatant by definition. "These people weren't gathering for a bake sale," officials explained to the press. "They were terrorists."[62]

Since the government was not forthcoming with numbers of civilian dead outside of the occasional leak, accounting was left to three main NGOs: the *Long War Journal*, the New America Foundation, and the Bureau of Investigative Journalism. Researchers from both Stanford Law School and NYU's School of Law weighed these numbers in their shocking 2012 report "Living Under Drones: Death, Injury, and Trauma to Civilians from US Drone Practices in Pakistan." The researchers argued that estimates of civilian dead from the first two organizations (roughly 100–200 dead from 2004 to 2012) were highly questionable due to secret and incomplete data sets, reliance on official accounts, and the assumption that unidentified dead must be "militants." The report instead cited the Bureau of Investigative Journalism's data set as "much more thorough and comprehensive" for a number of reasons.[63] Indeed, the BIJ had aggregated press reports, court proceedings, leaked documents, and field work since the drone war's early days. Its numbers told a vastly different story. In Pakistan alone, the BIJ estimated that between 2004 and 2016, U.S. drones killed between 2,500 and 4,000 people. Of these, up to 1,000 were civilians, including 200 children.[64] Figuring in military programs, BIJ estimated that as

of 2017, there had been more than 4,000 confirmed strikes and up to 17,000 total kills, which included as many as 2,700 civilians.[65]

As secret drone operations became an increasingly frequent object of public scrutiny, the administration began to acknowledge the civilian toll on a very limited level. In 2016, three years after promising to do so, the Obama administration finally released its drone death count. The news arrived late on Friday on a holiday weekend and amid declarations of a commitment to the protection of civilians. The report estimated that between 64 and 116 civilians had been killed during the president's two terms.[66] These number of course relied on the administration's practice of defining any military-age male killed by the blast as a "combatant" or "militant," nakedly propagandistic language that the press happily recycled.[67] Perhaps more troubling was the fact that the administration in large part could not name whom the strikes had hit, a fact that flew in the face of the drone program's mythic intelligence-gathering capabilities. As an illustration, the human rights group Reprieve released a study in 2014 that showed that in the attempt to kill 41 individuals named by the State Department, approximately 1,147 people died. This suggested that 96.5 percent had been unintended targets. To take a more detailed example, covert U.S. drones in Pakistan succeeded, after multiple attempts, in killing only 6 of 24 named targets. Those 6 successful hits, however, killed an additional 874 people, including 142 children.[68]

In the face of such public discussions, the presence of death in the era of drone vision took on some ambiguity. On the one hand, death became an accepted part of the public diet of images, a feature that distinguished it from previous views through the weaponized camera. Human bodies, albeit usually the most abstract renderings possible, began to appear as targets. In this view, the camera typically hovered over them before releasing its payload, a sequence pioneered in earlier attack videos from the perspective of the helicopter or AC-130 gunships. Although the drone strike video commonly ended with an all-consuming conflagration, it was also not uncommon for the bodies to fly to pieces, fall motionless to the ground, or, if still alive, run for cover. The body became such a regular feature in the frame that the drone control room lingo of "bugsplat" (direct hit) and "squirter" (a target body fleeing the initial strike) became part of the public argot.[69] As we have seen, mainstream entertainment media, even the officially supported variety, also did not shy away from the occasional incineration of a wedding as a plot point. This shift challenged the motif of the "clean war" that dominated previous iterations of the weaponized gaze.

On the other hand, gruesome firsthand stories of strikes, tales of civilian dead, and even the numbers alone were still shockingly incongruent with the public image of the drone war. This suggests that death, even if it had been normalized as more intimate and visible than decades past, had been successfully

contained. Perhaps this was a visual concession to the average citizen who no longer found the bloodless image credible in an age of information overload, leaks, and never-ending wars of occupation. Whatever the cause, the occasional appearance of what Ian G. R. Shaw calls the "fleshy side of the disposition matrix" made it necessary to recalibrate the caption.[70] The categorical denial of the body in smart bomb vision gave way to the body's rematerialization, if not quite humanization, as seen through the eyes of the drone era's guilt-ridden assassin, whose anxiety served to again balance the equation.

5

Sniper Vision

> [We] are in relation to this site of destruction absolutely proximate, absolutely essential, and absolutely distant . . . the sniper as a figure for imperialist military power.
>
> —Judith Butler, 1992

Until Clint Eastwood's 2014 film appeared in theaters, *American Sniper* referred only to Chris Kyle's autobiography, which had spent thirty-seven weeks on the *New York Times* bestseller list. Adaptation for the big screen would be a perfunctory task at most given that it already read like a screenplay. The book's opening sentence begged for its own title sequence: "I looked through the scope of the sniper rifle, scanning down the road of the tiny Iraqi town."[1] Eastwood was not the only one seduced by this mode of witnessing the Iraq War. Even the *New Yorker* assumed the position in its celebrity profile of Kyle, transporting its readership to the top of a four-story building in Ramadi: "Peering through his gun's scope," the article began, "Kyle scanned the streets below; as other American soldiers searched and cordoned off homes, he waited for insurgents to appear in his sight line."[2] The biopic was still in production, yet the view through the gun scope had already taken hold in the popular imagination. While the printed word could only tease the reader, however, the film consummated the kill by merging the cinema camera and gunsight into a singular apparatus of vision.

American Sniper's arrival on the big screen in some sense signaled the over-turning of an old order. At minimum, it definitively broke the curse of the Hollywood war movie. These had been touch-and-go investments during the decade of occupation in Iraq and Afghanistan, collectively gaining an industry reputation as a "toxic genre."[3] Even *The Hurt Locker* (2008), which won Academy Awards for Best Picture and Best Director, just barely managed to cover its production costs. It was not until *Zero Dark Thirty* (2012) that the genre even began to bounce back commercially. This upward trend led to *Lone Survivor* (2013), whose $125 million in box-office revenues placed it second only to *Saving Private Ryan*'s $216 million take in 1998. *American Sniper* shattered this record. Within a year of its release, the film had blown *Ryan* out of the water with $350 million in receipts, outmatching even *The Hunger Games* behemoth *Mockingjay* to become both the highest-grossing film of 2014 and the highest-grossing war movie of all time.

Beyond commercial significance, the question presents itself: What can one say about a film that drove the venerable Matt Taibbi of *Rolling Stone* to entitle his review "*American Sniper* Is Almost Too Dumb to Criticize"? We could briefly rehearse the mainstream critiques. Some pointed to the racist subtext and the lionization of the real-world Chris Kyle, a controversial figure who boasted of taking pleasure in killing and terrorizing Iraqi "savages" in his autobiography.[4] Others cataloged the film's maelstrom of misinformation. The story strongly implied, for instance, that the invasion of Iraq was an honest attempt to rout out those responsible for the attacks of 9/11, resurrecting the misleading justification for war that even the Bush administration ultimately abandoned.[5] Still others pointed out that much of the dramatic arc of the film had been fictionalized by Eastwood and company. Among the wholly invented characters was the "Butcher." This inexplicably evil villain, who appears nowhere in the autobiography, menaces fellow Iraqis—even children—with a power drill, continuing in what Nick Turse identifies as the proud Hollywood tradition of projecting unsavory U.S. military acts like torture onto those who suffered them.[6] Lastly, in 2016, it came to light that Kyle had greatly exaggerated the number of bronze and silver stars he had received, facts that the film producers had not bothered to check.[7]

These criticisms are all part of important discussions, but here we bracket them and ask something more fundamental. What is it about this period that allowed the figure of the sniper to break through and claim representative status? What role did the film play in the evolving practices of looking through the gun sight? Could the reappearance of the sniper indicate a recalibration to these tools of vision, distance, and violence? This chapter endeavors to understand *American Sniper* as a moment in U.S. culture where a new civic relationship to the military crystallized, a "representative anec-dote," in Kenneth Burke's terminology, around which common sense took

shape.[8] Not only does the film invite the viewer into the gaze of the weapon; its narrative strings these modes of vision together. As the analysis will demonstrate, this grammar is dominated by the *pastoral*, a metaphor with deep roots in the Western Judeo-Christian imagination. Structured by this metaphor, *American Sniper* functions not only to coax the viewer to see the war through the eyes of the military apparatus, but also to build a moral universe around its practices of seeing. Ultimately, this discourse of "sniper vision" works to contain the citizen's deliberative impulse and cultivate in its place a field of strict obedience.

We begin by putting the figure of the sniper into context to understand how it has evolved generally from a villainous to heroic character. We then turn to *American Sniper*'s deployment of the gaze and the ways it positions the viewer. Michel Foucault's treatment of the pastoral metaphor enters the picture at this point, allowing us to track its outlines through the visual economy of the film. Along the way, we encounter the ideal viewer-subject among discourses of oversight, sacrifice, martyrdom, territory, good and evil. The chapter concludes by fitting the film into larger trends regarding the drone war, state propaganda, and dominant cultural myths regarding geopolitical threats.

Sniper as Moving Target

Until recently, few figures had been more maligned and sidelined in our mythologies of violence than the sniper. Historically, these depictions have generally associated this figure with the enemy who resorts to ambushes and other unscrupulous tactics. At best, the sharpshooter had been consigned to a minor role behind those aspirational heroes who charge directly into firefights. This character instead sits, waits, selects, and does the deed through a thick wall of abstraction, distance, and technology. If we stop to consider the sniper in popular film overall, we find a consistent series of unflattering types: assassins for hire in thrillers like *Day of the Jackal* (1979) and *Sniper* (1993), the tormented ex-soldier framed as a presidential assassin in *Shooter* (2007), heist criminals like those in *Heat* (1995) and *Smokin' Aces* (2006), and twisted serial killers like the characters in *Wolf Creek* (2005), *Phone Booth* (2003), and *Jack Reacher* (2012), which were likely inspired by the twenty-three days of random sniper attacks that gripped the Washington, D.C., area in 2002.

In the proper genre of the "war film," the sniper has not fared much better. The iconic burning city scene from *Full Metal Jacket* (1987) is emblematic of the memory of the sniper in the shadow of Vietnam. Here an anonymous silhouette of a muzzle quietly assumes position from inside a blasted window, effecting a reversal of gaze that is standard technique for generating suspense: the audience has perfect knowledge of the danger while the main characters on the screen mill about in perfect ignorance. This image of doom initiates

a series of sneak attacks on our soldiers, who howl in frustration, blindly fire back, and suicidally rush forth. The film later reveals this sniper to be a woman, which, due to unfortunate but prevailing gender norms, helps mark the practice as the opposite of soldierly virtue. Indeed, the film ultimately punishes her by riddling her body with bullets in slow motion.

It is not until the late 1990s that we begin to see evidence of the sniper's rehabilitation as well as the positive valorization of sniper vision. In the CIA-supported film, *The Peacemaker* (1997), agents track a nuclear bomb stolen by terrorists as it makes its way toward New York. The climax appears in large part through the scope as sniper agents atop buildings try to get a clear shot at the terrorist running through the city. The real turn began a year later, however, with the Pentagon-sponsored blockbuster, *Saving Private Ryan* (1998). A sniper in *Ryan*'s rescue party assumes a central role in disabling those who attack from higher positions. In the Omaha Beach landing scene, for example, he aims uphill to fire the shot that finally breaks through the high German defenses and allows the embattled Americans safe passage. He also plays the underdog later in the film when he confronts the German sniper in a bell tower, who pins the Americans down in a rainstorm from his dry, privileged perch. Here the German represents the traditional cowardly opportunist version of the sniper, and just as in *Full Metal Jacket*, we see much of this action through the German's scope. The sequence plays out differently this time, however. The American on the ground fires first, his muzzle flashing through the curtain of rain. Now in third person, we witness the bullet striking the glass of the German's scope, traveling up through the lens tube, penetrating his eye, and exiting the back of his head. Here the German sniper, the villainous variety, undergoes a fate that has historically represented ultimate annihilation in the medium of film: the destruction of the eye itself. We also begin to see the outlines of the American sniper as hero, who stages a successful insurgency against the fascist eye in the sky. By the end of the film, this American sniper takes up a position in his own bell tower, and through his crosshairs, we viewers take righteous revenge on one hapless German after another.

The next decade carried forth this project of transforming the sniper as it crossed the zone of ambivalence. *Jarhead* (2005), the only mainstream war movie prior to *American Sniper* to feature the sniper as protagonist, functioned as another waypoint en route from villain to hero. In the film, Jake Gyllenhaal plays a sympathetic character, a trained sharpshooter who undergoes what can only be described as an existential crisis during his deployment during Desert Storm. He wanders through fields of charred bodies and otherwise watches idly as the satellite-driven air war sweeps through. Our antihero's sense of obsolescence culminates in a scene where he slouches against his long rifle and breaks into tears because he never got to fire it. The so-called Revolution in Military Affairs—the logic of the sniper rifle run amok—steals

away the last wisp of his warrior virtue. This soft critique earned director Sam Mendes a "no way" when he approached the Pentagon Entertainment Liaison Office for assistance.[9] Despite whatever antiwar ennui the film contained, however, it continued to transform the sniper from one of them into one of us. Here the loss of virtue that came with high-tech distance, a problem that gained prominence in the public negotiations of drone warfare, is cause for pity rather than scorn. Later films like *The Hurt Locker* (2008), which contains a brief scene where a group of American soldiers leans on their resident sniper to fend off enemy snipers attacking from windows on higher ground, pushed the sniper further into good-guy territory. Even amid this transformation, however, Hollywood still occasionally flashed back to the previous character type. Quentin Tarantino's *Inglourious Basterds* (2009), for example, portrays gleeful Nazi moviegoers enjoying a fictional propaganda film entitled *Stolz der Nation*. The "nation's pride" in this case is a German sniper who earns his fame by (almost comically) mowing down hundreds of American and English foot soldiers from a tower very similar to that in *Saving Private Ryan*.

For the sniper to fully assume its new place as a metonym for postindustrial warfare, this means of looking—having made the tenuous journey from evil to deflated to cautiously accepted—would need to be imbued with a new

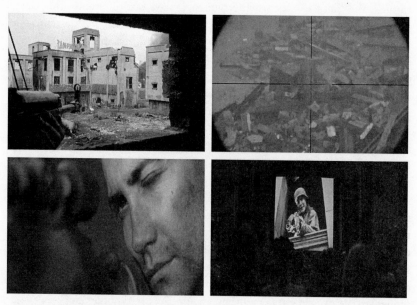

FIGURE 14 The ambivalent history of the sniper in film. Beginning top left, Vietnamese sniper menacing American GIs in *Full Metal Jacket* (1987), German sniper in the tower facing off with American sniper on the ground in *Saving Private Ryan* (1998), Jake Gyllanhaal playing a sniper who never gets to take his shot in *Jarhead* (2005), theatergoing Nazis celebrating their sniper hero in *Inglourious Basterds* (2009).

set of optical pleasures. The general template for doing so can be traced back to a trio of History Channel documentaries that stoked sniper fever early on. These included *Sniper: Inside the Crosshairs* (2009); *Sniper: Deadliest Missions* (2010); and *Sniper: Bulletproof* (2011). Internal documents show that all three of these documentaries were enthusiastically supported by the marine and army Entertainment Liaison Offices, which provided combat footage, shooting locations, and personnel for re-creations.[10] The series offered a predictable set of enticements: tales of improbable shots, close calls, and heroic feats. Above all, the trilogy paved the way for *American Sniper* with its fundamental offer to audiences: the opportunity to exert absolute scopic power over other bodies. As one interviewee breathlessly put it, "When you're looking through that scope and you take a target out, the immediate effect it has on those around them . . . Their whole agenda is now stopped. Now it's my agenda. I own them." The documentaries dramatized this ownership as a parade of experiments in forensic anatomy: blood sprays on the walls, 3-D flights into digital bodies, and the surrogate porn of bullets barreling through water bottles, watermelons, and dummy heads. The fundamental bargain not only rewarded viewer attention with the illusion of possessing another life but also married the weapon with the camera's lens, delivering its fleeting pleasures in a series of discrete quanta that cycled rhythmically through scene, scope, and kill. These excursions naturally aligned with more established image genres, quoting in some cases—consciously or not—the washed-out color palette of the drone camera. Overall, the series was careful to contain what might otherwise be the volatile politics of the hit man in the depoliticized frame of the technician. The series bypassed the question of whether American power was being wielded for noble purposes and instead busied itself with improbable tales of marksmanship.

Sniper vision, thus locked and loaded, would officially take up position in the public imagination in the following three years, its crosshairs sinking deeper into the public retina. Kyle's autobiography arrived in 2012 and flew off the shelves. In the wake of its release, a sudden influx of battlefield sniper videos also raided YouTube. The click frames for these videos were commonly stamped with some version of the rifle scope and thus the implied promise to reveal the morbid scene through the sniper's eye. The videos themselves, usually shot on a cell phone by bored GIs, invariably showed something else: soldiers pointing rifles and binoculars at the horizon and occasionally firing a shot. The dullness of this genre was of course due to the fact that most rifle scopes are not camera-driven. While these battlefield videos could not reveal the sniper vision per se, they did reveal an audience appetite for some kind of dramatic recreation. In the previous two decades, the first-person shooter video game experience had done much to conjure and install this way of seeing in the national psyche. As *American Sniper* took to the theaters, however,

it did more than emblazon the crosshairs across the screen. Sniper vision retrofitted the civic gaze with a powerful new discourse of virtue within the wider scope of the War on Terror. Indeed, the proof that the film had accomplished the long mission of rehabilitating the sniper's image was in the pudding. After its opening, documentary filmmaker Michael Moore issued a tweet that touched off a broad debate about the meaning of heroism: "My uncle killed by sniper in WW2. We were taught snipers were cowards. Will shoot u in the back. Snipers aren't heroes. And invaders r worse."[11] A *Vice* magazine follow-up interview called Moore's punishment for the utterance "swift and loud."[12] Public allegiances had clearly shifted. With help from an Academy Award nomination for Best Picture, *American Sniper* not only breathed new life into the war movie genre; it also elevated the sniper as a signature figure around which American identity—and American ways of seeing—could rally.

Cinema Goes Kinetic

The story of *American Sniper* is in large part a story of the eye: its directionality, its implied owner, the channels through which it sees, the targets in view, and those who remain occluded. At base, the film promises to capitalize on the shooting metaphors already embedded in the camera, thereby thoroughly infusing the cinematic experience with the politics of the weapon.[13] The usual voyeuristic enticements of the theater, according to this logic, morph into opportunities to annihilate those under the cinematic gaze. Indeed, for 133 minutes, the film grants the viewer the pleasures of contemplating mere mortals from an abstract distance before delivering the bolt of final judgment. Here, maximizing the money shot means maximizing the sense that targets cannot look back: they always never saw it coming. *American Sniper* substitutes scenes of warrior bodies, eyes locked in combat, with bodies perfectly excluded from the knowledge that the rifle scope "owns them." Subject to this aesthetic, these bodies either crumple suddenly under the weight of the look or haplessly escape its wrath at the last moment. The film raises the stakes of this power dynamic through its relentless focus on veracity, of delivering on the promise that this is indeed what it is like to inhabit the weaponized gaze. The experience is obviously worlds away from a "live kill" or "snuff film," but one indication that this is the drama's ideal target was the visibility of the living, breathing Chris Kyle whom promoters furiously chauffeured through the talk-show circuit in the pursuit of advance publicity. This real-life reference point cleared a way through the layers of simulation, contrivance, and screencraft and more neatly threaded the viewer's eye into the mechanics of sniper vision. After all, "American sniper" is a slippery signifier that offers multiple points of entry. It could signify a generic soldier, Kyle's on-screen character,

Kyle himself, the weapon, the memoir, the filmic adaptation, or even the casual theater patron stealing a glance through the scope.

The film opens with a scene of an American tank, flanked by soldiers, creeping through a wasted and smoldering Iraqi neighborhood. Rather than the usual lofty establishing shot, everything is already crammed inside telescopic vision: tank tracks mash a dusty street; the side of a Humvee slides past; a mound of rubble wiggles out of focus in the foreground, smudging a background scene of soldiers carefully stepping over rough terrain. Here the frame is constantly in motion, not in the on-the-spot manner of *cinéma vérité* but instead as seen through a long-distance lens held imperfectly still by human hands. The claustrophobia of this succession finally releases with our first view of the scene in its entirety. We find ourselves peering down on Kyle who lies prone with his rifle on a rooftop as he observes the ground troops advancing below him. In this frame, outside the rifle scope, the camera assumes a traditional, mathematical smoothness in its tracked movements and still frames. This aesthetic persists as the scene tightens. Suddenly, we are lying beside Kyle panning with almost erotic thoroughness from the tip of his rifle, past the scope, and finally to his eye, which remains stoically locked on target. After a quick joke with his compatriot who describes Iraq as a "fucking hot box" with "dirt" that "tastes like dog shit"—disparagements reserved for the first spoken lines of the film—we are again thrust back into the wandering telescopic lens as we witness storm troopers kicking down neighborhood doors. The scene cuts back to a still shot of Kyle again staring through his scope before it surprises us with our first glimpse through the crosshairs, the familiar circular frame that swoops over the surface of an apartment complex: clothesline, satellite dish, balcony.

This establishing sequence lays out the basic dynamics of the relationship between camera and weapon scope, audience and military, filmic gaze and sniper vision. The visual rhythms mark time in a dance between "looking at" and "looking through" the weapon. This dialectic finally resolves when the film etches the long-promised crosshairs across the screen. From one direction, the ground scene telescopes closer to meet the viewer's gaze. From the other direction, the film methodically lowers the viewer first into Kyle's body and then into his line of sight. The point at which these two vectors meet is not Kyle—as in the case of a more conventional dynamic of character identification—but rather at the junction of the camera-weapon assemblage. Here the viewer gaze flips from an encounter of the weapon as object to the weapon as subject. The movie camera, which was formerly "about" the sniper-object, assumes the subjective place and function of the scope. This particular trick requires that the camera wedge itself between Kyle's character and the weapon. In doing so, the film demotes the main character to a supporting role. The weapon does not exist in this instance to extend Kyle's agency; rather, he hangs on as a set piece, the weapon's vestige.

Popular press reviews of the film sensed this reversal but struggled to name it. *Washington Post* critic Alyssa Rosenberg summed up her reaction in the title: *"American Sniper's* Missing Element: The Man behind the Gun." Here she lamented that the film, which was billed as a "character study," curiously lacks a main character.[14] This same problem plagued *Newsweek's* Alexander Nazaryan (*"American Sniper* and the Soul of War") when he attempted to describe what makes Kyle's character so compelling. Rather than focus on specific traits, he settled on the notion that the generic quality of the character itself constituted the allure, much like the soldier silhouette one finds in countless military recruitment ads designed to provoke a your-face-here fantasy. This review came closer to the mark when it described the film as "a world reduced to the crosshairs of a scope, all moral quandaries compressed into the question of whether to squeeze the trigger."[15] If *American Sniper* retrieved the "soul of war," in other words, it discovered it not in the soldier but rather in the scope. Indeed, during the most dramatically intense moments of the film, Kyle goes missing in action, rescued only as a medium through which we as sniper-surrogates make our morbid calculations. Eastwood did not so much study the character as surgically excise him so that viewers could roll behind his rifle and assume his line of sight. In this way, the film merged cinema and military apparatuses, making way for a transference of light—the "soul of the gun barrel," recalling Virilio—as it flickered its way through the weapon, camera, screen, and public eye.[16]

The Battlefield Pastoral

American Sniper bookends its first main section with the signature moral quandary of the film, the decision to shoot both a woman and a child as they prepare to throw a grenade at a U.S. ground patrol. The scene unfolds through the scope while flashing images of a finger teasing a trigger. A gun does fire startlingly, but we realize that it is not the sniper rifle. Instead, it is a hunting rifle held by an adolescent Kyle, which marks a flashback to a scene in the woods when he bags his first buck. Surrounded by golden hues, Chris's father congratulates him for his kill, tells him he has a gift, and instructs him in proper rifle care. Thus begins the film's detour through a backstory that details Kyle's early life as a rodeo rider, his decision to enlist, his first deployment, and ultimately the moment when he must make the tough call to kill the Iraqi woman and child. Importantly, the prism through which the film initiates the flashback is the rifle sight, cutting at the precise moment of the gunshot. If the film indeed compresses all moral quandaries into the scope's view, then this flashback is an exercise in decompressing that moral universe. Part of the job is to justify the invasion of Iraq by resurrecting thoroughly debunked implications that it was the hotbed from whence the 9/11 hijackers came. Another part of

the job is to display the transformation of a regular, red-blooded civilian into a killing machine, a journey that cuts the path for the audience to do the same within the safe confines of the theater. Beyond these tasks, the film deploys a powerful set of pastoral metaphors that structure the story of the War on Terror, the role of the military, and ultimately the ideal citizen.

The key scene that firmly establishes the pastoral frame in *American Sniper* occurs within the flashback around the Kyle family dinner table. Here the family patriarch, seemingly unprompted, directs a stern lesson to an adolescent Chris and his younger brother. He explains that humankind is made up of three types of people: sheep, wolves, and sheepdogs. Wolves prey on the sheep, he says. Thankfully, there are some "blessed with the gift of aggression" who step in and protect the sheep. To underscore the rather obvious point that Chris is destined to be a sheepdog, the scene flashes to a playground where Chris steps into a fight and beats a bully's face to a bloody pulp. In one sense, the metaphor is a rather artless device for casting Kyle as protector and the invasion of Iraq as essentially defensive. As we will see, however, the metaphor overcodes *American Sniper* with a particular religious symbology. In doing so, it activates a whole set of political assumptions about human nature, the proper role of authority, and the moral imperative of duty. This dinnertime lesson may be the most explicit invocation of the metaphor, but its structure pervades the film, chaining out into news coverage of the real Chris Kyle as well as the discourse of the War on Terror more generally. Before returning to the film, we will take a moment to explore the pastoral metaphor with help from Michel Foucault. As we do so, it is important to note from the outset that the metaphor and its application in the film are fundamentally rooted in themes of vision, of sight and oversight.

In a late series of lectures at the Collège de France, Foucault describes the prevalence of pastoral imagery in Judeo-Christian mythology. Throughout, the language of shepherds and flocks is used to describe a variety of political relationships, applying not only to God but also to prophets (Christ), kings (David), and other spiritual figures all the way down to "pastor," which derives from the Old French word for shepherd: *pastur*. Foucault views metaphors of this kind, which are notably absent from Greek literature, as a political technology, a mode by which members of the group structure their relationships. The point of departure here is the self-constitution of the Israelites, where the metaphor outlines the relationship between Yahweh-the-shepherd and His nomadic flock. This political metaphor emphasizes not the governing of a territory but instead an "art of governing men," an art characterized not by enslavement but rather a general beneficence.[17] The shepherd rules by neither terror nor personality but rather by managing the livelihood of the flock, leading it to greener fields, and overseeing reproduction.

The widespread use of this particular set of metaphors crested in the Middle Ages, which in Foucault's words comprises the "origin, the point of formation,

of crystallization, the embryonic point" that "marks the threshold of the modern state."[18] Pastoral power, a particular early form of what he calls "governmentality," utilizes a range of strategies to maintain a population of bodies, what he later more formally elaborates as "biopower."[19] Foucault remarks that the West has for the most part exited the period characterized by pastoral power, but he also notes that the metaphor is stubborn. It has not yet been abolished and has even taken on more "meticulous" forms in Protestant Christianity due to its "hierarchically supple" formations.[20] His analysis can thus help us understand the contours of the pastoral metaphor as it is deployed in the contemporary period. For our purposes here, we focus on a moment when these religious metaphors cross into public life and become part of a political style, modes of national self-understanding, not just within the imaginary world of *American Sniper* but also within the broader discourse of the War on Terror. Tracking the pastoral metaphor here reveals ways it inscribes a matrix of identities, alliances, animosities, and collective purposes.

The function of vision is notably central to Foucault's analysis of the pastoral metaphor. In contrast to the more widespread image of the sovereign, the shepherd-god or shepherd-king does not exist as an object of vision or, as Foucault puts it, "in a striking display of strength and superiority."[21] The shepherd instead exists to keep watch, to maintain a vigil over the flock and look out for possible danger. Rather than draw the attention and adoration of subjects, in other words, the sovereign radiates care and attention outward. This observation naturally meshes with Foucault's earlier work on Bentham and the panopticon, particularly as he described it in *Discipline and Punish*. Foucault does not make the link explicitly in the lectures on pastoral power, only invoking the panopticon casually on a couple of occasions.[22] Still, it is worth raising the comparison as both pastoral and panoptic power mark an observational field as an effect. Just as pastoral power functioned as a predecessor to modern governmentality, one can speculate that the principle of observation in the pastoral form was an ancestor of the panopticon. In addition to the panoptic element of internalized surveillance (you are part of an overseen flock), pastoral power adds an active role (you are also a shepherd who oversees) that also drives the process of subjectification.

This element of active observation might seem to grant a certain measure of freedom and agency to the shepherd, but as Foucault notes, it instead aids in the diminution and in fact destruction of the shepherd's personality. Not only is the shepherd's attention directed outward; protection of the flock becomes a singular concern. The shepherd must take on the role of humble accountant who executes a task more out of a sense of burden than honor or self-aggrandizement. Although the shepherd is "in charge" of the sheep who submit, this role is the enactment of submission to the command of another watcher, who acts at the command of yet another, and so forth.

The result, for Foucault, is a matrix of nested submission where a command exists not to accomplish some external goal but rather functions to produce a "field of generalized obedience" as an end in itself.[23] Expression of individual will is anathema to the structure of obedience, which preserves processes of subjectification—that is, accounting for the "merits and faults" of the individual—while at the same time fosters the "destruction of the self," the individual ego, or will.[24]

This is the point where sacrifice enters the picture, although Foucault's account is less than fully developed. In the classical deployment of the pastoral metaphor, the shepherd's attention and sense of self are completely redistributed among the sheep. Foucault suggests that one version of sacrifice—the variety where the Christ-pastor dies for the sins of mankind—is a result of the shepherd's will to die for the sake of his sheep, because he must already be "lost along with his sheep."[25] Another version of sacrifice arises from the imperative to keep the flock absolutely united. In the event that one strays, this may mean abandoning and thus potentially sacrificing the flock in order to locate and recover the stray. In either case, "sacrifice" stands in as an image of the perfect subservience to the pastoral form described above. While Foucault limits the spectrum of violence to the self-directed variety, others influenced by his analysis suggest that the pastoral always harbors outward violence as well. In his review of Hebrew mythology, for example, Christopher Mays identifies King David as an archetypal shepherd who must defend the flock from the threat of lions and bears. The New Testament harbors pastoral violence too, Mayes argues, as it involves judgment: inviting some to partake of the blessings of God while condemning the unholy to be exposed to violence and death.[26] This added element helps fill out the concept of the pastoral metaphor, which is predicated on inward violence (subservience and sacrifice) and outward violence (policing the boundaries of the flock). Both gestures are at work in the civic parable of *American Sniper*, which mediates the scene through the shepherd's visual grammar of submission and oversight.

The Sniper's Pastoral Fields of Vision

Although *American Sniper* draws its pastoral language most sharply in the dinnertime conversation about wolves, sheep, and sheepdogs, this master metaphor cycles throughout, refracted along the way through the politics of vision. In the flashback sequence that anchors the film, for example, the scene cuts directly from the deer-hunting escapade to a church service. Here the Kyle family sits attentively in a pew listening to a sermon on the topic of faith, which in this case is rendered through the language of vision and its limits. The pastor delivers the well-known passage from Corinthians about seeing "through the glass, darkly" in the King James version, which many contemporary Protestant

texts have translated as a mirror. "We don't see with His eyes," says the pastor, "so we don't know the glory of His plan. Our lives unfold before us like puzzling reflections in a mirror. But on the day we rise, we will see with clarity, and understand the mystery of His ways." So begins the process of annealing of the Christian pastoral with the film's politics of sight. Here one's proper field of vision is limited by pastoral obedience and faith, which entails the narrowing of one's own visual field coupled with a constant deferral to a higher power's broader oversight.

Later the film more directly connects this metaphorical mirror to sniper vision. Trapped in a garage during a firefight, Kyle finds that using his rifle sight to look around would expose him to danger. Instead he grabs a broken rearview mirror and uses it to peek around a corner. The scene is chaotic. He "gets a bead on" Mustafa, Kyle's sniper nemesis, aiming from a high window. He turns the mirror to "get eyes on" the Butcher, who is about to take a power drill to a little boy's head. The mirror mediates the entire sequence before Mustafa, peering through his own rifle sight, shoots it out of Kyle's hand. In one sense, this use of a mirror is an action-sequence cliché. In another, however, the mirror enters the visual economy of the film as a metaphorical substitute for sniper vision's dark view through the glass. Overlaid with this image, each shot through Kyle's telephoto lens represents the drama of incomplete sight. The primary message is this: keep your eyes on your job; curtail your curiosity about the world beyond your predefined scope; disown any moral friction you experience. When Kyle contemplates pulling the trigger on a child, or actually does so, signs of discomfort rattle through his usual stoicism. He furrows his brow, shudders, sniffs, and adjusts his cap. The metaphor of the dark mirror resolves this consternation, however, in the blind faith that a shepherd further up the chain of command sees the bigger picture more clearly.

The church sermon scene initiates a parallel image when the young Chris Kyle picks up a small Bible from the pew in front of him. He begins to look through it as if to search for clarity himself. His mother scolds him for taking his eyes off the pastor, and he puts the Bible in his pocket. Much later, in a barrack in Iraq, the Bible reappears. A commanding officer remarks that it better be bulletproof, because he has never seen Kyle open it. Rather than refuting this, Kyle responds with a platitude that captures the pastoral's nested hierarchy: "God, country, family—right?" The unopened Bible here functions not as a tool of exploration but rather as a totem of limited vision, a badge of obedience to be looked at but never looked into. The lesson in both of these images is that proper vision must be localized and contained to the preordained task at hand. Kyle's character is cut with this aesthetic too. He dons wraparound sunglasses, pulls his billed hat low over his eyes, and pops his collar. He thus appears as a horse with blinders, whose world appears through a tunnel that the sniper scope extends. As we rhythmically assume Kyle's gaze

through the weapon, we rehearse the ritual of faith: subservience through self-inflicted limitations of vision.

Kyle sight is thus oriented around a very narrow task, which is to oversee and protect the marines in his charge, a drama where the themes of faith and obedience entail the salvation of others. Kyle assumes not only the position of obedient member of a flock but also that of a shepherd in charge of overseeing his own. Here the rifle does double duty as a shepherd's crook as Kyle struggles to care for the marines who roam below his position on the rooftop. Performing this structure, the action oscillates between the flock's view on the ground and the shepherd's view from above. In one early scene, a ground patrol hears a bullet zip by and strike something soft. An Iraqi body falls from the rooftop and lands on the street in front of them. "That's overwatch," says the patrol leader. "Thank him later." The camera immediately cuts to Kyle's gaze from a high window, from where he once again saves the patrol by shooting a suicide bomber driving an oncoming car. Oversight is indeed the essence of Kyle's job, captured in his catchphrase "You can't shoot what you can't see," which ricochets throughout the film. The final confrontation with Mustafa thrusts Kyle's role as ideal shepherd into the spotlight. Both are on rooftops overlooking ground troops. At more than 2,100 meters away, Kyle cannot see Mustafa through the haze and ripples of heat. Like him, we can only see through this glass, darkly. Regardless, Kyle senses Mustafa's presence out there beyond the range of sight and somehow knows that "he has eyes on our guys." Seized by a mystical moment of intuition rivaling only David's impossible hit on Goliath, Kyle pulls the trigger and successfully takes Mustafa out. The slow-motion scene is rendered as a contest of vision. We cut from Kyle's eyes to the scope and to the release of the bullet, which exits the barrel. Assuming the projectile gaze, the camera follows the round as it glides over the tops of stucco buildings. We zoom in on Mustafa, marking his eye for annihilation, even as he peers through his own scope. The successful strike reveals Kyle as a shepherd who possesses unique powers of vision. It is as if his self-imposed blinders have concentrated his field and thus blessed him with extended range. Or one might say that through an act of blind faith, he *can* shoot what he can't see.

The shepherd's duty of saving others becomes salient through Kyle's guilt for having occasionally failed in the task. In a key scene after he returns home from his fourth and final tour, for example, he visits the VA hospital to help with his flashbacks, frayed nerves, and depression. Here we expect Kyle to open up about the trauma of having to shoot women and children. The scene sets up this expectation as the psychologist mentions to Kyle that the navy had credited him with "over 160 kills" and then asks, "Do you ever think that you might have seen things or done some things over there that you wish you hadn't?" Kyle surprises us with his answer: "I'm willing to meet my creator and answer for every shot that I took." After a pause, he admits to the real source of

his guilt: "The thing that haunts me are all the guys that I couldn't save." The viewer cannot help but recall the scene when a teammate succumbs to one of Mustafa's long-range sniper bullets. This death is grievable not only because the teammate had just mentioned his marriage plans but because he represents a lamb lost to the arch-wolf under the direct watch of the shepherd. Kyle's kill count, which earns him the gratitude of other soldiers and the nickname of "Legend," is thus a source of anxiety instead of relief, because it indicates that he had the capacity to have done more. Insofar as *American Sniper* is a portrait of PTSD—a nearly universal characterization by the film's reviewers—the stress that gradually consumes Kyle is of a very peculiar variety. Ultimately, his "moral injury" is not attributed to having killed but rather to having not killed enough. It is not a result of having seen things but rather of not having seen enough. In short, it is the trauma of forever falling short of the pastoral imperative.

True to this metaphor, the language of evil dominates attempts to describe the forces that threaten Kyle's flock, which appear as metaphysical malevolence rather than predictable responses to historical circumstances. Those who antagonize our hero can never be understood as homegrown militia intent on defending against foreign invaders; their motives instead remain fully inscrutable. In this regard, the film takes a cue from the memoir, whose prologue is entitled "Evil in the Crosshairs" and begins with the representative story of the woman throwing the grenade. The word appears repeatedly: just as virtue bestows Kyle with extraordinary vision, she was "blinded by evil"; Kyle expresses that he "hated the evil that that woman possessed," which was "savage, despicable evil . . . what we were fighting in Iraq."[27] The film projects this looming specter onto the screen. When he returns from shooting the woman and child, Kyle remarks to his bunkmate that the act of giving a grenade to a child to throw at marines was "evil like I'd never seen before." The presence of pure, unfathomable, evil ex nihilo is all around, from child soldiers to ambushing militias to the Butcher, who both tortures his victims with a power drill and keeps a walk-in freezer full of human body parts as a dungeon.

In the discourse of evil, the language of holy war is never far away. As Kyle is being transported by helicopter to his forward operating base at the beginning of his second tour, his commanding officer boasts that he has an intimate knowledge of "every stone thrown since before the first century"—of the Christian era, we presume, when the war between good and evil apparently began in earnest. "These wars," he continues, lumping them all together into one long cosmic battle, "are won and lost in the minds of our enemies," a statement, one might say, that helps cast the mission as a task for the missionary. To drive the point home, the officer unfolds a sheet of paper, a wanted poster circulated by the insurgency with a picture of Kyle's tattoo on it. He asks, "That you?" Kyle identifies the symbol: "That's a crusader cross, yes sir." The officer leans in close as if to stare down subtlety itself: "I want you to put the fear of

God into these savages." Scenes like these invoke the language of the evangelical fundamentalist by painting a Manichean cosmological motif that meshes violence with God's work. Trafficking in these "stylistic tokens," as rhetorical scholar Edwin Black might call them, the film presses its audience into the armor of the holy warrior.[28]

The prevalence of the language of savagery also evokes the logic of the frontier. Indeed, the nature of this evil is territorial, manifesting as an essential property of the world "over there" beyond the barricades of civilization. Transposing the sniper rifle over the hunting rifle early in the film effectively equates Iraq with the wilderness, but here the term *savage* applies to the entirety of the population—from the Butcher, who amputates limbs, to the merchant who sold one of the soldiers a diamond ring for his future fiancé ("Dude, you bought it from savages. How do you know it's not a blood diamond?"). The very ground underfoot also figures prominently in drawing the lines between good and evil. In the opening pages of the book, Kyle describes Iraq is as having the "stench" of a "sewer," which Eastwood's film translates to "dirt" that "tastes like dog shit."[29] In another scene, Kyle's team leader, Mark, says "I just don't believe in what we're doing here," Kyle responds curtly, "Well, there's evil here, and we've seen it." Mark counters by saying, "Yeah, well, there's evil everywhere." Kyle sets him straight by again laying territorial lines, "You want these motherfuckers to come to San Diego or New York? We're protecting more than just this dirt." On a more essential level, the film goes out of its way to characterize the Iraqi "dirt" itself in a kind of negative image of "soil" as it has been traditionally used to drum up nationalism (from WWII-era German appeals to *Blut und Boden* to U.S. discourse of 9/11 as an attack on "American soil"). Here "evil" is rendered as endemic. The presence of violence is not a result of historical forces but rather exists as an essential property of the place and people. Territory thus comes to structure the struggle between good and evil, echoing the common refrain of the War on Terror: we fight them over there so that we don't have to fight them over here.

Within the frame of the frontier, Kyle's pastoral figure naturally appears as frontiersman, a more aggressive but familiar twist on the trope of the shepherd. The film plays up Kyle's persona early in life as a bronco-busting rodeo cowboy, a character consistently and dangerously poised at the edge of the domestic, tame world. When Kyle arrives in country, he refers to it as the "Wild West in the old Middle East." At another point, a fellow soldier says he's proud to see Kyle "back home on the range."[30] The film thus offers up the cowboy as a convenient referent for understanding the soldier-as-shepherd. Although the U.S. incursion into Iraq was imperialistic by any measure, the frontier as it operates in the film is not about expansionism. Rather, it is a defensive vision of a pasture beset on all sides by a lurking savagery. In this way, the territorial metaphors of the American frontier (violently policing an advancing fence

line in a range war) mingle with the more nomadic and population-oriented metaphors of the pastoral (taking care of and saving one's own).

This shepherd must manage evil that not only manifests in the enemy but also in the breakdown of the structure of obedience. When the team leader, Mark, questions "what we are doing here," it is couched in a larger conversation in which he suggests that he perhaps does not have a God. Kyle responds with a mix of concern and aggression ("You gettin' weird on me?") but is ultimately unsuccessful in nipping Mark's heels and straightening him out. Evil has crept into the ranks here appears as a kind of spiritual "straying" that has real consequences. In a later scene, the team works to clear insurgents from within a building. Suddenly bullets rain in through an almost divinely lit window. One hits Mark, who slumps against a wall lit by the shaft of light, his eyes wide open and lifted to the heavens as if having a deathbed epiphany. The next scene is the dark interior of a transport plane filled with flag-draped coffins on their way back to the U.S. Kyle sits alone among them, lost in thought and racked with guilt for not having done more to save Mark. The voice of Mark's mother intrudes as the scene transitions to an outdoor military funeral. She reads one of his letters home wherein he questions the merits of "glory" and asks when it becomes a "wrongful crusade," language that contrasts with the earlier invocation of that term. On the ride home from the funeral, Kyle's wife asks him what he thought of the letter. Kyle responds that even though they walked right into an ambush, "that's not what killed him. That letter did. That letter killed Mark. He let go, and he paid the price for it." Mark strayed in his heart, and extraworldly forces took him out. The metaphor of overwatch thus extends Kyle's imperative to the policing of souls, and sniper vision itself becomes a substitute for the maintenance of obedience and correct thinking in a world where the corrupting influence of evil floats in the ether.

The final scene in Iraq shifts its visual register dramatically from the ground into the sky. A commanding officer, ringed by a dozen screens with aerial maps, orders Kyle and his team on a mission to take out Mustafa once and for all. Here we get the strong sense that Kyle-the-overseer is himself overseen by a higher power. To intensify the changing dynamics of vision, we learn that the team is being sent into a blinding sandstorm to do the job. The next few shots are of a drone aircraft cruising above the city. We look down from its perspective on Kyle, and just as he sets up his rifle on one roof to peer through his sight, the camera cuts to a multiple-screened drone command center with Kyle's rooftop squarely in the black-and-white frame. Marking the equivalence, the drone camera zooms in just as the scene cuts to Kyle whose partner alongside him peers through a set of binoculars. Sniper vision thus seamlessly scales up to drone vision, a shift that transports the viewer through the tunnel of the weaponized gaze and into the eyes of the drone pilot. The cinematic eye repeatedly travels this route as Kyle executes his divinely assisted hit on Mustafa.

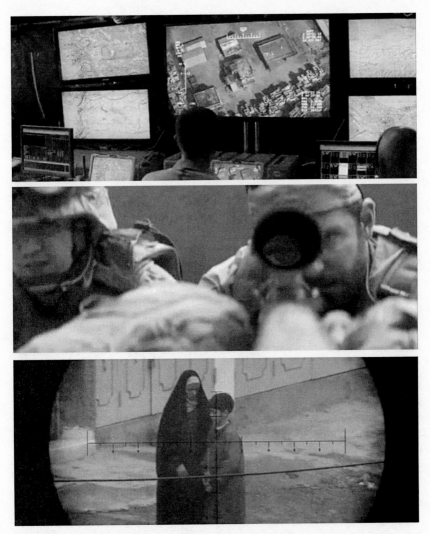

FIGURE 15 Nested layers of oversight in *American Sniper* (2014), from drone camera to rifle scope.

After the deed is done, Kyle learns from the drone command center that throngs of insurgents are heading toward his building. A climactic firefight ensues that distills the dramatic essence of the film and, one might argue, the War on Terror: a last stand of besieged soldiers mowing down waves of barbarians at the gate who swarm and bark nonsensically. In certain tense moments, we see from the enemy's threatening perspective. This view, typically through the chaos of trash or twisted rebar, serves as contrast with the overhead drone whose camera protects "our guys" through a purview of clean digital clarity. As viewers, we cannot help but invest our care and anxiety into the drama of

victimhood and protection. We shuttle between gazes such that when the drone commander warns that "those guys are sitting ducks," we are both operators on oversight and soldiers under siege. Through the drone camera, we see the sandstorm roll over the scene, which plunges the action on the ground into an orange darkness punctuated by a confusion of silhouettes and muzzle flashes. The scene separates heaven from earth, the bright view from above with the blackout on the ground, and true vision from the worldly shadows that appear through a dark glass. The drone, with its eye in the sky, thus steps in as God-the-Father to Kyle's shepherd-Christ, eventually guiding his wounded body out of the storm to be spirited away by escape convoy. This Great Chain of Being, in other words, positions the sniper as a metaphor for a new military paradigm whose axis runs straight up through the drone's camera.

The themes of faith, guilt, salvation, and verticality naturally connect to build an economy of sacrifice. This comes in a variety of forms that serve to underwrite Kyle's position as good shepherd. When a situation forces him to shoot children, who are still rarely killed on screen, the film invests our sympathy in the shooter rather than the child. We focus on Kyle's jostled conscience, a "guilt-ridden assassin" in the mold of the drone pilot who admittedly harbors more assassin than guilt. The overarching pastoral logic rewrites this trauma as a momentary and necessary sacrifice that proves his dedication to the flock can withstand even the most acute forms of mental anguish. He even decides to serve an additional tour in Iraq, all but sacrificing his marriage to pursue the bad guys. The motif would not be complete, however, if Kyle did not put his body on the line. Acting as an analog to Christ, the Legend sets about the task of descending from his eye-in-the-sky position to dwell in the flesh among his flock. He first makes the case to his superior officer to let him come down from the rooftop and join the marines as they do the dangerous work of house-to-house searches. The officer asks directly, "You got some sort of savior complex?" Kyle responds by positioning sacrifice as an extension of his vigil, "I just want to get the bad guys, but if I can't see 'em, I can't shoot 'em." Eventually, after being warned by his partner about the dangers, Kyle slings his rifle over his shoulder and literally takes the stairs down to join the marines who, like a wandering band of disciples, benefit from his teachings on how to stay safe as they kick down doors.

Kyle is never persecuted or tortured, unless one counts the Gethsemane of PTSD problems he experiences stateside, but he does ultimately undergo a public sacrifice. As widely reported in news media at the time, the real Chris Kyle was gunned down by Eddie Ray Routh, a mentally unstable veteran whom Kyle had met on a rifle range. The murder occurred during production of *American Sniper*, forcing Eastwood and company to rewrite the film's ending. The final sequence begins as Kyle bids a loving farewell to his family. As his wife kisses him good-bye, she glimpses the man we presume to be Kyle's

betrayer, some amalgam of Peter and Judas. The music goes discordant and we see her furrowed brow disappear behind the closing door. The next image consists of white words against a black screen: "Chris Kyle was killed that day by a veteran he was trying to help." A languid version of "Taps" plays over an epilogue, which runs real amateur footage of a blinking police motorcade leading the funeral procession past throngs of mourners, many of whom wave American flags from highway shoulders and overpasses. This fades into a slideshow of the real Chris Kyle and footage of his funeral held at Cowboys Stadium in Arlington, Texas. The decision to switch from a based-on-a-true-story mode to documentary at this point gives the moment special significance. The film takes the relatively contained event of Kyle's funeral and raises it a few orders of magnitude to the mass spectacle. Here the pastoral frames of the story combine with a ritual of common witnessing that turns Kyle's murder into Kyle's sacrifice. Even though Eastwood claimed he wanted to avoid doing "a big martyrism scene," the structure of this spectacle cleaves to the roots of the word, which derives from the Greek *martur,* or "witness."[31] This is entirely consistent with the dynamic of sacrifice in the pastoral frame, which is built around the ability to envision one's own self-annihilation in the service of the flock. Kyle appears both as the subjective vessel into which we pour our vision and the object whose mortification we behold from afar.

At Long Range

Much as a soldier might break down and reassemble a rifle, to this point we have attended closely to the film's visual mechanics and interlocking metaphorical parts. Here we take a step back and consider how this film functioned within a culture of militarism more broadly. In doing so, we find that many of its themes are not unique. This final section considers a question that has loomed since the beginning: How does *American Sniper* fit within dominant narratives? Charges that the film constituted "pro-war propaganda" multiplied in the weeks following the film's release, and sometimes it seemed as though the entire debate about *American Sniper* hinged on whether it qualified as such.[32] The film's heavy-handed nationalism, jingoism, and racism clearly had a role in feeding this sense. Actor-comedian Seth Rogen, for example, raised a storm when he tweeted that *American Sniper* resembled the fictional propaganda film *Stolz der Nation*, which plays for enthusiastic Nazis in Quentin Tarantino's *Inglourious Basterds* (2009).[33] Working through the propaganda question provides some context for understanding how the film worked to visually position the citizen in relation to the evolving mythologies of the American soldier and war in the post-9/11 era.

Perhaps the most useful way to begin is by asking what, if any, role the Pentagon's Entertainment Liaison Office (ELO) played in the production of the

film.[34] The ELO had operated under the radar for most of its history, but in the years prior to the release of *American Sniper*, its hand in shaping Hollywood narratives underwent a boost in public visibility. In particular, three films released in 2012 drew scrutiny for their degree of government involvement. The first was *Act of Valor*, which began as a series of recruitment ads that the navy later developed into a widely distributed feature-length film. The unorthodox choice to bill the film explicitly as navy-produced with real SEALs playing themselves lent a modicum of authenticity. Unfortunately for the navy, however, it also triggered the public's propaganda-detection system.[35] The sense that the government had been pushing its own narratives went stratospheric with the release that same year of *Zero Dark Thirty* (2012), Katherine Bigelow's follow-up to her Oscar-winning *The Hurt Locker* (2008). In dramatizing the killing of Osama bin Laden, the film drummed up controversy for its brazen advocacy of torture. Criticism from John McCain and others paved the way for a Freedom of Information Act request, which revealed that the Pentagon and CIA not only had assisted in production but also had been creative partners with Bigelow since the film's conception.[36] The CIA's role in the production of *Argo* (2012), which went on to win an Oscar for Best Picture, added momentum to the narrative.[37] By the release of *American Sniper*, the scent of official propaganda was in the air.

On its face, the military does not appear to have assisted in the production of *American Sniper*, however. The usual credits are absent. The film only acknowledges cooperation with private contractors like 1 Force for military advisors and Army Trucks for various pieces of equipment. Certain peculiarities, however, suggest that there was more to the story. For one, the film contains big-ticket items such as C-130 transport planes and attack helicopters, equipment that would not normally have been available to either of these two private firms. Second, the ELO already had a relationship with Eastwood, joining forces to produce *Flags of Our Fathers* (2006) and *Letters from Iwo Jima* (2006), so it is difficult to imagine that the two did not at least explore the possibility for *American Sniper*. Third, contrary to usual practice, there is no mention anywhere (in ELO press releases, military journals, or popular press) of why the film may have been turned down for assistance—or, at the very least, whether it had been under consideration in the first place. This is unusual for any film featuring a military element but especially one as visible and as embroiled in a "propaganda" controversy as *American Sniper*. The silence provoked journalists to file multiple Freedom of Information Act requests, but none uncovered Pentagon involvement.[38]

Despite the lack of direct evidence of collaboration, *American Sniper* fit well within the thematic frames that the ELO had supported in recent years. Foremost among these was the manner in which the film contained the drama of war in the rescue narrative, which came to dominate the genre through

government-supported films such as *Saving Private Ryan* (1998), *Blackhawk Down* (2001), *Behind Enemy Lines* (2001), *The Hurt Locker* (2008), *Act of Valor* (2012), and *Argo* (2012). Within this narrative frame, the military apparatus exists not as a tool to accomplish some external objective (such as civil defense) but rather to continually save itself. The frame thus works to self-justify its existence and quarantine the military from the political questions. As one critical review of *American Sniper* observed, the sheep that the sheep-dog must protect in the film are not the Iraqi people, nor are they necessarily the American people on the home front. Instead, the main objects of preservation are the endangered U.S. soldiers who just happen to be occupying Iraq.[39] *American Sniper* rather explicitly aligns the "military salvation narrative" with themes of Christian salvation, but religious imagery is not essential. Its basic function is to validate imperial aggression by suggesting that the largest military on the planet, whose budget approaches the rest of the world combined, is the real victim under siege. Rather than the reverse, the preservation of the military justifies the state's existence.

This new narrative frame dramatically transformed the logic of the endangered soldier-body. Traditionally, soldier casualties have triggered public aversion to war and strengthen voices of caution. Under the frame of military salvation, however, the endangered soldier becomes an argument for escalation. Embracing the new narrative has allowed the ELO to migrate away from the hard-sell recruitment-poster films of yore and embrace the authenticity that comes with gory realism. Used in this way, the endangered soldier has become a prime alibi for evading criticism. In the face of charges that *American Sniper* was a piece of jingoistic propaganda, for example, Eastwood repeatedly argued with a straight face that the film was "antiwar" because it showed the struggles of everyday soldiers.[40] One CNN reviewer even touted the film as "the most powerful anti-war film [he] had ever seen."[41] The premise of these statements seizes on the conventional wisdom that the visibility of suffering is automatically "antiwar." The new narrative of military self-rescue, however, repurposes the suffering soldier as an implicit call to arms.

Perhaps the most important quality of this dominant frame is the way it conditions the citizen. By suggesting that the civilian sphere exists to preserve the military, the salvation narrative relocates the citizen to the end of the chain of command to await orders rather than issue them. Here the citizen's aspirational ideal becomes the soldier, what Paul Mann calls the "slave as hero," a position already extracted from the realm of civic deliberation and debate.[42] Having no rightful role in authorizing war, this version of the citizen must silence misgivings and line up behind the mission. The technical question of how one might best preserve the troops on their mission supplants the public question of whether the mission is lawful, right, or wise in the first place. Consider the words of Bradley Cooper, the leading man in *American Sniper*,

who in press conferences argued that the film was "not political" but rather simply "about the horror of what something that a soldier like Chris has to go through."[43] Such claims ignore the fact that depoliticization—that is, shrouding the citizen's role in the authorization of war—is this narrative's precise political effect. Applied in this way, the "war is hell" frame pushes the subject of state violence into a political no man's land where expressions of solidarity with the military apparatus—grief, support, sympathy, and automatic deference to authority—simply outgun the will to question policy effectively.

American Sniper not only retells this narrative but also reinforces its visual grammar. Here the endangered soldier exists as the object of the citizen-subject's watchful gaze, a ritual mediated by Kyle and his weapon, that short-circuits the usual pathways that might lead to participation in the public sphere. Indeed, deliberation is the enemy to the structure of obedience mandated by the gaze, which has already laid out the task ahead and defined its boundaries by the circular cutout of the rifle scope. Sniper vision thus carries forth the aesthetics established by the embedded reporting system that brought the 2003 invasion of Iraq to American screens. Here hundreds of reporters delivered satellite microbroadcasts from their assigned units, which made for exciting television but ultimately served to put the squeeze on the flow of enlightening information. The aesthetic became widely criticized as the *view through the soda straw*, a phrase that captured both the sense of immediacy in the coverage and its self-imposed limits. The story told by embedded journalism was invariably what the troops were doing at the moment, which inevitably crowded out broader questions of why. The arrival of *American Sniper* extended this logic but stamped it with the visual icon of the crosshairs.

The scene in which this citizen-subject acts—specifically the pastoral tableau of wolves, sheep, and sheepdogs—fits into a broader public history as well. As already noted, it is part of the larger frontier myth, which has deep roots in the American imagination. The cowboy figure, a gun-slinging stand-in for the shepherd, has long been a national symbol. The idyllic imagery of the "presidential ranch," claimed by presidents from Teddy Roosevelt to Lyndon Johnson to Ronald Reagan, moved it toward the center of American identity. By the time George W. Bush arrived, the ranch and cowboy hat were practically synonymous with the office. In the months leading up to the Iraq invasion, "cowboy" became a widespread term of derision in much of the world, signifying the American inclination to shoot first and ask questions later—a characterization that the Bush administration embraced.[44] The new visibility of this pastoral imagery comfortably coincided with post-9/11 shifts in public discourse. In contrast to the bipolar contest of the Cold War, the dramatic motif of the War on Terror was defined by a never-ending siege of a "homeland." This spatial metaphor mainly signified the lines between security and danger embedded in the fine lattices of domestic life. "War," observed Michael

Hardt and Antonio Negri, had become "the general matrix for all relations of power," doing away with distinctions between home front and battlefield and making permanent what was formerly a state of exception.[45] Pastoral imagery, as a political technology for the governance of life, naturally fit this motif of everpresent and unending threat. A wolf in sheep's clothing could be anywhere.

Evidence of the salience of this metaphor came in the form of some the most enduring images from the 2004 George W. Bush presidential campaign. In a particular attack ad entitled "Wolves," a narrator tells us how Bush's Democratic challenger, John Kerry, voted against certain military expenditures in the early 1990s. Cuts in the military budget, the ad continues, weaken America's defenses, "and weakness attracts those who are waiting to do America harm." The imagery here consists entirely of a pack of wolves weaving through the woods and finally emerging at the edge of a field. It is likely that the pastoral motif resonated with Bush's evangelical base, but as Hardt and Negri observe, the symbol of the wolf already had broad currency.[46] Indeed, the repeated presidential language of "lone wolf terrorists," "smoking out," and "hunting down" all served to reinforce the pastoral frame. Bush's ad took a cue from a 1984 Reagan campaign spot entitled "Bear in the Woods," which attempted to dramatize the Soviet threat. ("Some say the bear is tame; others say it's vicious and dangerous. Since no one can really be sure who's right, isn't it smart to be as strong as the bear?") In contrast, the 2004 ad took the savagery and viciousness of the wolves for granted. While the drama plays out at the edge of a cleared field, the flock of sheep remain offscreen and abstract, signified only by the term *America*. Here wolves threaten those ordinary citizens channel surfing on the other side of the screen, those who must keep vigilant watch, especially against "cuts" that throw the scent of weakness into the air. Indeed, if *American Sniper* is any indication, the pastoral formula has since established itself as the master narrative in the *longue durée* of the "long war," casting the military apparatus as both the means of seeing and the eye's ultimate object of protection.

6

Resistant Vision

Her eyes say everything.
—artist unrolling a ninety-foot poster
of a child whose family had died in a
drone strike on the ground in northwest
Pakistan

In June of 2007, Reuters news agency learned that U.S. Apache helicopters had killed two of its cameramen in Iraq. The official story was murky. The U.S. military had released a statement to the press, reprinted most places without much reflection, that the two died, along with nine other "insurgents," in a clash with "militias." U.S. troops had come under rocket-propelled grenade and small arms fire, the statement continued, after which attack helicopters were called in for reinforcement.[1] Unsatisfied with this account, Reuters put in a Freedom of Information Act request for the particular cut of helicopter gun footage that featured the cameramen. The Pentagon summarily denied the request. The footage finally surfaced three years later, however, released not by the military but by the Wikileaks organization under the name "Collateral Murder." Appearing as a major glitch in the public's visual matrix, the video depicted the unprovoked strafing of up to eighteen civilians, including two children sitting in a van while the driver stopped to help injured survivors. In many ways, the raw footage of "Collateral Murder" was not dissimilar from the catalog of brutality that could be found at any time circulating through subterranean online channels. What allowed the video break out of the usual container of "war porn" and surface on the mainstream screen was Wikileaks's

choice to visually tag the two Reuters cameramen killed in the attack. This framing device limited the Pentagon's usual latitude for deniability by, at the very least, marking these two victims as civilian journalists linked to Western institutions (although both were Iraqi). This narrative hook pulled the video into the spotlight, creating a newsworthy event by casting the strike as an attack on the news. As a by-product, the video both illuminated the tragedy of civilian life under the boot of trigger-happy occupiers who could be heard in the video begging to shoot and willfully dismissing evidence of civilian life. For those accustomed to the weaponized gaze, this was unfamiliar territory.

Attempts to rhetorically quarantine the footage largely failed, including Secretary of Defense Robert Gates's suggestion that it was a view "through a soda straw," the oft-heard critique of the embedded reporting system.[2] This image bombshell had already sent concussions through the wire, dislodging the eye from the public relations apparatus, and opening up new questions. Soon after the footage began circulating, the U.S. soldier seen rescuing the two children from the destroyed van, Ethan McCord, went public with what the military might call a force multiplier. He detailed the horrors of the scene from the ground, including the cries of the little girl, which he followed to the van. He found her with glass in her eyes and a stomach wound: "It wasn't like a cry of pain really. It was more of a child who was frightened out of her mind."[3] In telling his story, McCord put what some had tried to dismiss as a case of bad apples into perspective: "What happened then was not an isolated incident. Stuff like that happens on a daily basis in Iraq."[4] The video thus contained its own small dose of shock and awe, forcing the public to confront the quality of life under violent occupation. This episode had, in other words, hijacked the usual safe ways of seeing and blown up the soda straw.

This incident gives a glimpse into the possibilities for resisting the prevailing discourse of the weaponized gaze, which otherwise functions to discipline compliant Western subjects to be as automatic as our weapons. Beyond the simple act of revealing "what really happened" that day, "Collateral Murder" used actual gun-camera footage to take aim at the frame of the gun-camera itself. This chapter explores other such strategies for denaturalizing the weaponized gaze, which do not just strive to create new images but also new frames of looking and new bodies to inhabit. If we abide by Althusser's suggestion that the "specular" subject crystalizes within a complex state machinery of optical recognition, then the question is how to adjust the angles of incidence in this house of mirrors.[5] Or if we take McKenzie Wark's updated notion that media "vectors" invoke identities and aggregate communities of watchers, then we might ask the slightly different question of how to create new lines of sight and therefore new geometries of collective being.[6] Luckily this effort has not had to start from scratch. We can look to those who have reverse-engineered ways out of the weaponized gaze by salvaging its parts.

The Wikileaks episode aside, these efforts have engaged the weaponized gaze primarily through the scopic regime of the drone war.[7] There are a few reasons for this, chief among them the fact that the drone became a cultural flash point representing the culmination of longtime trends fusing the gun and camera. Moreover, the drone has proved itself both a novel and thoroughly headline-grabbing technology whose camera-view has taken up permanent residence on the screens of civilian life. This has made drone vision available as a big target for critique by those working in the realms of political art, culture jamming, documentary film, and human rights activism. Finally, as we have seen, drone vision has entailed a peculiar intimacy with the target body, bringing it into view as a resource for challenging the dictates of the weaponized gaze. The following survey of resistant practices divides them roughly into three strategies: exceeding the scope, objectifying the weapon, and inverting the gaze. Beginning with officially sanctioned modes of seeing, we track the excesses of vision, the cracks in the frame that allow for unauthorized shadows to flicker on our perceptual walls. Further down this line of sight, we encounter attempts to render the weapon apparatus visible as an object to be looked at rather than seen through. Finally, we descend to the ground to examine those practices that invert the gaze, humanize the target bodies, and in some preciously rare cases, behold state violence from the perspective of those under aerial occupation. Taken together, these projects stand as vivid examples of what it might look like to transcend the frame of the weaponized gaze and see otherwise.

Exceeding the Scope

The rumblings of resistance always start on familiar territory. We saw in the previous chapter that official representations have elevated the drone pilot to a hot site of discursive investment whose dramatization paradoxically presents the imperial state as the victim of drone violence. These news stories invariably frame the issue from the culturally sanctioned perspective of the pilot, but the actual narrative sometimes exceeds this frame in destabilizing ways, especially when real pilots go off-script. The most visible of these rogue pilots was Brandon Bryant, a longtime drone operator who achieved widespread recognition when he went public with his story in 2013, a heroic act considering the risks. Bryant first told his story in *Der Spiegel*, which blazed a trail for profiles in mainstream venues like *GQ*, the *Guardian*, *Democracy Now*, *Rolling Stone*, *NBC*, and *NPR*. Along the way, other pilots joined in, including Michael Haas, his former colleague, and Heather Linebaugh. Technicians like Cian Westmoreland, Stephen Lewis, and Lisa Ling added their voices later but received less attention because they fell outside the established drama of the pilot.

On the one hand, mainstream discourse went to lengths to contain these critical narratives within the safe, conventional frame of the pilot-victim. *Der Spiegel* established the genre with "Dreams in Infrared: Woes of an American Drone Operator," which continued in *GQ* as "Confessions of a Drone Warrior" and the *Guardian's* "Life as a Drone Operator: 'Ever Step on Ants and Never Give It Another Thought?'" At first glance, it might seem that *Rolling Stone's* "The Untold Casualties of the Drone War" should give voice to those under occupation in its article, but its "untold casualties," in the end, were limited to the pilots. Just in case the reader's mind wandered off track and begins to consider other victims, the article quickly corrected: "Of course, drones have killed many more militants than civilians—and saved the lives of countless American troops."[8] Taken together, the dominant frame was the test of human nature, not the one conducted on drone-occupied populations but rather on the pilot in the Skinner box—or perhaps the Milgram-esque obedience box—of the control room.[9] The *GQ* article, for example, introduced Bryant with the words, "He was an experiment, really," alongside a bird's-eye photo of him looking up as if he were the target. In this frame, Bryant stood as the sacrificial lamb in a world where the biggest threat of the drone is as "an avatar for our technological anxieties."[10]

On the other hand, despite these gestures of containment, cracks in the official scopic regime begin to show in the narratives of drone operators. Bryant, for example, told a story in a variety of venues of watching a man, whose leg had been blown off below the knee by the drone strike, slowly die. He described sitting by helplessly as the infrared camera showed hot blood gushing out into a bright pool, which eventually, like the rest of the man, cooled to the color of the ground. In one sense, the image was neatly contained within weaponized vision and the frame of pilot anguish, described by *NBC News* as "a rare first-person glimpse into what it's like to control the controversial machines that have become central to the U.S. effort to kill terrorists."[11] In another sense, however, Bryant's account commandeered the thrills and anguish of drone vision to exceed its usual limits. "I wish my eyes would rot," he told *Der Spiegel*, a statement that threatened to undermine the enticement to look.[12] Here the horror of something other than an antiseptic war crept into public view as well. In this way, the image extended accounts of other pilots who challenged the claims of precision by invoking the possibility that civilian casualties constituted the norm rather than the occasional mistake. Pilot Heather Linebaugh wrote in the *Guardian* that the video feed provided by a drone is not usually clear enough to detect someone carrying a weapon, even under perfect conditions. In contrast to John Brennan's claim that drones allowed one to surgically cut out the "cancerous tumor" of terrorism "while limiting damage to the tissue around it," Linebaugh attested that drone operators "always wonder if we killed the right people, if we endangered the wrong

people, if we destroyed an innocent civilian's life all because of a bad image or angle."[13] Beyond mistakes borne of limited vision or bad intelligence, rogue pilots like Michael Haas told of the pugnacious attitudes that pervade the kill chain, where the language of "cutting the grass" and "pulling weeds" trivialized death, and children were jokingly referred to as "fun-sized terrorists" and "terrorists in training."[14]

A number of pilots also testified to their institution's capacity for denying its own eyes. Bryant frequently related the story, for example, of watching what looked to be a child wander into the crosshairs just before the missile struck, a ghostly image his superiors were quick to call a dog and expunge from the report.[15] Lisa Ling, a drone technician who worked on intelligence for a Distributed Ground System, testified in front of the European Parliament that the program had largely been "sanitized." Her comments in the *Guardian* harnessed the attention paid to the drone warrior to turn attention to the matter of framing: "The people who are out of the picture are the people who are on the ground within the drone programme, and the victims."[16] Finally, the pilot-technician's intimacy with the screen occasionally challenged abstract machine vision to humanize those under aerial occupation. Bryant spoke of regular people going about their everyday lives, having tea with friends, going to weddings, and playing soccer.[17] In this telling, the ghostly infrared figures of drone vision gave way to individuals, "good daddies" whom he observed with some sense of fraternity as they left to cultivate fields in the morning and came home to hug their families at night.[18]

Objectifying the Weapon

These excesses of vision paved the way for more deliberate projects that sought to wrest the eye from the embrace of drone vision by recasting the weapon as object. Such efforts opened up the weapon's critical availability and nudged it into deliberative space. One of the early advocates for doing so was photographer Trevor Paglen, who made a name for himself photographing "black sites." Using astronomy-grade telephoto lenses, Paglen captured the infrastructure of the extraordinary rendition program, secret prisons, research facilities, and communications installations through ripples of atmospheric interference. He took a special interest in the weaponized drone as emblem of the secret state that sees all but resists the gaze. In this way Paglen's photography worked to defictionalize the drone through a reversal that, as the *New York Times* put it, "turn[ed] military surveillance inside out: here the surveillant is surveilled."[19] Paglen's approach, however, did not so much unveil new information as it performed the very act of looking back. In a *New Yorker* profile of his work entitled "Prying Eyes," he noted that his photos are "useless as evidence, for the most part, but at the same time they're a way of organizing your attention."[20]

For the article, author Jonah Weiner accompanied Paglen on an expedition to Creech Air Force Base outside Las Vegas for some drone-watching, where the story turned again to the performance of contested optics. The drones appeared as specks in the distance before one suddenly drew closer and buzzed the two with its nose pointed down "like the crop duster in *North by Northwest*."[21] Weiner carefully noted that, while Paglen was certainly wary of the drone as "technology for killing," he was interested in it as a "technology for seeing, reconfiguring our sense of vision and distance."[22] Paglen's story thus began with the intrepid photographer out to reveal a secret, but it resolved as a gesture that objectified the drone overhead as a strange absence, an outline, a mirage, or a barely perceptible spot in the sky. His signature image of this endeavor, "Untitled (Reaper Drone) (2010)," appeared on the cover of the May 2011 issue of *Artforum*: a view of a red wispy sunset marked with an ominous dot on the far right edge.

The strategy of objectification was also central to the traditional peace movement. Beginning in 2013, for example, antidrone protesters began to get press for staging demonstrations in cities across the U.S., especially at drone manufacturing sites like the General Atomics facility in San Diego.[23] The visual centerpiece of these "days of action" was a scale model replica of a Predator drone mounted atop a rolling hoist. Nick Mottern, veteran and founder of one of the organizing groups, Know Drones, noted that as simple as they were, the replicas seemed to magnetically draw people into critically engaging the issue. They worked so well, in fact, that he began mass-producing them for dozens of groups across the country, a garage assembly line that he jokingly called the "anti-military-industrial complex."[24] The models attained a privileged place in public demonstrations, but they did more than identify the controversy to onlookers. As they cruised down American streets over churning crowds of chanting protesters, these low-altitude Predators charted a collision course with the usual ways of beholding the weapon. Indeed, Know Drones activists outfitted many of the model drones with off-the-shelf cameras that broadcast an image to a nearby screen so that passersby could witness themselves in the crosshairs. The group also handed out black T-shirts with "Unarmed Civilian" printed on the front in white block letters, a message to a would-be Predator in the sky. Under this imagined occupation, the display invited one to stare not only up the gun barrel but also back through the apertures of state violence. These arrangements forced one to know drones, to actively confront them as critical objects rather than merely absorb them as passive extensions of subjective vision.

Back in the realm of political art, digital artist Joseph Delappe was busy with a series of projects to objectify the weapon, beginning with his version of the low-altitude drone, entitled "Me and My Predator: Personal Drone System" (2014), a wearable headpiece that suspended a small model drone via a

long rod several feet above his head. Doing so displaced the weaponized gaze with a glimpse of, as he put it, "what it might be like to live under droned skies."[25] Another project, "In Drones We Trust," distributed a number of ink stamps for impressing the image of a drone on the backside of U.S. currency, where it appeared above the Lincoln Memorial or White House.[26] In yet another entitled "The Drone Project" (2014), Delappe built a life-sized Predator out of yellow plastic panels such that it had the appearance of a digital 3-D rendering that had been transported from virtual to real space. With his collaborators at Fresno State University, he then inscribed on the body of the drone the names, in both English and Urdu, of 334 Pakistani civilian drone victims that had been collected by the Bureau of Investigative Journalism as part of its "Naming the Dead" program.[27] In this single gesture, the project combined the tasks of materializing the drone as an opaque object and giving presence to its victims.

Delappe's later work in the series, and that which received the most public exposure, was *Killbox*, a serious video game that presented the same playable drone scenario from two different points of view. In the game, player one takes the familiar perspective of the sky-bound drone-cam and prepares to strike player two, who sees the world from the ground while wandering through the neighborhood collecting objects. The game renders avatars and territory as abstractly as possible (people appear as moving spheres), but the flattop stucco houses and the ring of mountains in the background evoke an Afghan

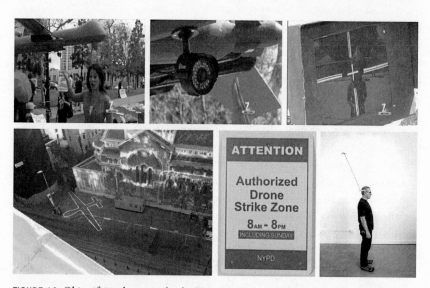

FIGURE 16 Objectifying the eye in the sky. Top row: Know Drones Reaper replica with target camera as seen on NBC San Diego, April 5, 2013. Bottom row: James Bridle's "Under the Shadow of the Drone," one of Essam's street signs, and Joseph Delappe's "Me and My Predator."

village. Revolving around the aerial strike, the action from the sky appears in a sequence of locking on, arming, and releasing the missile over a soundtrack of radio chatter. As the missile homes in, it appears from both the perspective of the distant drone camera as well as the missile's nosecone camera, thus linking the typical experience of drone vision to the smart bomb vision of wars past. For the player on the ground, the explosion comes out of nowhere as an arbitrary and catastrophic disjuncture in the flow of gameplay. Rather than simply going dark, the player on the ground persists like a ghost who haunts the rubble. *Killbox* thus tied together a number of themes, chief among them the impulse of the drone war to go interactive and replicate itself for the consumer shelf. The game affirmed this impulse in its own way but also asked, "Why stop there?" before plunging player two helplessly into the disorienting milieu of the target zone. Its hyper-low-res production values gave *Killbox* sharp conceptual clarity, presenting the action not so much to be repeatedly played as talked about, an experiment in monkey-wrenching the gaze within familiar environment of the interactive game.[28]

In this way, strategies of objectifying the weapon inevitably began to blend with strategies of inversion. Brooklyn street artist Essam pushed this logic a step further. As a former army geospatial analyst, Essam had served more than three years in Iraq over two deployments in the mid-2000s, poring over stacks of aerial surveillance photography. Already tuned into the politics of vision, he went on to train as a photographer at the School of Visual Arts at NYU, which eventually led to a pivotal street art campaign in 2012 that spoke directly to the issues of verticality, vision, and violence. Using professional methods, Essam constructed and posted dozens of very convincing red-and-white street signs, all stamped with the NYPD logo. They contained provocative messages like "Attention: Local Statutes Enforced by Drone," "Drone Activity in Progress," and, most controversially, "Authorized Drone Strike Zone." According to the *Daily News*, the signs, although blending well with the visual banalities of the urban landscape, quickly instigated a flurry of police activity and public buzz that beckoned the average American city dweller to consider the quality of everyday life under the gaze of the weapon.[29] Wishing to go even bigger with the project, Essam initiated a new wave of signage, repurposing more than one hundred of the city's permanent ad kiosks as venues for his own posters. This time the weaponized drone figured squarely into the message. The posters played on the aesthetic of early iPod ads, depicting a silhouette drone in the sky dropping a bomb on a family running for cover. A white line reminiscent of the iconic headphone cord traced the path of the bomb. Beneath the image ran the copy "NYPD Drones: Protection When You Least Expect It." Although the posters were meant to be read as satire, the city did not find them funny. Indeed, Essam had somehow managed to erect them under the NYPD's nose in Times Square during a moment of increased security, the first

anniversary of the Occupy Wall Street protests and days before the U.N. General Assembly was scheduled to meet.[30]

Essam had given an incognito interview to New York's *Animal* magazine, but it was not until a year after this project ran that he agreed to talk in person.[31] He was at the time attending the second annual Drone Summit organized by the NGO Code Pink at Georgetown University Law School in Washington, D.C.[32] Here he joined a lineup of voices ranging from Cornel West, a vocal critic of Obama's drone policy, to Faisal bin Ali Jaber, a Yemeni civil engineer who had recently lost both his brother-in-law and nephew in a strike. Like a sentinel at the front door of the school stood one of the Know Drones model Predators with the word *killer* painted in red on its fuselage and the Eye of Horus on its nose. Essam told of how the police used his *Animal* interview to track him down and arrest him. They came at him with everything they had, charging him, according to the *Daily News*, with fifty-six counts of criminal possession of a forged instrument, grand larceny, possession of stolen property, and criminal possession of a weapon.[33] The last charge stemmed from a search of Essam's apartment, which unearthed what he described as his grandfather's heirloom 1880s revolver "that doesn't even work." The NYPD eventually dropped all charges, but not before he had spent nearly two years contemplating felony jail time, running a "Free Essam" fundraiser for legal fees, and receiving a thorough education in "just how authoritarian the city really is."[34] In the end, as *Gawker* put it in a headline, "NYPD Prove[d] Street Artist Right by Tracking Him Down and Arresting Him."[35] In some ways, the magnitude of the state's response demonstrated the fragility of the usual ways of seeing and the ease with which they can be disrupted. In true Althusserian fashion, Essam's street signs, impersonating none other than the police, hailed a citizen-subject who suddenly appeared on very different territory relative to the apparatus of state violence.

Around this same time, other artists were busy objectifying the weapon and imagining daily life opposite its gaze. In 2013, British artist James Bridle initiated his series "Under the Shadow of the Drone," which emblazoned sidewalks and streets with sprawling outlines of the Reaper drone. Best viewed from a window a few floors up, the outlines invited onlookers into the scene through the familiar portal of the aerial gaze. This vantage point also encouraged them to snap and post photos, thus activating the latent sympathies between the drone and smartphone. The most famous of these outlines unmistakably commented on the politics of distance and territory by appearing directly across the street from the White House.[36] Bridle's simple gesture touched a nerve, garnering attention from the *BBC*, *Vanity Fair*, the *New Yorker*, and others. Recall from chapter 4 that it was Bridle who had initiated the discussion in the *Atlantic* about the image of the "canonical drone," which drew attention to the basic unreality of the weapon in the public imagination. His impulse for

"Under the Shadow," as he described it, was to make the wraithlike drone visible and rescue it from the washed-out realms of official stock imagery.

Indeed, the weaponized drone held a special place in Bridle's work and the broader New Aesthetic artistic movement he helped found. Emerging from the South by Southwest music and tech conference in Austin, Texas, in 2012, the New Aesthetic sought to, as its panel title suggested, "see like digital devices" and otherwise come to terms with the "eruption of the digital into the physical world."[37] For Bridle and others, the figure of the drone stood as a master metonym for digital vision and the vast hidden networks that govern everyday life. Although media coverage of "Under the Shadow" happily used the sweeping pronouncements of the New Aesthetic to divert the discussion to "our technological anxieties," Bridle's intervention into public space still managed to break out of drone vision's usual enclosure of the Western subject.[38] Or, as Vice magazine put it, the project arose from a "desire to create that tangible, touchable, physical presence for these otherwise ghostly aircrafts."[39] Not only did "Under the Shadow" recast the drone as an object to be looked at rather than seen through; it also inverted the weaponized gaze in the same way that Essam's "Drone Strike Zone" prompted the subject to glance up. Under these shadows, which in Bridle's project resembled the chalk outlines of a fresh crime scene, the drone's conspicuous absence takes on a certain object-presence. In the process, this particular image suspends its ideal witness in an implied target zone, somewhere between the weapon's facsimile underfoot and the reimagined skies above.

The invitation to look up at the weapon-object in Delappe's Killbox, Essam's signage and Bridle's shadows resembles those of Omer Fast's celebrated short feature art film, 5000 Feet Is the Best (2011), an early experimental mash of scripted drone pilot interviews, documentary interviews with real pilots, reenactments, and flyover footage. The reception of this film often categorized it as an attempt to grapple with the dreamlike quality of drone warfare by blurring the lines between documentary and fictive storytelling. The Independent, for example, called it "Groundhog Day with bodies" and wondered whether the drone makes it impossible to "trust our eyes."[40] Interpretations like these clearly portrayed the film as a story about what drone vision has done to us rather than what it has done to those who must endure its constant threat overhead. Indeed, in some ways, the film goes to lengths to excise those actually target bodies from the frame. This includes cleaving to the dominant cultural story of the thrills and anxieties of the drone pilot. In place of life in the target zone, the film substitutes aerial shots of Las Vegas, whose proximity to the control rooms of Creech Air Force Base commonly appears as a trope in mainstream drone discourse to accent the perils of simulation and the pilot's spiral of self-destruction.

In other ways, however, 5000 Feet manages to smuggle in alternative ways of seeing. Its signature image is a drone's-eye view of a little girl riding a bicycle

over a sprawling expanse of gravel, what immediately reads as a target zone in the Middle East to eyes trained by the weapon's gaze. As we follow the girl, however, we see that she is headed for the edge of a Las Vegas subdivision, where familiar first-world Spanish colonial houses, patches of emerald-green grass, and sapphire-blue backyard pools emerge incongruously from the desert. The simple reversal of "one of them" to "one of us" yields its own small challenge to the logics of drone vision. Another longer vignette plays on a similar theme as it tells the story of a family that winds up accidental victim to a drone strike while on vacation. The viewer hears the narrator's tale of what might be an Afghani or Iraq family, who, while driving into the mountains, encounters a group of men burying an IED in the road. As the family passes, a drone missile whistles down and kills them all. The film overlays this narration, however, with images of a typical American suburban family in a VW station wagon. The men digging in the road, too, wear hunting camo and baseball caps. The film does not simply substitute. By juxtaposing an audio narrative clearly about an Afghani-Pakistani scene ("Are they shepherds? There are no goats anywhere, no sheep." One is younger, "almost a teenager. He wears a traditional headdress.") with images of a thoroughly American scene, the film provides a rare portal for identifying with those on the ground, even if they are not strictly visible. As viewers, we are the hapless family, and even though we are wary of the shady characters burying a bomb in the road, we glimpse the mundane terror of life under the weapon's eye.

Inverting the Gaze

The examples so far have worked to trouble the usual ways of seeing the drone, rendering it an object to behold or imagine. To the extent that this objectification bids one to "look up," it urges consideration of life under aerial occupation. For the most part, however, the ground in these examples is still domestic space, which limits the potential of these resistant gestures. Recall from chapter 5 that in dominant discourse, if the gaze must step outside the drone camera, it often snaps into the mode of envisioning oneself as a target, a largely hypothetical scenario played out on domestic territory that diverts the eye away from those actually suffering. In these projects, victims do take on a degree of presence—the names written on the drone's body in "The Drone Project," the appearance of stucco houses in *Killbox*, and the narrator's reference to shepherds and headdresses in *5000 Feet Is the Best*—but these are in large part abstract indications. The interventions in this final set fully invert the gaze as they make their way down the weapon's flight path to the territory under the gun and the people who actually live there.

Some of these projects invoked the form of the memorial. In 2012, Josh Begley, an NYU graduate student and internet artist previously known for his

aerial photography exhibits mapping the U.S. prison system,[41] developed an iPhone app that alerted users to the time and location of drone strikes. Using data from the Bureau of Investigative Journalism, "Drones+" signaled a new strike with a chime and pinned it to a Google map. Perhaps the story really began, however, when Begley attempted to register Drones+ on the App Store. To his surprise, Apple rejected it as "not useful or entertaining enough." After the second and third rejections, Apple claimed that the app violated its prohibition against "excessively objectionable or crude content."[42] This was a curious explanation given that the app featured only Google maps and strike location data that had been available for some time through the *Guardian* website and other news aggregators. Both *Wired* magazine and *MSNBC* contacted Apple for an explanation, but the company declined to comment.[43] Undeterred, Begley took the information and began a Twitter feed called "Dronestream" that tweeted information regarding each U.S. drone strike since 2002. Due to the advance publicity, the feed quickly attracted more than twenty thousand followers. Around the same time, James Bridle, who had garnered attention through his "Under the Shadow of the Drone" project, brought the image closer with an Instagram account he called "Dronestagram." Using the same BIJ database, Bridle broadcasted close-up aerial images of buildings that had been struck by drones as the information became available. Before releasing the image, he also applied a color wash filter to directly evoke the drone's-eye view. This project, too, quickly amassed thousands of followers as well as attention from *Wired*, the *Guardian*, *RT*, and a host of other outlets.

The popular reception of these projects focused on the simple theme of exposure. The *Atlantic* speculated that Dronestagram was compelling because it corrected the drone war's general invisibility.[44] The *Guardian* followed suit, elaborating on Bridle's language that Dronestagram is an attempt to make the strikes "a little bit more visible, a little closer. A little more real."[45] Visibility was, of course, an important component to these projects, but a closer look begs them to be read in terms of how they position the viewing subject within a field of existing media practices. As *Wired* magazine noted, the connection between the smartphone and the drone was already well established by the time Drones+ went up for review.[46] Several other iPhone apps were already on the market including drone strike video games, software for flying actual toy drones, and apps that allowed one to augment the reality of the drone's camera to fire pretend weapons. Indeed, war in the post-9/11 era has been reorganized around a cluster of new metaphors and communications technologies that wire civilian life to the war zone. Cell phones and information networks have conditioned our concepts of terrorist cells and insurgent networks. Dronestream and Dronestagram thus tinkered with the tools that made the drone war legible. Their disruptive potential arose from their ability to harness the usual trappings of drone vision—the virtual cockpit, identification with

the weapon, and the depoliticized, out-of-time, soda-straw view of affairs on the ground—while adding a persistent accounting for the dead into the mix. With its reams of specifics, the information gathered by the Bureau of Investigative Journalism already acted as a critique of the "fire-and-forget" ethos of the weapon. (The U.S. Air Force tacitly acknowledged the power of this critique when, only a few months after the release of these apps, it withdrew all public data of its drone strikes in Afghanistan.[47]) As Begley put it, Drones+ was about provoking real-time "drone consciousness" while providing a glimpse from the receiving end of state violence. Even if the app itself never achieved distribution, it took potent form as a concept in media coverage that denaturalized drone vision by injecting the usual ways of seeing with a sense of place, rhythm, accumulation, and permanence. Here the landscape sprawled open as a memorial site in progress, transforming drone vision along the way from an exercise in surveilling the target to surveilling the aggression itself.

Others headed directly into the occupied zone in an effort to jam drone vision with the signs of human presence. Supported by the international human rights group Reprieve, a 2014 effort by a collective of Pakistani, American, and French artists printed a ninety-foot poster of a young girl who had lost two siblings and both parents to a 2010 drone raid. The group then unrolled the poster on a farm plot in the Khyber Pukhtunkhwa, a region adjacent to the Federally Administered Tribal Areas (FATA) heavily patrolled by drones. To publicize the project, they launched a small consumer drone into the sky to take a picture of the poster. The image, a simulation of the view from the Predator cockpit, quickly circulated through mainstream and social media.[48] The project, which the group called NotABugSplat, billed itself as a kind of reverse strike: "a giant art installation [that] targets Predator drone operators."[49] Beyond this premise, however, the real significance of the project could be found in the way it addressed those publics already used to seeing through the eyes of the drone operator. In the poster, the child clutches an object, perhaps a keepsake or a fragment from her previous life. She stares straight up, smoothed of resentment yet projecting an unstated question. "Her eyes say everything" to be sure, but they also shoot back confrontationally. In their proximity to the poster, the villagers become part of the confrontational motif, standing their ground by registering their plea to be recognized as lives that matter.

The project also recaptioned the usual ways of seeing. Terms like *bugsplat* (military slang describing the moment of the kill from the remote operator's point of view), *splash* (the explosion), and *squirter* (survivors of the initial strike who must be hunted down) had already migrated into the common Western lexicon as the drone pilot became a point of identification. Of these, *bugsplat* in particular gained cultural currency as a mode of describing death dealt from the air. The term dates back to 2003 when the U.S. Department of Defense designed a piece of software named "Bugsplat" for predicting civilian

casualties that might come from bombing raids during the Iraq invasion.[50] Thereafter, targeting technology gradually pushed the target body into view, a development that has necessitated such dehumanizing language for carrying out the task of killing. NotABugSplat capitalized on the fact that this cusp term, even as it invoked the familiar weapon's-eye view, still provoked moral revulsion. Of course, what made the project so immediately powerful was its simple gesture of rehumanization, its collapse of distance, and its ability to put a face and a story to these typically abstracted bodies. From the air, the villagers indeed looked "about the size of bugs" on the road, and on the ground, the poster looked "like a bunch of pixels."[51] The exchange of "our" vision for "theirs" thus constituted the very plot of NotABugSplat and its inversion of the gaze.

Some of the most powerful and sustained attempts to invert the logics of the weaponized gaze came in a wave of documentary films around the same time. These included Robert Greenwald's *Unmanned* (2013), Tonje Hessen Schei's *Drone* (2014), and Sonia Kennebeck's *National Bird* (2015). Each of these documentaries expertly sliced through the screens of drone vision to give a sense of life on the ground looking up. In so doing, the films added momentum to existing trends. Working with occupied populations, NGOs like the U.K.'s Reprieve and the Pakistani-based Foundation for Fundamental Rights

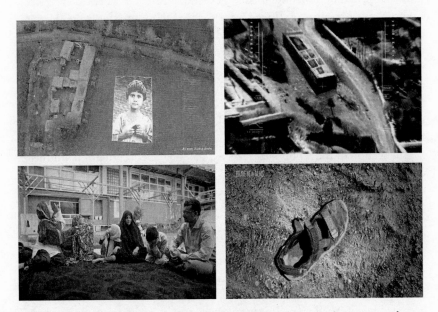

FIGURE 17 Inversions. Top row: The NotABugSplat poster of drone strike survivor and posters on rooftops in the documentary *Drone* (2014). Bottom row: Drone victim family reacts to helicopter flyover in *National Bird* (2016), and another family recounts finding grandmother's sandal after a strike in *Unmanned* (2013).

had seen some success in legal actions taken on behalf of drone victims. As mentioned previously, former drone pilots had begun telling stories in the U.S. that pushed the narrative beyond the official envelope. Finally, in 2012, researchers working at Stanford Law School and NYU School of Law released an explosive report entitled "Living Under Drones: Death, Injury, and Trauma to Civilians from US Drone Practices in Pakistan." The report documented findings collected over a nine-month period from visits near the FATA region of Waziristan and more than 130 interviews. While the report weighed in on the debate over civilians killed, it focused more on what life is like for the approximately eight hundred thousand people who for years have lived under the daily threat of strikes. The report made a significant media splash and persisted thereafter as a reference point that challenged the official narrative and, indeed, the official perspective.

Understanding the themes raised in "Living Under Drones" is key to understanding the wave of critical drone documentaries that began arriving in 2013. The report announced its politics of verticality with not only its title but also its cover image. The photograph came from within the home of Faheem Qureshi, a fourteen-year-old survivor of Obama's first drone strike authorization as president on January 23, 2009. Here the camera tilts up past shrapnel-pocked cement walls and into the hazy daylight sky through a gaping hole in the roof opened by a Hellfire missile. A section of the report entitled "Voices from Below: Accounts of Three Drone Strikes" tells Qureshi's story. He had been in a separate room of the house with the women and children when the missile struck. The blast killed upwards of eleven civilians as well as three other unidentified "militants" in pursuit of one named individual, the prominent and otherwise capturable town elder, Mohammad Khalil. We learn that the young Qureshi narrowly escaped the blast with a fractured skull, facial burns, shrapnel in his stomach and chest, the loss of one eye, and the loss of hearing in one ear.

The section of the report that received the most media attention, however, attended to the effects of aerial occupation on the Waziristani social fabric and collective mental health. Here the authors describe a population terrorized by the round-the-clock aerial occupation. It is a nightmarish scene where responders, humanitarian workers, and family members avoid attack areas for fear of "double-taps" or follow-up strikes that kill those who show up to help. Instead, family members must endure the cries of those trapped in the rubble for hours, and they cannot access the dead for burial. Interviewees also describe a persistent environment of extreme anxiety, a "hell on earth" where the buzz of drones overhead haunts the living. This is especially true at night, when drones commonly strike.[52] This quality has earned the drones the nickname of *bangana,* or "buzzing wasps" in Pashtu, the terror of which some observers compare that felt by Londoners under bombardment by its predecessor, the Nazi V-1.5[53] As one

interviewee puts it: "Before the drone attacks, it was as if everyone was young. After the drone attacks, it is as if everyone is ill."[54] From children to the elderly, symptoms of PTSD run rampant: sleeplessness, fainting, loss of appetite, mental breakdowns, and stress-related physical ailments. The occupation has also torn apart familial and social bonds. People are afraid to leave their houses and gather in groups. Children and young people have stopped going to school. Whole communities have stopped attending funeral services and weddings. People have stopped inviting guests over because they believe this will increase the likelihood of a strike on a house. Community trust has broken down due to runaway suspicion regarding who might be working for the CIA or trying to settle a personal feud by marking a house with a tracking "chip." Village elders hesitate to meet in public to conduct the traditional dispute resolution *jirga*. This was especially the case following the March 17, 2011, strike on a large *jirga* in North Waziristan, attended by thirty-five government-appointed officials sitting in two big circles in an open-air bus depot in the town of Datta Khel. The strike, which involved at least two missiles, killed forty-two and injured another fourteen.[55] The report notes that the violence has taken a devastating financial toll as well. Families must endure the loss of wage earners, and medical expenses for survivors in the form of surgeries and prosthetics often overwhelm meager incomes.

In certain ways, "Living Under Drones" is a storytelling exercise in giving presence to communities under an occupation rendered invisible by dominant ways of seeing. It is not surprising, then, that the researchers took the natural next step and crafted a short documentary entitled *Living Under Drones* (2012), which features firsthand narratives of Waziristanis. Before getting to the actual stories on the ground, the film presents us with our typical modes of envisioning the drone war: the reels of strike footage, the stock footage of take-offs and landings, and various officials celebrating the weapon's supposed precision. The researchers then abruptly invert the gaze as they begin telling the stories of suffering. Images of destruction flood the screen, especially of the kind exiled from the Western public frame: scenes of funerals, disabled survivors, injured children, and grieving families. Insofar as it directly challenges the aesthetics of drone vision, the short film stages a visual insurgency. It is thus entirely appropriate that it opens with an image of a home video camera raised like a rifle in a clenched fist, the logo of Robert Greenwald's Brave New Films nonprofit foundation that eventually stepped in as the film's distributor.

The later release of Greenwald's feature documentary, *Unmanned: America's Drone Wars* (2013), appeared as a more mainstream extension of the *Living Under Drones* project. *Unmanned* follows the work of human rights groups as they attempt to make the suffering visible, both legally and socially. The film draws its narrative through two people. The first is Tariq Aziz, a sixteen-year-old boy whom we first encounter attending a public hearing on

drone violence; three days later, a drone strike kills him and his younger cousin as they drive to meet his aunt at a wedding. The second is the story of schoolteacher Rafiq ur Rehman, who tells of a strike that killed his elderly mother and wounded eight more family members, including two children. Like all of the documentaries discussed here, *Unmanned* begins its journey into this world through the familiar frame of the pilot's eyes. In this case, the eyes belong to Brandon Bryant, who in an interview tells of his enlistment, initial trust, and eventual disillusionment. At a crucial point, Bryant begins describing the details he could see on a typical day from eight thousand feet, including kids playing soccer. The words become voice-over for a visual sequence that effects a deconstructive descent through the various layers of drone vision: from sky to ground, from digital overlay to high-resolution realism, from gray tones to earth tones, from computer blips to voices of kids at school recess. The sequence resolves with a close-up of a soccer ball, a segue to the story of Tariq Aziz, who was an avid player. After an hour visiting the horror and suffering on the ground, this motif of the soccer game returns at the end of the film. Through it, Greenwald intercuts Bryant's dashed hopes of "doing good" with the hopes of survivors who plead for the strikes to stop. The effect is to put both ends of this destructive equation into conversation, to humanize a visual frame that has, at least in mainstream culture, been thoroughly "unmanned."

Other documentaries played even more with the politics of drone vision by integrating its fractured aesthetics into the viewer's witnessing experience. The cover art of Hessen Schei's *Drone* (2014) features a stylized image of a child aiming a slingshot—invoking David and Goliath—at a drone in the hazy sky. As a portal into unofficial ways of looking, *Drone* too begins with Western eyes that float above the clouds, search the drone operator workstation, and peer through the crosshairs. All the while, we hear the voice of Brandon Bryant as he discusses the images that replay in his head from his "point and click" days as an "ultimate voyeur." In an abrupt inversion, this view then transitions to the perspective of a shaky home video camera tracking a Predator drone buzzing in the sky far overhead. The image introduces thirteen-year-old Zubair ur Rehman, who talks about the strike on his family and the ambient terror the drones' twenty-four-hour presence has brought to his community. "It's only when it's cloudy that we don't hear the drones," he says as the camera peers out over a hazy mountain range. Later the film documents Rehman's trip to Washington, D.C., where he delivers his memorable testimony in front of a congressional committee: "I no longer love blue skies. In fact, I now prefer grey skies. The drones do not fly when the skies are grey." At the time, these words managed to momentarily pierce the veil of drone vision that had shrouded the mainstream media landscape, prompting everyone within range to look up through the terrorized eyes of everyday civilians under occupation.[56] The

film, keenly conscious of the politics of vision, extends the moment with other jarring juxtapositions. Familiar drone-cam footage like "UAV Kills 6 Heavily Armed Criminals," for example, plays alongside kids having a game of cricket in the yard, pictures of bodies, the twisted remains of a missile found in the rubble, and home video of the panic after a strike.

These juxtapositions come to a head with a story of a photographer who documents those killed and injured by drones, especially children. If they survive the strike, he tells us, they scream for their parents. In taking the perspective of those who live behind the crosshairs, the photographer stands in for alternative ways of framing the drone war. It is fitting that the film's final sequence follows his effort to use his photos, in a contest of vision, to stave off more aerial attacks. With the help of Reprieve, he prints large posters of child victims and spreads them on the roofs of houses in clear view of the drone operators. (The effort would be the inspiration for NotABugSplat a few months later.) In the final image of the film, director Hassen Shei re-creates the aerial view of these posters, a searing challenge to weaponized Western eye.

The most prominent of the three documentaries, *National Bird* (2016), produced with help from documentary stalwarts Wim Wenders and Errol Morris, takes the most conventional approach by containing its story within the perspective of three prominent drone war whistleblowers. These include two signals intelligence analysts identified as Daniel and Lisa, as well as pilot Heather Linebaugh, all of whom tell stories of personal hardship, government harassment, and general misinformation emanating from Western centers of power. Beyond this frame, the film also takes a brief detour through the Middle East in an arresting sequence. Lisa, who has spent a career poring over aerial imagery, has committed to making the trip to meet "some of the families who have been affected by drone warfare." One family agrees to talk and travels three days to meet with the documentary crew. The film has used flyover shots of American cityscapes where the interviewees to this point reside, but here the aerial view cuts midflight to the stucco walls and flat-topped buildings of an Afghani neighborhood as if to compress both ends of the world into the same territory.

As we transition to a story of the particular drone attack that anchors the film, our perspective descends into a neighborhood yard where we sit on a ground cloth with members of an extended family. A woman talks about how much she loved her daughter and husband, both killed, and a boy holds up a prosthetic leg. As the family begins to recount the events leading up the devastating strike, the sound of a military helicopter paddling thunderously across the sky above them suddenly interrupts. Everyone tilts up in terror, including the camera. For a few beats, we dwell on the expression of dread in the face of the grandmother as her eyes follow the helicopter over the horizon. The image of looking up foreshadows the details to come, when we learn that

on February 20, 2010, the family lost twenty-three of its members, including many children, as U.S. drones and helicopters attacked their travel convoy. The attack became notorious in the region and, in a rare acknowledgment, prompted General Stanley McChrystal to issue an apology on Afghani television. Later, in 2011, the event gained exposure in the West when the *Los Angeles Times* obtained the drone operator transcript from the strike through a Freedom of Information Act request. In the transcript, the operators show clear excitement about hitting the "sweet target," express skepticism of any suggestion that children might be present, and willfully interpret indeterminate objects as weapons.[57] The filmmakers put the transcript to use by weaving a reenactment of the strike as seen through the drone camera, complete with pilot voice-overs and heartrending interviews with the family members. The effect is a powerfully distilled challenge to the logics of drone vision, undercutting its naked strategies of digital distance at every step with images of survivors, a bustling amputee hospital, McChrystal's wooden apologies, and horrifying home video footage of the wailing family transporting the victims' remains home in the back of a pickup truck.

What makes these final examples so potent and rare is their ability to fully upend the hierarchies of vision. If official discourses seek to embed the civic gaze in the military apparatus, these resistant efforts seek instead to push the viewer through the screen and further down the projectile's line of flight, persisting beyond the point of detonation to hear stories, attend to the wounded, bury the bodies, gather evidence on the ground, and ultimately confront the eye in the sky. Getting here requires penetrating through the many layers of the weaponized gaze. These artists, activists, and filmmakers, keenly attuned to fact that such inversions require a careful mimesis, deliberately insinuate the resistant gesture into the weapon's visual vectors. It is no mistake that nearly every one of these strategies begins with the story of the pilot before winding its flight path to stories on the ground. And it is no mistake that the mise-en-scène buries itself in the weapon's targeting camera as it traces this trajectory. This suggests that the strategies for unbinding the weaponized gaze are bound up within its own logics. Here the voyeuristic kick that fuses the civic eye to the military gaze becomes the momentum that propels this same eye beyond its official confines. The story harnesses the weapon's recoil at one end of the transaction to provoke moral recoil at the other.

7

Afterword

Bodies Inhabited and Disavowed

> The cyborg soldier exercises on the fields
> of denial.
> —Avital Ronell

Among the many definitions of "war," one might characterize it as the struggle to draw a line between bodies that matter and those that do not. As ultimate signifiers, bodies are targets of relentless rhetorical pressures to fix them in place as either subjects or objects of the military apparatus, those who either pull the virtual trigger or disappear behind the crosshairs. As we have seen, these rhetorical pressures enlist the gaze in addition to language, deploying strategies of visual discipline along a broad spectrum ranging from official propaganda to entertainment media. From smart bomb to satellite to drone, the practices of peering through the prism of the gun-camera we have examined so far have been characterized by distance. In this postscript, we get up close and personal by turning toward the body itself and its way of concentrating the dynamics and instabilities of weaponized vision. This reflection proceeds in three sections. The first attempts to account for the dead—or rather the ways we have willfully failed to do so. This effort uses the Iraq War as a point of focus and begins with a simple question: What are the numbers, and in what ways have they been rendered unimaginable—or as Stephen Graham

puts it, "violently censored"?[1] The next section examines, by way of contrast, the presence of the Western soldier-body. Here we track the frame of the soldier helmetcam, a refined form of the weaponized gaze, as it has appeared on the public screen. This virtual, surrogate relationship with the soldier-body is the subject of the final section, which meditates on the weaponized gaze as homologous to the figure of the dream.

Manufacturing Deniability

We begin with a simple inquiry regarding the appearance of bodily suffering. The Iraq War, which began in 2003 under what virtually everyone now acknowledges to be false pretenses, has officially come and gone, but the question still torments the screen: To what extent does a picture of this country's destruction remain? One place to start to address this question is with a study released in 2008 by the British research firm OBR that attempted to count the civilian dead. The firm, which regularly polled for the BBC and other clients, revealed that it had conducted door-to-door interviews with 2,414 persons across Iraq. The data showed that about 20 percent of households had experienced at least one death as a result of the conflict. Of these, 80 percent were directly due to coalition forces. Using these numbers, the study concluded that 1.03 million Iraqis had been killed in the conflict between 2003 and 2007.[2] This number put the Iraq toll somewhere between the Rwandan genocide (800,000) and the Khmer Rouge democide in Cambodia (1.7 million), something approaching the death rate of the U.S. occupation of Indochina (ultimately 2–4 million). The researchers noted that this figure might be on the conservative side given the fact that they were not granted permission to extend the sample into the two most dangerous Iraqi provinces, Kerbala and Anbar.

What would it take for Western publics to apprehend the full significance of one million Iraqi dead? We might try to understand this number with a familiar reference point such as September 11, 2001, the series of attacks that killed nearly 3,000 Americans, sent the nation into a spiral of shock, and was effectively used to authorize the invasions of both Iraq and Afghanistan in the first place. Those bodies continued to matter more than a decade later. In 2016, the nation marked the fifteenth anniversary. It was an emotional moment. Both Hillary Clinton and Donald Trump, front-running presidential nominees for the two major parties, attended ceremonies at the World Trade Center Memorial site to honor those who died that day. President Obama laid a wreath at the Pentagon. Defense Secretary Ash Carter spoke and promised that attackers, wherever they are in the world, will surely "come to feel the righteous fist of American might." Others gathered at the memorial where American Airlines Flight 93 crashed into a Pennsylvania field. Names

were read, loved ones mourned, citizens honored.[3] After fifteen years, the attacks were nothing if not present—both *here* and *now*—a fixture on a screen that continually reminds us to remember. By comparison, we could ask how salient the Iraqi civilian death toll has been in the eyes of the U.S. public. After all, this number works out to three hundred 9/11s, the equivalent of more than one per week for five years straight. And, as the Bush administration repeated, these were the same civilians the U.S. military hoped to save from a murderous dictator. An AP/Ipsos poll taken in early 2007, however, told the real story of how these bodies registered in the U.S. scale of concern. The poll found that while Americans could accurately estimate the number of U.S. troops killed in Iraq, they gave a median estimate of Iraqi civilian deaths of just 9,890.[4]

The full story of attempts to count the dead reveals even more about the politics of invisibility. Neither the U.S. nor U.K. governments showed any interest in the endeavor, and both seemed positively averse to numbers in any form. U.S. commanding general Tommy Franks made this clear early on when he declared, "We don't do body counts," and British officials followed suit with their own proclamations.[5] Moreover, those who tried to count were stopped in their tracks. In the first months of the invasion, the Iraqi health ministry kept a log of the bodies streaming into the Baghdad morgue, which at the time was inside of the U.S.-controlled Green Zone. Coalition command, however, quickly ordered the health ministry to cease publication of what it considered inflammatory numbers. The Bush administration even fired its own appointee to the post of interim Iraqi health minister, veteran health expert Frederick Burkle, for daring to request that the agency keep records. "No one was maintaining health records or death records, and I couldn't get the support to fill the gap," he told the press.[6] The director of the Baghdad morgue—faced with the accelerating pace of the grim work, pleas from Iraqi families to tell the truth about their loved ones, and pressure from occupied forces to keep silent about these numbers—eventually fled the country.[7]

The numbers vacuum eventually prompted third parties to step in and conduct their own studies. Among them was Iraq Body Count. Founded by Oxford psychologist John Sloboda, IBC used an extraordinarily conservative method that required at least two independent media accounts to register a death. By the end of 2005, it had confirmed 47,000 civilian deaths in this manner, and by the end of 2007, this figure had risen to 95,000.[8] This number probably said more about the scant level of journalistic scrutiny given to the issue than it said about the death toll itself. Other studies that used more standard epidemiological survey methods put the numbers much higher. In 2004, Britain's top medical journal, the *Lancet*, published one such survey by the Center for Refugee and Disaster Response at Johns Hopkins University's school of public health. Conducted in only the first months of the conflict from mid-2003 to the beginning of 2004, the door-to-door survey found 100,000 civilian deaths

had occurred above the normal background death rate. The researchers noted that they had omitted from this figure the city of Fallujah, the "city of temples" leveled by occupying forces, since it had an unusually high civilian casualty rate. Had Fallujah been included, the figure would have risen to approximately 198,000.[9] The appearance of the *Lancet* numbers pressured the Bush administration to give its own estimate in 2005, which put the figure at 30,000. How the administration arrived at such a number, it did not say.[10] The pressure rose again when the *Lancet* researchers repeated their study in 2006 and found conflict-related deaths in 2.5 percent of the population, which registered at around 600,000.[11] The Bush and Blair administrations dismissed the *Lancet* numbers out of hand, even though a leak later revealed that the chief scientific advisor to Britain's Ministry of Defence had warned British officials not to criticize what he regarded as a "robust study design" conducted at "close to best practice."[12] To counter this bad press, the Iraqi Ministry of Health, still under U.S. command, attempted to do a body count with the assistance of the World Health Organization. This health ministry/WHO study instead estimated the civilian death toll in the first three years of occupation to be 151,000.[13]

The range among these purported death tolls is unsettling by itself, an indicator that civilian casualties had been leading an immaterial and invisible existence in the West. At the low end stood the Bush administration's only estimate of 30,000 offered in 2005. By 2007, when interest in counting intensified, the numbers ranged from 90,000 (Iraq Body Count) to 151,000 (WHO/Health Ministry) to 600,000 (*Lancet*) to 1.03 million (OBR)—a range of a factor of ten. Of course, weighing these numbers was a complex task involving judgments of methodology, credibility, interests, and relative independence. Project Censored attempted to break down the body count issue, what they considered the number one top censored story of 2009. To do so, it used the military's own mission statistics to get a sense of what might seem reasonable. The U.S. military had been averaging about one thousand door-kicking patrols into "hostile neighborhoods" per day (a figure that increased to five thousand in 2007 with the "surge"). The Brookings Institution noted that this number of patrols resulted in about three thousand firefights per month or a staggering average of one hundred per day.[14] If these firefights resulted in an average of just one fatality each, it would put the death toll at 180,000 between 2003 and 2007. The average per firefight was likely much higher, however, which would boost the total death toll several orders of magnitude. Such a number would not include the combined effects of other standard military maneuvers including air strikes, roadblocks, armed convoys, and so on. In light of the intensity of occupation, one could easily conclude that the scale of the occupation comports with the death counts posited by the *Lancet* or OBR.

This, of course, only figures the number of dead until 2007. Officially, the occupation lasted four more years through the famous "surge" until 2011 when

the Obama administration withdrew most of the U.S. troops. And it did not end then either. As coalition forces withdrew, the U.S.-supported Iraqi military took up the baton. In 2014, moreover, U.S. troops returned to fight the Islamic State of the Levant (ISIL). During this period, the death toll continued to mount. Data from Iraq Body Count, the only organization still keeping track by this point, showed that from 2007 levels, the number of those killed proportionally rose 30 percent by 2011 and doubled by 2016.[15] To fully grasp the extent of the devastation, too, we must also consider not just the dead but the nearly four million Iraqis displaced by 2007 according to the U.N. High Commission for Refugees (UNHCR).[16] (Of these, incidentally, only five hundred were allowed sanctuary in the U.S.[17]) The refugee problem continued apace with the violence. To take only one example, in 2016, the UNHCR estimated that the impending U.S. siege of ISIL-held Mosul would produce an additional one million refugees. In 2016, as the two major presidential candidates debated about who would be tougher on ISIL, the aid organization prepared for what it called, even in the midst of an ongoing Syrian refugee crisis, a "massive displacement on a scale not seen globally in many years." A year later, in the face of the ensuing catastrophe, one journalist noted, "Now that stark warning has turned out to be cruelly accurate."[18]

Helmetcam Vision

It is indeed difficult to overestimate the suffering caused directly by the occupation, not to mention its lasting, indirect effects. It is even more difficult to square the picture painted by the numbers with that painted by dominant news, film, and other media representations. The signatures of this war instead remain the reality show of the embedded reporting system, the antics of George W. Bush dressed in a flight suit declaring "Mission Accomplished" aboard an aircraft carrier, jingoistic films like *American Sniper*, and lingering images of strikes recorded via drone or gunship camera. These and other dominant images show a marked tendency to displace other perspectives and filter the conflict through the eyes of the military apparatus itself—a perspective, again, that explicitly regards the visibility of the dead as a problem.

As one of the more prominent of these practices, the embedded reporting system surged toward the complete merger of public gaze and military machine early in the war. A political cartoon by Australian Peter Nicholson in 2004 attempted to capture this merger. In it, a phalanx of embedded reporters, dressed in army green and holding enormous cannon-like broadcast cameras on their shoulders, converge on a lone insurgent in the rubble of Fallujah, who points back a tiny, handheld camcorder. A reporter shouts, "Throw down your camera and come out with your hands up. We have got you covered." The word *covered*, of course, marks the point at which the camera and gun

functionally converge. The image illustrates Judith Butler's contention, in her own discussion of embedded reporting, that the image is defined by not only *what* it shows "but also how it shows what it shows. The 'how' not only organizes the image, but works to organize our perception and thinking as well. If state power attempts to regulate a perspective that reporters and cameramen are there to confirm, then the action of perspective in and as the frame is part of the interpretation of the war compelled by the state."[19] In other words, embedded reporting not only embeds the reporter but also embeds the image with the militarized reporter's perspective. The significance of this implicit contract between the gun and the camera resides both in what appears in the frame and in the frame's relation to the military aperture.

The end logic of the embedded reporter's gaze can be found in the figure of the soldier helmetcam, the terrestrial equivalent to the gun-camera's usual eye in the sky. The helmetcam is a complex amalgam of practices that have developed out of its original application in collecting human intelligence (HUMINT) and establishing situational awareness. This view has shown a tendency to go public, however, where it eventually arrived as a component of military public relations, in fictional renderings, and as unofficial video postings on social media. In its public form, the preponderance of helmetcam vision marked the transition out of the embedded reporting system, already a martial enclosure of journalism, to a way of seeing through the martial eye itself, a new view perhaps best represented by the subsequent rise of the Pentagon's DVIDS program for the production and distribution of its own "news." A defining moment came in April of 2003 when the military released the famous helmetcam footage of army private first class Jessica Lynch's rescue from an Iraqi hospital. At the time, mainstream news organizations went wall-to-wall with the Pentagon's story, which was so popular that NBC turned it into a made-for-TV drama entitled *Saving Jessica Lynch*. Later, facts emerged—even from Lynch herself—that the Pentagon's video news release had been highly choreographed and even fabricated.[20] The episode revealed not only the type of war story the Pentagon preferred to push, which replayed the captivity narrative of *Saving Private Ryan* (1998), but also its preferred aesthetics, which refracted the civic gaze through the night vision of the heroic, hospital-raiding soldier.[21]

As the occupation wore on and the embedding system waned, documentary films picked up the task of representing the war. Among them was a new genre of quasi-official, first-person films shot by soldiers, perhaps exemplified best by *The War Tapes* (2006). Director Deborah Scranton, originally asked by the Pentagon to be an embedded reporter, instead requested to "cut out the middleman" and give handheld cameras to soldiers themselves. For this as well as her later film, *Bad Voodoo's War* (2008), she fashioned herself as what she called a "virtual embed" who communicated with her soldier

cams via twenty-four-hour digital video uplink. Without setting foot on the battlefield herself, Scranton nevertheless guided the soldiers as they produced the eight hundred hours of footage that were ultimately cut into the fifty-six-minute final narrative. Films of this ilk could be called "drone documentaries," according to Christina M. Smith, insofar as they introduced the aesthetics of the drone's operation into the media production of war on the ground. Scranton appeared to be self-conscious of this aesthetic. The title sequence introduces the film with a scene of soldiers on base watching a popular reel of black-and-white Apache helicopter strike footage. In her choice to have soldiers mount their cameras on Humvee dash boards and gun turrets, too, we can also observe the easy slippage from news camera to weapon-camera. And like weapon-camera footage, these and other drone-docs, including *Combat Diary* (2006) and *This Is War* (2007), pitch themselves as authentic and unmediated conduits. Scranton was quick to point out in press appearances that this was footage shot by the troops "through their eyes" and thus by implication the very opposite of propaganda.[22] The facts on the ground were more complicated, however. Virtually every documentary venture of this kind conducted its business under advance military permission, production oversight, and final approval.[23] This way of seeing, like the embedded reporting system, had to adhere to official narratives if it was to gain access to all that supposed authenticity in the first place.

If there was a dominant ethos embedded in helmetcam vision, it was the tendency toward the absolute depoliticization of state violence. This was a tendency, too, of the earlier wave of more traditional embedded-director documentaries that Pat Aufderheide calls "grunt films," which include *Gunner Palace* (2004), *Off to War* (2004), and *Operation: Dreamland* (2005). These films found a narrative homeostasis such that they "do not directly address most American publics as voters" but rather as casual viewers and war buffs: "There is no public policy issue about the legitimacy or purpose of the war on the table in these films, because the soldiers can't tell you whether we should be there. As soldiers, they have to fight under orders."[24] The camera's position, which narrowed the frame of conflict to the individual or "band of brothers," also conditioned the drama. Even a film like *This Is War*, which did not require prior military approval due to the fact that it was composed of found footage, still adhered to the conventions of the personalized form and yellow-ribbon culture.[25] This is perhaps the true meaning of the helmetcam, which depoliticizes its reception by embedding the audience gaze at the end of the chain of command. Here a new aesthetic of embodiment that Kevin McSorley calls "somatic war" displaces political considerations with a drama of comradery and personal survival. This was evident in a similar wave of soldier-shot BBC serial documentaries set during the occupation of Afghanistan, one of which was aptly titled *Our War* (2011–12). Billing itself as "unmediated" with

vignettes like "My First Kill," the film portrays a conflict where "any particular geopolitical context largely disappears" and where the violence of occupation manifests as "essentially a defensive and inevitable act."[26]

This depoliticization has shifted the role of the target body in the portrayal of state violence. At least since Desert Storm, critical war scholars have regarded body horror as anathema to official goals. The "iron rule" for gaining public approval for military action, many supposed, demanded the absolute erasure of the body and the production of a screen scrubbed of all reference to suffering and death.[27] Writing about the Persian Gulf War, for instance, Margot Norris notes that while there was plenty of cherry-picked gun-camera footage, its defining feature was the disappearance of the body into the screen's simulacrum of deathlessness. While she argues that an honest war would broadcast the gun-camera in full, she surmises that this will never happen so long as the clean war remains a useful trope.[28] As we have seen in the case of the smart bomb and satellite, Norris's assumptions have for the most part held true. This iron rule seemed to lose explanatory strength, however, as the viral world of social media began to displace mainstream journalism. In the mid-2000s, Sue Tait observed the circulation of videos captured by soldiers—known as "trophy videos" or "war porn"—as they flowed through stateside sites like Ogrish.com (later renamed LiveLeak.com) and NowThatsFuckedUp.com. Tait noted that this exposure of body horror did not automatically turn its viewers into antiwar activists. Instead these sites managed to contain the political potential of the images by framing them in personal terms: the experience of revulsion, the loss of innocence, or the right to know.[29]

When the frame of the soldier helmetcam came online, it worked in a similar way by containing volatile images of bodily suffering within the perspective of the vulnerable soldier-body. Here the politically charged war shrank to a personal drama, a frame within which violence could appear without provoking too much ideological turbulence. Indeed, the eyes of the ground soldier became one of the few windows through which the average citizen was allowed to witness body horror. Precisely because it identified the viewer with the soldier's trauma in first person, for example, the helmetcammed *War Tapes* could afford to contain scenes of brutalized Iraqi bodies. These included twisted, dismembered, and charred corpses as well as normally taboo close-ups of destroyed enemy faces. A new formula thus entered the picture to augment the clean war thesis of yesteryear. The visibility of death appeared in direct proportion to the viewer's identification with the endangered soldier-body. The weaponized gaze presented the body along a spectrum. At one end, we encounter the smart bomb's mathematical hygiene, which stood as a measure of the soldier-technician's absolute immunity. Further down the spectrum, the soft body horror of a drone strike balanced itself against the vulnerability of the pilot's

psyche. At the far end, the relative gruesomeness of helmetcam vision came into view via the ground soldier's direct exposure to danger, which managed to frame, digest, and legitimate the brutality of the scene. "It's hard to look at," the soldiers say in one form or another in *The War Tapes*, "but it was either him or me." The helmetcam's airtight alibi perhaps accounted for the distinct uptick in its prevalence—from the shaky frames of the drone doc to the green haze of night vision goggles on the news—as it migrated to prime time.

On mainstream social media channels like YouTube, too, helmetcam video extended the mission of presenting a martial perspective. Perhaps the best example of the genre was a video posted on YouTube in the fall of 2012 by army private first class Ted Daniels, which eventually racked up some thirty million views. Watching the video, we take on his perspective during a hillside firefight in Afghanistan and suffer along with him as he incurs four bullet wounds. At first, Daniels posted the video anonymously through a central channel called "Funker530—Veteran Community and Combat Footage," which hosted a number of other helmetcam videos with hit-counts in the millions. After his video drew attention, Daniels decided to reveal himself and do press interviews. For its part, the army took no action against him, thereby granting the video de facto official status.[30] Indeed, not only did the helmetcam show that it was a politically safe channel for presenting the messy politics of war; some considered it an ideal public relations conduit. In 2014, the Israeli Defense Forces launched what Rebecca L. Stein calls the "GoPro Occupation," which involved distributing strap-on cameras to troops and establishing a "visual operations room"—much like the DVIDS system in the U.S.—where footage friendly to the official narrative could be quickly winnowed and released to news organizations.[31] The effort was a direct response to human rights groups like B'Tselem, which had been using home video cameras to document military abuses in the occupied territories since 2007. The IDF's dissemination of helmetcam vision helped counter the resistance narrative of "illegal occupier" with a colonial narrative of Israel as a "nation under fire" using the first-person soldier body as ideal medium.

Beyond its unmatched ability to impel allegiance, the structure of official helmetcam vision subordinated the viewer to eyes further up the chain of command. For example, while the military's release of helmetcam footage from the Jessica Lynch public relations stunt transported the viewer into the boots of the soldier, the subsequent made-for-TV drama *Saving Jessica Lynch* (2003) went the extra step to suggest that this soldier was subject to real-time remote control. In the Pentagon-supported film, military brass watch on their monitors, cheer, and issue orders from the moment the helmetcammed squad leaps from the helicopter to the moment they airlift Private Lynch out of danger. The Obama administration depicted the May 2, 2011, raid that killed Osama bin Laden in a similar fashion. Upon announcing the news, the White House

released the now famous photo of the presidential cabinet crammed in a small room looking up and focusing on what many assumed were video monitors. Obama's chief advisor John Brennan seemed to confirm this assumption later when he announced, "We were able to monitor the situation in real time and were able to have regular updates and to ensure that we had real-time visibility into the progress of the operation."[32]

The idea that a general or president might direct a ground force from afar through a composite helmetcam feed was a fiction, however. As the *Guardian* pointed out, Brennan's depiction was inconsistent with other administration statements that suggested the cabinet received updates every few minutes, often with long stretches of silence.[33] The technology for delivering such a view of the urban battlespace was only a fiction as well. In military weapons research, the dream began at least as far back as the 1990s with the arrival of the notion of "netwar."[34] The intention was to create a ground-based patrol fitted with sensors, GPS systems, cameras, and computers so that each soldier would be a node in a mobile, self-aware network under the command-and-control gaze of higher leadership. The platform went by many names but for most of its development was known as "Land Warrior" and more recently "Nett Warrior." The system never got off the ground, however. Perennially plagued by issues of technical feasibility and cost, it eventually earned a reputation as a boondoggle, the F-35 of ground warfare.[35]

Regardless, the dream of remote-controlling squad of foot soldiers was salient enough that it could be conjured as a reality. The Jessica Lynch episode had established its mechanics in the public imagination, which cleared the way for Brennan's insinuation. When the opportunity arrived for the Pentagon to sponsor a movie version of the bin Laden assassination, it wasted no time in restaging the formula. *Zero Dark Thirty* (2012) linked the helmetcam feed directly to the screens of the war room, where it appeared to the mission commander right alongside the view through the drone camera. In addition to dropping the viewer's eye into the ground soldier's, the film matriculated the gaze into an extended hierarchy of vision and control, a layered experience where the eye beheld itself rhythmically responding to orders. These sounded very similar to General Schwarzkopf's command, still echoing from an earlier made-for-TV spectacle, to "keep your eyes on the crosshairs." Whereas Schwarzkopf neatly loaded the otherwise deliberative citizen into the chamber, helmetcam vision snapped its heels to the "Attention!" of a spectral drill sergeant.

The Not-So-Lucid Dream

The figure of the helmetcam, whether real or fanciful, represented only one facet of the weaponized gaze, but it in some ways stood as the prototype and master metaphor. The process of translating the gaze, from body to body,

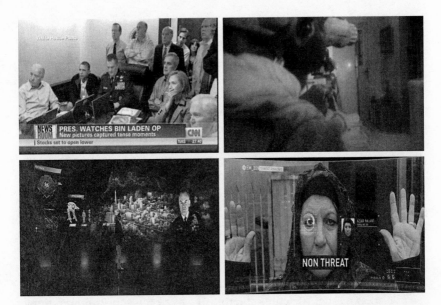

FIGURE 18 From war rooms to helmetcams. Top row: The iconic "Situation Room" photo taken during Bin Laden raid (by Pete Souza, courtesy of Official White House Flickr feed) and helmet-cam still from Pentagon-supported *Zero Dark Thirty* (2012). Bottom row: A critical treatment of the weaponized eye in the opening sequence of *RoboCop* (2014), with news-room-as-war-room on the left and its fusion with the weaponized drone camera on the right.

found its simplest operation here. This is why the development of the now dominant genre of first-person shooter game arrived without a conceptual hitch as it evolved out of film to television to digital media.[36] In addition to simple substitution, this translation involved some sleight of hand. Helmet-cam vision promised to transport us into the heart of darkness, that authentic place where the real meaning of war lives, through an immediacy that transcended interpretation. This view did not tell the real story of the soldier, however, as much as it emptied the soldier-body of significance so that it could be repurposed as an avatar, a vessel for the habitué of virtual war. In the same moment, the helmetcam also refigured the body of the occupied, whom this gaze rescripted as the true aggressor insofar as it immediately threatened the subject-body. At some point in this journey to find the essence of war, the gaze passed imperceptibly through the looking glass of critical reflection into an alternate world that contracted and reformed along the tunnel vision of the weapon. At either end of this dark passageway, subject and object identities went liquid and flowed into preset molds.

In helmetcam vision, therefore, we come close to glimpsing the soul of the weaponized gaze, which is the figure of the induced dream. Like the first-person shooter, this figure installs an uncanny set of hands in front of us and

fills the periphery with a body that jerks in more or less predictable directions. While the helmetcam might be its base of operations, the language of the dream runs the historical length of the weaponized gaze and the invitation to cycle compulsively through its pattern of sense-memories. After the Persian Gulf War, media critic Robert Stam described the view from the smart bomb as a form of "primary identification," which drew from psychoanalytic film theory and its instinct to approach the screen as a kind of formalized dream.[37] In 2014, *Vice* magazine's *Motherboard* curated a collection of nosecone camera reels under the title "These POV Smart Bomb Videos Are Surreal." Here the author, using a word coined by Andre Breton in his Freud-heavy manifestos of the 1920s, perhaps unintentionally summons the figure of the dream: what hovers above (*sur*) the real. "You can hear faint hissing as you experience the visceral reality of being a descending bomb," the author writes, acknowledging the uncanny mix of embodiment and estrangement. This dream of weaponized sight, although an "anxious historical artifact from the nineties," has a facility for transference. Their kind, he notes, have "inundated the popular consciousness of late," assuming the role of silent protagonist in everything from *Call of Duty* to the drama of drone warfare on the nightly news.[38]

Cleaving to the defining characteristic of the dream, such ways of seeing efface their own memory. Those on the other side of the targeting screen evaporate into abstraction and invisibility. When the bomb strikes, too, the screen goes blank. What persists is only the fact of repetition, a flickering frame, and the residual sense of having looked. This metaphor resonates intuitively in the age of postindustrial war. In his 2016 *Lo and Behold*, a film about the "connected age" and virtual reality, documentarian Werner Herzog asks a series of tech pioneers to respond to a supposedly famous quip from the versatile Clausewitz that "sometimes war dreams of itself."[39] While there is no evidence that Clausewitz said this—much less famously—the fact that the interviewees take this notion and run signals something important. Military action reverberates distantly in the dusky hues of the screen, tasting terror yet cheating death, exacting violence yet disowning suffering. The dream governs the smart bomb as its camera dives, the scope as the sniper holds his breath, the satellite as it glides through the stratosphere, and the drone as it hovers over its infrared prey.

The key to truly understanding this estranged subjectivity may lie, appropriately enough, in science fiction. We find one of the more trenchant critiques in an unlikely place: the 2014 reboot of *RoboCop*, which begins with a thinly veiled allegory for the drone war and the evolution of weaponized vision. The opening sequence features a Bill O'Reilly-style editorial show called "The Novak Element," where pundit Pat Novak (Samuel L. Jackson) paces around a high-tech stage, not unlike a war room, and waxes enthusiastic about robot weapons that have been used to successfully "pacify" Tehran with minimal loss

of soldier life. The sequence pulls out all the stops in dramatizing the weaponized gaze, which spirits between journalistic cameras and targeting systems. We begin as viewers of Novak's show, occasionally glancing over the shoulders of its producers who scan through various aerial images on advanced control panels as if themselves searching for targets. Novak then begins to talk about the zone in question, Tehran. The big screen behind him, which to this point has featured a dark map of Earth laced with spidery information networks, gives way to a slowly rotating 3-D satellite rendering of the city. A general from the Pentagon appears live beside it. Novak swipes the satellite image on the screen to reveal various colored indicators. "Could you walk us through what we are seeing here?" he asks the general, who explains the location of insurgents, ground-based drones, and Novak's own embedded camera crew. The show then cuts to the view through the embedded reporting crew's camera on the ground, which follows a "standard op" of autonomous ground drones sweeping a neighborhood and scanning its residents. "Enjoy the show," says the crew's military minder. Embodiment plays a central role here as the embeds are literally fitted with bracelets that mark their safety as high-priority for the drones. They are not so different from their minder, a soldier who wears a powered exoskeleton, which in turn is not dissimilar to the humanoid robots he commands. From Novak's god's-eye view through the first-person aesthetic of the reporter on the ground, the show's vision then leaps into the eyes of the robots themselves, which scan the city population with X-rays, crosshairs, and other digital overlays.

Embedded in these channels every step of the way, the sequence consolidates an entire spectrum of weaponized vision, which serves as a tacit critique in its absurd, dystopian intensity. A more direct critique arrives in the middle of the sequence as the cinematic camera steps out of the visual confines of Novak's show and wanders into one of the houses under patrol. Here we identify with a terrified Iranian family discussing (in Farsi, no less) what to do about the occupational forces. The father joins a suicide squad to attack the robots. The family's teenage son decides, against the will of his distraught mother, to charge one of the robots with a kitchen knife. The robot brutally guns him down as she watches from the window. As the situation escalates, we are suddenly back in the embedded reporter's lens and then back in the studio with Novak where he informs us that the Pentagon has cut the feed for "security reasons." The film thus sends the moviegoer on a journey that calmly shepherds the eye through the familiar forms, beginning with the hyperdigital dreamland of the studio, through the embed camera, and into targeting apparatus. Rather than stopping there, however, the momentum carries us further to land, startled and terrified, in the target bodies themselves. In doing so, the effect is not unlike waking from a chemically induced sleep with Novak hovering above us like a panicked anesthesiologist.

Another masterful sci-fi treatment, an episode in the 2016 season of the techno-dystopian television series *Black Mirror*, took the themes and turned them up to eleven. "Men against Fire" follows a group of soldiers in the not-too-distant future as they hunt what they call "roaches," grotesque Nosferatu-like humanoids who squat in abandoned buildings and terrorize the countryside. Later we find out that the roaches are in fact regular people who only appear subhuman to the soldiers. The government, which has designated part of the population to be exterminated as part of a eugenics pogrom, has fitted the unknowing soldiers with neural implants to augment their perception. For the soldiers, this turns the act of hunting and killing from an unbearable task to an exhilarating adventure. The drama unfolds as one soldier, "Stripe," experiences a malfunction in his implant such that the humanity of his victims begins to dawn on him.

This baseline theme is an old one: humans must be trained to kill. The episode in fact takes its name from a famous post-WWII study by combat historian S. L. A. Marshall entitled *Men against Fire: The Problem of Battle Command*. At the time, Marshall made the startling claim that no more than a quarter of combat troops fired their weapons in battle, even under direct threat, because of their innate hesitation to kill another human being.[40] In the 1990s, military historian and "killologist" Dave Grossman revisited the subject in *On Killing*. The book revealed that by the Vietnam War, the military had implemented certain conditioning techniques that had successfully increased the "firing rate" to more than 90%.[41] *On Killing* became a bestseller after its publishers reissued it in 2009, presumably for two reasons. First, the issue of soldier trauma—under the old designation of PTSD and the less corporeal newcomer of "moral injury"—had returned in force. Second, American society was at the time entering into protracted discussion about the morality of remote-controlled warfare. By the time it arrived, the *Black Mirror* episode had fully digested this killological thesis, all but quoting Grossman when a military psychologist explains in detail the necessity of the neural implant as "the ultimate weapon."

On one level, the episode plays out a techno-allegory for the military's ongoing process of fine-tuning the soldier's impulses. "It's a lot easier to pull the trigger," the psychologist says, "when you're aiming at the bogeyman." On another level, however, the figure of the soldier is only a medium through which the story critiques our emerging civilian ways of seeing. Throughout, the viewer encounters one eerily familiar weaponized perspective after another. The camera consciously mimics the frame of the helmetcam as it lopes along with the squad. The augmented-reality perspective of the soldier's vision further defines the aesthetic, appearing as an extreme vision of what Lev Manovich calls the progressive "automation of sight" in Western techno-culture.[42] Intel blips across the field of view, green-gridded aerial 3-D

maps appear suspended in space, and high-tech rifle sights gather information that appears on heads-up displays in real time. One particularly salient scene links this automaticity to the drone, which hovers overhead as soldiers plan a raid on a farmhouse. Rather than look at a screen, the soldiers patch their vision directly into the drone camera, which temporarily blinds them to immediate surroundings, a state signified by their cloudy-white eyes. This submission to machinic vision continues even off-duty. The soldiers' implants issue psychic rewards for successful kills in the form of realistic sexual fantasies. As Stripe sleeps, for example, the implant summons dreams of his ideal lover, even multiple copies of her, sexually submitting to him, lurid fantasies that the viewer experiences in first-person as well. Outside the dream, the camera pans over the soldiers slumbering in their bunk rows, each locked into a personal vision of orgasmic bliss. Their trigger fingers twitch rhythmically, suggesting that the implant is busy hardwiring "war" to "porn."

The "ultimate weapon" of the implant is thus an ultimate metaphor for the gun-camera's *coup d'oeil*, not only in its capacity as a precise targeting mechanism, but also because it aims its disciplinary will inward. Stipe's conditioning, a storyboard for our own, traverses the spectrum from linguistic to technological modes of control. Here, demonizing slurs like "roach" shade into digitally retouched enemy faces, and narratives that call for a violent response to this supposed threat shade into a world already cast through the weapon's camera. The result is the conceptual melding of ideology and interface that makes good on Butler's suggestion that the frame through which we look demands as much attention as what appears in that frame. The drama turns not on what Stripe sees per se but rather on whether the interface can contain his vision. The story's peripeteia arrives when the frame finally shatters. Stripe's failing implant opens a critical fissure that spreads across our entire field of perception in the form of glitches, freeze-ups, doubts, and questions. In the end, we experience Stripe's refusal to pull the trigger by sharing his visual crash.

Science fiction aside, the drama of this soldier fairly describes the progressive saturation of the public mediascape with the weaponized gaze. This reached a critical threshold in 2007 if the Discovery Channel's decision to air a three-part series entitled *Gun Camera* is any indication. Produced in cooperation with the air force and navy, the action thrust us in front of the roving crosshairs and successive explosions. Here a bellicose narrator bids us to "climb into the cockpit," "experience a bomb's-eye view as a two-thousand-pound Maverick obliterates a bridge," and "ride along as laser-guided munitions bust up a few bunkers," a round of convulsive therapy that trains our fingers to twitch and eyes to cloud over. The promises to reveal the drama of the gun-camera from the perspective of those who "lived it" of course refers to those on only one side of the targeting screen. The realities of the other side either disappear behind a wall of static or undergo radical retouching through selective

image management. Just as a military psychologist might surgically install a neural implant, the series extends the capacity of the gun-camera to surgically strike public consciousness.

The dream figures centrally here, because it is on this surreal plane that the interface operates to condition, distance, and, perhaps most importantly, forget. At the end of the *"Men against Fire"* episode, the psychologist offers Stripe, still stunned by the reality of his own actions, two options: either he can spend the rest of his days in prison being tormented by unfiltered images of killing human beings, or he can have the memory of his critical awakening erased and go back to the soldier he was. He chooses the latter, driving home the lesson that perhaps the ultimate weapon is one that aids and abets the human capacity for disavowal. There is another perhaps more hopeful ending embedded in the tale, however, about our capacity to overcome this nefarious training. We eventually discover the reason Stripe goes rogue: the roaches have developed a flashing handheld device that, when glimpsed by the soldier, hacks and disables the implant. The psychologist speculates that it must have been "reverse engineered from some of our drone parts." Perhaps the drone is an obvious choice for the raw material in this act of techno-sabotage given that its targeting camera is the current master referent for the weaponized gaze. On a conceptual scale, we can take a cue from the suggestion that the apparatus that figures vision provides the means to refigure it. The weaponized gaze is not yet hardwired into our gray matter. For the time being, a layer of representation separates the eye and screen. In this space lies the opportunity to rhetorically reverse engineer the frame—to flash the right code—so that we may again glimpse the humanity of others, as well as our own, staring us in the face.

Acknowledgments

The ideas contained in this book first began to subdivide during a fellowship at the University of Queensland's political science and international studies department in 2013. I owe much to Sebastian Kaempf and his colleagues, especially Mark Andrejevic and Zala Volcic, for hosting me, stimulating my pursuit of visual politics, and incubating the concept of the weaponized gaze. The barbecues were not bad either. I am grateful for my own Department of Communication Studies at the University of Georgia for funding a visit the Vanderbilt Television News Archive. My colleagues have been generous with their encouragement and brilliance. In particular, thanks to Ed Panetta for creating a space for us to thrive. The book benefitted tremendously from its readers and reviewers. Leslie Mitchner expertly guided the process with her no-nonsense editorial style, Matthew Sienkiewicz helped tremendously to refine the manuscript with his surgically precise suggestions, and Megan Grande smoothed the rough edges. Others who contributed to the ideas herein, some without knowing it, include Joshua Reeves, Andrew Nance, Jason Williamson, John Lucaites, Jon Simons, and Joe Peregine. I also have drawn a good deal of inspiration from those taking risks on the front lines through activism, art, and journalism. It has been an honor to meet you, Medea Benjamin, Essam, Nick Mottern, and Joseph Delappe. Thanks to Tom Secker and Matthew Alford for being there to field my strange questions, making all the FOIA requests, and maintaining SpyCulture, one of the best resources out there for mapping the securitainment complex. Finally, I want to say that this project would not exist if not for Kate Morrissey, the great solar heart around which I and

so many others orbit. Between this book's inception and publication, two impossibly adorable children appeared, infusing our lives with fresh hope and joy but also tightening up our schedules considerably. So thank you, Kate, for your time, love, sheer endurance, wit, and for reminding me it really is all about compassion.

Notes

Chapter 1 A Strike of the Eye

1 Gary Edgerton, *The Columbia History of American Television* (New York: Columbia University Press, 2010), 35–36.

2 Paul Virilio, *War and Cinema: The Logistics of Perception* (New York: Verso, 1989), 75.

3 Erik Barnouw, *A Tower in Babel: A History of Broadcasting in the United States, Vol I—To 1933* (New York: Oxford University Press, 1966), 231.

4 Walter Harte, *The History of the Life of Gustavus Adolphus, King of Sweden*, vol. 1 (London: Printed for the author, 1759), 390, https://archive.org/details/historyoflifeofgo1hart.

5 Carl von Clausewitz, *On War*, trans. Michael Howard and Peter Paret (Oxford: Oxford University Press, 2007), 47.

6 Martin Gulbert, *Winston S. Churchill, Vol. 3, Companion Part 1, Documents: July 1914–April 1915* (London: Heinmann, 1972), 193.

7 Paul S. Landau, "Empires of the Visual: Photography and Colonial Administration in Africa," in *Images and Empires: Visuality in Colonial and Postcolonial Africa*, ed. Paul S. Landau and Deborah Kaspin (Berkeley: University of California Press, 2002), 148.

8 Virilio, *War and Cinema*, 11.

9 Donna Haraway, "Teddy Bear Patriarchy: Taxidermy in the Garden of Eden, New York City, 1908–1936," *Social Text*, no. 11 (Winter, 1984–85): 39–40.

10 Virilio, *War and Cinema*, 3.

11 Virilio, 4.

12 Virilio, 83.

13 Virilio, 7.

14 Virilio, 83.

15 Peter Catapano, "War of Semantics," *Opinionator*, accessed June 25, 2015, http://opinionator.blogs.nytimes.com/2011/03/25/war-of-semantics/; Timothy Noah, "Birth of a Washington Word," *Slate*, November 20, 2002, http://www.slate.com/articles/news_and_politics/chatterbox/2002/11/birth_of_a_washington_word.html.

16 Paul Virilio, *Desert Screen: War at the Speed of Light* (New York: Continuum, 2002), 46, 118.

17 Virilio, 76.

18 Virilio, 23.

19 Jeremy Packer, "Becoming Bombs: Mobilizing Mobility in the War on Terror," *Cultural Studies* 20, no. 4–5 (2006): 378–99.

20 George W. Bush, "Address to a Joint Session of Congress and the American People," September 20, 2001, https://georgewbush-whitehouse.archives.gov/news/releases/2001/09/20010920-8.html.

21 H. Bruce Franklin, *War Stars*, 2nd ed. (Amherst: University of Massachusetts Press, 2008), 4.

22 As the Cold War wound down, James Der Derian made a similar point about the Western regime of cyber-surveillance, which displayed "the classic symptoms of advanced paranoia: hyper-vigilance, intense distrust, rigid and judgmental thought processes, and projection of one's own repressed beliefs and hostile impulses onto another." James Der Derian, "The (S)pace of International Relations: Simulation, Surveillance, and Speed," *International Studies Quarterly* 34, no. 3 (1990): 305–6.

23 Charles Kauffman, "Names and Weapons," *Communication Monographs* 56, no. 3 (1989): 273.

24 Caren Kaplan, "Air Power's Visual Legacy: Operation Orchard and Aerial Reconnaissance Imagery as Ruses de Guerre," *Critical Military Studies* 1, no. 1 (2014): 63.

25 Franklin, *War Stars: The Superweapon and the American Imagination*, 91–100; H. Bruce Franklin, *Vietnam and Other American Fantasies* (Amherst: University of Massachusetts Press, 2000), 11–12.

26 *Aerial Bombing of Obsolete Battleships*, newsreel, vol. 1119 (Signal Corps, U.S. Army, 1921).

27 As quoted in Virilio, *War and Cinema*, 74.

28 Caren Kaplan, "Precision Targets: GPS and the Militarization of U.S. Consumer Identity," *American Quarterly* 58, no. 3 (2006): 700–701.

29 *Victory through Air Power* (Walt Disney, 1943).

30 *Tale of Two Cities*, vol. 74 (U.S. War Department, 1946).

31 Philip D. Beidler, "The Last Huey," *Mythosphere* 1, no. 1 (1997): 54.

32 Marita Sturken, "Television Vectors and the Making of a Media Event: The Helicopter, the Freeway Chase, and National Memory," in *Reality Squared: Televisual Discourse of the Real*, ed. James Friedman (New York: Rutgers University Press, 2002), 185–202; Ole B. Jensen, "New 'Foucauldian Boomerangs': Drones and Urban Surveillance," *Surveillance and Society* 14, no. 1 (2016): 20–33.

33 Michael J. Arlen, *Living-Room War* (Syracuse, N.Y.: Syracuse University Press, 1997), 111–12.

34 Michael Herr, *Dispatches* (New York: Vintage, 2011), 35.

35 Virilio, *War and Cinema*, 4.

36 Nicholas Mirzoeff, *The Right to Look: A Counterhistory of Visuality* (Durham, N.C.: Duke University Press, 2011), 282.

37 W.J.T. Mitchell, *Picture Theory: Essays on Verbal and Visual Representation* (Chicago: University of Chicago Press, 1995), 15.

38 See, for example, work on the politics of verticality in Eyal Weizman, *Hollow Land: Israel's Architecture of Occupation* (London: Verso, 2012); Stephen Graham, *Vertical: The City from Satellites to Bunkers* (London: Verso, 2016). Others have focused on the politics and the practice of the witness. See Wendy Kozol, *Distant Wars Visible:*

The Ambivalence of Witnessing (Minneapolis: University Of Minnesota Press, 2014); Liam Kennedy and Caitlin Patrick, eds., *The Violence of the Image: Photography and International Conflict* (London: I. B. Tauris, 2014); Dora Apel, *War Culture and the Contest of Images* (New Brunswick, N.J.: Rutgers University Press, 2012); Fraser MacDonald, Rachel Hughes, and Klaus Dodds, eds., *Observant States: Geopolitics and Visual Culture*, 16 (New York: I. B. Tauris, 2010). Rebecca Adelman argues that the entire War on Terror since the televised spectacle of 9/11 has been a set of visual practices, from the consecrating event to virtual reality training and biometric surveillance. Rebecca Adelman, *Beyond the Checkpoint: Visual Practices in America's Global War on Terror* (Amherst: University of Massachusetts Press, 2014). Nathan Roger takes Virilio's "war of pictures" seriously in his analysis of what he calls the "weaponization of images" and "image munitions." Nathan Roger, *Image Warfare in the War on Terror* (New York: Palgrave Macmillan, 2013). Mitchell, too, cannot help but return to the theme with his 2011 investigation of the viral circulation of icons in the War on Terror, a new-media acceleration of the pictoral turn into a "war of images." William John Thomas Mitchell, *Cloning Terror: The War of Images, 9/11 to the Present* (Chicago: University of Chicago Press, 2011), 2. Such declarations of "image warfare" overextend the metaphor and threaten to legitimate the current war *on* images and free expression. See Roger Stahl, "Weaponizing Speech," *Quarterly Journal of Speech* 102, no. 4 (October 1, 2016): 376–95. This is especially concerning in an environment that followed the U.S. military's pronouncement in 2000 that "information dominance" would be added to its list of objectives alongside dominance in land, sea, air, and space. General Henry H. Shelton, *Joint Vision 2020* (Washington, D.C.: U.S. Government Printing Office, 2000). What is certain is that we have entered an era where the visual interface between civilian and military spheres has become a primary site of struggle, attention, and management—a battlefront itself.

39 Susan Sontag, *On Photography* (New York: Farrar, Straus, and Giroux, 1977), 7.

40 Sontag, 14–15.

41 David Spurr, *The Rhetoric of Empire: Colonial Discourse in Journalism, Travel Writing, and Imperial Administration* (Durham, N.C.: Duke University Press, 1993); Landau, "Empires of the Visual."

42 Catherine A. Lutz and James L. Collins, *Reading National Geographic* (Chicago: University of Chicago Press, 1993).

43 Michael J. Shapiro, *Cinematic Geopolitics* (New York: Routledge, 2008), 66.

44 Margot Norris, "Only the Guns Have Eyes: Military Censorship and the Body Count," in *Seeing through the Media: The Persian Gulf War,* ed. Susan Jeffords and Lauren Rabinovitz (New Brunswick, N.J.: Rutgers University Press, 1994), 285–300.

45 Jean Baudrillard, *The Gulf War Did Not Take Place* (Bloomington: Indiana University Press, 1995), 43–45; Sontag, *On Photography*, 21.

46 Donna Haraway, *Simians, Cyborgs, and Women: The Reinvention of Nature* (New York: Routledge, 1991), 192.

47 Mitchell, *Picture Theory*, 15.

48 Louis Althusser, *Lenin and Philosophy and Other Essays*, trans. Ben Brewster (New York: Monthly Review Press, 1972), 180.

49 Jacques Ranciere, Davide Panagia, and Rachel Bowlby, "Ten Theses on Politics," *Theory & Event* 5, no. 3 (2001).

50 Nicholas Mirzoeff, *Watching Babylon: The War in Iraq and Global Visual Culture* (New York: Routledge, 2005).

51 See Roger Stahl, "Why We 'Support the Troops': Rhetorical Evolutions," *Rhetoric & Public Affairs* 12, no. 4 (2009): 533–70.

52 Kevin Robins and Les Levidow, "Socializing the Cyborg Self: The Gulf War and Beyond," in *The Cyborg Handbook*, ed. Chris Hables Gray (New York: Routledge, 1995), 123.

53 Robert Stam, "Mobilizing Fictions: The Gulf War, the Media, and the Recruitment of the Spectator," *Public Culture* 4, no. 2 (1992): 102–3.

54 McKenzie Wark, *Virtual Geography: Living with Global Media Events* (Bloomington: Indiana University Press, 1994), 45.

55 Judith Butler, *Frames of War: When Is Life Grievable?* (New York: Verso, 2010), 11.

56 Butler, 29.

57 Brian Massumi, *Ontopower: War, Powers, and the State of Perception* (Durham, N.C: Duke University Press, 2015).

58 Judith Butler, "Contingent Foundations: Feminism and the Question of 'Postmodernism,'" in *Feminists Theorize the Political*, ed. Judith Butler and Joan W. Scott (New York: Routledge: 1992), 10.

59 Sarah Maltby, *Military Media Management Negotiating the "Front" Line in Mediatized War* (New York: Routledge, 2012).

60 Rey Chow, *The Age of the World Target: Self-Referentiality in War, Theory, and Comparative Work* (Durham, N.C.: Duke University Press, 2006).

61 Jeremy Scahill, "The Assassination Complex," *Intercept*, October 15, 2015, https://theintercept.com/drone-papers/the-assassination-complex/.

62 Matthew Alford, *Reel Power: Hollywood Cinema and American Supremacy* (New York: Pluto Press, 2010), 20.

Chapter 2 Smart Bomb Vision

1 Tom Shales, "The Voice in Command Schwarzkopf's Skill in War's Other Theater," *Washington Post*, January 31, 1991, LexisNexis Academic.

2 Edward Cody, "Allies Claim to Bomb Iraqi Targets at Will; U.S. Commander Says Opponents Not Giving Up," *Washington Post*, January 30, 1991, LexisNexis Academic.

3 Geoff Martin and Erin Steuter, *Pop Culture Goes to War: Enlisting and Resisting Militarism in the War on Terror* (Lanham, Md.: Rowman & Littlefield, 2010), 81.

4 James Adams, "Pentagon Bans Video of Doomed Iraqi Driver," *Sunday Times*, February 10, 1991, LexisNexis Academic.

5 Daniel C. Hallin, "Images of the Vietnam and the Persian Gulf Wars in U.S. Television," in *Seeing through the Media: The Persian Gulf War*, ed. Susan Jeffords and Lauren Rabinovitz (New Brunswick, N.J.: Rutgers University Press, 1994), 56.

6 Karl Vick, "Whole Truth of Gulf War Is Trickling Out," *St. Petersburg Times*, February 10, 1992, LexisNexis Academic.

7 Cody, "Allies Claim to Bomb."

8 Jay David Bolter and Richard Grusin, *Remediation: Understanding New Media* (Cambridge, Mass.: MIT Press, 2000).

9 For a critical read of the narrative that press freedom lost the Vietnam War for the U.S., see Daniel C. Hallin, *The "Uncensored War": The Media and Vietnam* (New York: Oxford University Press, 1986); William M. Hammond, "The Press in Vietnam as Agent of Defeat: A Critical Examination," *Reviews in American History* 17, no. 2 (1989): 312–23.

10 Susan Carruthers, *The Media at War: Communication and Conflict in the Twentieth Century* (New York: St. Martin's Press, 2000).

11 Margot Norris, "Only the Guns Have Eyes: Military Censorship and the Body Count," in *Seeing through the Media: The Persian Gulf War,* ed. Susan Jeffords and Lauren Rabinovitz (New Brunswick, N.J.: Rutgers University Press, 1994), 291.

12 Jason Deparle, "AFTER THE WAR; Keeping the News in Step: Are the Pentagon's Gulf War Rules Here to Stay?," *New York Times,* May 6, 1991, http://www.nytimes .com/1991/05/06/world/after-war-keeping-step-are-pentagon-s-gulf-war-rules -here-stay.html.

13 Robert Stam, "Mobilizing Fictions: The Gulf War, the Media, and the Recruitment of the Spectator," *Public Culture* 4, no. 2 (1992): 112.

14 Deparle, "AFTER THE WAR."

15 Deparle.

16 Deparle.

17 Caren Kaplan, "Precision Targets: GPS and the Militarization of U.S. Consumer Identity," *American Quarterly* 58, no. 3 (2006): 705; see also a similar claim in Paul Virilio, *Desert Screen: War at the Speed of Light* (New York: Continuum, 2002), 95–96.

18 Phillip McCarthy, "CNN: The Media's Own Missile," *Sydney Morning Herald,* September 30, 1996, LexisNexis Academic.

19 Scott Beauchamp, "The Moral Cost of the Kill Box," *Atlantic,* February 28, 2016, https://www.theatlantic.com/politics/archive/2016/02/the-cost-of-the-kill-box/ 470751/.

20 Stam, "Mobilizing Fictions," 101; See also McKenzie Wark, *Virtual Geography: Living with Global Media Events* (Bloomington: Indiana University Press, 1994), 46.

21 Susan Jeffords, *Hard Bodies: Hollywood Masculinity in the Reagan Era* (New Brunswick, N.J.: Rutgers University Press, 1994).

22 Sandra E. Moriarty and David Shaw, "An Antiseptic War: Were News Magazine Images of the Gulf War Too Soft?," *Visual Communication Quarterly* 2, no. 2 (1995): 4–11.

23 Daniel C. Hallin and Todd Gitlin, "Agon and Ritual: The Gulf War as Popular Culture and as Television Drama," *Political Communication* 10 (1993): 415.

24 Scott Shugar, "Operation Desert Store: First the Air War, Then the Ground War, Now the Marketing Campaign," *Los Angeles Times,* September, 29, 1991, 18, LexisNexis Academic.

25 Tom Engelhardt, "The Gulf War as Total Television," in *Seeing through the Media: The Persian Gulf War,* ed. Susan Jeffords and Lauren Rabinovitz (New Brunswick, N.J.: Rutgers University Press, 1994), 88.

26 Kenneth Burke, *A Grammar of Motives* (Berkeley: University of California Press, 1969), 275–87.

27 Daniel Bell, *The End of Ideology: On the Exhaustion of Political Ideas in the Fifties* (Cambridge, Mass.: Harvard University Press, 1988); Francis Fukuyama, *The End of History and the Last Man* (New York: Free Press, 2006).

28 Kaplan, "Precision Targets," 704.

29 "Defense Department Briefing," *Federal News Service,* January 22, 1991, LexisNexis Academic.

30 "US Official Footage of Airstrikes on Iraqi Hydroelectic Plant," *CBS Evening News* (CBS, January 22, 1991), LexisNexis Academic.

31 Patrick Sloyan, "What Bodies?," in *The Iraq War Reader: History, Documents, Opinions,* ed. Michael L. Sifry and Christopher Cerf (New York: Touchstone Books,

2003), 129–34; John Taylor, *Body Horror: Photojournalism, Catastrophe and War* (Manchester: Manchester University Press, 1998).

32 Norris, "Only the Guns Have Eyes," 290; "How Many Iraqi Soldiers Died?," *Time*, June 17, 1991; Vick, "Whole Truth of Gulf War."

33 Kaplan, "Precision Targets," 704.

34 Roger Stahl, *Militainment, Inc.: War, Media, and Popular Culture* (New York: Routledge, 2010), 25–27.

35 Judith Butler, "Contingent Foundations: Feminism and the Question of 'Postmodernism,'" in *Feminists Theorize the Political*, ed. Judith Butler and Joan W. Scott (New York: Routledge, 1992), 11.

36 Mary Rogan, "GULF: Oh, What a Wonderful War.," *Globe and Mail*, January 22, 1991, LexisNexis Academic.

37 H. Bruce Franklin, *Vietnam and Other American Fantasies* (Amherst: University of Massachusetts Press, 2000), 42.

38 Philip M. Taylor, *War and the Media: Propaganda and Persuasion in the Gulf War*, 2nd ed. (Manchester: Manchester University Press, 1998), 275.

39 Butler, "Contingent Foundations," 11. Kevin Robins, too, makes much of the figure of the serial killer in his assessment of the way electronic war separated viewers' tele-action from their capacity to empathize. It is no mistake, he notes, that a wave of such films—from *Silence of the Lambs* to *American Psycho*—appeared in the context of the Gulf War. Kevin Robins, *Into the Image: Culture and Politics in the Field of Vision* (New York: Routledge, 1996), 73–81.

40 "Official Footage of Airstrikes."

41 Stam, "Mobilizing Fictions," 102.

42 Kevin Robins and Les Levidow, "Socializing the Cyborg Self: The Gulf War and Beyond," in *The Cyborg Handbook*, ed. Chris Hables Gray (New York: Routledge, 1995), 121.

43 Wendy Kozol, *Distant Wars Visible: The Ambivalence of Witnessing* (Minneapolis: University of Minnesota Press, 2014), 112–13.

44 Deparle, "AFTER THE WAR."

45 John Pettegrew, *Light It Up: The Marine Eye for Battle in the War for Iraq* (Baltimore: Johns Hopkins University Press, 2015), 42.

46 Susan Jeffords, "Rape and the New World Order," *Cultural Critique*, no. 19 (1991): 203–15.

47 Linda Diebel, "Pentagon Now Urged to Prove Its Claims," *Toronto Star*, January 21, 1991, LexisNexis Academic.

48 Deparle, "AFTER THE WAR."

49 Sue Tait, "Pornographies of Violence? Internet Spectatorship on Body Horror," *Critical Studies in Media Communication* 25, no. 1 (March 2008): 91–111.

50 "Special Defense Department Briefing by: General Norman Schwarzkopf, Commander, Persian Gulf Forces; Lt. General Charles A. Horner, US Central Command, Air Force. Riyadh, Saudi Arabia," *Federal News Service*, January 18, 1991, LexisNexis Academic.

51 According to the *Guardian*, for example, "pictures taken on the raids showing bombs targeted down air shafts on the roofs of buildings suggest that US planes are making full use of their infrared nighttime navigation and targeting system, Lantirn." Larry Elliot, "War in the Gulf: Toys a Hit with the Boys," *Guardian*, January 19, 1991, LexisNexis Academic.

52 "Showdown in the Gulf; Iraq Attacks Israel," *CBS News Special Report: Showdown in the Gulf (9:00 AM ET)* (CBS, January 18, 1991), LexisNexis Academic; "Showdown in the Gulf Coverage Continues," *CBS News Special Report: Showdown in the Gulf (10:00 AM ET)* (CBS, January 18, 1991), LexisNexis Academic.

53 "US Ground Troops Preparing for Action," *CBS News Special Report (8:00 PM ET)* (CBS, January 18, 1991), LexisNexis Academic.

54 Paul Taylor, "U.S. Success Is Immediate, Victory Is Not; At 85%, Confidence in Military Strikes Highest Point in Years," *Washington Post*, January 31, 1991, A21, LexisNexis Academic.

55 Taylor.

56 "Pentagon Updates on Desert Storm," *CBS Special Report*, January 21, 1991, LexisNexis Academic.

57 Lee Bowman, "Schwarzkopf Paints Blitz of Iraqis," *St. Petersburg Times*, January 31, 1991, LexisNexis Academic.

58 Earl Lane, "The Gulf War: Smart Bombs Can Often Go Dumb," *Guardian*, February 11, 1991, LexisNexis Academic.

59 Thomas H. Guilliat, "'Someone Is Trying to Kill Me'—Crews Face Grim Reality of War," *Sunday Herald*, January 20, 1991, LexisNexis Academic.

60 R. Jeffrey Smith and Evelyn Richards, "Numerous U.S. Bombs Probably Missed Targets; Not All Munitions Used in Gulf Are Smart," *Washington Post*, February 22, 1991, LexisNexis Academic.

61 "Gulf Coalition Blamed for High Civilian Toll," *Toronto Star*, November 17, 1991, LexisNexis Academic; also see the full report, *Needless Deaths in the Gulf War: Civilian Casualties during the Air Campaign and Violations of the Laws of War* (New York: Human Rights Watch, 1991).

62 "Operation Desert Storm: Evaluation of the Air War" (U.S. General Accounting Office, July 1996), 5, https://www.gpo.gov/fdsys/pkg/GAOREPORTS-PEMD-96 -10/pdf/GAOREPORTS-PEMD-96-10.pdf.

63 Tim Weiner, "'Smart' Weapons Were Overrated, Study Concludes," *New York Times*, July 9, 1996, LexisNexis Academic.

64 Brett Thomas, "Smart Bombs Stupid," *Sydney Herald*, July 14, 1996, LexisNexis Academic.

65 "Crisis in the Gulf: Apache Pilots in Ground Attack Shooting Gallery," *Independent*, February 25, 1991, LexisNexis Academic.

66 David Martin and Dan Rather, "How Ground War Is Likely to Proceed in Gulf War; Update on War (8:00 PM)," *CBS News Special Report*, February 23, 1991, LexisNexis Academic.

67 Martin and Rather.

68 Martha Teichner, "United States' Apache Helicopter (11:00 PM)," *CBS News Special Report*, February 23, 1991, LexisNexis Academic.

69 Teichner.

70 Vick, "Whole Truth of Gulf War."

71 Shugar, "Operation Desert Store."

72 *Desert Storm: The War Begins* (CNN, 1991).

73 Walter Goodman, "TV Weekend; 'Desert Storm,' Four-Part Replay of the Gulf War," *New York Times*, June 28, 1991, LexisNexis Academic.

74 Cameron Stewart, "Silent but Deadly," *Weekend Australian*, March 13, 1999, LexisNexis Academic.

75 Roger Graef, "Television through the Distorting Lens," *Sunday Times*, May 10, 1998, LexisNexis Academic.

76 Patrick J. Buchannan, "The Return of Globocop; If 'the World' Loathes Saddam, Where Are Our Allies?," *New York Post*, January 31, 1998, LexisNexis Academic.

77 Jay Stone, "Satire Wags Its Finger at Political String-Pulling," *Ottawa Citizen*, January 16, 1998, LexisNexis Academic.

78 As quoted in Don Kaplan, "War Seen in Words; How Will News Coverage Look Minus Lots of Video?," *New York Post*, October 1, 2001, 83, LexisNexis Academic.

79 Jim Schembri, "Bomb Iraq Now. We Need the Footage," *Age*, October 31, 2002, LexisNexis Academic.

80 "Smart Bombs," *Modern Marvels* (History Channel, September 30, 2003).

81 Bruce Hoffman, "The Logic of Suicide Terrorism," *Atlantic*, June 2003, http://www.theatlantic.com/magazine/archive/2003/06/the-logic-of-suicide-terrorism/302739/. William J. T. Mitchell even succumbs to such equivalencies. "The final result and the whole tendency of the smart bomb and the suicide bomber are the same, namely, the creation of a biocybernetic life-form, the reduction of a living being to a tool or machine, and the elevation of a mere tool or machine to the level of an intelligent, adaptable creature" (W. J. T. Mitchell, *What Do Pictures Want?: The Lives and Loves of Images* [Chicago: University Of Chicago Press, 2005], 313).

82 Heather Chaplin and Aaron Ruby, *Smartbomb: The Quest for Art, Entertainment, and Big Bucks in the Videogame Revolution*, Reprint edition (Chapel Hill, N.C.: Algonquin Books, 2006); "'Smart Bomb': Inside the Video Game Industry," *NPR*, November 15, 2005, http://www.npr.org/templates/story/story.php?storyId=5011925; Ananth Baliga, "Antibiotic 'Smart Bomb' Can Target Bad Bacteria," *UPI*, January 30, 2014, http://www.upi.com/blog/2014/01/30/Antibiotic-smart-bomb-can-target-bad-bacteria/8961391109266/.

83 J. G. Ballard, "Old Bloodshed, As If in a Dream; Images of War: The Artist's Vision of World War II, Edited by Ken McCormick and Hamilton Darby Perry (Cassell, £35)," *Guardian Weekly*, March 17, 1991, LexisNexis Academic.

84 Ballard.

Chapter 3 Satellite Vision

1 Denis Cosgrove, *Apollo's Eye: A Cartographic Genealogy of the Earth in the Western Imagination* (Baltimore: Johns Hopkins University Press, 2003).

2 Martin Heidegger, *The Question Concerning Technology and Other Essays*, trans. William Lovitt (New York: Garland, 1977), 115–54.

3 Rey Chow, *The Age of the World Target: Self-Referentiality in War, Theory, and Comparative Work* (Durham, N.C.: Duke University Press, 2006), 31.

4 Chow, 34.

5 Chow, 35. The phrase *God's-eye view of battle* comes via Robert J. Stevens, CEO of Lockheed Martin, the biggest U.S. military contractor at the time. Tim Weiner, "Pentagon Envisioning a Costly Internet for War," *New York Times*, November 13, 2004, https://www.nytimes.com/2004/11/13/technology/pentagon-envisioning-a-costly-internet-for-war.html.

6 John Cloud, "Crossing the Olentangy River: The Figure of the Earth and the Military-Industrial-Academic-Complex, 1947–1972," *Studies in History and Philosophy of Science* 31, no. 3 (2000): 371–404.

7 Cloud.

8 John Cloud, "American Cartographic Transformations during the Cold War," *Cartography and Geographic Information Science* 29, no. 3 (2002): 263; Jimmy Carter, "Kennedy Space Center, Florida Remarks at the Congressional Space Medal of Honor Awards Ceremony" (The American Presidency Project, October 1, 1978), http://www.presidency.ucsb.edu/ws/?pid=29897; Jeffrey Richelson, "Declassifying the 'Fact of' Satellite Reconnaissance," *National Security Archive Electronic Briefing Book No. 231*, October 1, 2007, http://nsarchive.gwu.edu/NSAEBB/NSAEBB231/.

9 Timothy Barney, *Mapping the Cold War: Cartography and the Framing of America's International Power*, 2015, 38.

10 Barney, 179.

11 John W. Finneys, "Pictures of Earth Are Transmitted by Satellite," *New York Times*, September 29, 1959. ProQuest Historical Newspapers.

12 Telford Taylor, "Long-Range Lessons of the U-2 Affair," *New York Times*, July 24, 1960, ProQuest Historical Newspapers.

13 Steve G. Manuel, "Images from the Sky," *Technology in Society* 14, no. 4 (1992): 419–22.

14 Keith C. Clarke, "Maps and Mapping Technologies of the Persian Gulf War," *Cartography and Geographic Information Systems* 19, no. 2 (1992): 81.

15 David D. Perlmutter, *Visions of War: Picturing Warfare from the Stone Age to the Cyber Age* (New York: St. Martin's Griffin, 2001), 211.

16 Manuel, "Images from the Sky," 424.

17 Jean Heller, "Photos Don't Show Buildup," *St. Petersburg Times*, January 6, 1991, LexisNexis Academic.

18 Manuel, "Images from the Sky," 418.

19 Caren Kaplan describes the images as an obvious "public relations tool." Caren Kaplan, "Air Power's Visual Legacy: Operation Orchard and Aerial Reconnaissance Imagery as Ruses de Guerre," *Critical Military Studies* 1, no. 1 (2014): 70.

20 Peter Jennings, "*ABC News* Transcripts," *ABC World News Tonight* (ABC, August 8, 1984), LexisNexis Academic; Charles Mohr, "Salvador Arms—Aid Charges Detailed," *New York Times*, August 9, 1984, http://www.nytimes.com/1984/08/09/world/salvador-arms-aid-charges-detailed.html.

21 Lisa Parks, "Satellite Views of Srebrenica: Tele-visuality and the Politics of Witnessing," *Social Identities* 7, no. 4 (2001): 589, 600.

22 "Discoverer Capsule Falls in the Arctic; Recovery Is Possible," *New York Times*, April 16, 1959. ProQuest Historical Newspapers.

23 Donald M. Kerr, "National Reconnaissance Office Review and Redaction Guide" (National Reconnaissance Office, May 20, 2005), 155, Federation of American Sciences, https://fas.org/irp/nro/declass.pdf.

24 Tricia Jenkins, *CIA in Hollywood: How the Agency Shapes Film and Television* (Austin: University of Texas Press, 2012), 93.

25 *The Making of "Enemy of the State,"* documentary, short (2006), http://www.imdb.com/title/tt0985098/.

26 At the time of the film's release, producer Jerry Bruckheimer attempted to downplay its demonization of the NSA by suggesting that the agency had lent its assistance. He went on to claim that, as a result of the supposed cooperation, he had changed the script's villain from the entire agency to one bad apple. There are a number of problems with these statements. First, documents obtained via FOIA request in 2016 show that the agency in fact declined to cooperate with Bruckheimer after he inquired. Second, the film's villains are numerous and systemic to the agency. It

appears as though Bruckheimer's comments were an attempt to have his cake and eat it too—both to do business with the competitive CIA and fend off criticism following the film's release that it was an attack on the NSA. Neal Thompson, "NSA Goes to the Movies: As Technology Looms Ever Larger in Our Lives, Hollywood Is Seeking a New Vision of Villainy in the Secret Intelligence Agency at Fort Meade," *Baltimore Sun*, February 15, 1998, http://articles.baltimoresun.com/1998-02-15/features/1998046083_1_nsa-guy-fort-meade-nsa-agents; Andrew Kaczynski and Nathan McDermott, "NSA Tried PR Effort with Film 'Enemy of the State,' Was Massively Disappointed," *BuzzFeed*, January 20, 2016, http://www.buzzfeed.com/andrewkaczynski/nsa-tried-pr-effort-with-1998-film-enemy-of-the-state-was-ma.

27 See evidence for these racial representations in Paul G. Kooistra, John S. Mahoney, and Saundra D. Westervelt, "The World of Crime according to 'Cops,'" in *Entertaining Crime: Television Reality Programs*, ed. Mark Fishman (New York: Routledge, 1998), 141–58.

28 Seth Lubove, "We See You, Saddam," *Forbes*, accessed January 27, 2017, http://www.forbes.com/forbes/2003/0106/102.html.

29 Jenkins, *CIA in Hollywood*, 84.

30 Colin Powell, "Full Text of Colin Powell's Speech," *Guardian*, February 5, 2003, https://www.theguardian.com/world/2003/feb/05/iraq.usa.

31 David Zarefsky, "Making the Case for War: Colin Powell at the United Nations," *Rhetoric & Public Affairs* 10, no. 2 (2007): 287.

32 Lisa Parks, *Cultures in Orbit* (Durham, N.C.: Duke University Press, 2005), 80.

33 Philip Lee, "'Taking the Pulse of the Planet': Leaders of the Digital Earth Concept Want to Collect Vast Amounts of Environmental and Cultural Information to Create a Digital Image of the Planet," *Ottawa Citizen*, June 30, 2001, A4, LexisNexis Academic.

34 Kevin Maney, "Tiny Tech Company Awes Viewers," *USA Today*, March 21, 2003, 1B, LexisNexis Academic.

35 For overviews of the merging of digital gaming and contemporary war see Roger Stahl, "Have You Played the War on Terror?," *Critical Studies in Media Communication* 23, no. 2 (2006): 112; Marcus Power, "Digitized Virtuosity: Video War Games and Post-9/11 Cyber-Deterrence," *Security Dialogue* 38, no. 2 (2007): 271–88.

36 Daniel Levine, "TV War Coverage Good News for Software Firm," *San Francisco Business Times*, April 11, 2003, 3, LexisNexis Academic.

37 "I-Cubed Creates Satellite Mosaic of Middle East for Media Use," *Business Wire*, April 16, 2003, LexisNexis Academic.

38 "Geotech Industry Bolsters War Coverage," *GEO World*, May 1, 2003, 11, LexisNexis Academic.

39 Kristinha M. Anding, "On the Front Lines," *Video Systems*, June 1, 2003, 6, EBSCO Academic Search Complete.

40 Maney, "Tiny Tech Company," 1B.

41 Levine, "TV War Coverage," 3.

42 Reed Fujii, "Virtual Flights Possible with Internet Technology, Aerial Imaging," *Record*, April 14, 2003, LexisNexis Academic.

43 "DigitalGlobe and Keyhole Deliver QuickBird Imagery to New Business Customers and Consumers with Internet 3D Earth Visualization Applications," *PR Newswire*, January 27, 2004, LexisNexis Academic.

44 "In-Q-Tel Announces Strategic Investment in Keyhole; NIMA Uses Technology to Support the Conflict in Iraq," *PR Newswire*, June 25, 2003, LexisNexis Academic;

Bob Keefe, "Working for the CIA; Spy Agency's Venture Capital Arm Helps Fund Products to Aid National Security," *Atlanta Journal-Constitution*, October 12, 2004, 1D, LexisNexis Academic.

45 Vernon Loeb, "Candid Cameras Cover the Bases," *Washington Post*, December 15, 2002, A30, LexisNexis Academic.

46 Eric Lichtblau, "U.S. to Rely More on Private Companies' Satellite Images," *New York Times*, May 13, 2003, A26, LexisNexis Academic. For more on the recent shift to private military contractors, see Jeremy Scahill, *Blackwater: The Rise of the World's Most Powerful Mercenary Army* (New York: Nation Books, 2007); P. W. Singer, *Corporate Warriors: The Rise of the Privatized Military Industry* (Ithaca, N.Y.: Cornell University Press, 2003); Chalmers A. Johnson, *The Sorrows of Empire: Militarism, Secrecy, and the End of the Republic* (New York: Metropolitan Books, 2004).

47 Parks, *Cultures in Orbit*, 90.

48 "I-Cubed Creates Satellite Mosaic."

49 "Geotech Industry," 11.

50 Patrick Sloyan, "What Bodies?," in *The Iraq War Reader: History, Documents, Opinions*, ed. Michael L. Sifry and Christopher Cerf (New York: Touchstone Books, 2003), 129–34.

51 Elaine Scarry, *The Body in Pain* (New York: Oxford University Press, 1985), 71.

52 Asu Askoy and Kevin Robins, "Exterminating Angels: Morality, Violence, and Technology in the Gulf War," in *Triumph of the Image: The Media's War in the Persian Gulf*, ed. Susan Jeffords and Lauren Rabinovitz (Boulder, Colo.: Westview Press, 1992), 202–12; Robert L. Ivie, "Images of Savagery in American Justifications for War," *Communication Monographs* 47, no. 4 (1980): 279–91; Robert L. Ivie, "Savagery in Democracy's Empire," *Third World Quarterly* 26, no. 1 (2005): 55–65.

53 Parks, *Cultures in Orbit*, 90, 97.

54 Donna Haraway, *Simians, Cyborgs, and Women: The Reinvention of Nature* (New York: Routledge, 1991), 189.

55 Stahl, "Have You Played?"

56 John Letzing, "Google, Seeking to Diversify, Looks to Government Contracts," *MarketWatch*, March 13, 2008, LexisNexis Academic.

57 Katie Hafner, Saritha Rai, and Andrew E. Kramer, "Google Offers a Bird's-Eye View, and Some Governments Tremble," *New York Times*, December 20, 2005, A1, LexisNexis Academic.

58 Peter Godspeed, "The Google Hunt: Surfing for Missiles, Subs on the Web," *National Post*, September 16, 2006, A17, LexisNexis Academic.

59 Verne Kopytoff, "Top Secret, in Plain View; Censorship Is Spotty for Aerial Shots of Vulnerable Sites," *San Francisco Chronicle*, May 18, 2007, http://www.sfgate.com/news/article/TOP-SECRET-IN-PLAIN-VIEW-Censorship-is-spotty-2574214.php.

60 Hafner, Rai, and Kramer, "Google Offers a Bird's-Eye View," A1.

61 Godspeed, "The Google Hunt," A17.

62 Peter Eisler, "Commercial Satellites Alter Global Security; High-Definition Imagery Is Readily Available, Not Only to the World's Superpowers but to the Average Person with Computer Access," *USA Today*, November 7, 2008, 13A, LexisNexis Academic.

63 Clancy Chassay and Bobby Johnson, "Inside Gaza: Google Earth Used to Target Israel: Militants Use Google Earth to Target Israel," *Guardian*, October 25, 2007, 1, LexisNexis Academic.

64 Chassay and Johnson, "Inside Gaza," 1.

65 Tim Johnson, "Discovery of Military Sites Has Web Sleuths Buzzing," *Seattle Times Online*, September 13, 2006, http://seattletimes.nwsource.com/html/nationworld/2003256331_mysteryspots13.html?syndication=rss.

66 See Lisa Parks, "Digging into Google Earth: An Analysis of 'Crisis in Darfur,'" *Geoforum* 40, no. 4 (July 2009): 535–45.

67 "Mars Sucks—Can Games Fly on Google Earth?," *Gamasutra*, December 21, 2006, https://www.gamasutra.com/view/feature/130167/mars_sucks__can_games_fly_on_.php.

Chapter 4 Drone Vision

1 Spencer Ackerman, "Libya: The Real U.S. Drone War," *Wired*, October 20, 2011, https://www.wired.com/2011/10/predator-libya/.

2 Peter Finn, "The Do-It-Yourself Origins of the Drone," *Washington Post*, December 24, 2011, LexisNexis Academic.

3 Spencer Ackerman and Noah Shachtman, "Almost 1 in 3 U.S. Warplanes Is a Robot," *Wired*, January 9, 2012, http://www.wired.com/dangerroom/2012/01/drone-report/.

4 Gordon Lubold, "Pentagon to Sharply Expand U.S. Drone Flights Over Next Four Years," *Wall Street Journal*, August 16, 2015, http://www.wsj.com/articles/pentagon-to-add-drone-flights-1439768451.

5 Robert Gates, "Quadrennial Defense Review" (United States Department of Defense, February 2010), http://www.defense.gov/qdr/images/QDR_as_of_12Feb10_1000.pdf; "Drones Are Lynchpin of Obama's War on Terror," *Spiegel Online*, December 3, 2010, http://www.spiegel.de/international/world/0,1518,682612,00.html.

6 Michael Powell and Dana Priest, "U.S. Citizen Killed by CIA Linked to N.Y. Terror Case," *Washington Post*, November 9, 2002, LexisNexis Academic.

7 Mark Mazzetti, "The Drone Zone," *New York Times*, July 6, 2012, http://www.nytimes.com/2012/07/08/magazine/the-drone-zone.html.

8 Jeremy Scahill, "Inside the CIA and Pentagon Turf War over Drone Supremacy," *Intercept*, October 15, 2015, https://theintercept.com/drone-papers/find-fix-finish/.

9 Jeremy Scahill, "The Assassination Complex," *Intercept*, October 15, 2015, https://theintercept.com/drone-papers/the-assassination-complex/.

10 Daniel Swift, "Cultural Damage: A History of Bombing," *Harper's Magazine*, November 2011, 64; Grégoire Chamayou, *A Theory of the Drone* (New York: The New Press, 2015), 26.

11 Michael Dobbs, "Gary Powers Kept a Secret Diary with Him after He Was Captured by the Soviets," *Smithsonian*, October 15, 2015, http://www.smithsonianmag.com/smithsonian-institution/gary-powers-secret-diary-soviet-capture-180956939/.

12 Chamayou, *A Theory of the Drone*, 27.

13 Jeremy Packer and Joshua Reeves, "Romancing the Drone: Military Desire and Anthropophobia from SAGE to Swarm," *Canadian Journal of Communication* 38 (2013): 309–31.

14 Chamayou, *A Theory of the Drone*, 12; Quoted in Bob Woodward, *Obama's Wars* (Simon & Schuster, 2011), 6.

15 Donna Haraway, *Simians, Cyborgs, and Women: The Reinvention of Nature* (New York: Routledge, 1991); Marshall McLuhan, *Understanding Media: The Extensions of Man* (Cambridge, Mass.: MIT Press, 1994).

16 McLuhan, *Understanding Media*, 41–44; see also Marshall McLuhan, *The Gutenberg Galaxy: The Making of Typographic Man* (Toronto: University of Toronto Press, 1962), 25.

17 McLuhan, *Understanding Media*, 44.

18 Jessy J. Ohl, "Nothing to See or Fear: Light War and the Boring Visual Rhetoric of U.S. Drone Imagery," *Quarterly Journal of Speech* 101, no. 4 (2015): 622.

19 Ohl, 621.

20 Alexis C. Madrigal, "The 'Canonical' Image of a Drone Is a Rendering Dressed Up in Photoshop," *Atlantic*, March 20, 2013, https://www.theatlantic.com/technology/archive/2013/03/the-canonical-image-of-a-drone-is-a-rendering-dressed-up-in-photoshop/274177/.

21 Nico Hines, "Obama Schmoozes the Fourth Estate with Gags and Gaffes at Charity White House Bash," *Times (London)*, May 3, 2010, LexisNexis Academic.

22 Conor Friedersdorf, "How Team Obama Justifies the Killing of a 16-Year-Old American," *Atlantic*, October 24, 2012, https://www.theatlantic.com/politics/archive/2012/10/how-team-obama-justifies-the-killing-of-a-16-year-old-american/264028/.

23 Ryan Grim, "Robert Gibbs Says Anwar Al-Awlaki's Son, Killed by Drone Strike, Needs 'Far More Responsible Father,'" *Huffington Post*, October 24, 2012, http://www.huffingtonpost.com/2012/10/24/robert-gibbs-anwar-al-awlaki_n_2012438.html.

24 Jo Becker and Scott Shane, "Secret 'Kill List' Proves a Test of Obama's Principles and Will," *New York Times*, May 29, 2012, http://www.nytimes.com/2012/05/29/world/obamas-leadership-in-war-on-al-qaeda.html.

25 Greg Miller, "Plan for Hunting Terrorists Signals U.S. Intends to Keep Adding Names to Kill Lists," *Washington Post*, October 23, 2012, https://www.washingtonpost.com/world/national-security/plan-for-hunting-terrorists-signals-us-intends-to-keep-adding-names-to-kill-lists/2012/10/23/4789b2ae-18b3-11e2-a55c-39408fbe6a4b_story.html.

26 Eric Holder, "Attorney General Eric Holder Speaks at Northwestern University School of Law," *United States Department of Justice*, March 5, 2012, http://www.justice.gov/iso/opa/ag/speeches/2012/ag-speech-1203051.html.

27 Charlie Savage, "Secret U.S. Memo Made Legal Case to Kill a Citizen," *New York Times*, October 8, 2011, http://www.nytimes.com/2011/10/09/world/middleeast/secret-us-memo-made-legal-case-to-kill-a-citizen.html; Michael Isikoff, "Justice Department Memo Reveals Legal Case for Drone Strikes on Americans," *NBC News*, February 4, 2013, http://openchannel.nbcnews.com/_news/2013/02/04/16843014-justice-department-memo-reveals-legal-case-for-drone-strikes-on-americans.

28 Daniel Swift, "Drone Knowns and Drone Unknowns," *Harper's Magazine*, October 27, 2011, http://harpers.org/blog/2011/10/drone-knowns-and-drone-unknowns/.

29 Scott Shane, "C.I.A. to Expand Use of Drones in Pakistan," *New York Times*, December 4, 2009, http://www.nytimes.com/2009/12/04/world/asia/04drones.html.

30 Mark Mazzetti and Helene Cooper, "CIA Chief Indicates Strikes Will Continue in Pakistan," *International Herald Tribune*, February 27, 2009, LexisNexis Academic.

31 Richard Adams, "Anwar Al-Awlaki Killed in Yemen—as It Happened," *Guardian*, September 30, 2011, http://www.theguardian.com/world/blog/2011/sep/30/anwar-al-awlaki-yemen-live.

32 John O. Brennan, "Brennan's Speech on Counterterrorism, April 2012," *Council on Foreign Relations*, April 30, 2012, http://www.cfr.org/counterterrorism/brennans-speech-counterterrorism-april-2012/p28100.

33 Spencer Ackerman, "Pentagon Issues Drone War Talking Points," *Wired*, May 11, 2012, http://www.wired.com/dangerroom/2012/05/drone-talking-points/.

34 Mark Andrejevic, *Reality TV: The Work of Being Watched*, Critical Media Studies (Lanham, Md.: Rowman & Littlefield, 2003); Jodi Dean, *Publicity's Secret: How Technoculture Capitalizes on Democracy* (Ithaca, N.Y.: Cornell University Press, 2002).

35 "UAV Predator Takes Out Insurgent Mortar Team with Hellfire Missile in Iraq," June 18, 2008, https://www.liveleak.com/view?i=2e5_1213810145; Peter Yost, "Rise of the Drones," *NOVA* (PBS, January 23, 2013).

36 Ron Rosenbaum, "Ban Drone-Porn War Crimes," *Slate Magazine*, August 31, 2010, LexisNexis Academic; Keith Thompson, "Drone Porn: The Newest YouTube Hit," *Huffington Post*, December 30, 2009, http://www.huffingtonpost.com/keith-thomson/drone-porn-the-newest-you_b_407083.html.

37 Roger Stahl, "Why We 'Support the Troops': Rhetorical Evolutions," *Rhetoric & Public Affairs* 12, no. 4 (2009): 533–70.

38 Matthew Alford, *Reel Power: Hollywood Cinema and American Supremacy* (New York: Pluto Press, 2010), 20.

39 Declan Walsh, "80 Dead in Pakistan Madrasa Raid," *Guardian*, October 30, 2006, https://www.theguardian.com/world/2006/oct/30/alqaida.pakistan.

40 Lauren Walker, "What 'Good Kill' Gets Wrong about Drone Warfare," *Newsweek*, May 15, 2015, http://www.newsweek.com/2015/05/22/watch-drone-331949.html.

41 Stephen Holden, "Review: 'Good Kill' Stars Ethan Hawke Fighting Enemies Half a World Away," *New York Times*, May 14, 2015, https://www.nytimes.com/2015/05/15/movies/review-good-kill-stars-ethan-hawke-fighting-enemies-half-a-world-away.html?referrer=google_kp&_r=0.

42 Stephen Holden, "Review: *Eye in the Sky*, Drone Precision vs. Human Failings," *New York Times*, March 10, 2016, https://www.nytimes.com/2016/03/11/movies/review-eye-in-the-sky-drone-precision-vs-human-failings.html.

43 H. Bruce Franklin, *War Stars: The Superweapon and the American Imagination*, 2nd ed. (Amherst: University of Massachusetts Press, 2008), 219.

44 J. C. Herz, *Joystick Nation* (New York: Little, Brown, 1997), 197.

45 Marc Pitzke, "How Drone Pilots Wage War," *Spiegel Online*, December 3, 2010, http://www.spiegel.de/international/world/0,1518,682420,00.html.

46 Jane Mayer, "The Predator War," *New Yorker*, October 26, 2009, http://www.newyorker.com/reporting/2009/10/26/091026fa_fact_mayer.

47 Anna Mulrine, "Drone Pilots: Why War Is Also Hard for Remote Soldiers," *Christian Science Monitor*, February 28, 2012, https://www.csmonitor.com/USA/Military/2012/0228/Drone-pilots-Why-war-is-also-hard-for-remote-soldiers.

48 "Digital Nation," *PBS: Frontline*, February 2, 2010, http://video.pbs.org/video/2175892463/.

49 "America's New Air Force," *CBS News*, August 16, 2009, http://www.cbsnews.com/video/watch/?id=5245555n&tag=api.

50 John Arquilla and David F. Ronfeldt, *The Advent of Netwar* (Santa Monica, Calif.: RAND, 1996).

51 Mark Andrejevic, "Interactive (In)security: The Participatory Promise of Ready .gov," *Cultural Studies* 20, no. 4–5 (September 2006): 441.

52 Tyler Wall and Torin Monahan, "Surveillance and Violence from Afar: The Politics of Drones and Liminal Security-Scapes," *Theoretical Criminology* 15, no. 3 (2011): 243–44.

53 Andrew Pulver, "Harrison Ford Defends Ender's Game as 'Impressive Act of Imagination,'" *Guardian*, October 8, 2013, https://www.theguardian.com/film/2013/oct/08/harrison-ford-enders-game-gay-marriage; D. E. Wittkower, "What Ender's Game Tells Us about Real Drone Pilots," *Slate*, November 12, 2013, http://www.slate.com/blogs/future_tense/2013/11/12/ender_s_game_and_drone_operator _psychology.html.

54 P. W. Singer, *Wired for War: The Robotics Revolution and Conflict in the 21st Century* (New York: Penguin, 2009), 68.

55 Nathan Mawby, "Fly a Drone with iPhone Eye in the Sky," *Herald Sun*, April 21, 2012, LexisNexis Academic.

56 David Cornish, "ESA Launches Drone App to Crowdsource Flight Data," *Ars Technica*, March 17, 2013, http://arstechnica.com/gadgets/2013/03/esa-launches-drone -app-to-crowdsource-flight-data/.

57 Derek Gregory, "From a View to a Kill: Drones in Late Modern War," *Theory, Culture & Society* 28, no. 7–8 (2011): 204.

58 Chris Woods, "Analysis: Obama Embraced Redefinition of 'Civilian' in Drone Wars," *Bureau of Investigative Journalism*, May 29, 2012, https://www.thebureauinvestigates.com/2012/05/29/analysis-how-obama-changed-definition -of-civilian-in-secret-drone-wars/.

59 Chris Woods, "The Civilian Massacre the US Neither Confirms nor Denies," *Bureau of Investigative Journalism*, March 29, 2012, https://www.thebureauinvestigates.com/2012/03/29/the-civilian-massacre-the-us-will-neither -confirm-nor-deny/.

60 Scott Shane, "C.I.A. Claim of No Civilian Deaths from Drones Is Disputed," *New York Times*, August 11, 2011, http://www.nytimes.com/2011/08/12/world/asia/ 12drones.html.

61 Jonathan S. Landay, "U.S. Secret: CIA Collaborated with Pakistan Spy Agency in Drone War," *McClatchy*, April 9, 2013, http://www.mcclatchydc.com/news/ nation-world/world/article24747829.html; see also Jack Serle and Chris Woods, "Secret US Documents Show Brennan's 'No Civilian Drone Deaths' Claim Was False," *Bureau of Investigative Journalism*, April 11, 2013, https://www.thebureauinvestigates.com/2013/04/11/secret-us-documents-show-brennans-no -civilian-drone-deaths-claim-was-false/.

62 Salman Masood and Pir Zubair Shah, "C.I.A. Drones Kill Civilians in Pakistan," *New York Times*, March 17, 2011, http://www.nytimes.com/2011/03/18/world/asia/ 18pakistan.html; see also the account in "Living Under Drones: Death, Injury and Trauma to Civilians from US Drone Practices in Pakistan," *Living Under Drones*, September 2012, 57–62, https://www-cdn.law.stanford.edu/wp-content/uploads/ 2015/07/Stanford-NYU-LIVING-UNDER-DRONES.pdf.

63 "Living Under Drones," 43–54.

64 "Get the Data: Drone Wars Archives," *Bureau of Investigative Journalism*, February 3, 2017, https://www.thebureauinvestigates.com/category/projects/drones/drones-graphs/.

65 "Drone War," *Bureau of Investigative Journalism*, accessed March 3, 2017, https://www.thebureauinvestigates.com/projects/drone-war.

66 Ryan Devereaux, "Obama Administration Finally Releases Its Dubious Drone Death Toll," *Intercept*, July 1, 2016, https://theintercept.com/2016/07/01/obama-administration-finally-releases-its-dubious-drone-death-toll/.

67 Becker and Shane, "Secret 'Kill List'"; Glenn Greenwald, "Deliberate Media Propaganda," *Salon*, June 2, 2012, http://www.salon.com/2012/06/02/deliberate_media_propaganda/.

68 Spencer Ackerman, "41 Men Targeted but 1,147 People Killed: US Drone Strikes—the Facts on the Ground," *Guardian*, November 24, 2014, https://www.theguardian.com/us-news/2014/nov/24/-sp-us-drone-strikes-kill-1147.

69 Mayer, "The Predator War"; Noah Shachtman, "Air Force to Unleash 'Gorgon Stare' on Squirting Insurgents," *Wired*, February 19, 2009, http://www.wired.com/dangerroom/2009/02/gorgon-stare/; Chuck Bennett, "Remote-Control Really Hits the Splat," *New York Post*, October 1, 2011, http://nypost.com/2011/10/01/remote-control-really-hits-the-splat/; George Monbiot, "In the US, Mass Child Killings Are Tragedies. In Pakistan, Mere Bug Splats," *Guardian*, December 17, 2012, https://www.theguardian.com/commentisfree/2012/dec/17/us-killings-tragedies-pakistan-bug-splats.

70 Ian G. R. Shaw, "Predator Empire: The Geopolitics of US Drone Warfare," *Geopolitics* 18 (2013): 543.

Chapter 5 Sniper Vision

1 Chris Kyle, Scott McEwen, and Jim DeFelice, *American Sniper: The Autobiography of the Most Lethal Sniper in U.S. Military History* (New York: Harper Collins, 2012).

2 Nicholas Schmidle, "In the Crosshairs," *New Yorker*, June 3, 2013, http://www.newyorker.com/magazine/2013/06/03/in-the-crosshairs.

3 Martin Barker, *A "Toxic Genre": The Iraq War Films* (London: Pluto Press, 2011).

4 The term appears in the film as well, albeit in passing. Alyssa Rosenberg, "*American Sniper*'s Missing Element: The Man behind the Gun," *Washington Post*, January 23, 2015, https://www.washingtonpost.com/opinions/american-snipers-missing-element-the-man-behind-the-gun/2015/01/23/75826a06-a291-11e4-903f-9f2faf7cd9fe_story.html.

5 Dana Milbank, "Bush Defends Assertions of Iraq-Al Qaeda Relationship," *Washington Post*, June 18, 2004, http://www.washingtonpost.com/wp-dyn/articles/A50679-2004Jun17.html.

6 Eliana Dockterman, "The True Story behind *American Sniper*," *Time*, January 20, 2015, http://time.com/3672295/american-sniper-fact-check/; Nick Turse, "Torturing Iron Man: The Strange Reversals of a Pentagon Blockbuster," May 20, 2008, http://www.tomdispatch.com/post/174934/nick_turse_irony_man.

7 Matthew Cole and Sheelagh McNeill, "'American Sniper' Chris Kyle Distorted His Military Record, Documents Show," *Intercept*, May 25, 2016, https://theintercept.com/2016/05/25/american-sniper-chris-kyle-distorted-his-military-record-documents-show/.

8 Kenneth Burke, *A Grammar of Motives* (Berkeley: University of California Press, 1969), 59.
9 Bob Strauss, "Film Focuses Strictly on Marines," *San Diego Union Tribune*, November 2, 2005, http://legacy.sandiegouniontribune.com/uniontrib/20051102/news _1c02jarhead.html.
10 These documents were obtained by Tom Secker and released at SpyCulture .com: http://www.spyculture.com/biggest-ever-foia-release-from-pentagon -entertainment-liaison-office/; "USMC Television and Motion Picture Liaison Office: Los Angeles Weekly Reports, 2008–2015" (2015), http://www.mediafire .com/file/ejobce8tymr67m7/USMC-ELOreports-2008to2015.pdf; "OCPA-West Weekly Reports, 2010–2015" (Army Entertainment Liaison Office, 2015), http:// www.mediafire.com/file/28ocunxxp32660e/USArmy-EntertainmentLiaisonOffice -2010to2015reports.pdf.
11 Sarah LeTrent and Holly Yan, "Michael Moore Explains Snipers Are 'Cowards' Tweet," *CNN*, January 20, 2015, http://www.cnn.com/2015/01/20/entertainment/ feat-michael-moore-sniper-tweet/.
12 Eddy Moretti, "Michael Moore Talks to *Vice* about *American Sniper*, the End of Sarah Palin, and PTSD," *Vice*, February 2, 2015, http://www.vice.com/read/ exclusive-interview-michael-moore-on-american-sniper-sarah-palin-and-ptsd-261.
13 Susan Sontag, *On Photography* (New York: Farrar, Straus, and Giroux, 1977), 14–15.
14 Rosenberg, "*American Sniper*'s Missing Element."
15 Alexander Nazaryan, "*American Sniper* and the Soul of War," *Newsweek*, January 16, 2015, http://www.newsweek.com/2015/01/30/american-sniper-and-soul-war -299987.html.
16 Paul Virilio, *War and Cinema: The Logistics of Perception* (New York: Verso, 1989), 83.
17 Michel Foucault, *Security, Territory, Population: Lectures at the Collège de France 1977–1978*, ed. Michel Senellart, trans. Graham Burchell (New York: Palgrave Macmillan, 2009), 151.
18 Foucault, 165.
19 Michel Foucault, *The Birth of Biopolitics: Lectures at the Collège de France, 1978–1979*, ed. Michel Senellart, trans. Graham Burchell (New York: Palgrave Macmillan, 2008); Michel Foucault, *The History of Sexuality*, vol. 1, *An Introduction* (New York: Vintage Books, 1990).
20 Foucault, *Security, Territory, Population*, 149.
21 Foucault, 127.
22 Foucault, 66, 117.
23 Foucault, 179.
24 Foucault, 180.
25 Foucault, 170.
26 Christopher Mayes, "'The Violence of Care: An Analysis of Foucault's Pastor,'" *Journal for Cultural and Religious Theory* 11, no. 1 (2010).
27 Kyle, McEwen, and DeFelice, *American Sniper*, chap. "Prologue: Evil in the Crosshairs."
28 Edwin Black, "The Second Persona," *Quarterly Journal of Speech* 56, no. 2 (1970): 115.
29 Kyle, McEwen, and DeFelice, *American Sniper*, chap. "Prologue: Evil in the Crosshairs."

30 Such frames are not new, of course. Engelhardt provides a robust discussion of the frontier myth, especially as it recurred in the coverage of the Persian Gulf War. See Tom Engelhardt, "The Gulf War as Total Television," in *Seeing through the Media: The Persian Gulf War*, ed. Susan Jeffords and Lauren Rabinovitz (New Brunswick, N.J.: Rutgers University Press, 1994), 86.

31 Isaac Guzman, "*American Sniper*: When the Hero Dies at the End," *Time*, December 1, 2014, 110, http://time.com/3596959/american-sniper-hero-dies/.

32 Amanda Taub, "Every Movie Rewrites History. What *American Sniper* Did Is Much, Much Worse," *Vox*, January 22, 2015, http://www.vox.com/2015/1/22/7859791/american-sniper-iraq; David Edelstein, "Clint Eastwood Turns *American Sniper* into a Republican Platform Movie," *Vulture*, January 16, 2015, http://www.vulture.com/2014/12/movie-review-american-sniper.html; Andrew Pulver, "*American Sniper*: Propaganda Movie or Tale the Nation Needed to Hear?," *Guardian*, January 23, 2015, https://www.theguardian.com/film/2015/jan/23/american-sniper-propaganda-political-row; Erik Kain, "*American Sniper* Isn't Pro-war Propaganda," *Forbes*, January 29, 2015, http://www.forbes.com/sites/erikkain/2015/01/29/american-sniper-isnt-pro-war-propaganda/#518c55674ie0.

33 Jessica Chasmar, "Seth Rogen Compares *American Sniper* to Nazi Propaganda," *Washingtion Times*, January 19, 2015, http://www.washingtontimes.com/news/2015/jan/19/seth-rogen-compares-american-sniper-to-nazi-propag/.

34 The two most extensive studies of this relationship in recent years are David L. Robb, *Operation Hollywood: How the Pentagon Shapes and Censors the Movies* (Amherst, N.Y.: Prometheus Books, 2004); Matthew Alford, *Reel Power: Hollywood Cinema and American Supremacy* (London: Pluto Press, 2010).

35 Ann Hornaday, "'Act of Valor' with Real-Life SEALs: New Breed of War Movie or Propaganda?," *Washington Post*, February 22, 2012, https://www.washingtonpost.com/lifestyle/style/act-of-valor-with-real-life-seals-new-breed-of-war-movie-or-propaganda/2012/02/22/gIQAYimiYR_story.html.

36 David Sirota, "Pentagon, CIA Likely Approved *Zero Dark Thirty* Torture Scenes," *Salon*, December 20, 2012, http://www.salon.com/2012/12/20/pentagon_cia_likely_approved_zero_dark_thirty_torture_scenes/.

37 Tom Hayden, "When the CIA Infiltrated Hollywood," *Salon*, February 28, 2013, http://www.salon.com/2013/02/28/is_hollywood_secretly_in_bed_with_the_cia_partner/.

38 The most significant of these yielded the largest cache of documents pertaining military entertainment liaison offices yet released. Made by writer Tom Secker and Bath University professor Matthew Alford, the request returned over 3,000 document pages from the marines (2008–15), army (2010–15) and air force (2014–15). Janine Yaqoob, "Iron Man and Transformers Censored by US Military for Getting Too Close to the Truth," July 11, 2015, http://www.mirror.co.uk/news/world-news/iron-man-transformers-censored-military-6050507; FOIA documents on file at Tom Secker, "Biggest Ever FOIA Release from Pentagon Entertainment Liaison Offices," *Spy Culture*, July 12, 2015, http://www.spyculture.com/biggest-ever-foia-release-from-pentagon-entertainment-liaison-office/. In a separate instance, J. K. Trotter, a journalist with *Gawker*, made an FOIA request for any correspondence between the navy's Information Office, the most likely collaborator, and the producers of *American Sniper*. Again, the response stated that no documents of the kind existed. J. K. Trotter, "*American Sniper* Correspondence," *MuckRock*, accessed January 22, 2016, https://www.muckrock.com/foi/united-states-of-america-10/

american-sniper-correspondence-15535/; J. K. Trotter, "*American Sniper* Correspondence (DOD)," *MuckRock*, accessed January 22, 2016, https://www.muckrock.com/foi/united-states-of-america-10/american-sniper-correspondence-dod-22343/.

39 Taub, "Every Movie Rewrites History."

40 Eliana Dockterman, "Clint Eastwood Says *American Sniper* Is Anti-war," *Time*, March 17, 2015, http://time.com/3747428/clint-eastwood-american-sniper-anti-war/.

41 Dockterman; Dean Obeidallah, "*American Sniper* a Powerful Anti-war Film," *CNN*, accessed July 4, 2016, http://www.cnn.com/2015/01/27/opinion/obeidallah-american-sniper/index.html.

42 Paul Mann, *Masocriticism* (Albany, N.Y.: SUNY Press, 1999), 100.

43 Alex Needham, "Bradley Cooper Denies *American Sniper* Is 'a Political Movie,'" *Guardian*, December 16, 2014, sec. Film, https://www.theguardian.com/film/2014/dec/16/bradley-cooper-american-sniper-not-political.

44 Robert Hardt Jr, "Veep: Durn Right W.'s a 'Cowboy,'" *New York Post*, March 17, 2003, http://nypost.com/2003/03/17/veep-durn-right-w-s-a-cowboy/.

45 Michael Hardt and Antonio Negri, *Multitude: War and Democracy in the Age of Empire* (New York: Penguin, 2004), 13.

46 Hardt and Negri, 56.

Chapter 6 Resistant Vision

1 Alissa Rubin, Qais Mizher, and Ahmad Fadam, "2 Iraqi Journalists Killed as U.S. Forces Clash with Militias," *New York Times*, July 13, 2007, http://www.nytimes.com/2007/07/13/world/middleeast/13iraq.html.

2 Greg Mitchell, "When WikiLeaks Came to Fame, Two Years Ago, with 'Collateral Murder,'" *Nation*, April 5, 2012, https://www.thenation.com/article/when-wikileaks-came-fame-two-years-ago-collateral-murder/.

3 Kim Zetter, "U.S. Soldier on 2007 Apache Attack: What I Saw," *Wired*, April 20, 2010, https://www.wired.com/2010/04/2007-iraq-apache-attack-as-seen-from-the-ground/.

4 Vijay Prashad, "Bradley Manning, Crimes against Humanity and the Values of International Law," *Counterpunch*, August 22, 2013, http://www.counterpunch.org/2013/08/22/bradley-manning-crimes-against-humanity-and-the-values-of-international-law/. See also David Montgomery and David Montgomery, "What Happened in Iraq?," *Washington Post*, February 17, 2012, https://www.washingtonpost.com/lifestyle/style/what-happened-in-iraq/2012/02/17/gIQAo80CSR_story.html.

5 Louis Althusser, *Lenin and Philosophy and Other Essays*, trans. Ben Brewster (New York: Monthly Review Press, 1972), 180.

6 McKenzie Wark, *Virtual Geography: Living with Global Media Events* (Bloomington: Indiana University Press, 1994).

7 A full survey of resistant acts might otherwise extend at least back through the Persian Gulf War. Along the way there have been notable efforts to destabilize this gaze. For example, on February 2, 1991, Ramsey Clark, former attorney general under President Johnson, traveled far outside the press pools to video document the stories of civilians who were at the time enduring the heavy U.S. bombing. The resulting film, *Nowhere to Hide* (1991), singularly challenged the dictates of smart bomb vision and the near absolute erasure of the Iraqi people from the screen. In

the wake of the Iraq War a decade later, two adventurous documentary films, *Iraq in Fragments* (2006) and *Homeland: Iraq Year Zero* (2015), again gave full-throated voice to those under occupation.

8 Vegas Tenold, "The Untold Casualties of the Drone War," *Rolling Stone*, February 18, 2016, http://www.rollingstone.com/politics/news/the-untold-casualties-of -the-drone-war-20160218.

9 Indeed, the drama looks very much like the tests of human nature that Anna McCarthy notes can be traced from Milgram to *Candid Camera* and on through the confessionals of present-day reality TV. Anna McCarthy, "Stanley Milgram, Allan Funt, and Me: Postwar Social Science and the 'First Wave' of Reality TV," in *Reality TV: Remaking Television Culture*, ed. Susan Murray and Laurie Ouellette (New York: NYU Press, 2004), 19–39.

10 Matthew Power, "Confessions of an American Drone Operator," *GQ*, October 23, 2013, http://www.gq.com/story/drone-uav-pilot-assassination.

11 "Former Drone Operator Says He's Haunted by His Part in More Than 1,600 Deaths," *NBC Investigations*, June 6, 2013, http://investigations.nbcnews.com/ _news/2013/06/06/18787450-former-drone-operator-says-hes-haunted-by-his-part -in-more-than-1600-deaths.

12 Nicola Abé, "Dreams in Infrared: The Woes of an American Drone Operator," *Spiegel Online*, December 14, 2012, http://www.spiegel.de/international/world/ pain-continues-after-war-for-american-drone-pilot-a-872726.html.

13 Heather Linebaugh, "I Worked on the US Drone Program. The Public Should Know What Really Goes On," *Guardian*, December 29, 2013, https://www .theguardian.com/commentisfree/2013/dec/29/drones-us-military; John O. Brennan, "Brennan's Speech on Counterterrorism, April 2012," *Council on Foreign Relations*, April 30, 2012, http://www.cfr.org/counterterrorism/brennans-speech -counterterrorism-april-2012/p28100.

14 Tenold, "Untold Casualties"; Ed Pilkington, "Life as a Drone Operator: 'Ever Step on Ants and Never Give It Another Thought?,'" *Guardian*, November 19, 2015, https://www.theguardian.com/world/2015/nov/18/life-as-a-drone-pilot-creech-air -force-base-nevada.

15 Power, "Confessions of Drone Operator."

16 Alice Ross, "Former US Drone Technicians Speak Out against Programme in Brussels," *Guardian*, July 1, 2016, https://www.theguardian.com/world/2016/jul/01/us -drone-whistleblowers-brussels-european-parliament.

17 Power, "Confessions of Drone Operator."

18 Abé, "Dreams in Infrared."

19 Holland Cotter, "Art in Review; Trevor Paglen," *New York Times*, December 15, 2006, http://www.nytimes.com/2006/12/15/arts/art-in-review-trevor-paglen.html.

20 Jonah Weiner, "Prying Eyes," *New Yorker*, October 15, 2012, http://www.newyorker .com/magazine/2012/10/22/prying-eyes.

21 Weiner.

22 Weiner.

23 Paul Harris, "Anti-drones Activists Plan Month of Protest over Obama's 'Kill' Policy," *Guardian*, March 27, 2013, http://www.theguardian.com/world/2013/mar/ 27/anti-drone-activists-protest-obama.

24 Nick Mottern, "Nick Mottern of Knowdrones," interview by Roger Stahl, *The Vision Machine*, September 21, 2011, http://thevisionmachine.com/2012/11/ innerview-nick-mottern-of-knowdrones/.

25 Joseph Delappe, "Me and My Predator: Joseph DeLappe," *Delappe.net*, 2014, http://www.delappe.net/sculptureinstallation/me-and-my-predator/.

26 Jason Koebler, "100 People around the Country Are Stamping Predator Drones on Cash," *Motherboard*, November 17, 2014, https://motherboard.vice.com/en _us/article/100-people-around-the-country-are-stamping-predator-drones-on -cash.

27 "Naming the Dead," *Bureau of Investigative Journalism*, March 6, 2017, https://vi .thebureauinvestigates.com/namingthedead.

28 Edwin Evans-Thirlwell, "In This Game You Play a Drone Pilot, Then a Drone Tar- get," *Motherboard*, October 8, 2015, https://motherboard.vice.com/en_us/article/ in-this-game-you-play-a-drone-pilot-then-a-drone-target.

29 Janon Fisher, "Drone Hoaxer Takes Aim at the NYPD," *New York Daily News*, September 26, 2012, LexisNexis Academic.

30 Mike Opelka, "New York Cops Finally Nab Artist Who Posted Embarrassing 'NYPD Drone' Posters," *Blaze*, December 9, 2012, http://www.theblaze.com/ stories/2012/12/09/new-york-cops-finally-nab-artist-who-posted-embarrassing -nypd-drone-posters/.

31 Matt Harvey and Ayamann Ismail, "Wanted 'Drone' Poster Artist Discusses How He Punked the NYPD," *Animal*, September 24, 2012, http://animalnewyork.com/ 2012/wanted-drone-poster-artist-discusses-how-he-punked-the-nypd/; Adam "Essam" Attia, interview by author, at NYU Law School, November 17, 2013.

32 Cole Stangler, "Drone Free Zone," *In These Times*, November 20, 2013, http:// inthesetimes.com/article/15910/code_pink_hosts_second_annual_anti_drone _summit/%20.

33 Shayna Jacobs, "Street Artist Whose Mock Ads Claimed NYPD Used Spy Drones Is Busted," *NY Daily News*, November 30, 2012, http://www.nydailynews.com/new -york/street-artist-mock-ads-claimed-nypd-spy-drones-busted-article-1.1210708.

34 Attia, interview by author.

35 Hamilton Nolan, "NYPD Proves Street Artist Right by Tracking Him Down and Arresting Him," *Gawker*, November 30, 2012, http://gawker.com/5964619/nypd -proves-street-artist-right-by-tracking-him-down-and-arresting-him.

36 Bill McKenna, "Drone Art: James Bridle Poses Questions in White House's Shadow," *BBC*, June 24, 2013, http://www.bbc.com/news/magazine-22997396.

37 Bruce Sterling, "An Essay on the New Aesthetic," *Wired*, April 2, 2012, https://www .wired.com/2012/04/an-essay-on-the-new-aesthetic/.

38 Alex Carp, "The Drone Shadow Catcher," *New Yorker*, December 5, 2013, http:// www.newyorker.com/tech/elements/the-drone-shadow-catcher; Andrew Blum, "The New Aesthetic: James Bridle's Drones and Our Invisible, Networked World," *Vanity Fair*, June 12, 2013, http://www.vanityfair.com/news/tech/2013/06/new -aesthetic-james-bridle-drones.

39 Nathan Reese, "James Bridle Takes Us 'Under the Shadow of the Drone,'" *Creators*, May 3, 2013, https://creators.vice.com/en_us/article/under-the-shadow-of-the -drone.

40 Charles Darwent, "Visual Art Review: 5,000 Feet Is the Best—How Truth and Fiction Became Blurred," *Independent*, August 24, 2013, http://www.independent .co.uk/arts-entertainment/art/reviews/visual-art-review-5000-feet-is-the-best-how -truth-and-fiction-became-blurred-8783611.html.

41 Pete Brook, "Aerial Photos Expose the American Prison System's Staggering Scale," *Wired*, January 9, 2015, http://www.wired.com/2015/01/josh-begley-prison-map/.

42 Nick Wingfield, "Apple Deems Drone Strike App Inappropriate," *New York Times*,
 September 3, 2012, 4, LexisNexis Academic; Steve Henn, "Drone-Tracking App
 Gets No Traction from Apple," *NPR: All Things Considered*, August 30, 2012,
 http://www.npr.org/sections/alltechconsidered/2012/08/30/160328600/drone
 -tracking-app-gets-no-traction-from-apple.
43 Spencer Ackerman and Christina Bonnington, "Apple Rejects App That Tracks U.S.
 Drone Strikes," *Wired*, August 30, 2012, http://www.wired.com/2012/08/drone
 -app/; "Tracking U.S. Drone Strikes with Tech," *MSNBC*, February 9, 2013, http://
 www.msnbc.com/msnbc/watch/tracking-us-drone-strikes-with-tech-17864259804.
44 Rebecca J. Rosen, "The Places Where America's Drones Are Striking, Now on
 Instagram," *Atlantic*, November 12, 2012, http://www.theatlantic.com/technology/
 archive/2012/11/the-places-where-americas-drones-are-striking-now-on-instagram/
 265112/.
45 Nick Hopkins, "Dronestagram—the Website Exposing the US's Secret Drone War,"
 Guardian, November 12, 2012, http://www.theguardian.com/world/shortcuts/
 2012/nov/12/dronestagram-website-us-drone-war.
46 Ackerman and Bonnington, "Apple Rejects App That Tracks U.S. Drone Strikes."
47 David Alex, "US Air Force Stops Reporting Data on Afghanistan Drone Strikes,"
 NBC News, March 10, 2013, http://usnews.nbcnews.com/_news/2013/03/10/
 17255533-us-air-force-stops-reporting-data-on-afghanistan-drone-strikes.
48 "Aerial Protest Pakistani Artists Created," *Times (London)*, April 9, 2014, Lexis-
 Nexis Academic; "Pakistan's Artistic Appeal to Drone Pilots," *Daily Telegraph*,
 April 9, 2014, LexisNexis Academic; Zach Schonfeld, "#NotABugSplat, an Art
 Project Designed to Be Seen by Drones," *Newsweek*, April 8, 2014, http://www
 .newsweek.com/notabugsplat-art-project-designed-be-seen-drones-245191; Todd
 Krainin, "Photography as a Shield: #NotABugSplat," *Reason*, April 12, 2014, http://
 reason.com/blog/2014/04/12/photography-as-a-shield-notabugsplat.
49 "#NotABugSplat," accessed March 9, 2017, https://notabugsplat.com/.
50 Bradley Graham, "Military Turns to Software to Cut Civilian Casualties," *Washing-
 ton Post*, February 21, 2003, LexisNexis Academic.
51 Fatima Bhojani, "Meet the Artists behind the Giant Poster Targeting Drone Pilots,"
 Mother Jones, April 9, 2014, http://www.motherjones.com/mojo/2014/04/drone
 -art-poster-girl-installation-pakistan.
52 "Living Under Drones: Death, Injury and Trauma to Civilians from US Drone
 Practices in Pakistan," *Living Under Drones*, September 2012, 80, https://www
 -cdn.law.stanford.edu/wp-content/uploads/2015/07/Stanford-NYU-LIVING
 -UNDER-DRONES.pdf.
53 Clive Stafford Smith, "Drones: The West's New Terror Campaign," *Guardian*,
 September 25, 2012, https://www.theguardian.com/commentisfree/2012/sep/25/
 drones-wests-terror-weapons-doodlebugs-1.
54 "Living Under Drones," 82.
55 "Living Under Drones," 57–61.
56 See for example Alexander Abad-Santos, "This 13-Year-Old Is Scared When the
 Sky Is Blue Because of Our Drones," *Atlantic*, October 29, 2013, https://www
 .theatlantic.com/politics/archive/2013/10/saddest-words-congresss-briefing
 -drone-strikes/354548/; Karen McVeigh, "Drone Strikes: Tears in Congress as Pak-
 istani Family Tells of Mother's Death," *Guardian*, October 29, 2013, https://www
 .theguardian.com/world/2013/oct/29/pakistan-family-drone-victim-testimony
 -congress.

57 David S. Cloud, "Transcripts of U.S. Drone Attack," *Los Angeles Times*, April 8, 2011, http://documents.latimes.com/transcript-of-drone-attack/. Chamayou opens his book *Theory of the Drone* with the transcript, marking it as symptomatic of the when-you-have-a-hammer ethos of the kill chain. Grégoire Chamayou, *A Theory of the Drone* (New York: The New Press, 2015), 1–9.

Chapter 7 Afterword

1 Stephen Graham, *Vertical: The City from Satellites to Bunkers* (New York: Verso, 2016), 58.
2 Tina Susman, "Poll: Civilian Toll in Iraq May Top 1M," *Los Angeles Times*, September 14, 2007, http://www.latimes.com/world/la-fg-iraq14sep14-story.html; "Iraq Conflict Has Killed a Million Iraqis: Survey," *Reuters*, January 30, 2008, http://www.reuters.com/article/us-iraq-deaths-survey-idUSL3048857920080130.
3 Paul Berger, Jim Hook, and Bacon, John, "Emotional Tributes Mark 15th Anniversary of 9/11 Horror," *USA Today*, September 11, 2016, http://www.usatoday.com/story/news/nation-now/2016/09/11/their-memories-stay-alive-ceremony-honors-victims-911-terrorist-attacks/90167014/.
4 "Military/Civilian Deaths in Iraq Study" (AP/Ipsos Poll, February 16, 2007), http://surveys.ap.org/data/Ipsos/national/2007-02-16%20AP%20Iraq-soldiers%20topline.pdf.
5 John M. Broder, "A Nation at War: The Casualties; U.S. Military Has No Count of Iraqi Dead in Fighting," *New York Times*, April 2, 2003, http://www.nytimes.com/2003/04/02/world/nation-war-casualties-us-military-has-no-count-iraqi-dead-fighting.html.
6 Geoffrey Cowley, "Bush Promised Iraqi Civilians a Better Future. What Are Their Lives like Now?," *MSNBC*, October 17, 2013, http://www.msnbc.com/msnbc/bush-promised-iraqi-civilians-better-future.
7 Jonathan Steele and Suzanne Goldenberg, "What Is the Real Death Toll in Iraq?," *Guardian*, March 19, 2008, https://www.theguardian.com/world/2008/mar/19/iraq.
8 "Iraq Body Count," *Iraq Body Count: Database*, November 8, 2016, https://www.iraqbodycount.org/database/.
9 Les Roberts et al., "Mortality before and after the 2003 Invasion of Iraq: Cluster Sample Survey," *Lancet* 364, no. 9448 (2004): 1857–64.
10 Steele and Goldenberg, "What Is the Death Toll?"
11 Gilbert Burnham et al., "Mortality after the 2003 Invasion of Iraq: A Cross-Sectional Cluster Sample Survey," *Lancet* 368, no. 9545 (2006): 1421–28.
12 Steele and Goldenberg, "What Is the Death Toll?"
13 Amir H. Alkhuzai et al., "Violence-Related Mortality in Iraq from 2002 to 2006," *New England Journal of Medicine* 358, no. 5 (2008): 484–93.
14 "#1. Over One Million Iraqi Deaths Caused by US Occupation—Top 25 of 2009," *Project Censored*, April 30, 2010, http://projectcensored.org/1-over-one-million-iraqi-deaths-caused-by-us-occupation/.
15 "Iraq Body Count."
16 Peter Feuilherade, "Analysis: UNHCR Conference on Iraqi Refugee Crisis," *BBC Monitoring Middle East*, April 17, 2007, LexisNexis Academic; Nir Rosen, "The Flight from Iraq," *New York Times*, May 13, 2007, LexisNexis Academic; Ed Pilkington, "International: US Criticised for Limiting Iraqi Refugee Intake to 500," *Guardian*, January 3, 2007, LexisNexis Academic.

17 Pilkington, "International."

18 Lizzie Dearden, "Fight to Drive Isis Out of Iraqi City Will Cause 'Massive' Refugee Crisis," *Independent*, August 23, 2016, http://www.independent.co.uk/news/world/middle-east/war-against-isis-un-warns-that-offensive-to-retake-mosul-will-cause-refugee-crisis-on-massive-scale-a7205831.html; Igor Kossov, "Mosul's Growing Humanitarian Crisis Is as Bad as Feared," *USA Today*, March 15, 2017, https://www.usatoday.com/story/news/world/2017/03/15/mosul-refugees-iraq-camps/99137150.

19 Judith Butler, *Frames of War: When Is Life Grievable?* (New York: Verso, 2010), 71.

20 Stephen Gallagher, "Jessica Lynch, Simulacrum," *Peace Review* 19, no. 1 (2007): 119–28.

21 See a more extended treatment of this discourse in Roger Stahl, "Why We 'Support the Troops': Rhetorical Evolutions," *Rhetoric & Public Affairs* 12, no. 4 (2009): 541–42.

22 "Deborah Scranton's 'The War Tapes,'" *To the Best of Our Knowledge* (Wisconsin Public Radio, May 31, 2010), http://www.ttbook.org/book/deborah-scrantons-war-tapes.

23 Christina M. Smith, "Gaze in the Military: Authorial Agency and Cinematic Spectatorship in 'Drone Documentaries' from Iraq," *Continuum: Journal of Media & Cultural Studies* 30, no. 1 (2016): 95.

24 Pat Aufderheide, "Your Country, My Country: How Films about the Iraq War Construct Publics," *Framework: The Journal of Cinema and Media* 48, no. 2 (2007): 61.

25 Smith, "Gaze in the Military," 95.

26 Kevin McSorley, "Helmetcams, Militarized Sensation and 'Somatic War,'" *Journal of War & Culture Studies* 5, no. 1 (2012): 55.

27 Elizabeth Weber, "Vectorizing Our Thoughts toward 'Current Events': For Avital Ronell," in *Reading Ronell*, ed. Diane Davis (Urbana: University of Illinois Press, 2009), 230.

28 Margot Norris, "Only the Guns Have Eyes: Military Censorship and the Body Count," in *Seeing through the Media: The Persian Gulf War,* ed. Susan Jeffords and Lauren Rabinovitz (New Brunswick, N.J.: Rutgers University Press, 1994), 285–300.

29 Sue Tait, "Pornographies of Violence? Internet Spectatorship on Body Horror," *Critical Studies in Media Communication* 25, no. 1 (March 2008): 91–111.

30 Erik Ortiz, "'I Was Scared to Death': U.S. Soldier Who Made Helmet-Cam Video Identified," *NY Daily News*, January 28, 2013, http://www.nydailynews.com/news/world/u-s-soldier-made-helmet-cam-video-identified-article-1.1249696.

31 Rebecca L. Stein, "GoPro Occupation: Networked Cameras, Israeli Military Rule, and the Digital Promise," *Current Anthropology* 58, no. 15 (2017): S56–64.

32 Robert Booth, "The Killing of Osama Bin Laden: How the White House Changed Its Story," *Guardian*, May 4, 2011, https://www.theguardian.com/world/2011/may/04/osama-bin-laden-killing-us-story-change.

33 Booth, "Killing of Osama Bin Laden."

34 John Arquilla and David F. Ronfeldt, *The Advent of Netwar* (Santa Monica, Calif.: RAND, 1996).

35 Buck Clay, "The F-35 of Ground Warfare: The Army's Land Warrior Program," *Business Insider*, January 12, 2016, http://uk.businessinsider.com/the-f-35-of-ground-warfare-the-armys-land-warrior-program-2016-1; Noah Shachtman, "The Army's New Land Warrior Gear: Why Soldiers Don't Like It," *Popular Mechanics*,

October 30, 2009, http://www.popularmechanics.com/technology/military/4215715.

36 Alexander R. Galloway, *Gaming: Essays on Algorithmic Culture* (Minneapolis: University of Minnesota Press, 2006), 39–69.

37 Robert Stam, "Mobilizing Fictions: The Gulf War, the Media, and the Recruitment of the Spectator," *Public Culture* 4, no. 2 (1992): 102.

38 Ben Makuch, "These POV Smart Bomb Videos Are Surreal," *Motherboard*, October 27, 2014, http://motherboard.vice.com/read/these-pov-smart-bomb-videos-are-surreal.

39 See also the interview in Patrick House, "Werner Herzog Talks Virtual Reality," *New Yorker*, January 12, 2016, http://www.newyorker.com/tech/elements/werner-herzog-talks-virtual-reality.

40 S. L. A. Marshall, *Men against Fire: The Problem of Battle Command* (Norman: University of Oklahoma Press, 2000).

41 Dave Grossman, *On Killing: The Psychological Cost of Learning to Kill in War and Society* (New York: Back Bay Books, 2009).

42 Lev Manovich, "Modern Surveillance Machines: Perspective, Radar, 3-D Computer Graphics, and Computer Vision," in *CTRL [SPACE]: Rhetorics of Surveillance from Bentham to Big Brother*, ed. Thomas Y. Levin, Ursula Frohne, and Peter Weibel (New Haven, Conn.: MIT Press, 2002), 382–95.

Bibliography

"#1. Over One Million Iraqi Deaths Caused by US Occupation—Top 25 of 2009." *Project Censored*, April 30, 2010. http://projectcensored.org/1-over-one-million-iraqi-deaths -caused-by-us-occupation/.

Abad-Santos, Alexander. "This 13-Year-Old Is Scared When the Sky Is Blue Because of Our Drones." *Atlantic*, October 29, 2013. https://www.theatlantic.com/politics/archive/2013/ 10/saddest-words-congresss-briefing-drone-strikes/354548/.

Abé, Nicola. "Dreams in Infrared: The Woes of an American Drone Operator." *Spiegel Online*, December 14, 2012. http://www.spiegel.de/international/world/pain-continues -after-war-for-american-drone-pilot-a-872726.html.

Ackerman, Spencer. "41 Men Targeted but 1,147 People Killed: US Drone Strikes—the Facts on the Ground." *Guardian*, November 24, 2014. https://www.theguardian.com/us -news/2014/nov/24/-sp-us-drone-strikes-kill-1147.

———. "Libya: The Real U.S. Drone War." *Wired*, October 20, 2011. https://www.wired .com/2011/10/predator-libya/.

———. "Pentagon Issues Drone War Talking Points." *Wired*, May 11, 2012. http://www.wired .com/dangerroom/2012/05/drone-talking-points/.

Ackerman, Spencer, and Christina Bonnington. "Apple Rejects App that Tracks U.S. Drone Strikes." *Wired*, August 30, 2012. http://www.wired.com/2012/08/drone-app/.

Ackerman, Spencer, and Noah Shachtman. "Almost 1 in 3 U.S. Warplanes Is a Robot." *Wired*, January 9, 2012. http://www.wired.com/dangerroom/2012/01/drone-report/.

Adams, James. "Pentagon Bans Video of Doomed Iraqi Driver." *Sunday Times*, February 10, 1991. LexisNexis Academic.

Adams, Richard. "Anwar Al-Awlaki Killed in Yemen—as It Happened." *Guardian*, September 30, 2011. http://www.theguardian.com/world/blog/2011/sep/30/anwar-al-awlaki -yemen-live.

Adelman, Rebecca. *Beyond the Checkpoint: Visual Practices in America's Global War on Terror.* Amherst: University of Massachusetts Press, 2014.

Aerial Bombing of Obsolete Battleships. Newsreel. Vol. 1119. Signal Corps, U.S. Army, 1921.

"Aerial Protest Pakistani Artists Created." *Times (London)*, April 9, 2014. LexisNexis Academic.

Alex, David. "US Air Force Stops Reporting Data on Afghanistan Drone Strikes." *NBC News*, March 10, 2013. http://usnews.nbcnews.com/_news/2013/03/10/17255533-us-air -force-stops-reporting-data-on-afghanistan-drone-strikes.

Alford, Matthew. *Reel Power: Hollywood Cinema and American Supremacy*. New York: Pluto Press, 2010.

Alkhuzai, Amir H., Ihsan J. Ahmad, Mohammed J. Hweel, Thakir W. Ismail, Hanan H. Hasan, Abdul Rahman Younis, Osman Shawani, et al. "Violence-Related Mortality in Iraq from 2002 to 2006." *New England Journal of Medicine* 358, no. 5 (2008): 484–93.

Althusser, Louis. *Lenin and Philosophy and Other Essays*. Translated by Ben Brewster. New York: Monthly Review Press, 1972.

"America's New Air Force." *CBS News*, August 16, 2009. http://www.cbsnews.com/video/ watch/?id=5245555n&tag=api.

Anding, Kristinha M. "On the Front Lines." *Video Systems*, June 1, 2003. EBSCO Academic Search Complete.

Andrejevic, Mark. "Interactive (In)security: The Participatory Promise of Ready.gov." *Cultural Studies* 20, no. 4–5 (September 2006): 441–58.

———. *Reality TV: The Work of Being Watched*. Critical Media Studies. Lanham, Md.: Rowman & Littlefield, 2003.

Apel, Dora. *War Culture and the Contest of Images*. New Brunswick, N.J.: Rutgers University Press, 2012.

Arlen, Michael J. *Living-Room War*. Syracuse, N.Y.: Syracuse University Press, 1997.

Arquilla, John, and David F. Ronfeldt. *The Advent of Netwar*. Santa Monica, Calif.: RAND, 1996.

Askoy, Asu, and Kevin Robins. "Exterminating Angels: Morality, Violence, and Technology in the Gulf War." In *Triumph of the Image: The Media's War in the Persian Gulf*, edited by Susan Jeffords and Lauren Rabinovitz, 202–12. Boulder, Colo.: Westview Press, 1992.

Attia, Adam "Essam." Interview by author, at NYU Law School. November 17, 2013.

Aufderheide, Pat. "Your Country, My Country: How Films about the Iraq War Construct Publics." *Framework: The Journal of Cinema and Media* 48, no. 2 (2007): 56–65.

Baliga, Ananth. "Antibiotic 'Smart Bomb' Can Target Bad Bacteria." *UPI*, January 30, 2014. http://www.upi.com/blog/2014/01/30/Antibiotic-smart-bomb-can-target-bad-bacteria/ 8961391109266/.

Ballard, J. G. "Old Bloodshed, As If in a Dream; Images of War: The Artist's Vision of World War II, Edited by Ken McCormick and Hamilton Darby Perry (Cassell, £35)." *Guardian Weekly*, March 17, 1991. LexisNexis Academic.

Barker, Martin. *A "Toxic Genre": The Iraq War Films*. London: Pluto Press, 2011.

Barney, Timothy. *Mapping the Cold War: Cartography and the Framing of America's International Power*. 2015.

Barnouw, Erik. *A Tower in Babel: A History of Broadcasting in the United States, Vol. 1—To 1933*. New York: Oxford University Press, 1966.

Baudrillard, Jean. *The Gulf War Did Not Take Place*. Bloomington: Indiana University Press, 1995.

Beauchamp, Scott. "The Moral Cost of the Kill Box." *Atlantic*, February 28, 2016. https:// www.theatlantic.com/politics/archive/2016/02/the-cost-of-the-kill-box/470751/.

Becker, Jo, and Scott Shane. "Secret 'Kill List' Proves a Test of Obama's Principles and Will." *New York Times*, May 29, 2012. http://www.nytimes.com/2012/05/29/world/obamas -leadership-in-war-on-al-qaeda.html.

Beidler, Philip D. "The Last Huey." *Mythosphere* 1, no. 1 (1997): 51–64.

Bell, Daniel. *The End of Ideology: On the Exhaustion of Political Ideas in the Fifties.* Cambridge, Mass.: Harvard University Press, 1988.

Bennett, Chuck. "Remote-Control Really Hits the Splat." *New York Post,* October 1, 2011. http://nypost.com/2011/10/01/remote-control-really-hits-the-splat/.

Berger, Paul, Jim Hook, and Bacon, John. "Emotional Tributes Mark 15th Anniversary of 9/11 Horror." *USA Today,* September 11, 2016. http://www.usatoday.com/story/news/nation-now/2016/09/11/their-memories-stay-alive-ceremony-honors-victims-911-terrorist-attacks/90167014/.

Bhojani, Fatima. "Meet the Artists behind the Giant Poster Targeting Drone Pilots." *Mother Jones,* April 9, 2014. http://www.motherjones.com/mojo/2014/04/drone-art-poster-girl-installation-pakistan.

Black, Edwin. "The Second Persona." *Quarterly Journal of Speech* 56, no. 2 (1970): 109–19.

Blum, Andrew. "The New Aesthetic: James Bridle's Drones and Our Invisible, Networked World." *Vanity Fair,* June 12, 2013. http://www.vanityfair.com/news/tech/2013/06/new-aesthetic-james-bridle-drones.

Bolter, Jay David, and Richard Grusin. *Remediation: Understanding New Media.* Cambridge, Mass.: MIT Press, 2000.

Booth, Robert. "The Killing of Osama Bin Laden: How the White House Changed Its Story." *Guardian,* May 4, 2011. https://www.theguardian.com/world/2011/may/04/osama-bin-laden-killing-us-story-change.

Bowman, Lee. "Schwarzkopf Paints Blitz of Iraqis." *St. Petersburg Times,* January 31, 1991. LexisNexis Academic.

Brennan, John O. "Brennan's Speech on Counterterrorism, April 2012." *Council on Foreign Relations,* April 30, 2012. http://www.cfr.org/counterterrorism/brennans-speech-counterterrorism-april-2012/p28100.

Broder, John M. "A Nation at War: The Casualties; U.S. Military Has No Count of Iraqi Dead in Fighting." *New York Times,* April 2, 2003. http://www.nytimes.com/2003/04/02/world/nation-war-casualties-us-military-has-no-count-iraqi-dead-fighting.html.

Brook, Pete. "Aerial Photos Expose the American Prison System's Staggering Scale." *Wired,* January 9, 2015. http://www.wired.com/2015/01/josh-begley-prison-map/.

Buchannan, Patrick J. "The Return of Globocop; If 'the World' Loathes Saddam, Where Are Our Allies?" *New York Post,* January 31, 1998. LexisNexis Academic.

Burke, Kenneth. *A Grammar of Motives.* Berkeley: University of California Press, 1969.

Burnham, Gilbert, Riyadh Lafta, Shannon Doocy, and Les Roberts. "Mortality after the 2003 Invasion of Iraq: A Cross-Sectional Cluster Sample Survey." *Lancet* 368, no. 9545 (2006): 1421–28.

Bush, George W. "Address to a Joint Session of Congress and the American People." September 20, 2001. https://georgewbush-whitehouse.archives.gov/news/releases/2001/09/20010920-8.html.

Butler, Judith. "Contingent Foundations: Feminism and the Question of 'Postmodernism.'" In *Feminists Theorize the Political,* edited by Judith Butler and Joan W. Scott, 3–21. New York: Routledge, 1992.

———. *Frames of War: When Is Life Grievable?* New York: Verso, 2010.

Carp, Alex. "The Drone Shadow Catcher." *New Yorker,* December 5, 2013. http://www.newyorker.com/tech/elements/the-drone-shadow-catcher.

Carruthers, Susan. *The Media at War: Communication and Conflict in the Twentieth Century.* New York: St. Martin's Press, 2000.

Carter, Jimmy. "Kennedy Space Center, Florida Remarks at the Congressional Space Medal of Honor Awards Ceremony." The American Presidency Project, October 1, 1978. http://www.presidency.ucsb.edu/ws/?pid=29897.

Catapano, Peter. "War of Semantics." *Opinionator*. Accessed June 25, 2015. http://opinionator.blogs.nytimes.com/2011/03/25/war-of-semantics/.

Chamayou, Grégoire. *A Theory of the Drone*. New York: The New Press, 2015.

Chaplin, Heather, and Aaron Ruby. *Smartbomb: The Quest for Art, Entertainment, and Big Bucks in the Videogame Revolution*. Reprint ed. Chapel Hill, N.C.: Algonquin Books, 2006.

Chasmar, Jessica. "Seth Rogen Compares *American Sniper* to Nazi Propaganda." *Washington Times*, January 19, 2015. http://www.washingtontimes.com/news/2015/jan/19/seth-rogen-compares-american-sniper-to-nazi-propag/.

Chassay, Clancy, and Bobby Johnson. "Inside Gaza: Google Earth Used to Target Israel: Militants Use Google Earth to Target Israel." *Guardian*, October 25, 2007. LexisNexis Academic.

Chow, Rey. *The Age of the World Target: Self-Referentiality in War, Theory, and Comparative Work*. Durham, N.C.: Duke University Press, 2006.

Clarke, Keith C. "Maps and Mapping Technologies of the Persian Gulf War." *Cartography and Geographic Information Systems* 19, no. 2 (1992): 80–87.

Clay, Buck. "The F-35 of Ground Warfare: The Army's Land Warrior Program." *Business Insider*, January 12, 2016. http://uk.businessinsider.com/the-f-35-of-ground-warfare-the-armys-land-warrior-program-2016-1.

Cloud, David S. "Transcripts of U.S. Drone Attack." *Los Angeles Times*, April 8, 2011. http://documents.latimes.com/transcript-of-drone-attack/.

Cloud, John. "American Cartographic Transformations during the Cold War." *Cartography and Geographic Information Science* 29, no. 3 (2002): 261–82.

———. "Crossing the Olentangy River: The Figure of the Earth and the Military-Industrial-Academic-Complex, 1947–1972." *Studies in History and Philosophy of Science* 31, no. 3 (2000): 371–404.

Cody, Edward. "Allies Claim to Bomb Iraqi Targets at Will; U.S. Commander Says Opponents Not Giving Up." *Washington Post*, January 30, 1991. LexisNexis Academic.

Cole, Matthew, and Sheelagh McNeill. "'American Sniper' Chris Kyle Distorted His Military Record, Documents Show." *Intercept*, May 25, 2016. https://theintercept.com/2016/05/25/american-sniper-chris-kyle-distorted-his-military-record-documents-show/.

Cornish, David. "ESA Launches Drone App to Crowdsource Flight Data." *Ars Technica*, March 17, 2013. http://arstechnica.com/gadgets/2013/03/esa-launches-drone-app-to-crowdsource-flight-data/.

Cosgrove, Denis. *Apollo's Eye: A Cartographic Genealogy of the Earth in the Western Imagination*. Baltimore: Johns Hopkins University Press, 2003.

Cotter, Holland. "Art in Review; Trevor Paglen." *New York Times*, December 15, 2006. http://www.nytimes.com/2006/12/15/arts/art-in-review-trevor-paglen.html.

Cowley, Geoffrey. "Bush Promised Iraqi Civilians a Better Future. What Are Their Lives like Now?" *MSNBC*, October 17, 2013. http://www.msnbc.com/msnbc/bush-promised-iraqi-civilians-better-future.

"Crisis in the Gulf: Apache Pilots in Ground Attack Shooting Gallery." *Independent*, February 25, 1991. LexisNexis Academic.

Darwent, Charles. "Visual Art Review: 5,000 Feet Is the Best—How Truth and Fiction Became Blurred." *Independent*, August 24, 2013. http://www.independent.co.uk/arts-entertainment/art/reviews/visual-art-review-5000-feet-is-the-best-how-truth-and-fiction-became-blurred-8783611.html.

Dean, Jodi. *Publicity's Secret: How Technoculture Capitalizes on Democracy*. Ithaca, N.Y.: Cornell University Press, 2002.

Dearden, Lizzie. "Fight to Drive Isis Out of Iraqi City Will Cause 'Massive' Refugee Crisis." *Independent*, August 23, 2016. http://www.independent.co.uk/news/world/middle-east/war-against-isis-un-warns-that-offensive-to-retake-mosul-will-cause-refugee-crisis-on-massive-scale-a7205831.html.

"Deborah Scranton's 'The War Tapes.'" *To the Best of Our Knowledge*. Wisconsin Public Radio, May 31, 2010. http://www.ttbook.org/book/deborah-scrantons-war-tapes.

"Defense Department Briefing." *Federal News Service*, January 22, 1991. LexisNexis Academic.

Delappe, Joseph. "Me and My Predator: Joseph DeLappe." *Delappe.net*, 2014. http://www.delappe.net/sculptureinstallation/me-and-my-predator/.

Deparle, Jason. "AFTER THE WAR; Keeping the News in Step: Are the Pentagon's Gulf War Rules Here to Stay?" *New York Times*, May 6, 1991. http://www.nytimes.com/1991/05/06/world/after-war-keeping-step-are-pentagon-s-gulf-war-rules-here-stay.html.

Der Derian, James. "The (S)pace of International Relations: Simulation, Surveillance, and Speed." *International Studies Quarterly* 34, no. 3 (1990): 295–310.

Desert Storm: The War Begins. CNN, 1991.

Devereaux, Ryan. "Obama Administration Finally Releases Its Dubious Drone Death Toll." *Intercept*, July 1, 2016. https://theintercept.com/2016/07/01/obama-administration-finally-releases-its-dubious-drone-death-toll/.

Diebel, Linda. "Pentagon Now Urged to Prove Its Claims." *Toronto Star*, January 21, 1991. LexisNexis Academic.

"Digital Nation." *PBS: Frontline*, February 2, 2010. http://video.pbs.org/video/2175892463/.

"DigitalGlobe and Keyhole Deliver QuickBird Imagery to New Business Customers and Consumers with Internet 3D Earth Visualization Applications." *PR Newswire*, January 27, 2004. LexisNexis Academic.

"Discoverer Capsule Falls in the Arctic; Recovery Is Possible." *New York Times*, April 16, 1959. ProQuest Historical Newspapers.

Dobbs, Michael. "Gary Powers Kept a Secret Diary with Him after He Was Captured by the Soviets." *Smithsonian*, October 15, 2015. http://www.smithsonianmag.com/smithsonian-institution/gary-powers-secret-diary-soviet-capture-180956939/.

Dockterman, Eliana. "Clint Eastwood Says *American Sniper* Is Anti-war." *Time*, March 17, 2015. http://time.com/3747428/clint-eastwood-american-sniper-anti-war/.

———. "The True Story behind *American Sniper*." *Time*, January 20, 2015. http://time.com/3672295/american-sniper-fact-check/.

"Drone War." *Bureau of Investigative Journalism*. Accessed March 3, 2017. https://www.thebureauinvestigates.com/projects/drone-war.

"Drones Are Lynchpin of Obama's War on Terror." *Spiegel Online*, December 3, 2010. http://www.spiegel.de/international/world/0,1518,682612,00.html.

Edelstein, David. "Clint Eastwood Turns *American Sniper* into a Republican Platform Movie." *Vulture*, January 16, 2015. http://www.vulture.com/2014/12/movie-review-american-sniper.html.

Edgerton, Gary. *The Columbia History of American Television*. New York: Columbia University Press, 2010.

Eisler, Peter. "Commercial Satellites Alter Global Security; High-Definition Imagery Is Readily Available, Not Only to the World's Superpowers but to the Average Person with Computer Access." *USA Today*, November 7, 2008. LexisNexis Academic.

Elliot, Larry. "War in the Gulf: Toys a Hit with the Boys." *Guardian*, January 19, 1991. LexisNexis Academic.

Engelhardt, Tom. "The Gulf War as Total Television." In *Seeing through the Media: The Persian Gulf War*, edited by Susan Jeffords and Lauren Rabinovitz, 81–95. New Brunswick, N.J.: Rutgers University Press, 1994.

Evans-Thirlwell, Edwin. "In This Game You Play a Drone Pilot, Then a Drone Target." *Motherboard*, October 8, 2015. https://motherboard.vice.com/en_us/article/in-this-game-you-play-a-drone-pilot-then-a-drone-target.

Feuilherade, Peter. "Analysis: UNHCR Conference on Iraqi Refugee Crisis." *BBC Monitoring Middle East*, April 17, 2007. LexisNexis Academic.

Finn, Peter. "The Do-It-Yourself Origins of the Drone." *Washington Post*, December 24, 2011. LexisNexis Academic.

Finneys, John W. "Pictures of Earth Are Transmitted by Satellite." *New York Times*, September 29, 1959. ProQuest Historical Newspapers.

Fisher, Janon. "Drone Hoaxer Takes Aim at the NYPD." *New York Daily News*, September 26, 2012. LexisNexis Academic.

"Former Drone Operator Says He's Haunted by His Part in More Than 1,600 Deaths." *NBC Investigations*, June 6, 2013. http://investigations.nbcnews.com/_news/2013/06/06/18787450-former-drone-operator-says-hes-haunted-by-his-part-in-more-than-1600-deaths.

Foucault, Michel. *The Birth of Biopolitics: Lectures at the Collège de France, 1978–1979*. Edited by Michel Senellart. Translated by Graham Burchell. New York: Palgrave Macmillan, 2008.

———. *The History of Sexuality*. Vol. 1, *An Introduction*. New York: Vintage Books, 1990.

———. *Security, Territory, Population: Lectures at the Collège de France 1977–1978*. Edited by Michel Senellart. Translated by Graham Burchell. New York: Palgrave Macmillan, 2009.

Franklin, H. Bruce. *Vietnam and Other American Fantasies*. Amherst: University of Massachusetts Press, 2000.

———. *War Stars: The Superweapon and the American Imagination*. 2nd ed. Amherst: University of Massachusetts Press, 2008.

Friedersdorf, Conor. "How Team Obama Justifies the Killing of a 16-Year-Old American." *Atlantic*, October 24, 2012. https://www.theatlantic.com/politics/archive/2012/10/how-team-obama-justifies-the-killing-of-a-16-year-old-american/264028/.

Fujii, Reed. "Virtual Flights Possible with Internet Technology, Aerial Imaging." *Record*, April 14, 2003. LexisNexis Academic.

Fukuyama, Francis. *The End of History and the Last Man*. New York: Free Press, 2006.

Gallagher, Stephen. "Jessica Lynch, Simulacrum." *Peace Review* 19, no. 1 (2007): 119–28.

Galloway, Alexander R. *Gaming: Essays on Algorithmic Culture*. Minneapolis: University of Minnesota Press, 2006.

Gates, Robert. "Quadrennial Defense Review." United States Department of Defense, February 2010. http://www.defense.gov/qdr/images/QDR_as_of_12Feb10_1000.pdf.

"Geotech Industry Bolsters War Coverage." *GEO World*, May 1, 2003. LexisNexis Academic.

"Get the Data: Drone Wars Archives." *Bureau of Investigative Journalism*, February 3, 2017. https://www.thebureauinvestigates.com/category/projects/drones/drones-graphs/.

Godspeed, Peter. "The Google Hunt: Surfing for Missiles, Subs on the Web." *National Post*, September 16, 2006. LexisNexis Academic.

Goodman, Walter. "TV Weekend; 'Desert Storm,' Four-Part Replay of the Gulf War." *New York Times*, June 28, 1991. LexisNexis Academic.

Graef, Roger. "Television through the Distorting Lens." *Sunday Times*, May 10, 1998. LexisNexis Academic.

Graham, Bradley. "Military Turns to Software to Cut Civilian Casualties." *Washington Post*, February 21, 2003. LexisNexis Academic.

Graham, Stephen. *Vertical: The City from Satellites to Bunkers*. New York: Verso, 2016.

Greenwald, Glenn. "Deliberate Media Propaganda." *Salon*, June 2, 2012. http://www.salon .com/2012/06/02/deliberate_media_propaganda/.

Gregory, Derek. "From a View to a Kill: Drones in Late Modern War." *Theory, Culture & Society* 28, no. 7–8 (2011): 188–215.

Grim, Ryan. "Robert Gibbs Says Anwar Al-Awlaki's Son, Killed by Drone Strike, Needs 'Far More Responsible Father.'" *Huffington Post*, October 24, 2012. http://www .huffingtonpost.com/2012/10/24/robert-gibbs-anwar-al-awlaki_n_2012438.html.

Grossman, Dave. *On Killing: The Psychological Cost of Learning to Kill in War and Society.* New York: Back Bay Books, 2009.

Guilliat, Thomas H. "'Someone Is Trying to Kill Me'—Crews Face Grim Reality of War." *Sunday Herald*, January 20, 1991. LexisNexis Academic.

Gulbert, Martin. *Winston S. Churchill, Vol. 3, Companion Part 1, Documents: July 1914–April 1915.* London: Heinmann, 1972.

"Gulf Coalition Blamed for High Civilian Toll." *Toronto Star*, November 17, 1991. LexisNexis Academic.

Guzman, Isaac. "*American Sniper*: When the Hero Dies at the End." *Time*, December 1, 2014. http://time.com/3596959/american-sniper-hero-dies/.

Hafner, Katie, Saritha Rai, and Andrew E. Kramer. "Google Offers a Bird's-Eye View, and Some Governments Tremble." *New York Times*, December 20, 2005. LexisNexis Academic.

Hallin, Daniel C. "Images of the Vietnam and the Persian Gulf Wars in U.S. Television." In *Seeing through the Media: The Persian Gulf War*, edited by Susan Jeffords and Lauren Rabinovitz, 45–58. New Brunswick, N.J.: Rutgers University Press, 1994.

———. *The "Uncensored War": The Media and Vietnam.* New York: Oxford University Press, 1986.

Hallin, Daniel C., and Todd Gitlin. "Agon and Ritual: The Gulf War as Popular Culture and as Television Drama." *Political Communication* 10 (1993): 411–24.

Hammond, William M. "The Press in Vietnam as Agent of Defeat: A Critical Examination." *Reviews in American History* 17, no. 2 (1989): 312–23.

Haraway, Donna. *Simians, Cyborgs, and Women: The Reinvention of Nature.* New York: Routledge, 1991.

———. "Teddy Bear Patriarchy: Taxidermy in the Garden of Eden, New York City, 1908–1936." *Social Text*, no. 11 (Winter 1984–85): 20–64.

Hardt, Michael, and Antonio Negri. *Multitude: War and Democracy in the Age of Empire.* New York: Penguin, 2004.

Hardt, Robert, Jr. "Veep: Durn Right W.'s a 'Cowboy.'" *New York Post*, March 17, 2003. http://nypost.com/2003/03/17/veep-durn-right-w-s-a-cowboy/.

Harris, Paul. "Anti-drones Activists Plan Month of Protest over Obama's 'Kill' Policy." *Guardian*, March 27, 2013. http://www.theguardian.com/world/2013/mar/27/anti -drone-activists-protest-obama.

Harte, Walter. *The History of the Life of Gustavus Adolphus, King of Sweden.* Vol. 1. London: Printed for the author, 1759. https://archive.org/details/historyoflifeofgo1hart.

Harvey, Matt, and Ayamann Ismail. "Wanted 'Drone' Poster Artist Discusses How He Punked the NYPD." *Animal*, September 24, 2012. http://animalnewyork.com/2012/ wanted-drone-poster-artist-discusses-how-he-punked-the-nypd/.

Hayden, Tom. "When the CIA Infiltrated Hollywood." *Salon*, February 28, 2013. http:// www.salon.com/2013/02/28/is_hollywood_secretly_in_bed_with_the_cia_partner/.

Heidegger, Martin. *The Question Concerning Technology and Other Essays.* Translated by William Lovitt. New York: Garland, 1977.

Heller, Jean. "Photos Don't Show Buildup." *St. Petersburg Times*, January 6, 1991. LexisNexis Academic.

Henn, Steve. "Drone-Tracking App Gets No Traction from Apple." *NPR: All Things Considered*, August 30, 2012. http://www.npr.org/sections/alltechconsidered/2012/08/30/160328600/drone-tracking-app-gets-no-traction-from-apple.

Herr, Michael. *Dispatches*. New York: Vintage, 2011.

Herz, J. C. *Joystick Nation*. New York: Little, Brown, 1997.

Hines, Nico. "Obama Schmoozes the Fourth Estate with Gags and Gaffes at Charity White House Bash." *Times (London)*, May 3, 2010. LexisNexis Academic.

Hoffman, Bruce. "The Logic of Suicide Terrorism." *Atlantic*, June 2003. http://www.theatlantic.com/magazine/archive/2003/06/the-logic-of-suicide-terrorism/302739/.

Holden, Stephen. "Review: *Eye in the Sky*, Drone Precision vs. Human Failings." *New York Times*, March 10, 2016. https://www.nytimes.com/2016/03/11/movies/review-eye-in-the-sky-drone-precision-vs-human-failings.html.

———. "Review: 'Good Kill' Stars Ethan Hawke Fighting Enemies Half a World Away." *New York Times*, May 14, 2015. https://www.nytimes.com/2015/05/15/movies/review-good-kill-stars-ethan-hawke-fighting-enemies-half-a-world-away.html?referrer=google_kp&_r=0.

Holder, Eric. "Attorney General Eric Holder Speaks at Northwestern University School of Law." *United States Department of Justice*, March 5, 2012. http://www.justice.gov/iso/opa/ag/speeches/2012/ag-speech-1203051.html.

Hopkins, Nick. "Dronestagram—the Website Exposing the US's Secret Drone War." *Guardian*, November 12, 2012. http://www.theguardian.com/world/shortcuts/2012/nov/12/dronestagram-website-us-drone-war.

Hornaday, Ann. "'Act of Valor' with Real-Life SEALs: New Breed of War Movie or Propaganda?" *Washington Post*, February 22, 2012. https://www.washingtonpost.com/lifestyle/style/act-of-valor-with-real-life-seals-new-breed-of-war-movie-or-propaganda/2012/02/22/gIQAY1miYR_story.html.

House, Patrick. "Werner Herzog Talks Virtual Reality." *New Yorker*, January 12, 2016. http://www.newyorker.com/tech/elements/werner-herzog-talks-virtual-reality.

"How Many Iraqi Soldiers Died?" *Time*, June 17, 1991.

"I-Cubed Creates Satellite Mosaic of Middle East for Media Use." *Business Wire*, April 16, 2003. LexisNexis Academic.

"In-Q-Tel Announces Strategic Investment in Keyhole; NIMA Uses Technology to Support the Conflict in Iraq." *PR Newswire*, June 25, 2003. LexisNexis Academic.

"Iraq Body Count." *Iraq Body Count: Database*, November 8, 2016. https://www.iraqbodycount.org/database/.

"Iraq Conflict Has Killed a Million Iraqis: Survey." *Reuters*, January 30, 2008. http://www.reuters.com/article/us-iraq-deaths-survey-idUSL3048857920080130.

Isikoff, Michael. "Justice Department Memo Reveals Legal Case for Drone Strikes on Americans." *NBC News*, February 4, 2013. http://openchannel.nbcnews.com/_news/2013/02/04/16843014-justice-department-memo-reveals-legal-case-for-drone-strikes-on-americans.

Ivie, Robert L. "Images of Savagery in American Justifications for War." *Communication Monographs* 47, no. 4 (1980): 279–91.

———. "Savagery in Democracy's Empire." *Third World Quarterly* 26, no. 1 (2005): 55–65.

Jacobs, Shayna. "Street Artist Whose Mock Ads Claimed NYPD Used Spy Drones Is Busted." *NY Daily News*, November 30, 2012. http://www.nydailynews.com/new-york/street-artist-mock-ads-claimed-nypd-spy-drones-busted-article-1.1210708.

Jeffords, Susan. *Hard Bodies: Hollywood Masculinity in the Reagan Era*. New Brunswick, N.J.: Rutgers University Press, 1994.

———. "Rape and the New World Order." *Cultural Critique*, no. 19 (1991): 203–15.

Jenkins, Tricia. *CIA in Hollywood: How the Agency Shapes Film and Television*. Austin: University of Texas Press, 2012.

Jennings, Peter. "ABC News Transcripts." *ABC World News Tonight*. ABC, August 8, 1984. LexisNexis Academic.

Jensen, Ole B. "New 'Foucauldian Boomerangs': Drones and Urban Surveillance." *Surveillance and Society* 14, no. 1 (2016): 20–33.

Johnson, Chalmers A. *The Sorrows of Empire: Militarism, Secrecy, and the End of the Republic*. New York: Metropolitan Books, 2004.

Johnson, Tim. "Discovery of Military Sites Has Web Sleuths Buzzing." *Seattle Times Online*, September 13, 2006. http://seattletimes.nwsource.com/html/nationworld/2003256331 _mysteryspots13.html?syndication=rss.

Kaczynski, Andrew, and Nathan McDermott. "NSA Tried PR Effort with Film 'Enemy of the State,' Was Massively Disappointed." *BuzzFeed*, January 20, 2016. http://www .buzzfeed.com/andrewkaczynski/nsa-tried-pr-effort-with-1998-film-enemy-of-the-state -was-ma.

Kain, Erik. "*American Sniper* Isn't Pro-war Propaganda." *Forbes*, January 29, 2015. http:// www.forbes.com/sites/erikkain/2015/01/29/american-sniper-isnt-pro-war-propaganda/ #518c55674 1e0.

Kaplan, Caren. "Air Power's Visual Legacy: Operation Orchard and Aerial Reconnaissance Imagery as Ruses de Guerre." *Critical Military Studies* 1, no. 1 (2014): 68–78.

———. "Precision Targets: GPS and the Militarization of U.S. Consumer Identity." *American Quarterly* 58, no. 3 (2006): 693–714.

Kaplan, Don. "War Seen in Words; How Will News Coverage Look Minus Lots of Video?" *New York Post*, October 1, 2001. LexisNexis Academic.

Kauffman, Charles. "Names and Weapons." *Communication Monographs* 56, no. 3 (1989): 273–85.

Keefe, Bob. "Working for the CIA; Spy Agency's Venture Capital Arm Helps Fund Products to Aid National Security." *Atlanta Journal-Constitution*, October 12, 2004. LexisNexis Academic.

Kennedy, Liam, and Caitlin Patrick, eds. *The Violence of the Image: Photography and International Conflict*. London: I. B. Tauris, 2014.

Kerr, Donald M. "National Reconnaissance Office Review and Redaction Guide." National Reconnaissance Office, May 20, 2005. Federation of American Sciences. https://fas.org/ irp/nro/declass.pdf.

Koebler, Jason. "100 People around the Country Are Stamping Predator Drones on Cash." *Motherboard*, November 17, 2014. https://motherboard.vice.com/en_us/article/100 -people-around-the-country-are-stamping-predator-drones-on-cash.

Kooistra, Paul G., John S. Mahoney, and Saundra D. Westervelt. "The World of Crime according to 'Cops.'" In *Entertaining Crime: Television Reality Programs*, edited by Mark Fishman, 141–58. New York: Routledge, 1998.

Kopytoff, Verne. "Top Secret, in Plain View; Censorship Is Spotty for Aerial Shots of Vulnerable Sites." *San Francisco Chronicle*, May 18, 2007. http://www.sfgate.com/news/article/ TOP-SECRET-IN-PLAIN-VIEW-Censorship-is-spotty-2574214.php.

Kossov, Igor. "Mosul's Growing Humanitarian Crisis Is as Bad as Feared." *USA Today*, March 15, 2017. https://www.usatoday.com/story/news/world/2017/03/15/mosul -refugees-iraq-camps/99137150.

Kozol, Wendy. *Distant Wars Visible: The Ambivalence of Witnessing*. Minneapolis: University of Minnesota Press, 2014.

Krainin, Todd. "Photography as a Shield: #NotABugSplat." *Reason*, April 12, 2014. http://reason.com/blog/2014/04/12/photography-as-a-shield-notabugsplat.

Kyle, Chris, Scott McEwen, and Jim DeFelice. *American Sniper: The Autobiography of the Most Lethal Sniper in U.S. Military History*. New York: Harper Collins, 2012.

Landau, Paul S. "Empires of the Visual: Photography and Colonial Administration in Africa." In *Images and Empires: Visuality in Colonial and Postcolonial Africa*, edited by Paul S. Landau and Deborah Kaspin, 141–71. Berkeley: University of California Press, 2002.

Landay, Jonathan S. "U.S. Secret: CIA Collaborated with Pakistan Spy Agency in Drone War." *McClatchy*, April 9, 2013. http://www.mcclatchydc.com/news/nation-world/world/article24747829.html.

Lane, Earl. "The Gulf War: Smart Bombs Can Often Go Dumb." *Guardian*, February 11, 1991. LexisNexis Academic.

Lee, Philip. "'Taking the Pulse of the Planet': Leaders of the Digital Earth Concept Want to Collect Vast Amounts of Environmental and Cultural Information to Create a Digital Image of the Planet." *Ottawa Citizen*, June 30, 2001. LexisNexis Academic.

LeTrent, Sarah, and Holly Yan. "Michael Moore Explains Snipers Are 'Cowards' Tweet." *CNN*, January 20, 2015. http://www.cnn.com/2015/01/20/entertainment/feat-michael-moore-sniper-tweet/.

Letzing, John. "Google, Seeking to Diversify, Looks to Government Contracts." *MarketWatch*, March 13, 2008. LexisNexis Academic.

Levine, Daniel. "TV War Coverage Good News for Software Firm." *San Francisco Business Times*, April 11, 2003. LexisNexis Academic.

Lichtblau, Eric. "U.S. to Rely More on Private Companies' Satellite Images." *New York Times*, May 13, 2003. LexisNexis Academic.

Linebaugh, Heather. "I Worked on the US Drone Program. The Public Should Know What Really Goes On." *Guardian*, December 29, 2013. https://www.theguardian.com/commentisfree/2013/dec/29/drones-us-military.

"Living Under Drones: Death, Injury and Trauma to Civilians from US Drone Practices in Pakistan." *Living Under Drones*, September 2012. https://www-cdn.law.stanford.edu/wp-content/uploads/2015/07/Stanford-NYU-LIVING-UNDER-DRONES.pdf.

Loeb, Vernon. "Candid Cameras Cover the Bases." *Washington Post*, December 15, 2002. LexisNexis Academic.

Lubold, Gordon. "Pentagon to Sharply Expand U.S. Drone Flights Over Next Four Years." *Wall Street Journal*, August 16, 2015. http://www.wsj.com/articles/pentagon-to-add-drone-flights-1439768451.

Lubove, Seth. "We See You, Saddam." *Forbes*. Accessed January 27, 2017. http://www.forbes.com/forbes/2003/0106/102.html.

Lutz, Catherine A., and James L. Collins. *Reading National Geographic*. Chicago: University of Chicago Press, 1993.

MacDonald, Fraser, Rachel Hughes, and Klaus Dodds, eds. *Observant States: Geopolitics and Visual Culture*. 16. New York: I. B. Tauris, 2010.

Madrigal, Alexis C. "The 'Canonical' Image of a Drone Is a Rendering Dressed Up in Photoshop." *Atlantic*, March 20, 2013. https://www.theatlantic.com/technology/archive/2013/03/the-canonical-image-of-a-drone-is-a-rendering-dressed-up-in-photoshop/274177/.

The Making of "Enemy of the State." Documentary, short. 2006. http://www.imdb.com/title/tt0985098/.

Makuch, Ben. "These POV Smart Bomb Videos Are Surreal." *Motherboard*, October 27, 2014. http://motherboard.vice.com/read/these-pov-smart-bomb-videos-are-surreal.

Maltby, Sarah. *Military Media Management Negotiating the "Front" Line in Mediatized War.* New York: Routledge, 2012.

Maney, Kevin. "Tiny Tech Company Awes Viewers." *USA Today*, March 21, 2003. Lexis-Nexis Academic.

Mann, Paul. *Masocriticism.* Albany, N.Y.: SUNY Press, 1999.

Manovich, Lev. "Modern Surveillance Machines: Perspective, Radar, 3-D Computer Graphics, and Computer Vision." In *CTRL [SPACE]: Rhetorics of Surveillance from Bentham to Big Brother*, edited by Thomas Y. Levin, Ursula Frohne, and Peter Weibel, 382–95. New Haven, Conn.: MIT Press, 2002.

Manuel, Steve G. "Images from the Sky." *Technology in Society* 14, no. 4 (1992): 409–25.

"Mars Sucks—Can Games Fly on Google Earth?" *Gamasutra*, December 21, 2006. https://www.gamasutra.com/view/feature/130167/mars_sucks__can_games_fly_on_.php.

Marshall, S. L. A. *Men against Fire: The Problem of Battle Command.* Norman: University of Oklahoma Press, 2000.

Martin, David, and Dan Rather. "How Ground War Is Likely to Proceed in Gulf War; Update on War (8:00 PM)." *CBS News Special Report*, February 23, 1991. LexisNexis Academic.

Martin, Geoff, and Erin Steuter. *Pop Culture Goes to War: Enlisting and Resisting Militarism in the War on Terror.* Lanham, Md.: Rowman & Littlefield, 2010.

Masood, Salman, and Pir Zubair Shah. "C.I.A. Drones Kill Civilians in Pakistan." *New York Times*, March 17, 2011. http://www.nytimes.com/2011/03/18/world/asia/18pakistan.html.

Massumi, Brian. *Ontopower: War, Powers, and the State of Perception.* Durham, N.C.: Duke University Press, 2015.

Mawby, Nathan. "Fly a Drone with iPhone Eye in the Sky." *Herald Sun*, April 21, 2012. Lexis-Nexis Academic.

Mayer, Jane. "The Predator War." *New Yorker*, October 26, 2009. http://www.newyorker.com/reporting/2009/10/26/091026fa_fact_mayer.

Mayes, Christopher. "'The Violence of Care: An Analysis of Foucault's Pastor.'" *Journal for Cultural and Religious Theory* 11, no. 1 (2010).

Mazzetti, Mark. "The Drone Zone." *New York Times*, July 6, 2012. http://www.nytimes.com/2012/07/08/magazine/the-drone-zone.html.

Mazzetti, Mark, and Helene Cooper. "CIA Chief Indicates Strikes Will Continue in Pakistan." *International Herald Tribune*, February 27, 2009. LexisNexis Academic.

McCarthy, Anna. "Stanley Milgram, Allan Funt, and Me: Postwar Social Science and the 'First Wave' of Reality TV." In *Reality TV: Remaking Television Culture*, edited by Susan Murray and Laurie Ouellette, 19–39. New York: NYU Press, 2004.

McCarthy, Phillip. "CNN: The Media's Own Missile." *Sydney Morning Herald*, September 30, 1996. LexisNexis Academic.

McKenna, Bill. "Drone Art: James Bridle Poses Questions in White House's Shadow." *BBC*, June 24, 2013. http://www.bbc.com/news/magazine-22997396.

McLuhan, Marshall. *The Gutenberg Galaxy: The Making of Typographic Man.* Toronto: University of Toronto Press, 1962.

———. *Understanding Media: The Extensions of Man.* Cambridge, Mass.: MIT Press, 1994.

McSorley, Kevin. "Helmetcams, Militarized Sensation and 'Somatic War.'" *Journal of War & Culture Studies* 5, no. 1 (2012): 47–58.

McVeigh, Karen. "Drone Strikes: Tears in Congress as Pakistani Family Tells of Mother's Death." *Guardian*, October 29, 2013. https://www.theguardian.com/world/2013/oct/29/pakistan-family-drone-victim-testimony-congress.

Milbank, Dana. "Bush Defends Assertions of Iraq-Al Qaeda Relationship." *Washington Post*, June 18, 2004. http://www.washingtonpost.com/wp-dyn/articles/A50679-2004Jun17.html.

"Military/Civilian Deaths in Iraq Study." AP/Ipsos Poll, February 16, 2007. http://surveys.ap.org/data/Ipsos/national/2007-02-16%20AP%20Iraq-soldiers%20topline.pdf.

Miller, Greg. "Plan for Hunting Terrorists Signals U.S. Intends to Keep Adding Names to Kill Lists." *Washington Post*, October 23, 2012. https://www.washingtonpost.com/world/national-security/plan-for-hunting-terrorists-signals-us-intends-to-keep-adding-names-to-kill-lists/2012/10/23/4789b2ae-18b3-11e2-a55c-39408fbe6a4b_story.html.

Mirzoeff, Nicholas. *The Right to Look: A Counterhistory of Visuality*. Durham, N.C.: Duke University Press, 2011.

———. *Watching Babylon: The War in Iraq and Global Visual Culture*. New York: Routledge, 2005.

Mitchell, Greg. "When WikiLeaks Came to Fame, Two Years Ago, with 'Collateral Murder.'" *Nation*, April 5, 2012. https://www.thenation.com/article/when-wikileaks-came-fame-two-years-ago-collateral-murder/.

Mitchell, W. J. T. *Picture Theory: Essays on Verbal and Visual Representation*. Chicago: University of Chicago Press, 1995.

———. *What Do Pictures Want?: The Lives and Loves of Images*. Chicago: University of Chicago Press, 2005.

Mitchell, William John Thomas. *Cloning Terror: The War of Images, 9/11 to the Present*. Chicago: University of Chicago Press, 2011.

Mohr, Charles. "Salvador Arms—Aid Charges Detailed." *New York Times*, August 9, 1984. http://www.nytimes.com/1984/08/09/world/salvador-arms-aid-charges-detailed.html.

Monbiot, George. "In the US, Mass Child Killings Are Tragedies. In Pakistan, Mere Bug Splats." *Guardian*, December 17, 2012. https://www.theguardian.com/commentisfree/2012/dec/17/us-killings-tragedies-pakistan-bug-splats.

Montgomery, David, and David Montgomery. "What Happened in Iraq?" *Washington Post*, February 17, 2012. https://www.washingtonpost.com/lifestyle/style/what-happened-in-iraq/2012/02/17/gIQA080CSR_story.html.

Moretti, Eddy. "Michael Moore Talks to *Vice* about *American Sniper*, the End of Sarah Palin, and PTSD." *Vice*, February 2, 2015. http://www.vice.com/read/exclusive-interview-michael-moore-on-american-sniper-sarah-palin-and-ptsd-261.

Moriarty, Sandra E., and David Shaw. "An Antiseptic War: Were News Magazine Images of the Gulf War Too Soft?" *Visual Communication Quarterly* 2, no. 2 (1995): 4–11.

Mottern, Nick. "Nick Mottern of Knowdrones." Interview by Roger Stahl. *The Vision Machine*, September 21, 2011. http://thevisionmachine.com/2012/11/innerview-nick-mottern-of-knowdrones/.

Mulrine, Anna. "Drone Pilots: Why War Is Also Hard for Remote Soldiers." *Christian Science Monitor*, February 28, 2012. https://www.csmonitor.com/USA/Military/2012/0228/Drone-pilots-Why-war-is-also-hard-for-remote-soldiers.

"Naming the Dead." *Bureau of Investigative Journalism*, March 6, 2017. https://v1.thebureauinvestigates.com/namingthedead.

Nazaryan, Alexander. "*American Sniper* and the Soul of War." *Newsweek*, January 16, 2015. http://www.newsweek.com/2015/01/30/american-sniper-and-soul-war-299987.html.

Needham, Alex. "Bradley Cooper Denies *American Sniper* Is 'a Political Movie.'" *Guardian*, December 16, 2014. https://www.theguardian.com/film/2014/dec/16/bradley-cooper -american-sniper-not-political.

Needless Deaths in the Gulf War: Civilian Casualties during the Air Campaign and Violations of the Laws of War. New York: Human Rights Watch, 1991.

Noah, Timothy. "Birth of a Washington Word." *Slate*, November 20, 2002. http://www.slate .com/articles/news_and_politics/chatterbox/2002/11/birth_of_a_washington_word .html.

Nolan, Hamilton. "NYPD Proves Street Artist Right by Tracking Him Down and Arrest- ing Him." *Gawker*, November 30, 2012. http://gawker.com/5964619/nypd-proves-street -artist-right-by-tracking-him-down-and-arresting-him.

Norris, Margot. "Only the Guns Have Eyes: Military Censorship and the Body Count." In *Seeing through the Media: The Persian Gulf War*, edited by Susan Jeffords and Lauren Rabinovitz, 285–300. New Brunswick, N.J.: Rutgers University Press, 1994.

"#NotABugSplat." Accessed March 9, 2017. https://notabugsplat.com/.

Obeidallah, Dean. "*American Sniper* a Powerful Anti-war Film." *CNN*. Accessed July 4, 2016. http://www.cnn.com/2015/01/27/opinion/obeidallah-american-sniper/index .html.

"OCPA-West Weekly Reports, 2010–2015." Army Entertainment Liaison Office, 2015. http://www.mediafire.com/file/280cunxxp32660e/USArmy -EntertainmentLiaisonOffice-2010to2015reports.pdf.

Ohl, Jessy J. "Nothing to See or Fear: Light War and the Boring Visual Rhetoric of U.S. Drone Imagery." *Quarterly Journal of Speech* 101, no. 4 (2015): 612–32.

Opelka, Mike. "New York Cops Finally Nab Artist Who Posted Embarrassing 'NYPD Drone' Posters." *Blaze*, December 9, 2012. http://www.theblaze.com/stories/2012/12/ 09/new-york-cops-finally-nab-artist-who-posted-embarrassing-nypd-drone-posters/.

"Operation Desert Storm: Evaluation of the Air War." U.S. General Accounting Office, July 1996. https://www.gpo.gov/fdsys/pkg/GAOREPORTS-PEMD-96-10/pdf/ GAOREPORTS-PEMD-96-10.pdf.

Ortiz, Erik. "'I Was Scared to Death': U.S. Soldier Who Made Helmet-Cam Video Identi- fied." *NY Daily News*, January 28, 2013. http://www.nydailynews.com/news/world/u-s -soldier-made-helmet-cam-video-identified-article-1.1249696.

Packer, Jeremy. "Becoming Bombs: Mobilizing Mobility in the War on Terror." *Cultural Studies* 20, no. 4–5 (2006): 378–99.

Packer, Jeremy, and Joshua Reeves. "Romancing the Drone: Military Desire and Anthropo- phobia from SAGE to Swarm." *Canadian Journal of Communication* 38 (2013): 309–31.

"Pakistan's Artistic Appeal to Drone Pilots." *Daily Telegraph*, April 9, 2014. LexisNexis Academic.

Parks, Lisa. *Cultures in Orbit*. Durham, N.C.: Duke University Press, 2005.

———. "Digging into Google Earth: An Analysis of 'Crisis in Darfur.'" *Geoforum* 40, no. 4 (July 2009): 535–45.

———. "Satellite Views of Srebrenica: Tele-visuality and the Politics of Witnessing." *Social Identities* 7, no. 4 (2001): 585–611.

"Pentagon Updates on Desert Storm." *CBS Special Report*, January 21, 1991. LexisNexis Academic.

Perlmutter, David D. *Visions of War: Picturing Warfare from the Stone Age to the Cyber Age*. New York: St. Martin's Griffin, 2001.

Pettegrew, John. *Light It Up: The Marine Eye for Battle in the War for Iraq*. Baltimore: Johns Hopkins University Press, 2015.

Pilkington, Ed. "International: US Criticised for Limiting Iraqi Refugee Intake to 500." *Guardian*, January 3, 2007. LexisNexis Academic.

———. "Life as a Drone Operator: 'Ever Step on Ants and Never Give It Another Thought?'" *Guardian*, November 19, 2015. https://www.theguardian.com/world/2015/nov/18/life-as-a-drone-pilot-creech-air-force-base-nevada.

Pitzke, Marc. "How Drone Pilots Wage War." *Spiegel Online*, December 3, 2010. http://www.spiegel.de/international/world/0,1518,682420,00.html.

Powell, Colin. "Full Text of Colin Powell's Speech." *Guardian*, February 5, 2003. https://www.theguardian.com/world/2003/feb/05/iraq.usa.

Powell, Michael, and Dana Priest. "U.S. Citizen Killed by CIA Linked to N.Y. Terror Case." *Washington Post*, November 9, 2002. LexisNexis Academic.

Power, Marcus. "Digitized Virtuosity: Video War Games and Post-9/11 Cyber-Deterrence." *Security Dialogue* 38, no. 2 (2007): 271–88.

Power, Matthew. "Confessions of an American Drone Operator." *GQ*, October 23, 2013. http://www.gq.com/story/drone-uav-pilot-assassination.

Prashad, Vijay. "Bradley Manning, Crimes against Humanity and the Values of International Law." *Counterpunch*, August 22, 2013. http://www.counterpunch.org/2013/08/22/bradley-manning-crimes-against-humanity-and-the-values-of-international-law/.

Pulver, Andrew. "*American Sniper*: Propaganda Movie or Tale the Nation Needed to Hear?" *Guardian*, January 23, 2015. https://www.theguardian.com/film/2015/jan/23/american-sniper-propaganda-political-row.

———. "Harrison Ford Defends Ender's Game as 'Impressive Act of Imagination.'" *Guardian*, October 8, 2013. https://www.theguardian.com/film/2013/oct/08/harrison-ford-enders-game-gay-marriage.

Ranciere, Jacques, Davide Panagia, and Rachel Bowlby. "Ten Theses on Politics." *Theory & Event* 5, no. 3 (2001).

Reese, Nathan. "James Bridle Takes Us 'Under the Shadow of the Drone.'" *Creators*, May 3, 2013. https://creators.vice.com/en_us/article/under-the-shadow-of-the-drone.

Richelson, Jeffrey. "Declassifying the 'Fact of' Satellite Reconnaissance." *National Security Archive Electronic Briefing Book No. 231*, October 1, 2007. http://nsarchive.gwu.edu/NSAEBB/NSAEBB231/.

Robb, David L. *Operation Hollywood: How the Pentagon Shapes and Censors the Movies*. Amherst, N.Y.: Prometheus Books, 2004.

Roberts, Les, Riyadh Lafta, Richard Garfield, Jamal Khudhairi, and Gilbert Burnham. "Mortality before and after the 2003 Invasion of Iraq: Cluster Sample Survey." *Lancet* 364, no. 9448 (2004): 1857–64.

Robins, Kevin. *Into the Image: Culture and Politics in the Field of Vision*. New York: Routledge, 1996.

Robins, Kevin, and Les Levidow. "Socializing the Cyborg Self: The Gulf War and Beyond." In *The Cyborg Handbook*, edited by Chris Hables Gray, 119–26. New York: Routledge, 1995.

Rogan, Mary. "GULF: Oh, What a Wonderful War." *Globe and Mail*, January 22, 1991. LexisNexis Academic.

Roger, Nathan. *Image Warfare in the War on Terror*. New York: Palgrave Macmillan, 2013.

Rosen, Nir. "The Flight from Iraq." *New York Times*, May 13, 2007. LexisNexis Academic.

Rosen, Rebecca J. "The Places Where America's Drones Are Striking, Now on Instagram." *Atlantic*, November 12, 2012. http://www.theatlantic.com/technology/archive/2012/11/the-places-where-americas-drones-are-striking-now-on-instagram/265112/.

Rosenbaum, Ron. "Ban Drone-Porn War Crimes." *Slate Magazine*, August 31, 2010. Lexis-Nexis Academic.

Rosenberg, Alyssa. "*American Sniper*'s Missing Element: The Man behind the Gun." *Washington Post*, January 23, 2015. https://www.washingtonpost.com/opinions/american -snipers-missing-element-the-man-behind-the-gun/2015/01/23/75826a06-a291-11e4 -903f-9f2faf7cd9fe_story.html.

Ross, Alice. "Former US Drone Technicians Speak Out against Programme in Brussels." *Guardian*, July 1, 2016. https://www.theguardian.com/world/2016/jul/01/us-drone -whistleblowers-brussels-european-parliament.

Rubin, Alissa, Qais Mizher, and Ahmad Fadam. "2 Iraqi Journalists Killed as U.S. Forces Clash with Militias." *New York Times*, July 13, 2007. http://www.nytimes.com/2007/07/ 13/world/middleeast/13iraq.html.

Savage, Charlie. "Secret U.S. Memo Made Legal Case to Kill a Citizen." *New York Times*, October 8, 2011. http://www.nytimes.com/2011/10/09/world/middleeast/secret-us -memo-made-legal-case-to-kill-a-citizen.html.

Scahill, Jeremy. "The Assassination Complex." *Intercept*, October 15, 2015. https:// theintercept.com/drone-papers/the-assassination-complex/.

———. *Blackwater: The Rise of the World's Most Powerful Mercenary Army*. New York: Nation Books, 2007.

———. "Inside the CIA and Pentagon Turf War over Drone Supremacy." *Intercept*, October 15, 2015. https://theintercept.com/drone-papers/find-fix-finish/.

Scarry, Elaine. *The Body in Pain*. New York: Oxford University Press, 1985.

Schembri, Jim. "Bomb Iraq Now. We Need the Footage." *Age*, October 31, 2002. LexisNexis Academic.

Schmidle, Nicholas. "In the Crosshairs." *New Yorker*, June 3, 2013. http://www.newyorker .com/magazine/2013/06/03/in-the-crosshairs.

Schonfeld, Zach. "#NotABugSplat, an Art Project Designed to Be Seen by Drones." *Newsweek*, April 8, 2014. http://www.newsweek.com/notabugsplat-art-project-designed-be -seen-drones-245191.

Secker, Tom. "Biggest Ever FOIA Release from Pentagon Entertainment Liaison Offices." *Spy Culture*, July 12, 2015. http://www.spyculture.com/biggest-ever-foia-release-from -pentagon-entertainment-liaison-office/.

Serle, Jack, and Chris Woods. "Secret US Documents Show Brennan's 'No Civilian Drone Deaths' Claim Was False." *Bureau of Investigative Journalism*, April 11, 2013. https://www .thebureauinvestigates.com/2013/04/11/secret-us-documents-show-brennans-no-civilian -drone-deaths-claim-was-false/.

Shachtman, Noah. "Air Force to Unleash 'Gorgon Stare' on Squirting Insurgents." *Wired*, February 19, 2009. http://www.wired.com/dangerroom/2009/02/gorgon-stare/.

———. "The Army's New Land Warrior Gear: Why Soldiers Don't Like It." *Popular Mechanics*, October 30, 2009. http://www.popularmechanics.com/technology/military/4215715.

Shales, Tom. "The Voice in Command Schwarzkopf's Skill in War's Other Theater." *Washington Post*, January 31, 1991. LexisNexis Academic.

Shane, Scott. "C.I.A. Claim of No Civilian Deaths from Drones Is Disputed." *New York Times*, August 11, 2011. http://www.nytimes.com/2011/08/12/world/asia/12drones.html.

———. "C.I.A. to Expand Use of Drones in Pakistan." *New York Times*, December 4, 2009. http://www.nytimes.com/2009/12/04/world/asia/04drones.html.

Shapiro, Michael J. *Cinematic Geopolitics*. New York: Routledge, 2008.

Shaw, Ian G. R. "Predator Empire: The Geopolitics of US Drone Warfare." *Geopolitics* 18 (2013): 536–59.

Shelton, General Henry H. *Joint Vision 2020*. Washington, D.C.: U.S. Government Printing Office, 2000.

"Showdown in the Gulf Coverage Continues." *CBS News Special Report: Showdown in the Gulf (10:00 AM ET)*. CBS, January 18, 1991. LexisNexis Academic.

"Showdown in the Gulf; Iraq Attacks Israel." *CBS News Special Report: Showdown in the Gulf (9:00 AM ET)*. CBS, January 18, 1991. LexisNexis Academic.

Shugar, Scott. "Operation Desert Store: First the Air War, Then the Ground War, Now the Marketing Campaign." *Los Angeles Times*, September 29, 1991. LexisNexis Academic.

Singer, P. W. *Corporate Warriors: The Rise of the Privatized Military Industry*. Ithaca, N.Y.: Cornell University Press, 2003.

———. *Wired for War: The Robotics Revolution and Conflict in the 21st Century*. New York: Penguin, 2009.

P. W. Singer, Corporate Warriors: The Rise of the Privatized Military Industry (Ithaca, N.Y.: Cornell University Press, 2003)

Sirota, David. "Pentagon, CIA Likely Approved *Zero Dark Thirty* Torture Scenes." *Salon*, December 20, 2012. http://www.salon.com/2012/12/20/pentagon_cia_likely_approved _zero_dark_thirty_torture_scenes/.

Sloyan, Patrick. "What Bodies?" In *The Iraq War Reader: History, Documents, Opinions*, edited by Michael L. Sifry and Christopher Cerf, 129–34. New York: Touchstone Books, 2003.

"'Smart Bomb': Inside the Video Game Industry." *NPR*, November 15, 2005. http://www.npr .org/templates/story/story.php?storyId=5011925.

"Smart Bombs." *Modern Marvels*. History Channel, September 30, 2003.

Smith, Christina M. "Gaze in the Military: Authorial Agency and Cinematic Spectatorship in 'Drone Documentaries' from Iraq." *Continuum: Journal of Media & Cultural Studies* 30, no. 1 (2016): 89–99.

Smith, Clive Stafford. "Drones: The West's New Terror Campaign." *Guardian*, September 25, 2012. https://www.theguardian.com/commentisfree/2012/sep/25/drones-wests-terror -weapons-doodlebugs-1.

Smith, R. Jeffrey, and Evelyn Richards. "Numerous U.S. Bombs Probably Missed Targets; Not All Munitions Used in Gulf Are Smart." *Washington Post*, February 22, 1991. Lexis- Nexis Academic.

Sontag, Susan. *On Photography*. New York: Farrar, Straus, and Giroux, 1977.

"Special Defense Department Briefing by: General Norman Schwarzkopf, Commander, Persian Gulf Forces; Lt. General Charles A. Horner, US Central Command, Air Force. Riyadh, Saudi Arabia." *Federal News Service*, January 18, 1991. LexisNexis Academic.

Spurr, David. *The Rhetoric of Empire: Colonial Discourse in Journalism, Travel Writing, and Imperial Administration*. Durham, N.C.: Duke University Press, 1993.

Stahl, Roger. "Have You Played the War on Terror?" *Critical Studies in Media Communication* 23, no. 2 (2006): 112–30.

———. *Militainment, Inc.: War, Media, and Popular Culture*. New York: Routledge, 2010.

———. "Weaponizing Speech." *Quarterly Journal of Speech* 102, no. 4 (October 1, 2016): 376–95.

———. "Why We 'Support the Troops': Rhetorical Evolutions." *Rhetoric & Public Affairs* 12, no. 4 (2009): 533–70.

Stam, Robert. "Mobilizing Fictions: The Gulf War, the Media, and the Recruitment of the Spectator." *Public Culture* 4, no. 2 (1992): 101–26.

Stangler, Cole. "Drone Free Zone." *In These Times*, November 20, 2013. http://inthesetimes .com/article/15910/code_pink_hosts_second_annual_anti_drone_summit/%20.

Steele, Jonathan, and Suzanne Goldenberg. "What Is the Real Death Toll in Iraq?" *Guardian*, March 19, 2008. https://www.theguardian.com/world/2008/mar/19/iraq.

Stein, Rebecca L. "GoPro Occupation: Networked Cameras, Israeli Military Rule, and the Digital Promise." *Current Anthropology* 58, no. 15 (2017): S56–64.

Sterling, Bruce. "An Essay on the New Aesthetic." *Wired*, April 2, 2012. https://www.wired.com/2012/04/an-essay-on-the-new-aesthetic/.

Stewart, Cameron. "Silent but Deadly." *Weekend Australian*, March 13, 1999. LexisNexis Academic.

Stone, Jay. "Satire Wags Its Finger at Political String-Pulling." *Ottawa Citizen*, January 16, 1998. LexisNexis Academic.

Strauss, Bob. "Film Focuses Strictly on Marines." *San Diego Union Tribune*, November 2, 2005. http://legacy.sandiegouniontribune.com/uniontrib/20051102/news_1c02jarhead.html.

Sturken, Marita. "Television Vectors and the Making of a Media Event: The Helicopter, the Freeway Chase, and National Memory." In *Reality Squared: Televisual Discourse of the Real*, edited by James Friedman, 185–202. New York: Rutgers University Press, 2002.

Susman, Tina. "Poll: Civilian Toll in Iraq May Top 1M." *Los Angeles Times*, September 14, 2007. http://www.latimes.com/world/la-fg-iraq14sep14-story.html.

Swift, Daniel. "Cultural Damage: A History of Bombing." *Harper's Magazine*, November 2011.

———. "Drone Knowns and Drone Unknowns." *Harper's Magazine*, October 27, 2011. http://harpers.org/blog/2011/10/drone-knowns-and-drone-unknowns/.

Tait, Sue. "Pornographies of Violence? Internet Spectatorship on Body Horror." *Critical Studies in Media Communication* 25, no. 1 (March 2008): 91–111.

Tale of Two Cities. Vol. 74. U.S. War Department, 1946.

Taub, Amanda. "Every Movie Rewrites History. What *American Sniper* Did Is Much, Much Worse." *Vox*, January 22, 2015. http://www.vox.com/2015/1/22/7859791/american-sniper-iraq.

Taylor, John. *Body Horror: Photojournalism, Catastrophe and War*. Manchester: Manchester University Press, 1998.

Taylor, Paul. "U.S. Success Is Immediate, Victory Is Not; At 85%, Confidence in Military Strikes Highest Point in Years." *Washington Post*, January 31, 1991. LexisNexis Academic.

Taylor, Philip M. *War and the Media: Propaganda and Persuasion in the Gulf War*. 2nd ed. Manchester: Manchester University Press, 1998.

Taylor, Telford. "Long-Range Lessons of the U-2 Affair." *New York Times*, July 24, 1960. ProQuest Historical Newspapers.

Teichner, Martha. "United States' Apache Helicopter (11:00 PM)." *CBS News Special Report*, February 23, 1991. LexisNexis Academic.

Tenold, Vegas. "The Untold Casualties of the Drone War." *Rolling Stone*, February 18, 2016. http://www.rollingstone.com/politics/news/the-untold-casualties-of-the-drone-war-20160218.

Thomas, Brett. "Smart Bombs Stupid." *Sydney Herald*, July 14, 1996. LexisNexis Academic.

Thompson, Keith. "Drone Porn: The Newest YouTube Hit." *Huffington Post*, December 30, 2009. http://www.huffingtonpost.com/keith-thomson/drone-porn-the-newest-you_b_407083.html.

Thompson, Neal. "NSA Goes to the Movies: As Technology Looms Ever Larger in Our Lives, Hollywood Is Seeking a New Vision of Villainy in the Secret Intelligence Agency at Fort Meade." *Baltimore Sun*, February 15, 1998. http://articles.baltimoresun.com/1998-02-15/features/1998046083_1_nsa-guy-fort-meade-nsa-agents.

"Tracking U.S. Drone Strikes with Tech." *MSNBC*, February 9, 2013. http://www.msnbc
.com/msnbc/watch/tracking-us-drone-strikes-with-tech-17864259804.

Trotter, J. K. "*American Sniper* Correspondence." *MuckRock*. Accessed January 22, 2016.
https://www.muckrock.com/foi/united-states-of-america-10/american-sniper
-correspondence-15535/.

———. "*American Sniper* Correspondence (DOD)." *MuckRock*. Accessed January 22,
2016. https://www.muckrock.com/foi/united-states-of-america-10/american-sniper
-correspondence-dod-22343/.

Turse, Nick. "Torturing Iron Man: The Strange Reversals of a Pentagon Blockbuster."
May 20, 2008. http://www.tomdispatch.com/post/174934/nick_turse_irony_man.

"UAV Predator Takes Out Insurgent Mortar Team with Hellfire Missile in Iraq." June 18,
2008. https://www.liveleak.com/view?i=2e5_1213810145.

"US Ground Troops Preparing for Action." *CBS News Special Report (8:00 PM ET)*. CBS,
January 18, 1991. LexisNexis Academic.

"US Official Footage of Airstrikes on Iraqi Hydroelectic Plant." *CBS Evening News*. CBS,
January 22, 1991. LexisNexis Academic.

"USMC Television and Motion Picture Liaison Office: Los Angeles Weekly Reports,
2008–2015." 2015. http://www.mediafire.com/file/ejobce8tymr67m7/USMC
-ELOreports-2008to2015.pdf.

Vick, Karl. "Whole Truth of Gulf War Is Trickling Out." *St. Petersburg Times*, February 10,
1992. LexisNexis Academic.

Victory through Air Power. Walt Disney, 1943.

Virilio, Paul. *Desert Screen: War at the Speed of Light*. New York: Continuum, 2002.

———. *War and Cinema: The Logistics of Perception*. New York: Verso, 1989.

von Clausewitz, Carl. *On War*. Translated by Michael Howard and Peter Paret. Oxford:
Oxford University Press, 2007.

Walker, Lauren. "What 'Good Kill' Gets Wrong about Drone Warfare." *Newsweek*, May 15,
2015. http://www.newsweek.com/2015/05/22/watch-drone-331949.html.

Wall, Tyler, and Torin Monahan. "Surveillance and Violence from Afar: The Politics of
Drones and Liminal Security-Scapes." *Theoretical Criminology* 15, no. 3 (2011): 239–54.

Walsh, Declan. "80 Dead in Pakistan Madrasa Raid." *Guardian*, October 30, 2006. https://
www.theguardian.com/world/2006/oct/30/alqaida.pakistan.

Wark, McKenzie. *Virtual Geography: Living with Global Media Events*. Bloomington: Indi-
ana University Press, 1994.

Weber, Elizabeth. "Vectorizing Our Thoughts toward 'Current Events': For Avital Ronell." In
Reading Ronell, edited by Diane Davis, 222–40. Urbana: University of Illinois Press, 2009.

Weiner, Jonah. "Prying Eyes." *New Yorker*, October 15, 2012. http://www.newyorker.com/
magazine/2012/10/22/prying-eyes.

Weiner, Tim. "Pentagon Envisioning a Costly Internet for War." *New York Times*, Novem-
ber 13, 2004. https://www.nytimes.com/2004/11/13/technology/pentagon-envisioning
-a-costly-internet-for-war.html.

———. "'Smart' Weapons Were Overrated, Study Concludes." *New York Times*, July 9, 1996.
LexisNexis Academic.

Weizman, Eyal. *Hollow Land: Israel's Architecture of Occupation*. London: Verso, 2012.

Wingfield, Nick. "Apple Deems Drone Strike App Inappropriate." *New York Times*, Septem-
ber 3, 2012. LexisNexis Academic.

Wittkower, D. E. "What Ender's Game Tells Us about Real Drone Pilots." *Slate*, Novem-
ber 12, 2013. http://www.slate.com/blogs/future_tense/2013/11/12/ender_s_game_and
_drone_operator_psychology.html.

Woods, Chris. "Analysis: Obama Embraced Redefinition of 'Civilian' in Drone Wars." *Bureau of Investigative Journalism*, May 29, 2012. https://www.thebureauinvestigates .com/2012/05/29/analysis-how-obama-changed-definition-of-civilian-in-secret-drone -wars/.

———. "The Civilian Massacre the US Neither Confirms nor Denies." *Bureau of Investigative Journalism*, March 29, 2012. https://www.thebureauinvestigates.com/2012/03/29/ the-civilian-massacre-the-us-will-neither-confirm-nor-deny/.

Woodward, Bob. *Obama's Wars*. New York: Simon & Schuster, 2011.

Yaqoob, Janine. "Iron Man and Transformers Censored by US Military for Getting Too Close to the Truth." July 11, 2015. http://www.mirror.co.uk/news/world-news/iron-man -transformers-censored-military-6050507.

Yost, Peter. "Rise of the Drones." *NOVA*. PBS, January 23, 2013.

Zarefsky, David. "Making the Case for War: Colin Powell at the United Nations." *Rhetoric & Public Affairs* 10, no. 2 (2007): 275–302.

Zetter, Kim. "U.S. Soldier on 2007 Apache Attack: What I Saw." *Wired*, April 20, 2010. https://www.wired.com/2010/04/2007-iraq-apache-attack-as-seen-from-the-ground/.

Index

Numbers in italic represent pages with figures.

About the Author

ROGER STAHL (PhD, Penn State University) is an associate professor of communication studies at the University of Georgia who studies rhetoric, media, and culture. He is author of *Militainment, Inc.* (2010), which examines the military-entertainment complex, public relations, and propaganda. Dr. Stahl has been published in numerous academic journals such as the *Quarterly Journal of Speech, Rhetoric & Public Affairs* and *Critical Studies in Media Communication*. In a more public capacity, he has produced the documentary films *Militainment, Inc.* (2007) and *Returning Fire* (2011), both distributed by the Media Education Foundation. His commentary has appeared in such venues as NPR's *All Things Considered*, the *Guardian*, and *Al Jazeera*.